Wonder Strikes

Wonder Strikes

Approaching Aesthetics and Literature
with William Desmond

STEVEN E. KNEPPER

Foreword by
WILLIAM DESMOND

Published by State University of New York Press, Albany

© 2022 State University of New York

All rights reserved

Printed in the United States of America

No part of this book may be used or reproduced in any manner whatsoever without written permission. No part of this book may be stored in a retrieval system or transmitted in any form or by any means including electronic, electrostatic, magnetic tape, mechanical, photocopying, recording, or otherwise without the prior permission in writing of the publisher.

For information, contact State University of New York Press, Albany, NY
www.sunypress.edu

Library of Congress Cataloging-in-Publication Data

Names: Knepper, Steven E., author. | Desmond, William, 1951– writer of foreword.
Title: Wonder strikes : approaching aesthetics and literature with William Desmond / Steven E. Knepper, William Desmond.
Description: Albany : State University of New York Press, [2022] | Includes bibliographical references and index.
Identifiers: LCCN 2022005571 | ISBN 9781438489551 (hardcover : alk. paper) | ISBN 9781438489575 (ebook) | ISBN 9781438489568 (pbk. : alk. paper)
Subjects: LCSH: Desmond, William, 1951– | Aesthetics.
Classification: LCC B1626.D474 K59 2022 | DDC 111/.85—dc23/eng/20220218
LC record available at https://lccn.loc.gov/2022005571

10 9 8 7 6 5 4 3 2 1

For Catherine and Clare,
who continually strike me with wonder

Contents

Foreword by William Desmond	xi
Abbreviations	xvii
Acknowledgments	xix
Introduction	1

Part 1: Incarnate Wonder

1. Aesthetics in Flesh, Image, and Word	13
Receptivity	13
Abundance	23
Affirmation	32
Wonder	35
2. The Call of Beauty	45
Call and Response	46
Between Beauty and the Sublime	52
Will Beauty Save the World?	60
3. The Artist and the Between	73
Between Imitation and Creation	73
Between Inspiration and Skill	82
Between Tradition and the Individual Talent	86

4. Sacred Aesthetics	93
Hierophany	95
The Sacred in a Time of Serviceable Disposability	100
God's Grandeur	105
Poetry, Prayer, and the Unsayable	114
Asking Too Much, Asking Too Little	120

Part 2: Reading in the Between

5. Epiphanic Encounters	131
Criticism in the *Metaxu*	132
From Recognition to Epiphany	139
Epiphanic Things	151
The Poetry of Place	155
6. Tragic Howls and Being at a Loss	159
Macbeth, the Sleepless Tyrant	160
Lear, the Sleepwalking Sovereign	168
Philosophy at a Loss	171
7. Redemptive Laughs and Festive Rebirth	175
Laughter and Affirmation	175
Ahab's Absent Laugh	180
Can Philosophy Laugh at Itself?	187
The Festive in a Time of Need	194
Scrooge and Festive Anamnesis	198
Conclusion	205
Notes	217
Bibliography	251
Name Index	267

Great art has always drawn its admirers by its power to renew our astonishment before the mysterious happening of being, not of course in such a seemingly generalized way, but by an aesthetic fidelity to the inexhaustible singularities of the world, human and nonhuman. In its being true to these singularities, it recharges our sense of the otherness of being, and so it offers a gift and challenge to philosophy. The gift: here something of replete moment is opened or released. The challenge: now think *that!*

—William Desmond, *Art, Origins, Otherness*, 2

Foreword

William Desmond

Reading Steven Knepper's *Wonder Strikes*, I am reminded of a long love affair between the poetic and the philosophic. I am taken back to earlier days of love and am struck that the love persisted, and indeed that I have been faithful to it, in my own way, in the many intervening years. Between poetics and system: that might be one name for it. Being brought back to my earliest intellectual love, I am also reminded that from the time I was taken with philosophy, the intimate relation with the poetic and the religious could not be divorced from the venture of thinking.

Art, religion, philosophy: this is the triad that composes Hegel's philosophy of absolute spirit, and I have found myself in agreement with Hegel's placement of these in positions of ultimacy. I have tried to participate in a dialogue between these three, not exactly in the same spirit of Hegel's dialectical orientation, and more metaxologically. In Hegel's dialectical orientation, there is a hierarchy of ultimacy in which philosophy finally sublates what is of essential significance in art and religion into its own self-determining concept. By contrast, by participating metaxologically in their conversation, there is a companioning relation between the three that allows plurivocal dialogues between them: between art and philosophy; between art and religion; between religion and philosophy; between art, religion, and philosophy. The companions in conversations are in a betweening space that cannot rightfully be described in terms of the system of concepts that closes the circle on itself in claimed self-comprehension. Wonder is at the origin, companions the middle, and is there at the end, indeed outlives every finite completion.

Art, religion, philosophy: each of these three is subtended by what I call the overdeterminacy of being, the too muchness of given being. They address, explore, and give expression to that overdeterminacy in a variety of different modalities. They are exceeded by that overdeterminacy, even when they have attempted their most ambitious ventures, and even when in the process they have achieved a kind of qualified wholeness. The too muchness, the overdeterminacy is communicated from the outset, accompanies our middle journey and sojourn, and outlives all our efforts to make the best sense possible of beings and ourselves in the midst of things. There is a different logos of the *metaxu* that exceeds the terms of Hegel's speculative dialectic.

These considerations are at work in Steven Knepper's book, a work that itself is an admirable companioning venture in that middle space between the poetic and systematic. It formulates the issue in ways that do not bog down in the ancient quarrel between the poets and the philosophers, and that yet do not encourage a rationalistic supersessionism relative to the often-enigmatic communications that the poetic and the artistic offer us, and the religious too. I seem to be talking of a twosome here, but given the subtending, accompanying, and outliving between, all three are each participant in what allows them each their distinctness and shows them to witness a togetherness more fundamental than differences that they might assert over against each other. There is a porosity between art, religion, and philosophy that is testament to this.

It seems to me that this work itself embodies something of that porosity. While talking ostensibly about the aesthetic and the artistic in relation to the philosophical, the sense of the sacred is never absent in the writing. Equally, when talking about the sense of the sacred, the poetic communication of that, as well as the conceptual wrestling with it, are never siloed. The work as a whole offers a kind of worded enactment of that porosity. For reasons such as this, *Wonder Strikes* is itself a genuine metaxological engagement with a metaxological mindfulness of its own in relation to the particular words that I have tried to find for just that metaxological sense of being.

I find the spirit of the companioning relation in it. Sometimes this is evident in echoes of my words, sometimes in amplification of them, sometimes in the introduction of voices that are not in agreement with ways in which I have formulated matters, sometimes in the raising of perplexities that perhaps have not had enough of an innings. All that is in order, if indeed there is a companioning relation. Companions can be themselves and be other to each other, while yet being in significant relation. There is something of agapeic mindfulness in the work, if I am not mistaken. This to me is not just high achievement but witness to alert receptivity,

intelligent openness, and mindfully responsive words that speak in return to original words offered.

It is a pleasure to read and to be illuminated, in relation to the full range of my thoughts, especially as seen through the more focused lenses of the aesthetic and the artistic. It strikes me that *Wonder Strikes* would serve very well as an overall introduction to my work, as well as a particular illumination of its aesthetic concerns, and all through the elegant writing of a thinker whose attentive mind and searching grasp add to the exploration their own eloquent thoughtfulness. I would recommend the work as an excellent introduction in those terms, and yet it has its own singular register, which comes across through its special focus on aesthetic concerns.

The diverse explorations are never self-enclosed but are always in conversations with others, both overlapping and diverging, sometimes adding new lines of opening to connecting possibilities, possibilities as much new as already tried. The writing moves with crisp energy and is studded with cameos of well-articulated mindfulness. It engages me as a reader, and I am confident it will engage other readers, both those familiar with my work and those new to it. Yet this is a work to be savored.

One sees its virtues in the way the work is laid out. I am an admirer of authors who can offer titles to sections that are compact, precise, and suggestive all at once. What might look like a bare table of contents is redolent of thought that carries poetic power, indeed carries that power into the porosity with the sense of the sacred and with the call of urgency of philosophical perplexity itself. The whole comes across to me as itself possessing something of poised aesthetic form—surely a sign that the writer has worked to excellent effect. There is an artistic hand at work in this.

I appreciate the sorties in bringing metaxological thoughts to bear on some rich samplings of literary texts, especially in the second part: reading in the between. This book is marked by a plurivocal attention to my work as well as to the work of many other thinkers and critics. It is admirably attentive to the what of what I say as well as to the how of my way of saying it. It is full of telling detail. It is acute in its reflective remarks about the detail as well as the sense of the whole. It is full of apt citation and not least again in its attentiveness to the how of the wording.

When the word "aesthetic" is here used, it is not used in any self-enclosed sense of a specialized zone of experience to be cut off from the full economy of human existence. Quite to the contrary: at stake is a more holistic, indeed metaxological sense of the aesthetic, as a constituent dimension of all being in the between. This does not preclude a more singular incarnation of our aesthetic being in art and its works. It does make art in

that more intensive sense permeable to what is more englobing in a holistic and metaxological sense. Indeed, it opens art to the ethos within which we come to be ourselves, the ethos that itself takes form in the articulations of our ethical being, as well as in our being religious and philosophical. A sense of metaxological betweenings is relevant to the conversations between the aesthetic, the religious and philosophical, and indeed the ethical, and Knepper displays exemplary lucidity in handling these betweenings. He does justice not only to each of them in their singular characteristics, but also in being attuned to their fruitful porosity all along the way.

To say a word more about Knepper's attentiveness to the porous boundary between the aesthetic and the ethical: the aesthetic is undergirded by the ecology of life and the incarnate ethos in which our ethical formation takes shape. This is an important stress in the book that connects the importances of the aesthetic with the dominion of serviceable disposability, as I called it. I am referring to what is often spoken of as the instrumentalizing of all things, and indeed creation as a whole, so pervasive in modernity. Knepper is very attuned to concerns attached to this orientation, attuned to its pervasiveness and to the potentially catastrophic implications if the dominion of serviceable disposability is taken to be coincident with the whole. I referred to his finessed eye and admirable deployment of apt citation, but relevant here are lyrical touches of his own. I am thinking of the kind of phenomenological poetry that we find in his way of describing going outdoors on a winter morning, for instance. I recall his reference to Hildegard of Bingen, and her advocacy of the healing power of green things (*viriditas*).

Knepper brings many authors into the conversation, too numerous to mention, creating something of a call and response interplay. I do think he is right in mentioning the figure of Gabriel Marcel. Exhibiting an admirable knowledge of literature, in the final part of the book there are very interesting and engaging discussions with several significant literary artists, not least Charles Dickens. Dickens is often out of favor with some postmodern thinkers, perhaps because he favors a kind of festive affirmation of life, even though there is a darkness in Dickens that is grossly underestimated by those who think of him as a cheery writer. Knepper is aware of all of that.

In these very rich chapters, I mention Gerald Manley Hopkins, whose sense of "the dearest freshness deep down things" is very much my own sense of things, and whose vision of the selving of things enters into the texture of my own exploration of the intimate singularity of all beings. The figure of Dostoyevsky appears throughout the work particularly in connection with my own venture of posthumous mind and what that has to say about our

finitude and reawakening to the second wonder of resurrected astonishment before the gift of being. There is a very illuminating discussion of Herman Melville and the figure of Ahab in connection with *eros turannos*, and the erotic sovereign running the limits of finitude and beyond. Interestingly enough, the comic appears even in a work destined to end in the drowning of all the participants on the *Pequod*, excepting Ishmael.

The figure of Dante appears often in connection with the descent into hell. In going down to the deepest point of frozen Satanic darkness, the movement of the poets Virgil and Dante turns upward and back again to the bright world and the stars still shining in the sky, though night be over the world. The inseparability of going down from turning up is explored multiply. The point is relevant to confronting a postmodern anti-Platonism, which often seems not to want to go up in the direction of the shining sun. The impression is untrue that earlier thinkers and writers were idlers when it comes to the underground and what is under the underground.

And then there is, of course, the glorious Shakespeare. There are impressive discussions of Shakespeare's extraordinary works *Macbeth* and *King Lear*, both of which have been companions over a lifetime to my own struggles for illumination. The matter is handled with grace and adroitness. Once again, I am an admirer of the aptness of citation, the illuminating attention to particular wordings, whether in Shakespeare himself, or in my own efforts to hear Shakespeare's words.

I should mention two other writers, both manifesting the comic vision. I mean Aristophanes and again Dickens. Aristophanes is a figure of great philosophical significance, in his lampoon of Socrates, but also in his ability to debunk a false sense of the divine, even to the point of risking the nihilistic outcome where nothing at all seems to be sacred. Can philosophy laugh at itself? That is the question. And: in the very skepticism about our absurdity is there a redeeming laughter and a companioning of the divine, out of joint with our too familiarized world?

Redeeming laughter is of great moment in my own view of things. Indeed, there is something paradoxically visionary about a laughter that tries to go to the end of the most extreme absurdity and yet finds not just empty absurdity but a surd that is a kind of benign surd, a threshold to a meaning mysteriously communicated and yet also mysteriously withheld. I mentioned how Dickens is not to the taste of many of the postmoderns, often perhaps because there is too much of the festive to him. Festivity, whether Dickensian or other, need not be separable from lucid vision of our dark condition. If to be philosophical is to come to thought in the cave, the philosopher needs night vision. This is worth bearing in mind: one does

not have to be a pessimistic postmodern to be a pilgrim in perplexity, in bafflement by the darkness of things. Such perplexity is as ancient as it is modern, as much medieval as it is postmodern. We are not newcomers in wrestling with the chiaroscuro of the finite between. The affirmative festivity of redeeming laughter has something to do with *singing thought*: thought singing the other to thought only thinking itself.

Knepper's conclusion brings us back to the theme of the underworld. A final word about going underground: Knepper very helpfully draws attention to the word used by Plato about those who manipulate the images in the cave. Plato refers to those who cast shadows in the cave as wonder workers: the Greek word is *thaumatopoioi*. This is something important that I regret I did not notice, and see its significance, significance both constant and contemporary. Knepper connects such wonder workers with the cybernetic culture that now is so pervasive in framing our contemporary world. These wonder workers produce counterfeit wonders. The question is whether our cybernetic culture is not at all struck with wonder, but rather relentlessly turns out simulacra of wonder that counterfeit astonishment and all its promise. The point is fruitfully relevant to the dominion of serviceable disposability ascendant in our contemporary world. Wonder workers are present everywhere in that dominion. But a wonder that is at the behest of serviceable disposability must inevitably be a counterfeit wonder, a faking of astonishment. It may take the form of the ceaseless curiosity that is voyeuristic rather than glorifying. We remain curved into our cybernetic selves, cells distended with curiosity but playing false with true wonder.

This book is a wonderful book, the work of a wonder maker who does not play false. I am fortunate to have Steven Knepper as a reader of, interpreter of, and writer on my work. If I say this is an excellent book, perhaps I am prejudiced, but if so, it is because the *book* is excellent, and its author deserves praise.

William Desmond
David Cook Chair in Philosophy, Villanova University, USA
Thomas A. F. Kelly Visiting Chair in Philosophy,
Maynooth University, Ireland
Professor of Philosophy Emeritus, Institute of Philosophy,
KU Leuven, Belgium

Abbreviations

I cite William Desmond's major works parenthetically, using the following abbreviations.

AA	*Art and the Absolute*
AOO	*Art, Origins, Otherness*
BB	*Being and the Between*
BHD	*Beyond Hegel and Dialectic*
DDO	*Desire, Dialectic, and Otherness*
EB	*Ethics and the Between*
GBPB	*The Gift of Beauty and the Passion of Being*
GB	*God and the Between*
G	*Godsends*
ISB	*The Intimate Strangeness of Being*
IU	*The Intimate Universal*
IST	*Is There a Sabbath for Thought?*
PO	*Philosophy and Its Others*
PU	*Perplexity and Ultimacy*
VB	*The Voiding of Being*
WDR	*The William Desmond Reader*

Acknowledgments

Three people deserve special thanks for their support of this venture. I am grateful to Annie Knepper for her patience and encouragement during the long writing process. She read every page several times, offering insightful feedback and suggestions. Rob Wyllie was always ready to talk through a tough spot and to read a new draft. His criticisms improved the manuscript in many ways. William Desmond has been unfailingly generous. He encouraged the project from the beginning, gave feedback on drafts, and provided a foreword.

Many other people helped along the way. I am grateful for the support of my colleagues and administrators at Virginia Military Institute, especially Emily Miller and Christina McDonald. A number of friends and colleagues provided feedback on chapters: Patrick Eichholz, Fred Guyette, William Christian Hackett, Ryan Holston, Andrew Kuiper, Catharine Ingersoll, Rob McDonald, Duncan Richter, Ethan Stoneman, and Jim Tuten. They helped me improve the manuscript throughout. I am grateful to Michael Rinella and Diane Ganeles at SUNY Press for shepherding this project from the proposal to printing. My research assistant, John Delaney, improved the manuscript with his sharp eye and helped assemble the index. Errors that remain herein are my own.

Some parts of this manuscript appeared elsewhere in earlier form. Brief passages in chapter 1 first appeared in "Jane Kenyon's Peonies," in *Commonweal* 145, no. 12 (2018): 46–47 and in "Gabriel Marcel: Mystery in an Age of Problems," in *Critics of Enlightenment Rationalism*, ed. Gene Callahan and Kenneth B. McIntyre, 125–37 (Cham, Switzerland: Palgrave Macmillan, 2020). Passages in chapter 1 and the fourth section of chapter 4 appeared in "Marcel and the Philosophy of Place," in *Marcel Studies* 4, no. 1 (2019): 1–12. Some passages in the fifth section of chapter 4 appeared

in a July 2017 blog post, now unavailable, titled "William Desmond on Beauty and Being" on the website *Dappled Things*. A version of chapter 6 appeared as "Heroes, Tyrants, Howls: Approaching Tragedy with William Desmond," in *Renascence: Essays on Values in Literature* 72, no. 1 (2020): 3–23. A few pages in the conclusion first appeared in "Climbing the Dark: William Desmond on Wonder, the Cave, and the Underworld," in *Radical Orthodoxy: Theology, Philosophy, Politics* 5, no. 1 (2019): 25–46. I am grateful to the editors of these publications for providing a venue for this work and for allowing me to revisit it here. I am grateful as well to Virginia Military Institute for a grant-in-aid of research.

Biblical quotations are from the Revised Standard Version of the Bible: Catholic Edition, copyright © 1965, 1966 the Division of Christian Education of the National Council of the Churches of Christ in the United States of America. Used by permission. All rights reserved.

Jane Kenyon, excerpts from "Peonies at Dusk," "Who," and "Things" are from *Collected Poems*. Copyright © 2005 by The Estate of Jane Kenyon. Reprinted with the permission of The Permissions Company, LLC on behalf of Graywolf Press, graywolfpress.org.

Introduction

William Desmond's philosophy begins in wonder. It wonders at the aesthetic richness of the world, at our own mysterious depths, at the strangeness of there being anything at all. Dennis Vanden Auweele claims, "It is abundance that propels thought [for Desmond], not emptiness."[1] Desmond argues that being is excessive, "overdetermined." It is more than we can take in. Being manifests a worth that we did not put there, a worth that can move us to care. The strike of wonder (re)awakens us to this abundance and worth. Perhaps we are struck by a starlit sky or by mote constellations suspended in a window's light. Perhaps we are struck by the face of a newborn child, the face of a lover, or the face of a suffering stranger.

Desmond's philosophy describes being's abundance and affirms its worth. He moves beyond the modern tendency to focus on the determinate, on what can be pinned down in propositions. Many philosophers, for instance, dismiss wonder at the strangeness of anything existing at all. They treat such wonder at the mystery of being as philosophical nonsense, subjective mysticism, or mere superfluity precisely because it cannot yield a determinate answer. Desmond, on the other hand, thinks that our thought must be continually renewed in such astonished wonder. Otherwise, it will be prone to false closure or bone-dry rationalism. Still, Desmond does not wish to trade a (modern) focus on the univocal and the determinate for a (postmodern) focus on the equivocal and the indeterminate, which when taken to an extreme seems to allow for no determinations at all.

Desmond instead stresses the "overdeterminate." He often turns to the work of art as an illustration of this. A work of art is "a unique singular," Desmond explains, "which is yet big with an inexhaustibility that no set of finite determinations can deplete" (*BB*, 187). Persuasive analysis must attend to an artwork's concrete particulars, must try to discern what

it communicates, but no analysis can exhaust the artwork's richness. Even the most authoritative critic cannot claim the last word. Another critic can always contest or supplement. This means that the artwork is neither simply determinate nor purely indeterminate. Desmond would say that it offers an excess of plausible determinations. This is what he means when he calls the artwork overdetermined.[2] For Desmond, reality itself and the many others we encounter are best understood as overdetermined. We can make any number of determinations about them, but we can never fully grasp them. "What is true of great works of art," explains Ryan Duns, "is true of anything or anyone worthy of love: we embrace mystery. The surplus of meaning behind a text, a painting, a person invites us into ongoing engagement."[3]

Desmond claims that philosophy needs not only propositions, then, but also poetic description. The latter evokes the overdetermined richness of being. Such description recurs throughout Desmond's writings. In his books *God and the Between* (2008) and *Godsends* (2021), Desmond even includes some original poems. One tells of a walk "Along the verge / Of the bay." The speaker notes "People promenading," a jet plane overhead tracing "a white line / To somewhere / Unknown," a limping man who "pretends / He does not need / His cane." The speaker notes a resurfacing cormorant, tracks the blood trail of a wounded creature, and then sits down on a bench to "Rest and write / Of these saturations":

> Soul a dripping sponge
> Medium of a meaning
> Whose message
> It cannot pinion
> As it passes

This poem dramatizes several of Desmond's key concerns: our sponge-like receptivity; the sensual excess of the world that saturates it; the way universal propositions cannot contain the excess; the mystery of being, suggested here by the ocean depths and the "Unknown" passage overhead. This poem is marked by the "intimate strangeness of being," to use Desmond's own evocative phrase, by an awareness that we are intimately a part of a world that we can never fully grasp. It is not a saccharine poem. It reminds us of fragility (the limping man), finitude (the blood trail), and natural violence (the cormorant eating a fish). Yet it still affirms the excess and enigmatic worth of things:

> I do nothing
> To merit it
> I ask for nothing
> I have already received
> Everything (*GB*, 116)

The speaker begins to write on the bench, and the words come to "consecrate" these things. Desmond's philosophy often consecrates, blesses, affirms. It draws attention to this as one of the primal capacities of language, as a primal vocation of not only religion but also poetry and philosophy.[4] This is a controversial or at least unfashionable claim in many philosophical circles. But Desmond argues that the affirming philosopher will be attentive to crucial dimensions that other philosophers forget, ignore, or refuse.

Desmond is a poetic thinker, then, but he is also a systematic thinker.[5] He wishes to offer a systematic metaphysics of overdetermined being, a "metaxological" account of the relationships "between" overdetermined entities. Robert Cummings Neville claims, "William Desmond is one of those rare philosophers who has a philosophy, indeed a philosophical system. In this he is like Plato, Aristotle, Plotinus, Thomas Aquinas, Duns Scotus, Descartes, Leibniz, Spinoza, Hegel, and Whitehead."[6] As should be clear, though, Desmond does not offer a closed system that ignores or explains away excess; nor does Desmond's metaphysics adopt a god's eye view. He resists the temptation to disappear behind an impersonal system. His departure point is his own astonished wonder at the world, like that of the speaker walking along the beach in his poem. This seemingly humble departure point, however, launches Desmond on a wide-ranging, adventurous quest. "If Desmond is a major critic of philosophical gluttony that insists on speculatively mastering the entire range and depth of the real," explains Cyril O'Regan, "this should not disguise the fact that the refusal of system does not function to narrow, but rather open up multiple phenomenological-metaphysical vistas into individuals, communities, selves, desire, drive, receptivity, the nature of art, religion and philosophy, and the good, the true, and the beautiful to name but a few."[7] Desmond's philosophy ranges widely, but it both begins *and* ends in wonder at a world about which we can continually learn yet never fully comprehend.

Because he attends to excess, Desmond evades the common charges that continental philosophers often level at metaphysicians. His metaphysics is not one of static presences or totalizing concepts. It is neither onto-theo-

logical nor logocentric. As his departure point in wonder suggests, he shares much with Heidegger, the great critic of metaphysics. Desmond acknowledges several valid concerns about metaphysics in the wake of Heidegger, concerns about overreach, static system, and false closure. Still, Desmond claims that Heidegger and his followers caricature the tradition(s) of philosophical metaphysics when they reduce it to, say, the forgetfulness of being.[8] Desmond notes Aristotle's claim that "being is said in many senses" (*VB*, 2).[9] Desmond argues there are practices of metaphysics that do not run afoul of Heidegger's concerns, and they are not as forgotten in the history of philosophy as Heidegger sometimes holds.

Furthermore, we cannot avoid metaphysics. We all have assumptions about the nature of being and its worth. We live an implicit metaphysics.[10] Assumptions animate our cultural milieu as well. These of course mold our own. "Metaphysical presuppositions about the 'to be,'" Desmond observes, "are at play mostly unacknowledged, in common sense, in politics, in ethics, in art, in science, in religion, in philosophy, indeed in 'postmetaphysical' philosophy itself" (*VB*, 4). Desmond notes a pervasive modern sense of being as a neutral resource, of "real" value as use value, of other values as secondary or subjective. Desmond calls this the "ethos of serviceable disposability," wherein "things must be serviceable for us, but once they have served their use, they are disposable" (*WDR*, 216). He notes that "persons too are often treated as items of serviceable disposability" (*WDR*, 216). Desmond joins many continental thinkers in decrying crudely instrumental approaches to people and the world.[11] He breaks with most of them, though, in holding that the answer is not to "overcome" metaphysics but to offer a metaphysics that affirms value beyond use. Desmond wishes to recover a richer sense of being to counter the pervasive ethos of serviceable disposability and the politics it subtends. Our ongoing ecological crisis makes this a pressing metaphysical task.

It is also an aesthetic task. For Desmond, aesthetics does not narrowly pertain to art and literature. It deals broadly with our sensual experience of the world. It begins in the "aesthetics of happening," in the stream of sensuality that continually washes over and through us. Close attention to the aesthetics of happening reveals that being is not inert. It is not neutrally, flatly there. It manifests in aesthetically rich ways. It thrills, soothes, and stings. It makes our skin crawl or prickle in gooseflesh. It grabs our attention and startles. We can only treat being as neutral if we abstract it from this primordial experience. Such abstraction involves a dubious subject-object dualism, one untrue to our constitutive receptivity. We are not self-contained

subjects sealed off from the world "out there." We internalize, and we are drawn out of ourselves. We are, as Desmond says, "porous."

Still, while Desmond begins in the broad aesthetics of happening, he does not disregard art and literature. They not only depict being's excess and worth—they also incarnate it. As noted earlier, the artwork is overdetermined. A single analysis can never exhaust it. The richness of the artwork can reawaken us to the richness of being more broadly. The artwork has the "ability to recharge our sense of the world" and its worth (*DDO,* 155). It can challenge the ethos of serviceable disposability.

According to Desmond, though, art cannot counter this pervasive ethos on its own. It needs religion and philosophy, its ancient "siblings." All three have their origin in wonder at the mystery of being. This wonder is not stupefying. It stirs self-transcending desire. It might give rise to a work of art, to worship, or to speculative thought; it might give rise to care for being in its excess and mystery. Like so many siblings, art, religion, and philosophy have grown more distant over time and have often been hostile to one another. Desmond does not deny either the differences or the tensions between them. Yet he insists that their ancient kinship remains. To be healthy, to thrive, all three must still draw on wonder, and they must communicate this wonder to others. He claims that our contemporary crises call for a renewed sense of this kinship.

Desmond's own roots are in art, religion, and philosophy.[12] He was born in Cork, Ireland, in 1951. His childhood passions were poetry and mathematics. He notes that his "family background contains no philosophical prefigurements" (*PU,* 2). He did grow up in a deeply religious community, though, "the Middle Ages" of mid-century Irish Catholicism, as he jokingly puts it. He was "fostered on a sense of the mystery of God and God's ways, on a sympathy for the rejected and the outsider whom we cannot judge not to be God's favored, fostered, too, on an esteem that God's creation, nature, was good" (*PU,* 2). He spent time in the Dominican novitiate at age seventeen, claiming, "I took and still take religion with ultimate seriousness" (*PU,* 4). He began undergraduate studies in engineering, in part for pragmatic reasons and in part because of his aptitude in math, but he soon transferred to English to study his other first love, poetry. The big questions these studies raised, though, led him to transfer once more, this time to philosophy: "Great poetry exhibits a spiritual seriousness which can shame the thought of some philosophers. But then [at his university] poetry was presented as if it had nothing to do with thought" (*PU,* 5). Desmond stayed on at University College Cork to pursue an MA in philosophy, writing a

thesis on the aesthetics of R. G. Collingwood. He went on to study for a PhD with Carl Vaught and Stanley Rosen at Pennsylvania State University.

Desmond grappled with Hegel's philosophy at Penn State. He appreciated Hegel's sense of dynamic mediation, his feel for the concrete, his sophisticated aesthetics, and his claim that art, religion, and philosophy are "the three highest modes of human meaning" (*AA*, xii). Desmond later contributed to the North American Hegel revival and served as president of the Hegel Society of America. Even in his doctoral studies, though, Desmond feared that Hegel's dialectic tilted too much toward categorical determination and self-mediation. Hegel, he concluded, did not attend enough to the excess of being. In his dissertation, Desmond tried to honor this excess and to draw the Hegelian dialectic back toward the openness of the Platonic dialogue, to keep the dialectic open as a *metaxu*, a between, where self and other are not exhausted in mediations from either side. This dissertation, eventually published as *Desire, Dialectic, and Otherness* (1987), established the framework of Desmond's "metaxological" philosophy, which he would develop across more than a dozen other books, including his trilogy *Being and the Between* (1995), *Ethics and the Between* (2001), and *God and the Between* (2008). Desmond spent his early career at Loyola College in Maryland, but he eventually returned to Europe to take up a professorship at Katholieke Universiteit Leuven's Institute of Philosophy. He currently holds visiting chairs at Villanova University and Maynooth University. Desmond is highly regarded as a Hegel scholar, a philosopher of religion, and an original metaphysician. Paul Weiss, an influential metaphysician in his own right, once called Desmond "the leading philosopher of his generation."[13]

This is a study of Desmond's aesthetics. Because aesthetics are central to his thought, though, it offers an introduction to Desmond's philosophy as well as a more focused study of his aesthetic concerns. It aims both to orient newcomers and to offer texture to those who already know Desmond's work well. With the first goal in mind, I presuppose no prior knowledge of Desmond's philosophy. This study can serve as a primer for those who want to make their way into it.[14] With the second goal in mind, I offer exegesis and synthesis but also extend Desmond's thought to topics such as literary influence and epiphanic art. I give Desmond a sympathetic reading, but I also note the prominent criticisms of his work and raise my own questions. I bring Desmond into conversation with a range of thinkers beyond the usual philosophical suspects. Among the most prominent of these dialogue partners are the twentieth-century philosopher Gabriel Marcel (a major but largely neglected influence on Desmond), the recently deceased polymath

George Steiner, and the contemporary philosopher Byung-Chul Han.[15] Other interlocutors include Iris Murdoch, Hans Urs von Balthasar, Susanne Langer, Charles Taylor, Jean-Louis Chrétien, Catherine Pickstock, John Milbank, Rita Felski, Richard Kearney, William Franke, and Elaine Scarry. Many of these thinkers share, in their own ways, Desmond's concerns with receptivity, relationship, and affirmation. Several of them share his concern with religion. Another aim of this study, then, is to sketch out a loose philosophical countercurrent that has steadily persisted throughout the past century, one moved more by astonished wonder than by skeptical doubt. I aim to situate Desmond as an important figure in this countercurrent, indeed a particularly important one given the capacious, open metaphysics that he offers. This study would have gone in other directions with a different cast of dialogue partners. The same could be said about the choice of literary works. I discuss some that recur throughout Desmond's writings (Dante's *Commedia*, Shakespeare's *Macbeth* and *King Lear*, Hopkins's poetry), others that he mentions (Melville's *Moby-Dick*, Dostoevsky's *The Idiot*, Baldwin's "Sonny's Blues"), and others of my choosing. Plenty of possibilities remain.

This is not only a study of Desmond's aesthetics, though. It is also an attempt to approach aesthetics and literature with Desmond, to give an account of them that can stand on its own. In this regard, I take my cue from Desmond's first published book, *Art and the Absolute* (1986), which is both a study of Hegel's aesthetics and a probing account of art. I hope this study might appeal, then, to some without a prior interest in Desmond (while also convincing them to read his works). It might appeal to those interested in contemporary aesthetics or the relationship between philosophy, art, and religion. It might appeal as well to humanities scholars looking to balance critique with affirmation. This is a hard time for the humanities, a time of declining enrollments and slashed budgets. Desmond offers a strong case for why art and literature matter.

This book might especially appeal to those interested in contemporary Christian thought about metaphysics, aesthetics, and art. Philip John Paul Gonzales claims that Desmond offers "the most complete and open systematic vision of a Catholic metaphysics" since Erich Przywara's *Analogia Entis* appeared in 1932.[16] And, like Przywara's student Balthasar, Desmond gives aesthetics central importance in his metaphysics. Desmond's religious concern also might appeal to those interested in the "post-secular" turn of continental thought. Others, though, may be wary of the religious dimensions of Desmond's thought. Desmond insists on the essential importance of religion, but he does not shrink from how it can be a problem rather

than a cure. Desmond draws on his Catholic tradition but, like the greatest figures in that tradition, remains open to what can be learned from other religions and from secular thinkers. To dismiss him as a sectarian or an apologist would be a mistake.

This study is divided into two parts. The first part offers a broad pass through Desmond's aesthetics. The second part focuses on literature. Chapter 1 begins in the aesthetics of happening, in our sensual experience. It surveys four main concerns in Desmond's thought: receptivity, abundance, affirmation, and wonder. It gives special attention to the similarities and differences between Hegel's dialectic and Desmond's metaxology.

Chapter 2 explores Desmond's account of beauty and the sublime. Desmond resists both the modern opposition of beauty and the sublime and the postmodern privileging of the latter. He claims there is a "permeable threshold" between them. Experiences of beauty and the sublime are experiences of wonder at aesthetic excess. They issue a call that we can respond to in many ways, including in gratitude and care. The final section of chapter 2 elaborates on this complex relationship between aesthetics and ethics. Desmond argues that aesthetics, broadly conceived, continually shapes our lives and actions. It does not, however, directly translate into a systematic ethics. It is instead an ethical "potency," an affordance that can be developed (or betrayed) in many ways.

Chapter 3 examines Desmond's account of artistic creation. Desmond stresses that art involves receptivity and the mediation of otherness. The artist does not create ex nihilo. Desmond conceives mimesis as the creative mediation of external otherness and inspiration as the creative mediation of inner otherness. The third section of this chapter explores the related question of artistic influence, using Dante and Virgil in the *Commedia* as its paradigmatic instance.

Chapter 4 ranges across aesthetics, art, and religion. It first surveys how different religious forms mediate the excess of being. The second section examines how the decline of religion contributed to the rise of the ethos of serviceable disposability. The third explores Desmond's own approach to God and ends with a brief consideration of Gerard Manley Hopkins as a key "companion" in his thought. The fourth section focuses on how religion and poetry both approach the unsayable. The final section of chapter 4 takes up Desmond's provocative claim that, having once asked too much of art, we now ask too little. It traces various modern attempts to re-enchant the world via art rather than religion and how those attempts failed in their grandest aspirations. The danger now, Desmond claims, is that we often

ask too little from art. We shortchange its ability to "recharge our sense of the world." He claims that a renewed porosity between art, philosophy, and religion offers the fullest challenge to the ethos of serviceable disposability.

Part 2 of this study offers more focused forays into literature. The first section of chapter 5 sketches a "metaxological" approach to literature and briefly situates it vis-à-vis other approaches within literary studies. The chapter then develops an account of epiphanic encounters in art. It touches on a wide range of literary works, from the *Epic of Gilgamesh* to James Joyce's "The Dead," from the biblical account of Joseph to James Baldwin's "Sonny's Blues."

Chapter 6 turns to tragedy. For Desmond, tragic figures become tyrants when their exaggerated wills close off their receptivity. The first section attends to Macbeth, who self-consciously becomes a tyrant. In killing the king, Macbeth also kills trust and sleep. He cuts himself off from the rejuvenating goodness of being. His life eventually becomes absurd. The second section considers Lear, a self-deluded tyrant. His suffering on the heath breaks him open. It returns him to porosity. In Desmond's take on catharsis, such dramatized suffering returns the audience to porosity as well. This can lead to despair, but it can also renew our sense of the fragile goodness of things. The chapter's third section considers what philosophy can learn from tragedy. It takes up Desmond's argument that to be true to the singular, philosophy must attend to Lear's howl at the loss of Cordelia. It must risk "being at a loss."

Chapter 7 considers "redemptive laughs" and "festive rebirth." The first section surveys philosophical accounts of laughter and then turns to Desmond's own account of affirming laughter. The second considers Melville's *Moby-Dick,* a novel of many kinds of laughs. Perhaps its most important laugh, though, is an absent one: the laugh of release that will not come to Ahab's lips. The third section turns to Aristophanes's satirical Socrates and how comedy can "ground" philosophy. It can pull philosophy's head out of the clouds, returning it to the body and the earth. The fourth section surveys theories of the festival from Desmond and a range of other thinkers. While these thinkers' accounts differ in marked ways, they agree that true festivals involve collective affirmation and a heightened sense of time. They also agree that commodification and secularization warp the modern festival. Art can help keep the spirit of festivity alive, though. The final section of the chapter considers Charles Dickens's *A Christmas Carol* as a novel of festive anamnesis. The three ghosts remind Scrooge (and perhaps the reader as well) that goodness beyond utility is not mere "humbug."

The conclusion reviews a few ways that philosophy and literature relate to one another. It nods to their quarrels but focuses more on kinship and collaboration. The philosopher can draw on literature for illustrations, but even this is more reciprocal than it sounds because the philosopher must attend to the particulars of the illustration. The philosopher can also turn more openly to literature for insight (and vice versa). At the deeper level of shared language use, the philosopher "must go to school with the poets." There are philosophical analogues to literary genres: epiphanic philosophy, tragic philosophy, and comic philosophy. Each offers different attunements to reality.

Following Vico, Desmond holds that philosophy grows out of poetic myth, which provides it with resonant images, "imaginative universals." Plato, too easily dismissed as a critic of poetry, turns to myth at the limit of discursive reasoning. He offers philosophy some imaginative universals of its own—most famously the cave. The second half of the conclusion thus returns to Plato's cave with Desmond. The ambiguity of everyday life plays on the cave's wall: the "chiaroscuro" of peace and strife, pain and joy, love and hate. Desmond wants to ascend toward the sun. He wants to affirm the goodness of being. There are other possibilities, though. Many modern thinkers burrow down into the cave, seeking to uncover a subterranean origin that sources the horror of being. Desmond turns to another imaginative universal to model a different type of descent: Dante's *Inferno* dramatizes a kenotic descent, one that opens Dante anew to the goodness of being when he emerges under the starlit sky. Sometimes, as Desmond says, one must go down to go up.

PART 1
INCARNATE WONDER

Chapter 1

Aesthetics in Flesh, Image, and Word

This chapter surveys four key themes in William Desmond's philosophy: receptivity, abundance, affirmation, and wonder. It focuses on their place in lived experience, in what Desmond calls the "aesthetics of happening." Desmond uses aesthetics here "in its widest traditional sense, that is, as relating to sensuous appearance (*to aisthētikon*) and the modes of mindfulness bound to sensuous appearance" (*PO*, 63). Desmond builds his philosophy around this broad sense of aesthetics. As receptive creatures, as creatures of porous flesh, we are also aesthetic creatures. We live in an aesthetic "between," an ongoing "intermediation" of sights, smells, sounds, and textures. We easily take this intermediation for granted. We become numb to the excess of being and focus more on our projects and concerns. Nonetheless, sensual excess continues to pour over and through us. At times, it breaks through our numbness, striking us. This is wonder.

Art and literature come to the fore in later chapters, but they still offer paradigmatic instances here. The artwork does not merely "imitate" the richness of the world. It incarnates richness. Nor does it merely imitate singular things. It is itself singular. Still, the richness of the artwork can indeed attune us to the richness of the world. Art calls for receptive perception, and this in turn sharpens our perception more broadly. Likewise, our everyday perception is more "artistic" than we usually notice. It involves "framing" significances within the "too-muchness" of the world.

Receptivity

Desmond stresses our constitutive receptivity or "porosity." Consider how we continually breathe in and out. Consider the food and drink we continually

take into our bodies. Consider our porous bodies and their sense organs, through which we receive the sights, sounds, smells, and textures of the world. A sensual wave "flows around us, flows into us, and this whether we make it focally an object of attention or not" (*IU,* 253–54). We continually receive this wave, and we continually respond to it. We winnow, adjust, react, connect, and attend.[1] We live out an ongoing exchange, a continual back and forth, an intermediation of sensual excess.

Our receptivity challenges any dualistic opposition of subject and object. The boundary between inside and outside is not an impermeable barrier but a porous threshold. Our very body is a between. We are always receiving the outside world within us. We are always mediating it. As Heidegger shows, a rigid opposition between subject and object creates the false problem of "how this knowing subject comes out of its inner 'sphere' into one which is 'other and external,' of how knowing can have any object at all, and of how one must think of the object itself so that eventually the subject knows it without needing to venture a leap into another sphere."[2] This false problem plagues modern philosophy.

We often receive and mediate unreflectively. Walking down the street, for instance, I take a wide step over a puddle or slow to accommodate another pedestrian without a thought. At times, however, I am consciously aware of both my receptivity and my response. Perhaps I hear a song through an open upper-story window. The song seeps into me. I linger and listen, searching for its title in my memory, recalling an earlier time when this song touched my life, perhaps a time shared with friends whom I now remember. This shows that we are porous in our memories, thoughts, and desires as well as our sense organs. We are receptive in our intimate depths, which in their own ways continually receive and mediate "the press of being in its otherness on that inwardness" (*BB,* 386).[3] Our intermediation of the sensual world, what Desmond calls the "aesthetics of happening," is thus holistic. It involves the whole of us.

Modern philosophy does not give much attention to receptivity. It instead emphasizes will and autonomy. For Spinoza and Hobbes, a human is a *conatus,* or will. While Kant challenges such reductionist accounts of the human, he still downplays receptivity. For Kant, receptivity makes us too beholden to the "heteronomy" of the world beyond and thus threatens our "autonomy." Given our constitutive porosity, though, Kant's insistence on autonomy results in distortions and strange emphases. Consider Kant's own account of an overheard song in the *Critique of Judgment.* There Kant

criticizes how music exerts "its influence (on the neighborhood) farther than people wish, and so, as it were, imposes itself on others and hence impairs the freedom of those outside of the musical party." In this way, the musician is like "someone who pulls his perfumed handkerchief from his pocket [and] gives all those next to and around him a treat whether they want it or not." Earlier Kant notes of the visual arts that "if the imagination involuntarily repeats them [impressions], they are more likely to be irksome to us than agreeable."[4] It is possible, then, that Kant wishes us to consider both how we cannot help but hear music played nearby and how an unwelcome song can get "stuck" in our heads. These are common enough experiences, and they can be annoying.

Still, Kant's account is somewhat curmudgeonly. It is telling that he treats unavoidable music so negatively. Desmond claims that Kant "does not quite like the way music moves us before we move ourselves. It sweetly violates our autonomous self-determination. Music comes upon us, steals upon us, as it were. It moves us without asking prior approval of our reason or our will" (*GBPB*, 116). Kant frowns at how this music subtly slips through the armor of our autonomy. While the unexpectedly overheard song can be annoying, however, it can also bring us solace or joy. Kant neglects these positive possibilities. For his part, Desmond notes "the power of *music* to reach places of the human heart, even when the heart is hardened; music touches the porosity and opens it again."[5] He offers yet another take on the overheard song: "One goes about the grim work of this disenchanted world and a melody or air is sounded, and suddenly we are elsewhere, something in our lost souls resonates with the beauty we have forgotten or betrayed."[6] Our receptivity does not always subject us to the heteronomy of the world. At times, it allows us to receive gifts, like this sort of overhead song, that release us out of the claustrophobic confines of our brooding subjectivity. This is a freeing gift rather than an infringement on our autonomy.

Our porosity also offers ethical affordances. It opens us to others and our environs. As Hans Urs von Balthasar observes, "Receptivity signifies the power to welcome and, so to say, host another's being in one's own home."[7] It is a precondition of recognition and responsive care. We easily become inattentive, caught up in boredom or worries or hopes or cares or projects or daydreams. The present slips by unnoticed as we ponder the future or mull over the past. Our days become routinized and repetitive. Our porosity becomes "clogged." The digital age connects us in unprecedented ways, but it can also exacerbate these tendencies. I pull out my smartphone at the bus

stop or in line at the grocery store or even during a lull in a conversation. I spurn the shared world for one that is algorithmically tailored to me. Perhaps, in doing so, I spurn others and their needs.

In the words of Gabriel Marcel, an important influence on Desmond, "It can easily happen that, in general, I feel opaque, non-permeable, and this state can be attributed to a number of different causes (fatigue, moral deterioration, the habit of concentrating on myself too much; intimacy with oneself, like any other relation or liaison, can degenerate and become vicious)."[8] Marcel notes the role that selfishness and vice can play in this.[9] He suggests, though, that opaqueness is not always a moral failing. Deep fatigue dulls the world, or at least dulls our receptivity of it. Opacity can also arise from depression or from struggling to make ends meet.

Regardless of the cause, though, habituated self-enclosure entails certain dangers. We easily settle into a default egotism. Our interactions with others become cursory or transactional. We interact with others to get something we desire—help, information, affirmation—and then draw back into our selves. We do not truly attend to others. Iris Murdoch observes, "We are anxiety-ridden animals. Our minds are continually active, fabricating an anxious, usually self-preoccupied, often falsifying *veil* which partially conceals the world."[10] She argues that virtue "is concerned with really apprehending that other people exist."[11] Practical ethics requires receptivity and attention. It requires us to see and hear others. If we become self-enclosed, then, too caught up in our concerns, we are more likely to be inattentive to others, to treat them as means (or threats) to our ends.

Self-enclosure rarely leads to self-awareness. If we are not receptive, we easily become out of touch, even delusional. We struggle to see our situation clearly, to adapt to what happens around us. We filter our perceptions in narrow ways, becoming sensitive to what stirs our anxieties or strokes our ego. Tragic drama often teaches this lesson. Consider the self-absorbed Lear, unable to discern the false from the true, unable to listen to the loyal. He banishes Cordelia and brings chaos to the kingdom. He sees his anger as righteousness rather than as a tantrum. Edith Stein notes that empathy—construed as the recognition of others as three-dimensional beings like ourselves—is crucial not only for ethics but also for navigating life: from "the zero point of orientation gained in empathy, I must no longer consider my own zero point as the zero point, but as a spatial point among many."[12] Such empathy is, in effect, the social equivalent of depth perception. Self-enclosure, on the other hand, can leave us lonely, anxious, restless. Our inner lives become troubled and fragmented. The world becomes absurd or

insipid.[13] Others become threatening or frustrating. Yet we still feel empty and incomplete. Wary of others on one level, perhaps racked by envy or suspicion or resentment, we nonetheless remain hungry for connection, for a release out of our preoccupations.

Desmond's metaphor of clogged porosity is helpful, but, like any metaphor, it has its limits. One must not allow it to obscure the range of possibilities or to oversimplify the dynamics involved. For instance, it is often more complex than a simple "open" versus "closed." General self-enclosure is often combined with a heightened—albeit limited and distorting—sensitivity. Envious persons, for instance, have a certain habituated attunement—even hyper-attunement—to what others have and they do not. Paranoid persons are hypersensitive to whatever can stoke paranoia. There are, then, habituated vicious attunements as well as virtuous attunements. What tends to mark the former, what makes them "clogged" in Desmond's parlance, is that they are narrowly preoccupied with the self. The latter are more broadly open to otherness, less filtered by preoccupation.

The modern world did not invent distraction, selfishness, instrumentalism, or tyranny. These are perennial dangers. Still, they take different forms and are more or less pronounced in different times and places. While Desmond criticizes rigid historicism and cultural determinism, he recognizes the pervasive influence of cultural milieu in this regard. Cultures cultivate an "ethos of being," a sort of metaphysical common sense, a set of background assumptions about being and its worth. As Plato, Augustine, and more recently René Girard demonstrate—and as advertisements continually attest—others' desires shape our own. We are porous to cultural influence.

Like many continental philosophers, Desmond decries the modern tendency to reduce value to use value, to treat being as a malleable, exploitable resource. As noted in the introduction, he calls this the "ethos of serviceable disposability."[14] Things are there for us to use and then discard. They are extraneous if they do not serve our needs. This ethos has complex roots, from late medieval nominalism and voluntarism to reductive ideology and commodification to the "mathematical objectification and technological manipulation" of nature (*IU*, 381). The consequences of this ethos are likewise multiform, from environmental degradation to modern chattel slavery to a technocratic politics that reduces humans to "bare life" or to data points. There are, of course, countervailing forces in modernity. Desmond is not simply antimodern. He would not deny, for instance, the real goods brought about by modern medicine or how technology eases the rigors of life. There have been powerful accounts of, and movements for,

the worth of both humans and nature in modernity. At its best, modern law protects this worth. These countervailing forces, however, struggle to displace the wider ethos of serviceable disposability, which continues to shape our economics, policy, and daily life.

This ethos also has existential consequences. A world of objectified things is a lonely world, a world of "it" rather than "Thou." It is a world in which there is no inherent worth. We instead project worth onto meaningless matter. In the wake of Nietzsche, this projection is often celebrated as liberating, as offering the world as a canvas for aesthetic experimentation. Desmond is not convinced. He claims that this sense of aesthetic possibility, of humans as the sole source of value, easily collapses into a sense that everything, including ourselves, is worthless.[15] Desmond agrees instead with Marcel, who holds that humans have an ontological need for real connection that transcends our physical needs and narrow self-interest. He agrees with Martin Buber: "All real living is meeting."[16] The hunger here is for a meeting with *others*, with their own integrity and worth. The hunger is to participate in a dense and meaningful reality that we recognize and affirm as so.

Within the ethos of serviceable disposability, this need often goes unmet. We instead often try to meet our ontological need via consumption or achievement or, increasingly, digital distraction.[17] This leads to a vicious loop. Consumption offers only fleeting satisfaction, so we consume more, searching for something that will give lasting or more intense gratification. We become restless even in our relationships with family, spouses, and friends. We wonder if we could find more satisfaction elsewhere. Desmond calls this the "distention" of desire, "a voracious seeking of this and that as good" (*EB*, 209). As Augustine testifies, this too is a perennial human danger. We aim "merely to satisfy the appetite for wealth and for glory," but find that "the appetite is insatiable."[18] Still, this distention takes pervasive and extreme forms in modernity.[19] "Nobody but we, the residents of the contemporary capitalist societies, are more surrounded by the madness of this distention," Takeshi Morisato claims. He notes the omnipresence of advertisements, stoking desire for "new cellphones, computers, cars, or whatever we are running low on in our kitchens, bathrooms, bedrooms, etc."[20] Morisato goes on to suggest the distention of desire can grip even the seemingly well-adjusted and conscientious—even those of us whose weakness is buying books. At its most extreme, the distention results in despair.

As a remedy for the ills of self-enclosure, Desmond holds that we should cultivate receptivity—especially receptivity to other value. Desmond explains that "porosity is perhaps more evident with early stages of life, but

a person always remains porous, and suffering and joy as they happen to us can keep it more or less open, as can ethical disciplines and practices of mindfulness and contemplation."[21] Ancient philosophy, which was a "way of life" rather than a methodology or field of warring arguments, often stressed the cultivation of such practices.[22] Desmond agrees with Byung-Chul Han that recovering contemplative practices is particularly important in our own time of distraction and hyperactivity. We need to relearn what Han calls the "art of lingering."[23] Indeed, for Desmond (and here his proximity to phenomenology is perhaps most apparent) the primary corrective to our enervated ethos of being is to attend to things, to allow them to draw us out of ourselves, to unsettle our assumptions, to manifest worth via their singularity and aesthetic richness. Desmond's more systematic metaphysics departs from, and continually returns to, this unsettling.

Ryan Duns holds that "Desmond's philosophy is best approached as something that must be practiced, undertaken, and undergone, as a practice."[24] An immersive reading of Desmond's writings, Duns argues, can change how we experience the world. Desmond also offers several explicit practices for cultivating receptivity. Desmond recommends, for instance, the cultivation of a non-grasping openness that he calls "agapeic mind."[25] This involves a "state of high alert that paradoxically has nothing insistent about it. It demands a strange mix of active mind and patient readiness, energy of being and of being nothing" (*PU*, 122). It is a "noninstrumental vigilance" (*PU*, 123), a "*motiveless mindfulness*" (*G*, 128).

Desmond describes his practice of agapeic mind on a beach near Clonakilty in Ireland. At first what comes to him are the observations that anyone could pause and take in: "I look out at the sea and watch. The waves come in, retreat, come in, retreat; there is the background murmur of a low whoosh. On the other side of the bay, the hill is a motley of greens; there is fog on the horizon" (*PU*, 122). This is not agapeic mind, but it is the first step toward it. With greater patience "the self comes to sink into a place with time; the place tends to pass over into the mind. The mind is in the place; the place is in mind" (*PU*, 122). For Desmond such mindfulness is agapeic because it entails recognition and affirmation of the place for its own sake. It recovers both our intimate relation to the world and our awareness of how the world transcends us. Agapeic mind can give rise to care. It is rich with ethical promise.

"Posthumous mind" is a related practice of receptivity in which we imagine returning from death to see the world again: "The metaphysical imagination of posthumous mind forces us to consider: freed by death from the

lie of selfhood closed on itself in grandiose but monadic self-congratulation, the released self asks: What in being do we love for itself?" (*PO*, 282). Posthumous mind is a thought experiment in which we contemplate the goodness of being as if we had lost it in a seemingly irrevocable way but have now returned to it. One might think of the maxim, "Live every day as if it were your last." Of course, this saying can lead to dubious conclusions. It can provide a license to splurge ("YOLO!") or a justification for selfishness. But the saying can also call us to be present and appreciative, to see the world with the eyes of wonder. This is what Desmond aims for with his posthumous mind. It makes us newly aware of goodness that we easily take for granted. Posthumous mind is Desmond's variation on ancient philosophical and religious practices of calling to mind one's own death.

Posthumous mind is not always achieved via spiritual exercise, though. Circumstances at times thrust it upon us. Perhaps I have a brush with death or disaster. Perhaps death brushes close to a loved one. In either case, the near miss leaves me overwhelmed with gratitude. I see the world anew. Desmond frequently cites Dostoevsky's death sentence and last-minute reprieve. Dostoevsky "tilted over the brink of nothing," but this reprieve "brought [him] back from death, resurrected to life again. The sweetness of the morning air struck him, the song of morning birds, the sky. He was stunned into marveling at the sheer fact of being" (*BB*, 25).[26]

Desmond also illustrates posthumous mind via the parable of the prodigal son in St. Luke's Gospel. The father could be angry with the younger son, but he is instead overjoyed that his son still lives and has returned. "Bring quickly the best robe," the father says, "and put it on him; and put a ring on his hand, and shoes on his feet; and bring the fatted calf and kill it, and let us eat and make merry; for this my son was dead, and is alive again; he was lost, and is found" (Luke 15:22–24). The son's motives are ambiguous. His return could be due to desperation more than contrition. But perhaps the son achieves posthumous mind amid the affirmation and the festivity. Perhaps he sees the goodness of the people and life he once scorned. Perhaps his destitution and his father's welcome give him eyes to see beyond calculation and selfish desire. Desmond concludes: "The prodigality of goodness is given in the feast, in festive life. The stray has spent his season in hell, and he has died perhaps many times, and now is come back to life: coming to nothing means coming back to being again as good" (*EB*, 379).[27]

Marilynne Robinson's *Gilead* illustrates a different sort of posthumous mind. It is set in the middle of the twentieth century in a small Iowa town.

An aging pastor, John Ames, narrates the novel. He does not expect to live much longer. He writes a book-length letter (the novel's conceit) to the young son of his old age, the son of an unexpected second marriage after long decades of loneliness. Ames wants his son to read the letter upon reaching adulthood. It is his attempt to communicate something of himself, to pass on wisdom. Ames notes, "There's a lot under the surface of life, everyone knows that. A lot of malice and dread and guilt, and so much loneliness, where you wouldn't really expect to find it, either."[28] This is true of his own life. Ames attempts to make sense of fraught relationships with his father, brother, and godson. One of the first stories Ames shares is about how his own father sought out his grandfather's grave in the drought-stricken Kansas countryside. Father and grandfather were estranged, and this desperate mission, with its echoes of biblical sojourns in the wilderness, was an attempt to make amends.

Ames's letter, however, is also an exercise in posthumous mind. His impending death makes him see the world anew. He writes, "I really can't tell what's beautiful anymore."[29] Ames has not lost his sense of beauty. It is instead strangely extended. He recalls the beauty of certain seemingly mundane moments. He recalls two young mechanics relaxing, smoking cigarettes, and laughing in the sunshine outside the garage. He recalls a young couple walking under a rain-soaked tree, the boy jumping up to bring a shower of glistening droplets down on them. They laugh and run away: "It was a beautiful thing to see, like something from a myth."[30] He describes his wife, Lila, and his son blowing an "effulgence of bubbles rising" for their cat Soapy to chase. He exclaims, "Ah, this life, this world."[31] (Note the emphasis on resplendent, radiant light in each of these scenes. There is illumination, aesthetic and ontological, in Ames's original experiences, in his recollections of them, in Robinson's descriptions of them.) Ames wishes to convey these experiences, this attunement, to his son. The letter is his own exercise in posthumous mind. Through it, he offers the exercise to his son as well.

Desmond also points to how attending to art can encourage patient receptivity. If we rush from painting to painting in a museum, if we quickly scroll or swipe through images, if we speed-read a poem, we miss much. Likewise, we are not truly being attentive if we rush to critical judgment or if we bring cookie-cutter criticism to bear on the artwork. "Art needs distance, respect, aloofness," Desmond claims, "in order to be allowed to speak to us out of the quiet spaces of its otherness" (*PO*, 102). Art calls for its own form of agapeic mind. This need not preclude critique, but patient receptivity should come first.

One can also cultivate receptivity by becoming an artist. Early in the televisual age, Josef Pieper claimed that people were losing the capacity for deep perception because of "visual noise."[32] He saw art as a remedy. Art can cultivate attention both to one's surroundings and to the artwork itself. It can yield "a deeper and more receptive vision . . . an eye for things previously overlooked."[33] The artist can develop an eye that sees more and sees differently.[34] Think, for instance, of how the best nature poetry reflects an agapeic mind. Desmond notes how the artwork can incarnate a joy "in sheer seeing, seeing for the sake of seeing, seeing freed from ulterior motivations" (*PO,* 103). The artist's seeing need not entail a narrowly conceived realism in depiction. The artist never simply imitates but always imaginatively mediates. Nor must the artist's seeing be blithe. The sharp-eyed artist can perceive the unsettling and the incongruous to which we have become inured. The artist can perceive overlooked suffering and injustice. The artwork can testify to, and protest, the fragile finitude of things.

Desmond's critics sometimes equate his receptivity with passivity. This misunderstands his account. Recall how agapeic mind is a "state of high alert," of "vigilance." It is similar to what Marcel calls "*disponibilité*"—a state of attentive readiness, one particularly ready to serve and to care.[35] Note too that one can be passively unreceptive, perhaps bingeing shows on the couch after a long day's work. Desmond rejects simple oppositions between contemplation and action, receptivity and willing, patience and striving. For Desmond, we live our lives between what he calls the "*passio essendi*" and the "*conatus essendi.*" The latter is our self-affirmation, our "endeavoring to be," our willing. The *passio essendi,* on the other hand, is a "patience of being" that entails vulnerability and openness. It is closer to our constitutive porosity. The *passio essendi* and *conatus essendi* are not opposed to one another, though. The rest of the night, for instance, enables the action of the day.

Furthermore, when we act, when we endeavor to be, we can do so in aware and open ways. Indeed, Desmond claims that we must attend to receptivity if we are to understand the human potential for dynamic, skillful action. Recall the earlier example of walking down the street. We need some degree of openness to cope with our surroundings. Distracted or lost in thought, I may be more likely to stumble, bump into someone, or walk out in front of a car, but often I continue to navigate my surroundings reflexively. A baseline receptivity remains. Dancers and athletes model a refined companioning of *passio* and *conatus.* They are fluidly, dynamically, attuned to otherness.[36] They show us that true agency comes from supple

companioning and intermediation, from responsive receptivity. The self-enclosed *conatus,* cut off from otherness, becomes brittle and blind.

Kant's insistence on autonomy again distorts. "The more I enter into the whole of an activity with the whole of myself," Marcel claims, "the less legitimate it is to say that I am autonomous." Yet such "non-autonomy" can ultimately offer a higher "freedom."[37] Consider once more how the agency of the dancer or athlete (or artist or artisan, or comedian or stage actor, or medic or emergency room doctor) comes from attentive, skillful intermediation, from responsive navigation of the given situation. To excel in these pursuits requires assent and even submission. This is certainly true of the beginner, who is learning the basics and often apprenticed to an expert. Even the expert's mastery, though, entails masterful intermediation rather than absolute control or imposition. We rightly call such mastery "transcendent," not only because it transcends other experts but also because "freedom must first give itself over to the nameless outside that transcending bespeaks" (*EB,* 33).

Our perception is an intermediation as well. We are continually immersed in sensual excess, but we are not passive receivers. Otherwise, we would simply be lost in the deluge. We continually discern significances out of it. For Desmond, this makes our perception imaginative. He describes the imagination as a "threshold power" of synthesizing intermediation (*WDR,* 206).[38] "Much of experience is a muddy flux of happenings," he claims, "a passing pandemonium, but one might claim that *all significant* experience partakes in some measure of artistic form" in that it involves an imaginative synthesis (*PO,* 103). This synthesis "frames" experience, gathering "a flux of immediacy into discernible, meaningful wholes. Such gatherings stud all significant experience, indeed testify to its poetic character" (*PO,* 104). Art concentrates this imaginative dynamic. Each artwork is itself a gathering of significant experience, a creative mediation or "framing."

Abundance

Desmond is a philosopher of abundance, of "overdetermined" excess, of the "too-muchness" of being. Desmond highlights several ways in which being is superabundant. There is excess, for instance, in the sheer number and variety of things that surround us.[39] "The world teems with things," Desmond writes, "throngs with beings, great, small, ugly, sweet, on and beneath the earth, things soaring above, things exuberant or menacing in the unknown seas. The world as given is an excess" (*BB,* 230). There is also the excess noted at

the end of the last section: the excess of our continual sensual immersion, what William James aptly calls the "much-at-onceness," the mingled sights, sounds, smells and textures that continually wash over us.[40] We consciously register only a fraction of this and easily become inured to the excess in which we are immersed. "Often," Desmond observes, "we maneuver through the world with vision that has been neutralized by mechanical perception or dulled by humdrum familiarity" (*DDO*, 155). Furthermore, we are too caught up in our projects and cares to attend to the excess. As Wordsworth suggests, worldly concerns are often "too much with us" for us to attend to the too-muchness of the world.[41]

Nor do we attend to the "too-muchness" of singular things. Things are dynamic rather than static. They change over time. They are born, grow, bloom, feed, reproduce, play, and undergo metamorphoses. They crystalize and accumulate. They die, deteriorate, rot, erode. Vis-à-vis human experience, the changes things undergo may take place quickly or at an unperceivably slow pace. The long eons of evolution shape organisms. Mountains rise and fall in vast expanses of geologic time. Still, the changes are continual, whether we register them or not.

The sensual manifestation of things, their aesthetic "presencing," continually shifts as well. Things manifest differently from each angle of perception, in different degrees of light, in relation to different surroundings. The presencing of things is thus "plurivocal." "The thing, a unity," Desmond explains, "is also many, is a self-pluralization, a series of presentations of itself" (*BB*, 307). Our perception of a thing is only ever partial. We can never see a thing from every angle at once, for instance. Its aesthetic richness is inexhaustible in this regard.

Drawing on Merleau-Ponty, David Abram illustrates this with the example of a clay bowl. The bowl "meets my eyes with its curved and grainy surface. Yet I can only see one side of that surface—the other side of the bowl is invisible, hidden by the side that faces me." Some aspects of the bowl are resolutely hidden—"most obviously the patterns hidden *between* its glazed and unglazed surfaces." Even breaking the bowl apart would not reveal those aspects. It would simply destroy it. The plurivocal presencing of the clay bowl is fragile. One slip of the hand, one bump, one careless moment, and it shatters. This fragile presencing nonetheless resists our mastery. It can be neither completely plumbed nor delimited.

Things manifest differently to a human than to, say, a fly or a dog or a bat or an eagle. Indeed, things manifest differently to different humans. There is a strong tendency in modernity to claim that perception is merely subjective because of this: "The presencing of things, their aesthetic appearing,

is reduced to a set of *perspectives* that are not inherent in the thing itself but mind-dependent" (*BB*, 307). Desmond again insists, though, that perception is an intermediating between. There is indeed subjective mediation from the side of the perceiver, but there is also manifestation from the side of the perceived. Desmond concludes, "The appearance of things may be for mind; but it is for mind to be true to the appearance of things, to their own self-showing" (*BB*, 307–8). Returning to the example of the clay bowl, Abram notes, "Each time that I return to gaze at the outward surface of the bowl, my eyes and my mood have shifted, however slightly; informed by my previous encounters with the bowl, my senses now more attuned to its substance, I continually discover new and unexpected aspects."[42] The observer shapes the observation, but the act of observation also changes the observer. The intermediation at work here deepens both intimacy and a sense of otherness. The aesthetic richness of things knocks us over at times, striking us with wonder. However, the richness is often subtle. It would be easy to use the bowl without attention, to treat it as just a bowl like any other. Its richness only manifests to patient, receptive attention.

Desmond calls this richness of things "overdeterminacy." I can measure and sketch and photograph the bowl. I can carefully note its details. I can track down who made it and by what technique, comparing it to bowls by this artist or others. I can make many accurate determinations about it, but I still have not completely plumbed its richness. Indeed, my determinations can never fully exhaust the richness of the bowl. This is what Desmond means when he calls something overdetermined. It offers an excess of determinability that can never be fully mastered.[43]

We might think as well of artists who return to the same subject again and again, such as Paul Cézanne's repeated paintings of both humble apples and of majestic Mont Sainte-Victoire. Such a painter is attuned to overdetermined possibilities. Or we might think of the scientist, who is at times too simply opposed to the artist. Consider an ecologist who studies the same patch of forest or coastline for years and who has learned much about the flora and fauna, about the intricate relationships between them. It is hard to imagine a good ecologist deciding that there is nothing more to study there, that everything has been determined. Again, historical examples are not hard to find. We might turn to Cézanne's contemporary and compatriot Jean-Henri Fabre, an entomologist who observed and wrote about the insects around his home with continual relish and astonishment.[44] The patient fidelity of Cézanne and Fabre reveals inexhaustible richness.

Carefully attending to things, we discover that each is unique. It belongs to a kind, category, type, or species, but it is still a singular instance. This

bowl is not that bowl. This child is not that one. Each tree, limb, and leaf is singular. Mass production may numb us to this. Abram again provides helpful examples. He points out the uniqueness of organic patterns: "The patterns on the stream's surface as it ripples over the rocks, or on the bark of an elm tree, or in a cluster of weeds, are all composed of repetitive figures that *never exactly repeat themselves*." Such patterns sharpen our attention to difference. Abram contrasts these organic patterns with "the mass-produced artifacts of civilization, from milk cartons to washing machines to computers, [which] draw our senses into a dance that endlessly reiterates itself *without variation*."[45] They consequently dull our attention to differences. As Desmond notes, however, even in the case of mass-produced widgets, each is still singular in the most basic sense that it is this widget and not that one. This means that each singular thing is also a "once." When this particular bowl shatters, when this particular tree falls or burns or is cut, when it is reduced to humus or ash or boards, when this particular widget deteriorates hundreds of years from now in a landfill, its unique singularity will be lost forever.

Patiently attending to things can attune us to another excessive dimension of being—the mystery that things exist at all, that there is something rather than nothing. This reaches a deeper level than the laws of nature that govern things' becoming, as these laws are themselves still something. The mystery reaches deeper than biology or physics to ontology. It lies at the limit of thought and beyond determinate inquiry. It is an irreducible enigma, a mystery. Desmond agrees with Heidegger that " 'Why are there beings at all instead of nothing?' " is "the most originary question."[46] It is of fundamental philosophical importance. We cannot give a determinate answer to it, but it both prods and chastens our thought: "At this limit, finite reason encounters what is not finitely comprehended or explained. The fact that being *is* settles no ultimate question. Rather it raises it" (*DDO*, 183).[47] Desmond agrees with Heidegger that we need to be continually reminded of this question, particularly in the contemporary milieu, but Desmond does not think this question is as broadly forgotten in the philosophical tradition as Heidegger tends to claim. It is often implicit in philosophers' wonder, and at times it is made explicit. Desmond notes Aquinas's third way, Leibniz, and Schelling, as well as Heidegger.

Caught up in our day-to-day interaction with things, we become numb to this ontological mystery of being. In Desmond's parlance, we are so "intimate" with being that we become numb to its "strangeness." Because each thing in its ontological contingency incarnates the mystery,

however, mindful attention to a thing can raise the "originary" question. Desmond claims that "the fact that a thing is at all is close to the ultimate enigma" (*DDO,* 183). A thing does not sensually manifest this mystery in any straightforward or reductive way. The mystery of being does not have a color, smell, or a taste. Yet the aesthetic presencing of things can still draw us toward the mystery. Our wonder at their presencing can lead to a wonder at their existing at all, at anything existing at all. Desmond thus argues that there is a way in which the mystery of being "haloes" things, attends them as "something shimmering and elusive" (*PU,* 62). This halo is tied to sensual manifestation but not simply reducible to it.

Desmond often uses the word "idiocy" to evoke the singularity of things, especially in their intimate depths. He does not use it in the pejorative sense common in everyday speech. He uses it in the sense of the Greek *idios*, as something peculiar to the self, as in an "idiom" or an "idiosyncrasy." Desmond claims that the idiocy of things cannot be made fully determinate. It remains elusive. Consider again how even the humble clay bowl evades our conceptual mastery. Consider as well our own idiocy. We often feel an urge to convey what it is like to be us.[48] The fact that communication works fairly well, and that we have moments of shared recognition, suggests that solipsism gives a poor account of the world. Yet we never fully convey what it is like to be us. (Much less do we know with certainty what it is like to be someone else.)[49] We may have successes, but no full or final success. "Each of us lives idiotically," Desmond explains, "insofar as each of us is a singular being, whose very singularity seems to verge on being incommunicable in terms of conceptual abstractions and neutral generalities" (*IU,* 422). Desmond claims that our desires, imagination, and memories all have roots in our idiocy even as they transcend beyond us to mediate otherness. All three are bound up in our own continual development or "selving," which we can cultivate and discipline but never fully control. We find otherness not only outside us, then, but also within, and we remain porous in even our most idiotic depths. Indeed, in our idiocy we reencounter the mystery of being once more: "This inward idiocy opens into the enigma of the *that it is*" (*BB,* 188). Hidden in the intimate depths of ourselves and of all things is the ontological wellspring that continually sources our being. In Augustine's words: "I myself cannot grasp the totality of what I am."[50]

Desmond insists on the singularity of things, then, but this does not mean that he shortchanges their relationships to one another. Indeed, these relationships are often constitutive rather than extrinsic. A tree, for instance, is shaped by its access to light and water and space to grow, by

climate and soil, by pests and disease. Desmond notes that a tree "not only receives from air, soil, and sky, it also constitutes a neighborhood of being for other entities whose independence is grounded on their dependency on it: birds nest in it, insects infest it, mosses grow on it. The others of the tree are both within it and outside, and we cannot fix the within and the without in any finalized sense" (*BB,* 320). Desmond claims that "a thing does not simply live *in* its locale; it lives its locale" (*BB,* 306). What capacitates one thing, of course, often destroys or drains another. The same wind that spreads pollen can also spread a deadly blight. A snake slithers up a trunk to eat the birds' eggs. Nonetheless, all things need sustaining relationships. Things are interdependent in the "community of being." If things are singular, then, they are not singular in an atomistic way. They are not self-subsistent wholes. Desmond is once more the philosopher of porosity, of the relationships between "open wholes," whole in the sense that they have a singular integrity, but open in that they are always in relation, in that they are neither self-creating, self-sustaining, nor self-contained.

When we attend to constitutive relationships and receptivity, we recognize how hard it is to strictly delimit things. Consider the vast distances involved in a tree's ongoing photosynthesis, with its exchanges of sunlight, carbon dioxide, and oxygen. Because of such relations, Desmond endorses Alfred North Whitehead's critique of the fallacy of "simple location." This fallacy allows things to be fixed in space and time. For instance, we fix the location of a tree on a map. Such fixing is highly useful, even essential, for many activities. It captures an important truth about the tree's location, but it is only a partial truth, and it is a fallacious truth if made absolute. For fixing the tree in a "simple location" neglects how each thing affects and is affected by other things.[51] It abstracts the tree out of its web of relationships. If we cut down the tree and update the map, only a small coordinate will change on the paper or screen. Yet the felling of the tree impacts its whole locale and beyond. Location is far harder to delimit when we consider the manifold relationships between things.

Desmond claims that we need to be able to describe relationships in supple ways that move beyond simple oppositions. At times, one side does absorb another, like the snake eating the egg. Often, though, the relationship is an ongoing intermediation, like that between the sun and the tree. For such relationships, Desmond proposes a model of dialectic that maintains an open "between," with mediations from both sides and where the otherness of neither side is ever fully exhausted. We see this in friendship, to take a different sort of example, where we learn more about each other in a deep-

ening relationship and where both sides are changed but neither exhausts the other. We also see it in Desmond's account of perception covered earlier, with its play of receptivity and responsiveness, with its capacitating and never-exhausted flow of sensual excess. These examples suggest the range of possible intermediations and that each instance must be attended to in its specificity. Desmond calls his philosophy a "metaxology," from the Greek word for between (*metaxu*). It is a philosophy of the between in that it stresses our constitutive porosity, but it is also a philosophy of the between in the attention that it gives to such "metaxological" intermediation.

There are debts to Hegel's dialectic in Desmond's metaxological intermediations. As Christopher Ben Simpson summarizes, "From Hegel he gleans the dynamic resources of dialectic, the unfolding play of determinacy and indeterminacy; the persistent attentiveness to the question of intelligibility in the progression of thought; the sense of a complex whole even opening beyond dialectic."[52] Desmond claims that Hegel is a philosophical "companion" in his own philosophy, a thinker to whom he continually returns as a dialogue partner. There can be deep disagreement with a companion, but there is also the debt of dialogue and spurred thought. Much of Desmond's early scholarship was on Hegel, and his own philosophy shows both continuities and differences, both sympathies and criticisms. Consider how Desmond distinguishes his metaxological dialectic from Hegelian dialectic. The latter stresses the determinate knowledge that the dialectic between self and other yields. It also stresses the transformative self-mediation involved in one's encounter with the other. These are important dynamics, but Desmond argues that Hegel does not attend enough to mediation from the side of the other. Nor does he attend enough to the inexhaustibility of the other, to the otherness that remains after dialectical (self-)mediation. Merold Westphal thus describes Desmond's philosophy "as an attempt to think Hegel without closure."[53] A major, much-debated question is whether Hegel's own account allows for such an "open" reading of the dialectic. Is Desmond opening up Hegel's dialectical closure, or do Hegel's own works suggest this possibility (or at least not foreclose it)? Given Hegel's complexities, this is not an easy question to answer, but Desmond clearly has a much more pronounced sense of excessive otherness and of its philosophical importance.[54]

Hegel is not alone in muting these dimensions. Indeed, he is far less reductive and far more attentive to the concrete than many modern philosophers. While modern philosophy often emphasizes the determinate, which is indeed important, it often does not attend enough to the overdeterminate, to what resists or evades or remains in the wake of determination.

This quest for conceptual precision—to the extent that it erases a complex reality—ultimately leads to imprecision. Desmond at times quotes Whitehead to this effect: "The exactness is a fake."[55] This philosophical tendency toward abstraction is one reason why Desmond sees art and literature as crucial "others" for philosophy. Art can remind philosophy of the singular and excessive. It can be "a great celebrator of singularity just in its many-sidedness, just in its plurivocity" (*BB*, 311).

One danger in Desmond's philosophical project, as Stephen Houlgate points out, is that, rather than respecting the singularity of things, discussion of "otherness" can be abstract, ambiguous, even empty. It might not "disclose or open up the matter under discussion" but instead "reduce it and run the risk of evacuating it of meaning."[56] A leading Hegel scholar, Houlgate points out that the emphasis on determinability in Hegel's thought makes sure the other is not an abstraction but a concrete entity with actual characteristics. Desmond would argue that his metaxology allows for these determinations too, but that it attends as well to the never-exhausted excess that funds these determinations and exceeds them.[57] Still, Houlgate is not wrong that talk of the "other" and "otherness" risks eliding the rich singularity of things rather than preserving it.

Desmond acknowledges this danger, which is why he frequently offers passages of "poetic" description. Perhaps with Houlgate's criticism in mind, Desmond writes, "I am conscious of the generality of what I am saying, and of the tension between this and my stated aim of doing justice to the concrete singularity of things. Can this tension be eradicated? It seems not. Yet we can remind ourselves of the singularity we risk forgetting" (*BB,* 318). He goes on to describe swallows that "dynamically dot the sky" on "a glorious summer evening" (*BB,* 318). "What is a swallow?" he asks: "An integrity of vibrant energy. It flies, a speck of free being, spry against the background of blue heaven. It is like an acrobat over the void, buoyed up in air, the element of almost nothing" (*BB,* 318). Such descriptions are illustrations, but they are not merely illustrations. They keep "otherness" from becoming a philosophical abstraction.

Desmond notes a number of philosophical tendencies that obscure the singularity and excess of being. One common move is to privilege a constituent element of reality (atoms, genes, etc.) as the actually real. The complex wholes formed out of these constitutive elements become epiphenomenal. Constituent elements are of course important, but it does not follow that they should be given ontological primacy. Desmond also critiques monistic philosophies in which the whole ultimately subsumes the singular. He calls

such a whole an "absorbing god" (*DDO*, 29). Parmenides is a key figure here in ancient philosophy with his "view of being as a dense, homogenous sphere" (*DDO*, 29). Absorbing gods have also had a powerful influence on modern philosophy, especially via Spinoza's Substance. Desmond claims that any absorbing god runs into philosophical difficulty, though, in that "a truly absorbing god would not, properly speaking be an absorbing god at all; for if it were the absolute whole, it would already have assimilated all its parts, in a manner that would make it inert and inarticulate in itself" (*DDO*, 32).

Many philosophers also neglect aesthetic richness. Desmond criticizes the pervasive legacy of Locke's classical empiricism in this regard. Empiricism privileges "primary" qualities (bulk, figure) over "secondary" qualities (colors, sounds, tastes) because they are purportedly observer independent. Empiricism relegates secondary qualities to the subjective domain of how things appear to us, to mere impressions in the mind. In our most basic experience of the world, though, things manifest themselves in sensually rich ways. Primary qualities are not fundamental, then, as the empiricists claim, but "*mediated intellectual interpretations* of being as matter" (*PU*, 109). The empiricist interpretation of experience results in a "cold objectivity" that is ultimately "denuded of the charged thereness of being that we find in the aesthetic presencing of things" (*PU*, 109). It strips things of the qualitative worth inherent in their presencing.

Desmond further questions the way in which empiricism tries to isolate "objective" sensation from "subjective" emotion. As we have seen, the sensing flesh is a "between," continually mediating the excess of being. Desmond holds, "From the start experience is charged with emotion through and through. Even emotional neutrality is itself an emotional mood, not itself entirely neutral" (*PO*, 68). Desmond refers to Heidegger, who challenges how we often think of emotions, moods, or states of mind as purely subjective phenomena. We assume we must bracket these moods to get at "objective" reality. Yet Heidegger argues, and Desmond concurs, that this is misleading. A mood is always a comportment or attunement to being. Different moods attune us in different ways to things, including ways that make us more or less receptive. Moods disclose and obscure.

Furthermore, we never experience the world without a mood. Even the scientist's detachment is not only a methodology; it is also a mood. This does not condemn us to subjectivity, though. Moods are neither subjective nor objective in any simple sense. A mood "comes neither from 'outside' nor from 'inside,' but arises out of Being-in-the-world, as a way of such Being."[58] The mood does not simply start with us, like a set of glasses we

don and then attend to the world. Desmond might stress the ongoing intermediation involved in moods, the way external otherness continually shapes our mood, while at the same time our moods dispose us toward and shape our experience of that otherness. Again there is no simple way to differentiate between inner and outer, between the subjective and the objective, in this always ongoing intermediation: "Experience is a complex conjunction of self and world into which emotion is inextricably woven" (*PO*, 67). Still, we can cultivate certain moods, certain attunements, as we saw earlier with Desmond's agapeic mind.

Affirmation

In Desmond's metaxology we are doubly related to otherness. We are receptive to it in our porous flesh, and we reach out to it in our self-transcending desire. Desmond titled his first major work of constructive philosophy, based on his doctoral dissertation, *Desire, Dialectic, and Otherness*. In treating desire, Desmond again resists reductive tendencies in modern thought, especially tendencies to treat desire as lack or as will to power. These tendencies obviously contain truth. Hunger and thirst do register a lack. Indeed, the lack that desire tries to fill yawns deeper than such necessities of life. It can even seem to be a bottomless pit. We are finite creatures, but there is something infinite about our protean desires, about the possibility for distention. Likewise, our desires can be self-assertive, even domineering. Desire can take the form of Plato's *eros turannos*, of Augustine's *libido dominandi*.[59]

But what of the desire to affirm the beauty of, say, a blossoming apple tree or the desire to write a poem in praise of it? According to Desmond, we are dealing here with a desire not animated by lack so much as by fullness, not animated by will to power but by a desire—perhaps even a need—to affirm the sheer existence of this apple tree. Such a desire, according to Desmond, can be stirred in experiences of astonished wonder. Desire is often ambiguous, of course, as Plato and Augustine again show. Nonetheless, eros entails the possibility of "ennoblement" as well as "debasement" (*DDO*, 211n14).

Desmond often explores desire through two ancient works: Plato's *Symposium* and the creation account in Genesis. In the former, he points to how, in Socrates's retelling of Diotima's myth, Eros is the paradoxical child of both Penia (lack) and Poros (plentitude). The parentage of Penia is obvious, as discussed above. Desire does often involve a lack. What of the

parentage of Poros? We see plentitude in how Eros "is a schemer after the beautiful and the good; he is brave, impetuous, and intense, an awesome hunter, always weaving snares, resourceful in his pursuit of intelligence, a lover of wisdom through all his life, a genius with enchantments, potions, and clever pleadings."[60] We also see it in how erotic desire "keeps coming back to life."[61] We see it, Desmond notes, in how it can lead to the creation of new art, new thoughts, new life. Perhaps we see the influence of Poros/plentitude as well in "the final and highest mystery" of erotic desire, the vision of the form of beauty, a point where contemplation, beauty, and virtue converge.[62]

For Desmond, this Poros/plentitude suggests an "agapeic" potential in eros, a potential to affirm the goodness of the other beyond the other's goodness for us. If eros is desire that turns back toward the self, in ways that range from the possessive and the consumptive to the reciprocal and mutual, agape desires the good of the other as an other, for the other's own sake. For Desmond, the agapeic potential in eros is sourced in how we are ourselves not simply a "lack" or a self-assertive will but an endowed surplus of being. This surplus allows us to move beyond our own needs and wants to generously affirm others. Agape is also, for Desmond, often more proximately sourced in desire-stirring experiences of astonished wonder, including experiences of beauty.

There are agapeic affordances in Platonic dialogues like the *Symposium*, but Desmond's use of the term signals his debts to Christian tradition. Modern thought largely delegates (or relegates) agape to theology while philosophy focuses on eros. Yet Desmond insists that agape names something important about desire, something that modern thought often neglects. It names desire's fullest affirmative and ethical possibilities.[63] Desmond insists, "Agapeic service is not the exclusive possession of the Christian tradition or of the religions of the Bible. Signs of this ultimate community are not exclusive to one and only one tradition" (*IU*, 180). He points, for instance, to the Buddha.

Crucially, Desmond does not simply oppose eros and agape. He sees the two as different facets or possibilities within desire. (Plato's myth is again helpful in this regard.) If agape is the highest possibility of eros for Desmond, this does not mean that it simply leaves eros behind. Interlocutors at times criticize Desmond's emphasis on agape, like his emphasis on the *passio*, for privileging the passive or the disinterested.[64] As Desmond's reading of the *Symposium* suggests, though, agapeic affirmation and care can be charged with erotic dynamism. Agapeic service to the other is not the rejection of

our dynamic becoming or self-transcendence but its highest culmination. It is the form of self-transcendence that carries us most fully beyond ourselves, a self-transcendence "released in a being for the other that is for the other and not for any return to self" (*IST,* 215). Likewise, the "agapeic mind" discussed earlier is not simply passive, but a state of the *passio* that is alertly receptive to the goodness of things. Such alertness is not resolutely opposed to desire—it is itself a yearning receptivity.

Desmond draws on biblical as well as Platonic myth to explore the agapeic potential in desire. In Genesis, after completing the creation, "God saw everything that he had made, and behold, it was very good" (1:31). Desmond claims this is not an expression of God's "erotic self-satisfaction," but instead "an agapeic release of the otherness of creation into the goodness of its own being for itself" (*IST,* 325). This affirmation comes immediately before the first Sabbath. The Sabbath's purpose, then, "is not recuperation from weariness but enjoying peace before the good of what has been given to be" (*IST,* 325). As we will see later, Desmond conceives God as an "agapeic origin" who creates singular beings endowed with their own integrity and inherent goodness. Here, though, Desmond uses the Genesis narrative to indicate that we can keep the Sabbath in turn through agapeic affirmation.[65] Such affirmation may be underpinned by a general sense of the goodness of being, but it is also attentive to the singular. It affirms the goodness of particular beings, just as God proclaims not only the superlative goodness of creation as a whole but also the goodness of the particular things created on particular days. By extension, the Golden Rule and other biblical injunctions to love the neighbor or the needy are not a formal ethic like the categorical imperative. They are calls to attend to the singular goodness of the person before one, to love *this* person.

Desmond's emphasis on agape may seem naive about self-interest. Desmond acknowledges, "True enough: every 'It is good' we human beings utter tends to be entangled in some open or secret 'It is good for me, for us.'" (*IST,* 326). If we are porous, though, if we are always in relation to otherness, our basic, reflexive self-affirmation does not affirm ourselves alone—it implicitly affirms the air we breathe, the food and drink we consume, the family and friends who bring us joy. It affirms the broader community of being of which we are a part and which sustains us.[66] In sum, our basic self-affirmation does not only affirm the self. For sure, this affirmation can contract into a narrow, vicious self-interest. (Here again the *conatus* recesses the *passio.*) But on Desmond's account, the joy we get from affirming or

caring for others is not necessarily derived from a hidden self-interest. It may manifest our joy in the being we share with others. It may affirm our community with others.

To turn the criticism around, flatly reducing affirmation to either self-interest or will to power greatly circumscribes the possibilities for love, friendship, community, service, care, gratitude, hospitality, and forgiveness.[67] It pours solvent on every instance of them we have experienced, every instance of them we have offered to others. It takes our continual "entanglement" with self-interest as evidence that *all* is self-interest. It discounts the ways that humans sacrifice themselves for others, often in humble and unrecognized ways but at times in ways that are dramatically heroic. Balthasar points out, and Desmond would agree, that many contemporary theories (and some ancient ones as well) make such suspicious moves, explaining away apparent goodness "in terms of mores, changing customs, unconfessed laziness and selfishness, a natural will to power concealed under various disguises."

> If, however, such people [holding these theories] come face to face with the evidence of a selfless act that another, say a friend, performs for its own sake, and they realize by their own inward experience that the naked overcoming of self is a really attainable possibility, they forget for the moment their entire theory and bow before the simple fact of goodness.[68]

There is of course no shortage of hypocrisy, manipulation, and exploitation in the world.[69] Suspicious philosophers like Nietzsche and Sartre deftly uncover this. But there is also a distention of suspicion that distorts rather than reveals. Indeed, there is suspicion that betrays and blights.

Wonder

Desmond agrees with the ancient claim that philosophy begins in wonder.[70] For him it begins in a particular mode of wonder. It begins in astonishment at the "too-muchness" of being. Such wonder does not distort perception but heightens it. It results from a dramatic, striking "jolt of otherness," one that breaks through habituated perception (*BB*, 9). Such wonder strikes purify our perception. They unclog our porosity. Astonished wonder recurs in human experience. It strikes out of both the ordinary (a foggy morning)

and the extraordinary (the face of a newborn child).

Such astonished wonder is a primal experience for Desmond, one that especially marks childhood: "The child *lives* this primal and elemental opening; hence wonder is often noted as more characteristic of earlier stages of life, often accompanied by an asking of the 'big questions'" (*VB*, 111). As we grow older, our childlike receptivity and responsiveness tend to calcify. The *conatus* recesses the *passio*. But such wonder can always strike us anew in profound ways. Astonished wonder is the height of receptivity for Desmond, but it leaves us neither slack-jawed nor stupefied. For it ultimately stirs a response. According to Desmond, the origins of not only philosophy but also religion and art are in astonished wonder. It launches them on the quest for "ultimacy." It remains their taproot. They become brittle or wither when cut off from it.

Perplexity is Desmond's second mode of wonder. Astonishment entails an implicit, spontaneous affirmation. It is agapeic in this regard. It easily gives rise to gratitude and reverence. Perplexity, on the other hand, rattles and disturbs. It makes us search for solid ground, for a secure grip on things. Perplexity "can awaken an urgent *seeking* for what is true in all significant art, in all intellectually honest philosophy, in all spiritually serious religion" (*VB*, 113). Perplexity, in this regard, is necessary and healthy. Furthermore, perplexity and a more affirmative astonishment are not always opposed. They mingle in experiences such as the sublime.

In perplexity, though, the mystery of being can become threatening or infuriating: "Filled with dismay, we can be driven to distraction, can even be driven mad" (*VB*, 113). In Melville's *Moby-Dick*, Ahab exemplifies such maddening perplexity.[71] On the quarterdeck of the *Pequod*, he explains to Starbuck, "All visible objects, man, are but as pasteboard masks." In slaying Moby Dick, Ahab aims to "strike, strike through the mask!" Racked by perplexity, Ahab cannot bear the mystery of being. He rejects it *qua* mystery. He seeks to wrench knowledge from it. He *will* know what animates reality—even if "there's naught beyond."[72] But of course he will not know. Perplexity, Desmond explains, can arise from "the dismaying destitution of not-knowing *and* the ignorance of a voracious desire to know" (*VB*, 113).[73]

Ahab displays a Luciferian pride and a hunger for domination. "The tyrannical person," Desmond notes, "hates equivocities because in all ambiguous signs he can only detect the possibility of hostility or threat" (*IU*, 381). But Ahab has also suffered in body, mind, and soul. His perplexity festers in old wounds. It arises as well from the captain's long familiarity with a

bloody business in "sharkish" seas. Ahab attempts to armor his porosity, to recess his *passio*, because he well knows that it makes him vulnerable. He aims to be all *conatus*. For if porosity opens us to the richness of being, it also opens us to suffering. Think of disease, of tapeworms wending through our guts. Pascal: "A human being is only a reed, the weakest in nature, but he is a thinking reed. To crush him, the whole universe does not have to arm itself. A mist, a drop of water, is enough to kill him."[74] Think of the manifold cruelties, often random or gratuitous, that humans inflict on one another. Think of the ways we inevitably wound even those we love. We may attempt to clog our porosity, then, out of self-preservation rather than self-absorption or pride. We may attempt to stop up the porosity so as to staunch wounds and stop wounding.[75] Our vulnerability can give rise to anguished perplexity in this regard.

Melville was an avid reader of Schopenhauer in his later life, and Desmond recognizes Schopenhauer as a great philosopher of perplexity. Schopenhauer observes, "No beings, with the exception of man, feel surprised at their own existence." He goes on to explain,

> And its wonder is the more serious, as here for the first time it stands consciously face to face with *death*, and besides the finiteness of all existence, the vanity and fruitlessness of all effort force themselves on it more or less. Therefore with this reflection and astonishment arises the *need for metaphysics* that is peculiar to man alone; accordingly, he is an *animal metaphysicum*.[76]

If for Desmond philosophy begins in wonder-as-astonishment, for Schopenhauer it begins in wonder-as-perplexity. It is the experience of "finiteness," of standing "face to face with death," which makes Schopenhauer's human an "*animal metaphysicum*." Schopenhauer is one of many philosophers who take their bearings from such urgent perplexity. We might think, for instance, of the importance of *angst* or anxiety for the Heidegger of *Being and Time* and for the existentialists.

Perplexity seems to be as primordial as astonishment; perhaps, as Schopenhauer suggests, even more primordial. Children are given to perplexed horror as well as delighted astonishment. Perplexity, like astonishment, is also at the origins of religion, art, and philosophy. (Consider the sufferings of Job. Consider how astonishment marks some of the psalms, perplexity others.) Life is a hybrid affair, a mix of sustenance and threat, of joy and

pain. It is a "chiaroscuro" of light and shadow, to use Desmond's metaphor. We find ourselves *between* good and evil, he says. If astonished wonder is philosophy's departure point, as it is for Desmond, it must nonetheless pass through perplexity. It must furrow its brow at the chiaroscuro of existence. It must seek a renewed astonishment beyond naiveté or innocence, on the other side of perplexity.

Desmond would defend this particular sequence, though, where astonishment is basic and later recurs. Desmond claims that perplexity is not truly equiprimordial with astonishment. It is instead "a first-born child of primal astonishment" (*VB*, 118). Astonishment is an experience of radical porosity. Perplexity, on the other hand, involves at least a partial recoil from openness. It involves a stronger sense of the difference between subject and object, of the fragility and finitude of the former. In this regard perplexity is at one remove from astonishment, and thus perplexity can indeed grow out of astonishment. Alexandra Romanyshyn claims this is true of children:

> Imagine the wonder of a baby, discovering for the first time commonplace items that adults take for granted: a door swinging on its hinge, the sound of a rattle, a splash of water. Yet with age and experience, the innocence of the wonder becomes tainted: hinges can pinch, rattles can herald a threat, and water can burn the lungs.[77]

Astonishment here gives way to perplexity at the threat of the other. Variations on this dynamic play out over the course of a life. I step outside at midnight on a starry night. The thousand pinpricks of gently pulsing light astonish me. But that astonishment gives way to perplexity about the distances involved, about my own (in)significance in such a vast universe, about my children's (in)significance. Pascal again: "The eternal silence of these infinite spaces terrifies me."[78] Perplexity may seem to be the more responsible and mature form of wonder because it does not shy away from the thorniest questions. Desmond agrees that perplexity raises crucial questions, but he resists the notion that astonishment is necessarily limited and naive. Instead he would say that the porosity of astonishment actually enables perplexity, and one danger of anxious perplexity is that it might come to see this porosity reductively, as only a problem. Likewise, astonishment is a sort of limit experience, a maximum awareness, of being as overdeterminate. Perplexity tends, on the other hand, to focus on the interplay of indeterminacy

and determinacy. It is actually the narrower mode of wonder. On its own, perplexity loses track of the richer sense of overdeterminacy.

Perhaps most importantly, Desmond argues that astonishment's affirmation of being's goodness is properly basic. Perplexity on its own obscures the worth of being. Desmond claims that this sort of perplexity haunts modernity. We fear that being is not neutral, as the dominant ethos of serviceable disposability assumes, but hostile or even evil. Desmond notes that radical evil preoccupies twentieth-century art and thought, while radical goodness receives scant attention. At times this entails a serious grappling with the crises of the century. At other times the preoccupation with evil seems more like a fixation, a fascination.[79] Perplexity gives way to lurid curiosity. O'Regan observes, "Curiosity, even curiosity which thinks of itself as an ethical necessity, brings one to the threshold where you run the danger of becoming what you see or . . . becoming what you imagine."[80]

Desmond is not simply critical, however, even of this modern fixation on evil and violence. He claims, "It is as if evil, and its shock, were one of the last spaces where something of a kind of excessive transcendence might be felt, albeit in the form of horror."[81] Horror can break through our boredom, routines, and self-absorption, returning us to the *passio* in a way that troubles but also strangely refreshes. Yet there are also obvious dangers here—a trivialization of violence and evil, the reduction of them to spectacle, perhaps an attendant desensitization to the realities of them, perhaps even in some cases an encouragement to enact or embody them.

Our "lopsided" focus on evil and violence also leaves us with scant resources for affirming the intrinsic worth of things, for cultivating care and gratitude. A perplexed fascination with evil may even make us capable of seeing only evil. I may think I have a realist's unflinching eye when I actually have an "evil eye," tainting what I see. I might be like the sullen in Dante's *Inferno*. Trapped beneath slime, Virgil must rehearse their speech for them:

> "Sullen were we in the air made sweet by the Sun;
> in the glory of his shining our hearts poured
> a bitter smoke. Sullen were we begun;
>
> sullen we lie forever in this ditch."[82]

The sullen betrayed the goodness of the world. They scorned the sun and the sweet air as gifts of God. Their punishment literalizes the way they saw the world, as coated in slime.

One of Desmond's imperatives is to balance out this lopsidedness, to recover a sense of the goodness of being. This does not mean denying that our existence is a chiaroscuro, a mix of peace and war, reciprocity and struggle, rest and strife. But it does entail insisting that astonishment is more basic than perplexity. It likewise entails rejecting the ancient tendency, which becomes pervasive in modern and postmodern thought once more, to make *polemos* fundamental, to make conflict the central metaphor for being as such.[83] Desmond argues,

> War is not the father of all: there is a father/mother more primordial than this father. One might say: War takes for granted being given to be, the primordial gift of being; war may have its deepest roots in forgetfulness of this gift, indeed in refusal of it as gift. To fight for life presupposes being given the gift of life, and the good of this gift. (*IST,* 331)

Desmond does not see suffering as "an argument for the evil of being, nor for the ultimacy of war. That we shun it, seek to alleviate it, shows the opposite" (*IST,* 331n11). As noted earlier, a brush with death, a recovery from disease or suffering—or the recovery of someone we love—can itself be an experience of affirmative wonder, a restoration not just to health but also to a sense of the goodness of being.[84] Agapeic astonishment can be reborn out of perplexity.

Curiosity is Desmond's third mode of wonder. Astonishment discloses being as richly overdeterminate. Perplexity discloses it as ambiguously indeterminate. Curiosity, on the other hand, is concerned with determinate knowledge, with how things work, with identifying and solving problems. The modes of wonder can intermingle here too. Astonishment and curiosity, for instance, need not be opposed. A child might delight in birds, seeking to learn everything she can about them but never losing a sense of awe. When that child grows up and becomes an ornithologist, the same awe can still accompany her quest for determinate knowledge.[85]

Curiosity can also give way to astonishment at discovered excess. Consider how Thomas in St. John's Gospel seems to think that touching Christ's wounds will resolve the mystery. Caravaggio's famous painting gives Thomas the face of an incredulous skeptic, aggressively thrusting his finger into the wound, leaning over to better peer into the parted flesh. But Thomas discovers that touching the mystery is not the same as grasping it. Antonio Busca's Baroque Thomas seems to be painted a moment later. The

once-incredulous apostle is now astonished. He draws back, wide-eyed, the mystery deepened rather than dispelled.

Desmond does not disparage curiosity. It is "absolutely indispensable to the essential determination of being and cognition" (*VB*, 116). It is obviously crucial to scientific inquiry. While Desmond criticizes scientism and scientific hubris, he also criticizes epistemologies that completely relativize the findings of science. Desmond steers between modern claims that science is purely neutral and objective and postmodern claims that science is only a social construct. Methodology, assumptions, critical acumen, ideology or aspiration can all shape (or misshape) mediations from the side of the scientist, but there is also mediation from the otherness that the scientist tries to discern. The capable "scientist sounds nature, and rejoices when the sounding resounds with the intelligibility of what previously seemed mere noise" (*BB*, 341).[86]

Curiosity carries a risk, though. It can "run roughshod" over a deeper sense of ontological wonder (*VB*, 116). Desmond sometimes presents the three modes of wonder as a sequence: agapeic astonishment gives rise to restless erotic perplexity that gives rise in turn to determinate curiosity. Desmond writes, "When the child points to the night sky and murmurs—'Look, the moon!'—the astonishing has won its way into its heart. Later, the astonished child is recessed, even driven underground, in the curious project of (say) space exploration which lifts off the earth" (*VB*, 111). With a nod to Giambattista Vico, Desmond suggests that not only individuals but also cultures can follow this trajectory, leading to a "barbarism of reflection" where curiosity shorn of astonishment reigns.[87] Such curiosity animates (perhaps it would be better to say desiccates) the modern ethos of serviceable disposability.[88] Stark curiosity manipulates a world treated as a resource with no meaning, no worth, apart from its usefulness for us. Desmond quotes Wordsworth's apt phrase, "We murder to dissect."[89]

Still, Desmond avoids metaphors for the modern predicament that suggest complete enclosure, such as Weber's "iron cage" or Heidegger's "enframing." Wonder can still strike the most hardened or alienated modern. We never fully close off our porosity—not even within the ethos of serviceable disposability and its curious projects.[90] The urgency of a deeper astonishment and perplexity cannot be quelled in art, religion, philosophy, or indeed science as well. They compel us beyond mere curiosity. Desmond has much sympathy for Charles Taylor's account of modernity, for instance, but he qualifies Taylor's contrast of the "buffered" modern self with the "porous" premodern self.[91] While Desmond agrees that modernity

discourages receptivity in many ways, he notes that we cannot make too sharp a contrast between "porous" premoderns and "buffered" moderns. For Desmond, the "porosity of being is ontologically constitutive, not just historically relative, though it may be true that some epochs exhibit a feel for it, while others reconfigure the ethos of being, and human being, and the porosity is driven underground, say, or out of mind, say, or warped into forms not true to the promise of the original givenness."[92] The modern self is never fully buffered. The "reconfigured" ethos of serviceable disposability may distort or obscure the excess of being, but the "primal" ethos of the excess can still break or seep through our porous selves, our porous cultures. For Desmond, Terence Sweeney explains, "Humans dwell in a primal ethos (being as originally given) which we overlay with a secondary ethos (being as a human construct)."[93] While Desmond recognizes the profound influence of culture, then, he is not a cultural determinist. The culture must still mediate the excess of being, and that mediation can never be fully reduced to the side of the culture. It is always an intermediation.

We might close this chapter by returning once more to the sensual immersion that continually washes over us, this time contrasting how Desmond and Hegel understand this immersion as a departure point for philosophy. This contrast underscores both the importance of primal astonishment for Desmond and the difference between his metaxological intermediation and Hegelian dialectic. Hegel's *Phenomenology* begins with a treatment of "sense-certainty," which establishes entities "Now" and "Here" within time and space.[94] Our first move within sense-certainty thus unfolds toward the universal, toward categorical intelligibility. The language we use registers this mediation ("this is," "it is"). Hegel concludes that "the universal is the true [content] of sense-certainty and language expresses this true [content] alone."[95] Hegel recognizes the apparent excess of the "concrete content" of our sensual immersion:

> Because of its concrete content, sense-certainty immediately appears as the *richest* kind of knowledge, indeed a knowledge of infinite wealth for which no bounds can be found, either when we *reach out* into space and time in which it is dispersed, or when we take a bit of this wealth, and by division *enter into* it.

Yet Hegel holds that this apparent excess in sense-certainty is actually not the richest knowledge but the "poorest" because it only ascertains the "sheer

being of the thing" until it has been mediated toward categorical intelligibility.[96] Being thus turns out to be indigent rather than excessive for Hegel.

Desmond parts ways with Hegel here. He agrees about the need for mediation, about the impulse to make things categorically intelligible. Yet he fears that Hegel's dialectical mediation neglects the overdetermined singularity that remains after mediation:

> The question is whether there still is something about the singular that remains unmediated in terms of the mediation of the universal category. It is not that there is no mediation, but perhaps the immediacy of the "this" calls for a different mediation than the Socratic *eidos* or Hegelian universal. Perhaps it calls for a mindful respect towards the "this" as "this." (*PU,* 59)

As discussed above, Desmond's "metaxological" intermediation keeps the dialectic open in a "between" so that determinations, including determinations of categorical intelligibility, can be made while still recognizing the ways in which the other can be neither exhausted by mediation nor fully assimilated to categories.

There is another, related difference between Desmond's account and Hegel's. Donald Verene observes that in the opening pages of Hegel's *Phenomenology*, "The phenomenon of sense-certainty is not simply that of having a world but of how the world is known. It is the first attempt by consciousness to face the question of knowledge."[97] The *Phenomenology* thus offers a ladder of philosophical knowing, with sense-certainty as the first rung. Verene recalls Ernst Cassirer's criticism that Hegel should have started his ladder of knowing lower, with a rung in primordial feeling, in what Desmond would call primordial porosity: "Cassirer maintains that experience begins in a world of mythical forces and energies, before consciousness senses the object and the I as discrete thisness and as heres and nows."[98] At this level, everything is charged with elusive significance. Desmond would say that at this level being manifests as overdeterminate. Astonishment and perplexity saturate the mythic.

Using Desmond's modalities of wonder, we might say that Hegel's treatment of sense-certainty, as complex as it may be, begins more with curiosity than astonishment. Curiosity is marked by a desire to know what things are, by a desire for determinate knowledge. It marks out a sort of knowledge gap. Desmond notes how in Hegel's treatment of sense-certainty

"immediacy seems to be equated with a defective condition" (*ISB*, 70). Recall that for Hegel the "sheer *being* of the thing" offers only "poor knowledge." For Hegel, "The overdeterminacy, the 'too-muchness,' of the beginning counts more as an indeterminacy to be made more conceptually determinate and self-determining rather than an astonishingly rich matrix in which all thought germinates, which endows all thought, and which no thought of ours can exhaust" (*ISB*, 66). Desmond, as we have seen, is concerned with how being can strike us with astonishment. This does not leave us perpetually dumbfounded or speechless. It offers a departure point for philosophical reflection in its own right.

Climbing the ladder out of astonishment rather than curiosity yields a different attunement to otherness in its singularity, excess, and contingency.[99] In fact, with curiosity we may well believe that we are building the ladder from below, that it is simply our accomplishment. With astonishment, however, our inquiry begins in the overdetermined strike of otherness, which stirs and stokes our desire to know, to climb the ladder. As Catherine Pickstock provocatively claims, with curiosity we forget "that Jacob's ladder must first be let down to us."[100] An inquiry that proceeds from astonished wonder does not simply leave the mythic narrative or image behind as it climbs, nor does it simply use them as illustrations. It thinks with them along the way and especially at the limits of discursive reasoning, as we see throughout Plato's dialogues. Such a philosophy not only begins in wonder but ends in it as well—not because it is stuck in place, but because it recognizes that it can never exhaust the richness of being, that it can never reach the top of the ladder.

Chapter 2

The Call of Beauty

This chapter surveys Desmond's account of beauty, which challenges several trends in modern and postmodern aesthetics. The last chapter surveyed Desmond's account of wonder. The experience of beauty, considered here, is a particularly prevalent and particularly important instance of astonished wonder. In experiences of beauty, we are struck, or "called," by the aesthetic richness and singularity of things. Desmond attends to this wondrous, receptive aspect of beauty, which is often neglected in modern aesthetics, where the emphasis is on criteria of judgment—on our critical initiative vis-à-vis beauty rather than our receptivity to its strike or call. This does not mean that Desmond's account of beauty is passive, though. As we will see, Desmond explores how the call of beauty (like the strike of wonder more broadly) calls forth our response, how it stirs an eros within our cleansed porosity. This chapter's first section thus considers the "call" of beauty and how that call elicits a range of responses, from simple affirmation to artistic creation to ethical care. The second section discusses the relationship between beauty and the sublime. In modernity, the two have often been opposed to each other, with the sublime eclipsing beauty. Desmond argues against this opposition and the subsequent trivialization of beauty. He claims there is a "permeable threshold" between the beautiful and the sublime. The third section takes up the relationship between aesthetics and ethics. Desmond argues that aesthetics continually shapes our lives and our ethical action. Nonetheless, there is no necessary or univocal translation of aesthetic worth into a more determinate ethical approach. Aesthetic worth is an ethical "potency," an affordance that our ethical norms and practices can draw upon or betray.

Call and Response

Desmond's account of beauty, like his account of perception in general, stresses receptivity. Beauty, like wonder, begins with a "jolt of otherness." Indeed, experiences of profound beauty simply are experiences of astonished wonder. In beauty, we wonder at the aesthetic richness of things. John O'Donohue says, "The wonder of the Beautiful is its ability to surprise us. With swift, sheer grace, it is like a divine breath that blows the heart open. Immune to our strategies, it can take us when we least expect it."[1] Beauty, as an instance of wonder, breaks through our habituated perception, through our usual routines or concerns or projects. It unclogs our porosity and reawakens us to the "too-muchness" of being. In such experiences of beauty, "our astonishment becomes ontological appreciation of the incarnate glory" of things (*VB*, 207). We are struck by aesthetic excess, and this strike calls forth our spontaneous affirmation.

Perhaps I wake on a January morning and begin my usual hurried preparations for work. I step outside as the sun rises on freshly fallen snow. Each tree is a glittering statue, the neighborhood a wonderland. The windows on each house blaze gold. I am pressed for time, but I cannot help but stop on my doorstep, entranced by the sight, forgetful at least for a moment of my daily cares. Even when I do return to those cares, I find myself calmer but also energized and more aware. Elaine Scarry observes that "attention to any one thing normally seems to heighten, rather than diminish, the acuity with which one sees the next."[2] Beauty returns us to porosity. It leaves us more broadly attentive, more broadly appreciative.

Beauty is notoriously difficult to pin down. Plato's *Greater Hippias* explores the difficulty of determining what property (if any) the beautiful mare, lyre, pot, and law all share. Even if we set aside the beautiful law and focus on sensual beauty, Socrates's endorsement of the old proverb at the end of the dialogue is apt: "What's fine [beautiful] is hard."[3] Hegel likewise notes:

> It might indeed appear at first as if the beautiful were a perfectly simple idea. But it soon becomes evident that manifold sides may be found in it, one of which is emphasized by one writer and another by another, or, even if the same points of view are adopted, a dispute arises on the question which side after all is to be regarded as the essential one.[4]

One venerable approach to beauty emphasizes number, proportion, and symmetry. Another links beauty and light.[5] Plotinus attempts to bring form and light together in his *Enneads*. Aquinas does as well in his discussion of the marks of beauty—*integritas, consonantia, claritas*.[6] Desmond finds affordances in these traditions. Together, they help illuminate beauty as a diverse happening. Beauty can be more tied to visual splendor, to pattern or order, to the consonance between things, to the strikingly singular. Often, the factors mingle. Often, the beauty at play seems to exceed them altogether. Beauty is a happening of "saturated equivocity," which means that attempts to make it too determinate are reductive and disfiguring (*GBPB*, 27). Broadly put, beauty is a manifestation of aesthetic excess. Because it manifests, beauty testifies to forms that are not closed but open. It testifies to open wholes that communicate beyond themselves. Beyond that, beauty calls for finesse and attention to the specific instance.

Desmond notes the differences between natural beauty and artistic beauty, between the "given" and the "wrought," but he does not dualistically oppose them. Nor does he privilege one over the other. Both involve aesthetic excess. Likewise, Desmond resists a simple opposition of nature and culture. Recall the discussion in the last chapter of how culture is itself porous rather than self-contained. Culture forms our sense of the beautiful, our sense of which bodies are pleasing, of which landscapes have aesthetic worth, of which clothes are stylish. It can make us scoff at, or recoil from, what other cultures find worthy. Yet Desmond resists the notion that beauty is fully culturally determined. If so, we could not be surprised by beauty. We could not discover overlooked beauty. Cultural norms of beauty shift because of interactions within and between cultures, or because we critically examine them, but Desmond would argue cultural norms also shift because the aesthetic excess of being can always unsettle them.

Desmond focuses on the experience of beauty, including how beauty often seems to offer rest and release. Some of the major figures in modern aesthetics also explore how beauty offers release. Desmond's account of how beauty punctures the *conatus* and returns us to the *passio* resonates, for instance, with Schopenhauer's evocative claim that beauty offers a "Sabbath" of the will, a soothing respite from striving desire.[7] Schopenhauer points to "the abundance of natural beauty that invites contemplation, and even presses itself on us."[8] Contemplating this beauty offers at least momentary peace and solace. Yet in modern aesthetics broadly the press of beauty—its jolt of otherness—is often downplayed in favor of our aesthetic judgment. Beauty

becomes something we discern and then evaluate. Surprising beauty does not gift us with release. Desmond again thinks the post-Kantian emphasis on autonomy is a major reason for beauty becoming a matter of judgment and taste. It obscures, perhaps even makes embarrassing, our vulnerability to the beautiful.

Desmond finds a better sense of "originating receptivity" in premodern philosophy. Desmond recalls how one of the Greek words for beauty is "*to kalos*," which "has been connected to 'calling'" (*EB,* 179). Scarry likewise notes how "Plato, Aquinas, Plotinus, Pseudo-Dionysius, Dante, and many others repeatedly describe beauty as a 'greeting.'"[9] Desmond takes up this etymology. He explores how beauty calls in many ways and in many voices. Sometimes it calls in a whisper. I might visit a new friend's home, and even as I exchange pleasantries, a painting on the wall quietly calls out to me. It draws my eyes. Perhaps it even draws my body across the room to stand before it. Sometimes, as in the case of an unfamiliar landscape, seemingly stark or drab or barren, one may not hear the call of beauty for a long time. There are many possibilities. The face of the beloved calls in one way, the face of a great-grandmother's portrait in another. We can cultivate receptivity and sensitivity to the varied calls of the beautiful. The study of art and art history, for instance, deepens our receptivity, discernment, and appreciation. Subtler calls often go missed without trained receptivity. Our own varying degrees of receptivity, changes in our mental state and state of life, also affect how, and whether, we hear the call. They may explain why an artwork enthralls us at one point and leaves us indifferent at another. At times, though, beauty overwhelms. It shakes the scales off our eyes or blasts through our stopped-up ears. Stendhal famously suffered a near-collapse from the beauty of Florence. Today, some speak of "Stendhal Syndrome" to describe such an intense reaction to beauty.

When we attend to our experience of beauty, we find not only a call, but a response as well. It is another "between" happening. Beauty offers release by reopening our porosity, but it also stirs a response to the otherness to which we are newly attuned. Beauty "makes us still," Desmond says, "and yet moves us deeply" (*GBPB,* 44). Beauty has a paradoxical effect. It arrests our ongoing cares, but it also stirs a new eros. The response to beauty wells up inside us before we more consciously mediate it. Beauty thus reminds us that we are porous even in our most intimate depths. In general, modern aesthetics tends to stress the "rest" offered by beauty, while premodern philosophy—especially in the Platonic tradition—tends to stress the "restlessness." There are important exceptions, however. Friedrich Schiller,

well-attuned to beauty's paradoxical character and its experiential range, notes how beauty can be more "melting" or more "energizing."[10]

The eros stirred by beauty can become grasping at times. Our response to beauty's call can be tyrannical. "It may be," Simone Weil suggestively remarks, "that vice, depravity, and crime are nearly always, or even perhaps always, in their essence, attempts to eat beauty, to eat what we should only look at."[11] Socrates's first speech in the *Phaedrus* describes a possessive eros oriented toward self-gratification, manipulation, and jealous possession of the beloved. The danger of tyranny is especially present in romantic or sexual eros. Erotic desire can take consumptive form, reducing the other to a sexual object. As Byung-Chul Han notes, the erotic—attuned to the mystery of the other—can be flattened into the pornographic.[12] We might think of Sartre's analysis of how the other's "look" can dominate or of related critical concern in both Lacanian psychoanalysis and feminist thought with the objectifying gaze.[13] This can take subtle forms, as again Sartre shows, in which the desire is not to consume another's body but to make the other love in return. The desire can be to manipulate or psychologically coerce the other into a "bad faith" love.

The eros stirred by beauty need not be tyrannical, though. Many philosophers hold that beauty actually tends to mollify grasping desire. Kant claims beauty is "disinterested."[14] Hegel claims that "art has the capacity and the function of mitigating the fierceness of the desires."[15] Recall, too, Schopenhauer's claim that beauty offers a "Sabbath" of the will. Weil claims that beauty can unsettle our habitual egotism and cause us "to give up being the center of the world in imagination."[16] Iris Murdoch claims that "great art teaches us how real things can be looked at and loved without being seized and used, without being appropriated into the greedy organism of the self." She concludes, "Beauty is that which attracts this particular sort of unselfish attention."[17]

Desmond extends this well-trodden philosophical path, but he also does not leave behind the way beauty stirs desire at the same time. He suggests that beauty often "generates an unrest, but in another dimension to the functionality of a will that would manipulate and utilize what has come to alight before us" (*GBPB*, 44). He contrasts "instrumental mind" with "aesthetic mindfulness" (*PO*, 103). He contrasts the apple that "disappears from sight" because he is hungry and eats it, with the apple that he instead contemplates: "I see more. I discern something coming to appearance that before was unshown. . . . I reach for my brush and make the first stroke of a still life" (*PO*, 103). One cannot tyrannically consume a sunset, and our

usual response to a painting is not some instrumental calculation (unless one is an art investor). Even the art we hang on our walls is usually not for us alone or for us to simply "use." It involves a richer relationship than simple utility, an appreciation of the artwork, the artist, or the subject, as well as the others who may share in contemplating it.

Nonetheless, note that Desmond's "aesthetic mindfulness" of the apple still stirs a desire—a desire to paint the apple rather than to consume it. Desmond claims that the eros stirred by beauty is rich with agapeic promise. Perhaps the most common response to beauty, after all, is an implicit or explicit affirmation of the beautiful *as* beautiful. The response may be an awed, lingering stillness before the beautiful, a smile, or simply saying to ourselves or others, "How beautiful." Our response to artworks is often agapeic. Desmond notes how "the *appreciation* we bring to art shows an attentiveness to the work as other, and as good for itself" (*BB*, 41). The response to beauty can take the form of gratitude, compassion, contemplation, care. Beauty can even call us to a radical conversion, a *metanoia*. Rilke's "Archaic Torso of Apollo" famously ends: "You must change your life."[18]

In the *Symposium*, the priestess Diotima tells Socrates that the eros stirred by beauty seeks to beget or give birth in beauty.[19] This manifests in varied ways in the *Symposium*, from the desire to procreate to the desire to make beautiful laws. It also offers a basic exigence for both philosophy and art. If beauty can return us to the *passio*, it can also launch a new companioning of *passio* and *conatus*, a new artistic (or philosophical) endeavoring. Recall again how the "aesthetic mindfulness" of Desmond's apple stirs a desire to paint a still life. Scarry, with the *Symposium* in mind, observes,

> Beauty brings copies of itself into being. It makes us draw it, take photographs of it, or describe it to other people. Sometimes it gives rise to exact replication and other times to resemblances and still other times to things whose connection to the original site of inspiration is unrecognizable.

She describes how "a beautiful face drawn by Verrocchio suddenly glides into the perceptual field of a young boy named Leonardo. The boy copies the face, then copies the face again. Then again and again and again." Eventually, Walter Pater "replicates—now in sentences—Leonardo's acts."[20] As Scarry suggests, artists do not only beget on the given beauty of a particular human face or of the natural world. They also beget on the beauty of other artworks. (Pater shows that the best art criticism does so as well.)

Such ekphrastic art signals the richness of art itself. Artistic begetting on the beautiful is often bound up with affirmation and gratitude. Desmond notes "the witness of pure praise in the poetry of Czeslaw Milosz" (*GBPB*, 121).[21]

Such praise is not necessarily naive or escapist. Milosz was no stranger to the violence of the twentieth century. His praise points to what violence affronts. As Weil claims, "The love of the beauty of the world . . . involves, as a love secondary and subordinate to itself, the love of all the truly precious things that bad fortune can destroy."[22] The *Phaedrus* says there is "pain and joy" in beauty.[23] As Weil's words suggest, the pain of beauty can at times come from our sense of the beautiful thing as a perishable "once." The fragile, ephemeral blossom is one of the great images of this: "All flesh is grass, and all its beauty is like the flower of the field" (Isaiah 40:6). The poets recur to this image.[24] Shakespeare: "Rough winds do shake the darling buds of May, / And summer's lease hath all too short a date."[25] Shelley: "The flower that smiles today / Tomorrow dies."[26] Frost: "Nature's first green is gold, / Her hardest hue to hold. / Her early leaf's a flower; / But only so an hour."[27] The flower is an archetypal image for the fleetingness of all things, including ourselves. In Jane Kenyon's poem "Peonies at Dusk," the blossom's fragile, fleeting singularity mingles with the fragile, fleeting singularity of the beloved human: "I draw a blossom near, and bending close / search it as a woman searches / a loved one's face."[28] The pain of beauty can be tied to its transience, to our transience, to the transience of the time we have to linger with it.

Astonishment can mingle with perplexity in the experience of beauty. The point at which the disturbing begins to eclipse the beautiful is often difficult to discern.[29] Philosophers have often noted beautiful depictions of disturbing or ugly material.[30] Desmond thinks the difficulty lies deeper, though. Consider the relationship between beauty and disgust.[31] Desmond illustrates a surprising affinity between them with an anecdote from Arthur Danto. In 1990, Damien Hirst installed a rotting cow head in a glass box, livid with maggots and swarming flies. Danto "tells of a friend's reaction who approached the work with anticipations of earlier canonical aesthetics about beauty. Initially puzzled, the light did dawn and the exclamation came: 'How beautiful!' The person, expecting beauty according to traditional canons, finally did find beauty in the revolting" (*GBPB*, 20).[32] One could conclude that Danto's friend is willfully obtuse or naive, that the friend was working under the assumption that all art must be beautiful in the traditional sense. Yet Desmond thinks something more complex could be at work. The disgusting, like the beautiful, strikes us. Desmond claims that

"it is right that we grant that the arousal of disgust belongs to the *same family of possibilities*, including beauty, that are the reserves of the passion of being. In these matters we must always be alert to saturated equivocities, equivocities replete with a twosomeness of appeal and revulsion, fullness and emptiness, promise and poverty, the beautiful and the monstrous (*GBPB*, 20).[33] A critic schooled in modern aesthetics might claim that this is precisely why critical discernment is necessary. Desmond may not disagree, but he would give a warning that any such judgment calls for finesse. His point is not to collapse the difference between the beautiful and the disgusting but to suggest a certain kinship, the possibility of ambiguities and paradoxical combinations.

Desmond is concerned with how twentieth-century art and aesthetics recess—indeed often deride—beauty. He also has qualms about the shock art of the "Intractable Avant-Garde" (as Danto calls it), about its incessant attempts to subvert and transgress, attempts that have by now lost their ability to shock a desensitized public. He often sees a cynical bid for publicity and relevance in such art, a sign of art's declining status more than its Dionysian vigor. But this does not mean he thinks art should not explore what shocks, horrifies, or disgusts.[34] Nor does he deny that they can mingle in the saturated equivocity of beauty.

Between Beauty and the Sublime

In the wake of Edmund Burke and Kant, modern aesthetics tends to make a sharp distinction between the beautiful and the sublime, especially in terms of their effects: beauty soothes; the sublime exhilarates. Beauty offers mental rest, the sublime mental agitation. Scarry notes how Burke and the early Kant at times neatly sort aesthetic phenomena between the two:

> In the newly subdivided aesthetic realm, the sublime is male and the beautiful is female. The sublime is English, Spanish, and German; the beautiful is French and Italian. The sublime resides in mountains, Milton's Hell, and tall oaks in a sacred grove; the beautiful resides in flowers and Elysian meadows. The sublime is night, the beautiful day.[35]

Scarry explains that the opposition of a soothing beauty and a stirring sublime ultimately led to the former's "demotion." It was hardly Burke's or

Kant's intention to trivialize beauty. Yet such trivialization played out over the course of modernity. Beauty became all sweetness and light: saccharine, bourgeois, boring to the serious artist or thinker.

Desmond's account of the sublime follows the main line of modern aesthetics in certain regards.[36] Like Burke and Kant, he focuses on the sublime in nature. Desmond notes, "Often the sublime is depicted in terms of settings in nature that display aweful [sic], terror-inspiring power: hurricanes, wild storms, craggy peaks of mountains, turbulent clouds, irresistible rivers rolling over high waterfalls and tumbling into an abyss" (*DDO*, 156). Recalling Kant's distinction between the dynamic and mathematical sublime, Desmond holds that the sublime is often tied to either wild nature's excessive power or its expansive space.[37] Desmond acknowledges an at times marked contrast between the beautiful and the sublime: the beauty of a well-manicured flower garden, the sublimity of a raging wildfire. Desmond notes how "form in its splendor is to the fore in beauty," while the sublime seems to strike "our own deepest intimacy with a kind of violent formlessness" (*IU*, 100). In the sublime we encounter otherness that overpowers us. We encounter something "unmastered," perhaps something "infinite" (*DDO*, 156).

Still, while Desmond contrasts the beautiful and the sublime, he does not draw a sharp distinction. There is a "*permeable threshold*" between them (*GBPB*, 117). Both return us to the *passio* and reopen us to otherness. Beauty often offers a pleasing release from self-enclosure. The sublime often reopens us in a more harrowing way: "The sublime causes us to be newly exposed—as skin rubbed raw is exposed, and more intimately than surface skin" (*IU*, 101). It can feel as if "the soul is flayed" by the sublime, by "dreadful exposure to terrible otherness" (*IU*, 101). Still, this difference should not be overstated. Note how modern "soothing" beauty elides the more striking calls of beauty and the eros they can stir.

It is tempting to suggest a continuum between beautiful release and sublime ravage. Yet this is again too simple. Beauty can at times undo us in dramatic ways. Byung-Chul Han notes how even seemingly "inconspicuous events such as white dust swirled up by a drop of rain, snow falling silently in the morning twilight, or a scent coming off a rock in the summer heat" can be experienced as "disastrous events." Such events can result in the (at least momentary) "death of the autoerotic subject which clings to itself," of the self-enclosed ego, of what Desmond would call the hardened *conatus*.[38] The wound of such events reopens us. One might chalk up such "events" to the vicissitudes of subjectivity. Neither Han nor Desmond would deny the influence of one's state of mind or degree of awareness on them. Yet both

would also protest reducing them to subjectivity alone. Han claims that the "disaster" of inconspicuous events entails a shocking recognition of otherness.

Desmond points to how such events can convey "the bite of infinite power" (*DDO*, 158). Even something as fragile as a flower can evoke the creative power of being, the ongoing ontological coming-to-be. We may sense how the "beautiful form is pierced by what is beyond form," pierced "by the sublimity of being, as the ultimate originative source" (*DDO*, 159). Sublimity can thus strike through the open whole of the beautiful. This does not mean, though, that the beautiful form is simply a husk for the sublime power of being. The particular beautiful form is not left behind as the sublime universal is disclosed. The universal is instead disclosed within the intimately particular. Separating one from the other distorts both. There is an intimate link between them. In recent works, Desmond uses the language of the "intimate universal" to suggest such links.[39]

This infinite power touches on additional paradoxes of the beautiful and the sublime. As discussed earlier, the pain of beauty can come from an awareness of finitude—of the beautiful thing's finitude, of our finitude, of the finite time we have to linger with beauty. If the poignancy of this finitude is strong enough, it might verge upon the sublime. Burke again: the sublime is tinged with fear. But the evanescent flower blossom can convey not only finitude but also "originative" being itself, subtending the coming-to-be and perishing of finite things. We can be struck not only by the finitude of the beautiful flower, but also by beauty's continual resurrection in other flowers. This sense of the continual coming-to-be can offer its own segue into the sublime.

This qualifies the association of beauty with form and the sublime with flux. Desmond holds that both premodern and postmodern philosophies of indeterminacy rightly stress the flux of becoming. He demurs from such philosophies, though, when they reduce all form or order to an illusion or epiphenomenon. This reduction does not do justice to the "startling doubleness" on display all around us: "the conjunction of the fluency of flux with the constancy of form" (*VB*, 262).[40] Desmond notes how even the seemingly harmonious form of something beautiful is always dynamized. It manifests aesthetically, making it an "open" form rather than a "closed" form. After all, as suggested above, the form's aesthetic manifestation is in effect a communication beyond itself. There is a tension between form and flux even in the flower, a tension that should not be collapsed.[41]

Desmond likewise argues that the sublime, even at its most amorphous and dynamic, can never be fully separated from conceptions of form—at least

from the form that is being ruptured or that provides the contrast for sublime dynamism. Again, we must think of flux and form together. Many instances of the sublime are less a rupture of form than a striking communication of hyperbolic otherness through form. Consider the sublime flowstone draperies deep in limestone caverns. Is there flux here? Yes—at the rate of perhaps an inch every century. Philip Shaw reaches similar conclusions: "In practice, sublimity cannot be separated from the appreciation of form. What attracts us to the sublime is not an abstract quality but the fact that the sense of the awe-inspiring or overpowering is conveyed in *this* particular mountain, in *this* particular moment."[42] In the case of the mountain, its sublimity testifies less to its formlessness than to how its "open" form communicates grandeur.

The sublime involves a call and response too. Even when the sublime threatens to obliterate, it still stirs "a strange excitement, even joy" (*DDO*, 156). The response may be an adrenaline rush, a thrill in danger, a desire to ride the wave or shout into the storm. The sublime plays on the desire for risk, for adventure. In the experience of the sublime, we can become so porous as to seemingly merge with the overwhelming otherness. The sublime can involve what Desmond calls "the rapturous univocity of the elemental" (*BB*, 273). "One is caught up," Desmond explains, "and one is not caught up, for one hardly distinguishes oneself from the play of the flux" (*BB*, 274). We ride the wave but also in a sense become the wave. We scream into the storm but also become the storm screaming. The paradoxical mix of fear and pleasure associated with the sublime at times comes from this doubling, from a fear of how the otherness threatens us, a joy in how we can nonetheless flow with the otherness. In the sublime of wild nature,

> We find the need to experience the overpowering presence of something other than the human, something beyond human will, whose ambiguous majesty—for this storm or gale or flood might kill us—seems to lift the individual to a strange, seemingly superhuman exaltation. The danger is courted out of an almost religious desire to experience the transcendent in nature itself. (*DDO*, 156)

Such a response speaks to a hunger for transcendence through an encounter with exceeding otherness, for exposure to it, even if that exposure rends or flays. The sublime thus pushes our intimacy with otherness to an extreme.

Desmond turns to J. M. W. Turner as a great painter of the sublime. In Turner, "There is coming to form, but it is not just the form but the

fluidity and the dynamism of emergence—this is not static form" (*IU*, 101). Turner thus moves beyond "precious subjectivity" and "fixated objectivity" (*IU*, 102). On the night of October 16, 1834, an inferno consumed the Palace of Westminster. A crowd gathered on the banks of the Thames to watch. Turner was part of that crowd and may have sketched the spreading flames. Regardless, he would eventually paint the fire in all its awful sublimity. Great wings of fire and smoke rise from the engulfed palace. They reflect on the surface of the Thames and play on the spectators. All are illumined or shadowed by the inferno. Desmond writes that in this painting Turner "is catching the conflagration as it flamed and his painting hand catches fire" (*IU*, 102).

Desmond also points to Turner's 1844 painting *Rain, Steam, and Speed—The Great Western Railway*, in which "the train [is] a flash of unstoppable energy, crossing a bridge, devouring the countryside and its distance, and alongside these inexorable tracks, the blurred dot of a hare in alarmed flight" (*GBPB*, 39). Desmond notes that this painting has been interpreted as "a hymn to capitalistic invention and its unleashed mechanical speed" (*GBPB*, 39–40). Desmond interprets the painting a different way:

> Turner is painting the overdeterminacy, even in the Industrial Revolution. . . . Seeing beyond serviceable disposability, his smear of paint that is the hare does not smear being. . . . The smear glories in the overdeterminacy as giving the dynamic coming to be, including too the dynamic becoming of the onrushing train. (*GBPB*, 40)

Throughout his work Turner is a painter of great "aesthetic fidelity," especially of fidelity to the sublime dynamics of forming and deforming, of both becoming and the more primordial coming-to-be.

The modern (and subsequent postmodern) fascination with the sublime would seem to qualify the modern emphasis on autonomy. This is true to an extent. Yet in Kant's influential account, the sublime puts autonomy to the test only to reaffirm it. In Kant's sublime, the might or magnitude of nature reminds us of our physical fragility. Our senses fail to provide the measure. This humiliation causes pain. Yet even as our senses seem to fail, the idea of the infinite rises to encompass the might or magnitude. Hence our reason transcends the external otherness:

> though the irresistibility of nature's might makes us, considered as natural beings, recognize our physical impotence, it reveals in

us at the same time an ability to judge ourselves independent of nature, and reveals in us a superiority over nature that is the basis of a self-preservation quite different in kind from the one that can be assailed and endangered by nature outside us. This keeps the humanity in our person from being degraded, even though a human being would have to succumb to that dominance [of nature].[43]

Ultimately, Kant concludes that "sublimity is contained not in any thing of nature, but only in our mind, insofar as we can become conscious of our superiority to nature within us, and thereby also to nature outside us (as far as it influences us)."[44] Kant thereby recasts the sublime's apparent rupturing otherness as a subreption, as "an attribution to the object of what belongs to the subject" (*IU*, 101). The threat of the sublime turns into "reconfirmation of moral self-determination" (*IU*, 101). Desmond is again wary of how Kant privileges autonomy over receptivity and otherness, and of how this in turn sets the coordinates for subsequent thought. In Kant's sublime, "the breakdown is not allowed to be a more exceeding breakthrough" of otherness (*IU*, 101). For Kant, autonomy ultimately withstands the barrage.

The sublime dominates postmodern aesthetics. There are different strands of development, some of which resonate with Desmond's concerns. The postmodern sublime often rightly stresses indeterminacy. At times, though, the stress on indeterminacy takes the form of negation. This can obscure the "positive indeterminacy" or overdeterminacy of the sublime. As Shaw explains, "The postmodern condition therefore lays stress on the inability of art or reason to bring the vast and the unlimited to account. In what amounts to a retreat from the promise of enlightenment, its dream of freedom and transcendence, the postmodern affirms nothing beyond its own failure, and it does so without regret and without longing."[45] This postmodernism does not find solace in Kant's subreption but instead radicalizes the disjunction of phenomenon and noumenon.

Some versions of the postmodern sublime are indebted to Hegel, and particularly the Hegel of Kojève's influential reading. The experience of the sublime is one of radical negativity that is subsequently cancelled out via dialectical determination. There simply is no noumenon. Slavoj Žižek develops an important post-Hegelian account of the sublime along these lines.[46] In Shaw's summary, Žižek holds that the sublime "ought not to be conceived as a transcendent 'Thing-in-itself' beyond the field of representation, but rather as an indicator of the traumatic emptiness, the primordial lack, residing at the heart of all forms of symbolisation."[47] Put simply, the sublime reifies,

indeed mystifies, a lack. Žižek is particularly interested in how the sublime works within political ideology, where the sublime lends an aura of power and mystery to rulers, parties, nations, empires. This sublime masks the lack at the core of these ideologies, the emptiness of the idea of the Big Other or of the nation or of ideology's demonized enemies. The "sublime objects of ideology" can be demystified by exposing this emptiness.

Desmond agrees about the dangers of the political sublime, noting "the abuse of sublime aesthetics by tyrannical and totalitarian regimes" (*IU*, 368). He would further agree that the demystification of the political sublime is frequently necessary. Still, he rejects the reduction of the sublime broadly, beyond the political, to a reified lack. In some strands of postmodern art and aesthetics, the sublime seems to devolve along these lines into the uncanny. Things are not haloed with the mystery of being, revealing and concealing at the same time out of intimate depths. They are just weirdly, absurdly there.[48]

Georges Bataille takes the postmodern emphasis on indeterminacy in a different direction. Bataille describes an erotic desire for radical negation of the self, an ecstatic dissolving of the "I" that presses even further than Desmond's "rapturous univocity." Bataille seeks this dissolution through excess of pleasure and pain. Bataille's *Inner Experience* is full of classically sublime (and beautiful) imagery, yet beyond the positive excess that such imagery usually connotes, Bataille seeks to annihilate the determining self.[49] The pleasure of the sublime is in this annihilation. Bataille thus goes beyond the Freudian death drive to seek a sort of chthonic mysticism. He ecstatically affirms the ultimate negation.

Bataille is a compelling thinker to consider alongside Desmond. Indeed, he is in a way Desmond's doppelgänger. They are both concerned with the relationship between philosophy, art, and religion, and they are both attuned to the idiocy of our "inner experience." Yet they handle these shared concerns in markedly different ways.[50] Bataille is a thinker of absolute indeterminacy, Desmond of overdeterminacy. Bataille's eros consummates in self-sacrificial erotic negation, Desmond's in self-sacrificial agapeic service. Bataille rejects any attempt at wording inner experience as a betrayal of it. For Desmond, we can never fully word our experience, but words do not necessarily betray it. Indeed, Desmond holds that "idiotic intimacy is at the source of communication" (*G*, 164). More broadly, Desmond points to the agapeic possibilities that Bataille spurns, the way Bataille tends toward a sadomasochistic "mysticism of the obscene."[51] The other takes on an ambiguous role here, becoming at times (à la the Marquis de Sade, who was an important influence on Bataille) the exploited means to excess.

Desmond criticizes other versions of the postmodern sublime that claim to move beyond modern autonomy yet remain subtly captive to it. Some versions are theoretically self-referential in ways that tame the sublime as surely as Kant's subreption. Desmond points to Barnett Newman's art and to Lyotard's theorization of it.[52] In such a sublime, "The rupture of the unrepresentable seems to owe more to the constructing/deconstructing 'activity' of the artist, albeit shrouded in the enigma of its own night, than to the sublimity of nature as other and given" (*GBPB*, 105). He notes how some postmodern theorists and artists are less concerned with the sublime in non-human nature than in the "wrought" sublime of human artifacts.[53] The postmodern sublime is at times born of the reconfigured ethos of the city, seen not in its cosmopolitan promise, as a community of vibrant life, but as a site of alienation: "The hyper-reflection of the human to itself in the artificial city results in the loss of the human to itself in the infinitely multiplied reflections of itself, for in these infinitely multiplied reflections there seems no longer to be any original true self" (*GBPB*, 114). Among the glaring lights and glass, one can seem enclosed entirely within human artifacts, within a sort of bewildering mirror world. In such a world, we are not at home among our artifacts but alienated from them. We have not encountered otherness so much as our own unsettling reflection. We become caught in a trap (autonomy?) of our own devising. Desmond suggests that some theories of the postmodern sublime ultimately reify this alienation into an epistemology. They confuse a legitimate desire for transcendent otherness with a "nostalgia for the absolute." Desmond wonders if some postmodern accounts of artistic creation are not hypermodern rather than truly postmodern, "an accentuation of just the twin pillars of modernity, objectification to an extreme, subjectification to a matching extreme."

> Thus we find together these two sides: on one hand, a tendency to reductionism in which the human presence seems to be absent (the death of the author, the death of man); on the other hand, a difficulty in seeing the aesthetic sources of origination in anything other than human making. Human constructions maybe testify to something other, something even inhuman. But given that we cannot name this other without circling back to ourselves, in practise the high priest remains the human being—even if a strange priest. (*GBPB*, 114)

Such a sublime is still implicitly structured by autonomy, albeit a "lacerated autonomy" (*GBPB*, 106).

Will Beauty Save the World?

In his account of the sublime, Kant wishes to maintain human dignity despite physical and sensory frailty. Desmond, however, sees this "exceeding breakthrough" of otherness in the sublime as ethically significant in its own right. This is especially true of the sublimity of wild nature. The Romantics became newly attuned to the sublime at least partly in reaction to the "dark Satanic Mills" of industrial modernity, in reaction to the emerging ethos of serviceable disposability.[54] This ethos neutralizes being, reduces it to an inert resource to be reworked for our ends. The sublime shatters this sense of neutral, inert nature. It also chastens our aim to master all. In the sudden storm or tossing sea or deep forest, the sublime shows "nature's power in its otherness to our mastery" (*EB,* 181). Perhaps at times the allure of the sublime is akin to a death drive. At others, it might be an erotic desire to test ourselves against wild nature, to see if we are strong, fast, courageous, resourceful enough to endure. Desmond discerns another possibility, though. Our joy in the sublime can also be an agapeic affirmation of otherness:

> The affirmation of value [in the sublime] is not my value, or my moral value; it is the value of being as other that I now am released to sing. There is a self-transcending towards the transcendence of nature as other, a transcending not for self but for this other as other. At last I find myself at home, there where I had always been tending towards, namely, to be beyond myself in the between, there with the gifts of creation, though I know I am frail, and a small swat will snuff out my singularity. And yet there is the "yes." This is an agapeic "yes," not an erotic "yes"; and not the rational "yes" to the moral destiny of self, understood in Kantian terms. (*EB,* 182)

Desmond's claim that the sublime can help us be "at home" may surprise. The sublime does not make us feel safe or secure, after all. Desmond notes that "the ambiguous world is often like the Sphinx: beneath the breasts that suckle, we see the claws that twist and rip" (*DDO,* 157). These claws flash in the sublime. Still, the sublime can help us affirm our place within the world. It can help us accept that we are fragile creatures within a world of fragile and fierce creatures. This is a world charged with a power and glory that transcends us, that may well threaten us, but one to which we nonetheless intimately belong.

The sublime can chasten our ambitions. It "scorns the pretensions of our projects. It mocks absolute claims made by our *conatus essendi*. It occasions an initially involuntary revelation of the *passio essendi,* a revelation that yet may mutate into a wiser patience and consent" (*GB,* 136). The sublime can lead to a respect and even reverence for nature and its creatures. Think of the voice in the whirlwind in the Book of Job, which evokes the wondrous, terrifying variety and scope of creation. Alexandra Romanyshyn notes how in an agapeic experience of the sublime, "A lightning storm is no longer perceived as a threat, but as something to behold with awe, as well as with awareness that it has the power to obliterate us. Lightning is beautiful, but it can kill you; it is striking in two senses of the word!"[55] Being at "home" here does not mean complete control of the environment. It means being vulnerably at home within a dynamic world. There is risk, but there is also the drama of living in such a world. Romanyshyn concludes that Desmond's metaxology counters "anthropocentrism, first, because it counteracts the belief that we possess absolute power over nature, and second, because it defends the transcendence and intrinsic value of nature."[56] She shows that Desmond's thought is a rich dialogue partner for environmental ethics.

Contemporary environmental thinkers at times turn to the sublime for similar reasons. The sublime reminds us of the otherness of nature, and it encourages respect for what does not have an obvious use value for us. Suspicion of the beautiful at times accompanies this championing of the sublime, and there is some reason for this. The sublime seems to be more inclusive of nonhuman nature—the strange, the disturbing, the desolate, the asymmetrical, the slimy or prickly or poisonous—while beauty seems more limited to the conventionally pretty parts. An ethics of beauty would have no problem defending "beautiful" Monarch butterflies and their milkweed habitats, but it may have trouble responding to the white-nose syndrome that has devastated North America's "sublime" bat colonies. Historically, the Romantic sublime did raise appreciation of landscapes widely regarded as wastes, such as the Alps and Scottish Highlands. Desmond would not dismiss the dangers of a narrowly conceived beauty that constrains our sense of what is worthy of affirmation, care, or preservation. He would deny that this is the best way to conceive of beauty, though. For Desmond, we cannot predetermine what may issue the call of beauty. Likewise, beauty as well as the sublime can return us to porosity and decenter us. If environmental ethics takes its suspicion of beauty too far, it risks the opposite problem—a denigration of nonhuman nature that is too pleasing or orderly, or at least

a suspicion that concern for the conventionally beautiful entails a lack of concern for the conventionally unattractive.

The aesthetic roots of ecological concern in Romanticism have embarrassed other environmentalists. These roots seem too emotional, too subjective, and too concerned with the particular to respond to the scale of our environmental crisis. Hugging a tree—or wondering at one—will not reduce global carbon emissions. Environmental ethics at times recurs to the hard logic of utility. It seeks to price in the costs of pollution, for instance, or to model how, in the long term, it will cost less to reduce carbon emissions now than it will to deal with the damages accrued later. This may well be strategically wise at times and gain some important results, but Desmond doubts such a logic can protect all that is worthy of protection. It cannot, for instance, easily protect "useless" species or landscapes. At best, it might argue that they may have some use that we do not now foresee. It seeks better outcomes within the ethos of serviceable disposability, but it leaves the ethos intact.[57] Desmond concludes, "There is no adequate environmental ethics without reverence beyond all functionality; simply joy in the being other of the world, joy that enacts a lived praise of its worth" (*EB*, 181n9). We need a different ethos than that of serviceable disposability, one where a richer sense of otherness is widespread and where utilitarian logic does not reign supreme. Wondering at a tree may not directly reduce carbon emissions, but it may be crucial to inspiring such a renewed ethos, which will in turn shape our practices.

As we can see, then, for Desmond the boundary between aesthetics and ethics is itself highly porous. Aesthetic affirmations are always affirmations of qualitative worth. Of course, these are not simple, univocal pronouncements. The affirmations are plural, and so are the senses of the worth involved. We can, and perhaps often do, take direct ethical action due to aesthetic experience. Walking through the park, I may bend over to pick up the discarded carton not out of ethical duty or environmental concern but because it besmirches the park. I may resist the city's decision to mill the ancient oak tree down to bench boards because I have so often marveled at its gnarled singularity. We continually respond to the sensuous manifestation of things. "How one walks through the world," Scarry writes, "the endless small adjustments of balance, is affected by the shifting weights of beautiful things."[58] She notes how beauty "makes life more vivid, animated, living, worth living."[59] Jean-Louis Chrétien points out the corollary: we are troubled when we see beauty destroyed or debased. He claims that "anyone who destroys beauty seems to us to be profaning, in some degree,

that by which the world really is a world, containing things that demand that one stop and consider them (in the dual sense of looking at them and respecting them)—not a simple stock of raw material for our vital needs."[60] This sense of profanation can unsettle us even within the ethos of serviceable disposability.

Crucially for this study, the artwork can draw us from I-it relationships into I-Thou relationships. It can draw us into such a relationship with itself, as we attend to the work in its singular, concrete otherness. It can also draw us into such relationships with others beyond the artwork. Paintings, poems, and photographs of the natural world, for instance, can make us more attentive to the world beyond the work. Narratives can heighten our awareness of other people. Iris Murdoch argues, "Prose literature can *reveal* an aspect of the world which no other art can reveal, and the discipline required for this revelation is *par excellence* the discipline of this art."[61] It reveals "that other people exist."[62] She points to the great novels of the nineteenth century, with their vast casts of differentiated characters, with the nuances of the relationships between them. The greatness of "the works of Tolstoy or George Eliot" is indicated by how when we recall these works "we are not remembering" the authors themselves but characters like "Dolly, Kitty, Stiva, Dorothea and Casaubon."[63]

Martha Nussbaum likewise argues that art can cultivate the virtues necessary for citizenship. Literature is particularly important in that "narrative art has the power to make us see the lives of the different with more than a casual tourist's interest—with involvement and sympathetic understanding, with anger at our society's refusals of visibility."[64] Literature can cultivate recognition beyond the page by dramatizing not only such recognition but also the failure to recognize. She explores Ralph Ellison's *Invisible Man* as a powerful instance of the latter. Again, sometimes the artwork calls forth recognition spontaneously.[65] There is no guarantee of this, though. The approach to the artwork matters, both the mood of our approach as well as the more explicit concerns we bring to it. Nussbaum recognizes this by arguing for a humanistic pedagogy.[66] Cultivating modes of receptivity is once more important.

Even still, there are no guarantees that art or literature will deliver more sensitivity and care for otherness. There are always many possibilities here. Kierkegaard argues that aesthetic concern can give rise to a relentless pursuit of novelty. Kierkegaard's pleasure-seeking aesthete is indifferent to ethics.[67] Desmond notes Theodor Adorno's example of the cultured Nazi, weeping at Rilke. George Steiner meditates on this as well: "We know now

that a man can read Goethe or Rilke in the evening, that he can play Bach and Schubert, and go to his day's work at Auschwitz in the morning. To say that he has read them without understanding or that his ear is gross, is cant."[68] Steiner notes that "a wide gap" can open up between artistic sensitivity and sensitivity to the living other. He claims that it is even possible for the former to mute the latter. It is possible, in at least some cases, "that a trained, persistent commitment to the life of the printed word, a capacity to identify deeply and critically with imaginary personages or sentiments, diminishes the immediacy, the hard edge of actual circumstance. We come to respond more acutely to the literary sorrow than to the misery next door."[69] Steiner does not reject the humanistic approach to literature, but he claims that we must not be blithe about such possibilities. Simone Weil develops a related concern. She worries that literature, and especially the literature of the early twentieth century, often makes the good seem bland and evil intriguing.[70] Weil argues that, rather than being true to life, this inverts our usual experience, where true virtue (rather than its saccharine or self-righteous counterfeits) is remarkable and habituated vice is banal. The concerns of Socrates in the *Republic* echo in Weil's critique. Desmond champions the ethical affordances of art and literature, but he does not brush these cautions aside. Recall the lopsidedness Desmond discerns from the early twentieth century onward, the greater interest in radical evil than radical good, the suspicion of beauty. Steiner and Weil testify to how the image and narrative can not only form but also deform our ethical attunements.

It is not easy, then, to determine how aesthetic worth translates into consistent ethical actions, practices, conventions, and laws. Desmond describes the aesthetic as a "potency" upon which a determinate ethics may draw. He describes ethical potencies as "basic sources of value" that offer ontological affordances for ethics (*EB*, 10). The "aesthetic potency" attends to the "*showing* of the worth of being that is aesthetic—given to our senses and our bodies" (*EB*, 11). This does not mean that the aesthetic potency is a mere option, add-on, or supplement. It instead indicates how the deepest roots of the ethical and the aesthetic intertwine in a way that precedes more determinate ethics, in a way that more determinate ethics can either draw upon or obscure (or even betray). Desmond concludes that if we tap into the aesthetic potency, "the promise of human doing is all the more rich," while acknowledging that this "does not mean that the promise will be acted on properly" (*EB*, 179).

At the most fundamental level, aesthetics and ethics intertwine in our porous flesh. Recall that for Desmond aesthetics begins in our embodied

mediation of sights, sounds, smells, textures, tastes. This embodied mediation is never neutral. It entails pleasure and pain, ecstasy and suffering. Desmond notes how the major approaches to philosophical ethics continually recur to pleasure: "Epicureanism, hedonisms ancient and modern, modern materialism, Hobbes, utilitarianism, Freud (pleasure principle), and so on. It is [also] important in views that incorporate pleasure into a wider perspective, such as Aristotle's" (*EB*, 57). These ethics may not dwell on how that pleasure is rooted in our sensing bodies, but that root is there nonetheless.[71] All of them draw on the aesthetic potency in this regard, even if they do not give enough attention to the importance of value-charged flesh, both our own and the flesh of the world.

We are "adorning beings" (*PO*, 76). Traditional peoples adorned their homes, tools, and weapons in ways that belie the modern tendency to oppose the utilitarian and the aesthetic. For them adornment entailed sacred significance, a significance that actually guided and inflected use.[72] Desmond acknowledges, "We must use. There is no survival and prospering without it. But how we use, that is the question" (*IU*, 278). If use plays out in a richer ethos of being, one attuned to the worth of things beyond their use, our necessary use will take a different shape: "Reverence of that other-value can shape our modality of use" (*IU*, 276). Aesthetic worth can be a source of that other-value. It can make us better users. But this is only the case if aesthetic worth is not seen as subjective or merely decorative without deeper significance. It needs to be a recognition of the other's worth. Then, for instance, it can shape how we farm a landscape, how we harvest timber in a forest, or what we throw in the dumpster.

Even within the ethos of serviceable disposability, beauty is not brushed aside. We still wish to live in aesthetically pleasing homes, to wear aesthetically pleasing clothes, to be aesthetically pleasing ourselves, though our sense of this as spiritually significant is often thin or nonexistent. Corporations often instrumentalize this desire to fuel consumption. Desire for beauty becomes an advertising strategy. Its power to move us is "deflected in the direction of the shopping mall and the cash register" (*GBPB*, 108). This can be insidious and misleading, but it still "pays *a secret tribute to the power of beauty*, even as it uses it for purposes that are not always very beautiful" (*GBPB*, 108).[73] Indeed, if the image is striking enough, the advertisement can exceed its original purpose and become a work of art. There are also nefarious obfuscations, though. The ethos of serviceable disposability often needs an aesthetic mask in its affluent center. The bald instrumentalism of production is often hidden from sight on the margins: the sweatshops, the

factory farms, the mountaintop removal mining. We prefer to live in a world of smooth aesthetic surfaces and unlimited options.[74] We prefer not to think about where the rare earth metals in our sleek digital devices come from.

This helps us to understand the ethos of serviceable disposability in its complexity. From the outside, the ethos of modernity can seem like a great bloom of values rather than a starkly utilitarian ethos. For the ethos actually encourages the multiplication of subjective values. But these values, because they are understood as a matter of personal belief or inclination, rarely challenge the broader ethos. They are understood as "useful" to the individual (and to the market that can capitalize on them). Meanwhile, the "objective" value that tends to structure economics and politics is often that balder use value.

The consolation of beauty is another primal meeting place of the aesthetic and the ethical. Hegel reflects, "Beauty and art, no doubt, pervade all the business of life like a kindly genius, and form the bright adornment of all our surroundings, both mental and material, soothing the sadness of our condition and the embarrassments of real life."[75] Music can soothe a troubled mind or sustain one in grief. We might think of David's harp music soothing Saul when an "evil spirit" besets the king. Nietzsche claimed that life would be unbearable for him without music. Steiner concurs regarding music, and he further holds, "To starve a child of the spell of the story, of the canter of the poem, oral or written, is a kind of living burial."[76] Sunlight and certain colors can ease depression. St. Hildegard of Bingen, a singular theologian and a pioneer in medieval medicine, insisted on the power of *viriditas*, or greenness, coursing through all things, a divine power that intermingles the ontological and the organic. She suggested that the ill should be surrounded by green things, especially living green things.

The consoling power of beauty, meager as that consolation may be at times, is a persistent concern of Toni Morrison's novel *Beloved*. Baby Suggs, in despair from the relentless violence and brutality of slavery, spends the rest of her life in bed, using "the little energy left her for pondering color," such as swatches of lavender.[77] Elsewhere in the novel, Amy Denver, who helps Sethe give birth while escaping from slavery, is perplexed by the suffering and evil in the world: "Wonder what God had in mind."[78] But Amy Denver also wonders at velvet. She is on her way to Boston to get some Carmine velvet. She says that "velvet is like the world was just born. Clean and new and so smooth."[79] There is an Edenic trace in the beautiful velvet. There is perhaps something of the feel of velvet, or the hunger for the feel of it, in the fingers that Amy Denver uses to massage Sethe's feet

and legs. It is a touch both painful and restorative. *Beloved* is also a novel about the treachery of beauty. The plantation upon which Sethe was enslaved and from which she sought to escape is ironically called Sweet Home. She sees taunting beauty in its trees and fields, though perhaps in this case the treachery is more a matter of how a society that enslaves betrays the promise of the beautiful.[80] There are many "Sweet Homes" in the world, beautiful places that humans have desecrated.

Whatever its affordances for an ethics of non-human nature, the "aesthetic potency" may seem especially vexed when it comes to our relationships with other humans. Desmond acknowledges how the beauty of the human other can be bent to sexual objectification and exploitation. Still, sexual eros should not be equated with objectification. Sex at its richest involves affirmation and recognition, a companioning of the erotic and the agapeic. As Luce Irigaray argues, "Sexual relation could be a path to becoming more aware and attentive, above all to intersubjectivity, and to approaching each other instead of appropriating one another."[81] Furthermore, there are erotic responses to the human other that are not sexual and that are more than sexual. Consider our response to the athlete or the dancer, for instance. Desmond argues that we also recognize the worth of the flesh in our agapeic care for the other in, say, medicine or hospice work. "The gift of the body, understood as such," Desmond writes, "induces reverence for the embodied other as the incarnation of singular but infinite worth" (*EB*, 177–78).

For Desmond the body is not only porous. It is also dynamically, aesthetically expressive. It is "an entire system of communication" (*PO*, 73). The dancer and athlete are again exemplars. The body expresses in posture and gesture. The mouth "is not just a grinding maw for food but as the bodily organ of the voice, it expressly communicates the entire self, in its innerness and outerness" (*PO*, 71). The eyes, as the old adage says, are "windows to the soul." They can show kindness or malice, concern or haughtiness, good humor or sorrow. Looks can kill—Desmond nods to Sartre—and in a variety of ways. Desmond cautions that one should not "bore into the eyes" of the other, "for there is an absolute intimacy of the soul that is not to be violated, and intrusive looking is a violation of the intimacy" (*IU*, 88). Still, there are positive, affirming looks as well. There are looks that reveal the intimate depths of the soul and looks that try to bar the way, to draw curtains over the windows.[82] The expressive face is part of why human beauty is not merely "skin deep." The perfectly symmetrical face can be disfigured by the malice or vanity it communicates. The aesthetically "disfigured" face can be made beautiful by the kindness or wit it

communicates. The expressive face suggests the idiotic depths out of which expression surfaces, depths that always hold much in reserve. The face is often ambiguously expressive. Consider the *Mona Lisa* and its enigmatic smile as an icon of the otherness of the other.

Ancient sculptures and paintings of the human form tend to be sacral depictions. Desmond notes how Greek sculptures of "wrestlers, boxers, warriors, [and] athletes" are marked by a "celebration [that] seems to grow out of the motive of reverence" (*PO*, 74). The two-dimensionality of the Byzantine icon, "written" in tempera on wood, represents a very different approach to art, the body, and the sacred. The face is (seemingly) depicted as emotionless, the eyes as vacant, so that the venerator of the icon does not become an idolater of the face. The contemplation passes through the icon to the divine. Yet the face and eyes have an undeniable power, so that even nonbelievers can feel as if the icon is gazing at them in return. The vacancy of the eyes is not mere vacancy but kenotic depth. The icon and religious art continue to echo in secular portraiture. Desmond notes how "the portrait painter offers us the aesthetic vision of a whole world present in this one countenance" (*IU*, 89). The face intimately "incarnates" the universal.

Desmond writes, "The appeal of the face is a threshold of the aesthetic, the place of permeable passage to the religious and the ethical" (*IU*, 89). In terms of ethics, Desmond notes, "Levinas impressively appeals to us to face this" (*IU*, 89).[83] The encounter with the face of the other is of utmost importance for Levinas, and Desmond agrees with him about its importance. Yet Levinas can also tilt toward abstraction. "The face" is not necessarily the literal face of this particular other before me. Desmond wishes to remain on the more concrete level. He argues that, within a human life, "the primordial *expression*" of the face is not "you shall not commit murder," as Levinas avers.[84] This expression is crucial, but it is not primordial. The first encounter is not with " 'the face' but [with] the particular faces of father and mother—singular, unique to this family—that bear, less the general command, as the enactment of the good in the singular and possibly exemplary parent" (*EB*, 410n28). This resonates with a suggestive remark of Hans Urs von Balthasar's: "After a mother has smiled at her child for many days and weeks, she finally receives her child's smile in response. She has awakened love in the heart of her child."[85] There is a between here, a loving call issuing from the mother's smiling face, a call eventually returned by the child's own smile.

What of the gaze of eros in romantic love? Again, this can be flattened into objectifying forms, but this is not a necessary movement. The gaze that

lovers share can be one of intimate, mutual recognition. It can be attuned to depths rather than flattening. Likewise, while infatuation can turn obsessive, constricting one's world to the desired other, romantic love can also reopen our porosity. The world becomes strangely illuminated. Colors are brighter, smells and tastes are more delicious. We are alert and open. There may be a distorting love sickness, but the "enchantment" of love can also be a healing spell that reattunes us, that reopens our porosity.[86]

What of the look of agapeic love? The mother's loving gaze may come to mind again or the haunting eyes of the icon (or how both come together in a Renaissance Madonna). These are powerful examples, though Desmond would suggest that the agapeic can also be festive, jubilant. There is the look of festive celebration, of the child at play. The agapeic renews porosity as well, in a similar way to the renewed porosity of erotic love. (Again, it is important to recall that for Desmond eros always carries with it the promise of the agapeic, and the agapeic does not necessarily leave the erotic behind.) Here, though, the ethical import is less equivocal. The look of agapeic love is beneficent. It sees both the good that is there and the possibility of the good to be done. Martin Buber is suggestive in this regard:

> In the eyes of him who takes his stand in love, and gazes out of it, men are cut free from their entanglement in bustling activity. Good people and evil, wise and foolish, beautiful and ugly, become successively real to him; that is, set free they step forth in their singleness, and confront him as *Thou*. In a wonderful way, from time to time, exclusiveness arises—and so he can be effective, helping, healing, educating, raising up, saving.[87]

It might seem that such a look is beyond concern with beauty. As Buber suggests, it can affirm not only the beautiful and the good but also the evil and the ugly. But perhaps the look of agapeic love instead sees the beautiful and the good within the evil and the ugly. This would unsettle refined aesthetic judgments and canons of taste. It would get at a more elemental sense of beauty, of beauty as the showing of the singular.

Desmond notes how "freaks were *used* in past times as shows in circuses, such as the elephant man" (*EB*, 180). They were often leered at, shrieked at, or laughed at. He argues that another look is possible, though, "a recoil from our recoil" (*EB*, 180). This look does not self-righteously bestow dignity. It recognizes a dignity already there, already manifesting itself as "the presence of the divine" (*EB*, 181). The classic models could not recognize

beauty here either, but there may be another beauty that comes not from, say, symmetry but from the singular worth of the human. Beauty is once more not a matter of surfaces alone but of the surface—the face—saturated with worth. The face of the rejected other can manifest as the image of God, to use theological language. Desmond offers the example of St. Francis of Assisi kissing the leper, how "he overcame the natural revulsion of self-being to the diseased other" (*PO,* 274). "This might seem like sick masochism," Desmond acknowledges, like the "kiss of life" foolishly "courting" death (*PO,* 274). Yet Desmond claims that Francis's kiss reveals him "as a being beyond death in a loving of being beyond death, in his own willingness to die" (*PO,* 275).

Desmond calls this a sort of "idiot wisdom," a wisdom that recognizes the worth of the singular in a way that will seem excessive, even foolish, to "universal" reason. A philosophy of the abstract concept or a utilitarian ethics will see idiot wisdom as simply idiotic in the negative sense. Both elide the worth of the singular. In Francis's kiss, Desmond sees the idiot wisdom of the holy fool. Again, many philosophers might scoff at the fool as simply foolish (though Desmond suggests that Diogenes and the Cynics are philosophical "fools" of idiot wisdom, and in a way Socrates is too). But Desmond claims that the philosopher should not simply dismiss the holy fool. Here is another necessary dialogue partner. There is significance, and a challenge, in the story of St. Francis approaching the singular leper with the look of agapeic love, with the same pursed lips that offered the canticle of kinship with all creation, even with Sister Death.

With idiot wisdom in mind, we might consider Desmond's continual returns to the disturbing portraits of Francis Bacon and Lucian Freud. He seems to be haunted by them, and it is not clear that he has reached anything but tentative conclusions. From one angle, Bacon and Freud are in "the business of assaulting their subjects" (*IU,* 89). They could be seen as painting the freak show on canvas and of inviting dehumanizing, voyeuristic looks. Desmond thinks this is truer of Freud, where one senses that the painter is "keeping disgust at bay" (*GBPB,* 103n6). Desmond discerns something more than disgust in Bacon's paintings, though: "Some of Francis Bacon's representations awaken a visceral horror before howling and deformed faces, and yet there is a haunting beauty, even glory in some of the paintings themselves" (*GBPB,* 19). There is something true to the intimacy of being human in the paintings, true to the intimacy of horror, of vulnerability: "Not the word but the howl made flesh" (*IU,* 89). Desmond wonders if it would not take an "agapeic hand" to paint such intimate horror (*IU,*

89). Desmond wonders too about our recoil from such paintings. Perhaps we are recoiling from an intimate recognition: "The horrifying other is my intimate: I am brother of the monster; I myself am the monster" (*IU*, 89). Desmond could be accused of being as naive as Danto's friend before the Hirst installation—or of trying to be St. Francis kissing Francis Bacon's faces. But I think his point is that even when Bacon paints the body and face as agonized, "screaming meat," as already-decomposing flesh, they still call out for recognition. There is an ethical affordance here, though it may call for (call forth?) an idiot wisdom, an aesthetic attunement to the worth of the singular.

Chapter 3

The Artist and the Between

This chapter focuses more squarely on art and especially on the practice of the artist. Desmond again stresses receptivity and intermediation.[1] Desmond argues that the artist mediates both external and internal otherness. Desmond recovers two old, somewhat unfashionable words for this—imitation and inspiration. The chapter's first section shows how the artist, for Desmond, always works between imitation and creation. Imitation is not flat, "naturalistic copying" (*PO*, 88). It is the imaginative mediation of external otherness. The second section discusses the interplay of inspiration—understood as the imaginative mediation of internal otherness—and skill in art. The last chapter discussed how the experience of beauty can inspire art. This chapter elaborates on such inspiration. The final section extends Desmond's thought to the related topic of artistic influence, which receives relatively little attention in his writings. It considers the intermediation between what T. S. Eliot calls "tradition" and the "individual talent." The relationship between the artist and artistic tradition can give rise not only to anxiety and rivalry but also to gratitude and affirmative "companioning." Here Dante's *Commedia* suggests the range of possibilities.

Between Imitation and Creation

The history of art is often sketched as premodern imitation giving way to modern creativity. This is a crude sketch, the stuff of polemics. Depending on one's inclinations, it can be a story of progress (the triumph of artistic freedom) or decline (the triumph of artistic navel gazing). Some changes in

modernity give this story plausibility—the increased autonomy of both art and artist, the increased conceptual importance of imagination and genius, the increased emphasis on artistic originality and experimentation. In writing about art, imitation has indeed given way to creativity as the guiding conceptual framework. When we turn to artistic creation itself, though, we see the limits of such a narrative. Desmond argues that the artist always works *between* imitation and creation. They are intimately linked rather than dualistically opposed. The accent can fall more on one or the other in any given artwork. Likewise, one or the other can be recessed or take different forms in different eras, in different movements, in the work of different artists, or in different stages of an artist's career. Still, both are always present in practice: "imitation is an incipient form of creation; creation is imitation completing itself" (*PO,* 91).

From the Romantics onward, aesthetics tends to define and deride mimesis/imitation as straightforward copying. Modern aesthetics then rejects mimesis-as-copying as the governing ideal for art. Desmond agrees that such an ideal is flawed. It makes the success of the artwork dependent on its fidelity to an external original. Here is my painting of this bowl of fruit. Look how accurately I depict it. The artwork does not seem to have inherent value here. Its value is borrowed from the original. Desmond notes how "the paradigm [or original] cannot be reduced totally to the imitation, but the imitation can be reduced to the paradigm, at least in so far as there is something external to the imitation itself which the imitation seeks (albeit unsuccessfully) to realize" (*AA,* 4). While attempting to defend art's ability to convey truth, such flat notions of imitation ultimately render the artwork redundant. Desmond points to Hegel's critique: why make an artwork at all if it adds nothing new?

Desmond holds, however, that no coherent philosophy of art is possible without a notion of imitation—albeit one significantly less limiting than the notion of mimesis-as-copying.[2] For Desmond, artists always "imitate" in that they mediate external otherness. After all, no artist creates ex nihilo.[3] The artist's mediation of external otherness need not entail flat copying. External otherness provides more of a departure point than a governing "rule" (*AA,* 7). Desmond argues that the artist's mediation is always creative, at times very creative.[4] Nonetheless, all artists must "imitate" in this broad sense: all must mediate external otherness. This is evident enough in representational art. Maybe an artist paints a bakery, real or imagined, or a poet writes a poem about one. Obviously, the artist's familiarity with actual bakeries and buildings and streets feeds into the art. Yet the point holds true even for

nonrepresentational art. George Steiner asks, "Has any painter invented a new colour?"⁵ A canvas where sweeps of blue shade into gray will suggest the choppy sea, or an overcast day, or mist rising in the morning twilight, or the cold in all its literal and figurative dimensions. Indeed, subversion of association requires an initial recognition. This can devolve into a naive or ham-fisted way to approach such art. One should not treat such a work as a poorly executed representation or only as a puzzle in which the critic tries to discern the work's real-world referent. Still, the persistent associations and the artwork's broader debts to the given must be acknowledged. As Dwight Lindley claims, "We create because, since our childhood, we have always already been given the creation."⁶

The materiality of the artwork attests to another way in which the artist must mediate external otherness. Susanne Langer notes that the artist "does not create oil pigments or canvas, or the structure of tonal vibrations, or words of a language if he is a poet, or, in the case of a dancer, his body and its mobility."⁷ Langer draws our attention to how the artist must work with the canvas, the block of marble, the words on the page. The artist must use paints and brushes and pens and chisels and cameras. The artist must cooperate with them, attending to their specificity. Desmond notes "Michelangelo's patience before the rock. Something other, a form in the rock, calls to be released. Creative cooperation with the otherness of the secret form is not just our freedom as self-creativity" (*IU*, 70). The master artist may give the illusion of full control, but the mastery involves working within material constraints, working with the material. Again, the master artist is an exemplar of the sensitive companioning of *passio* and *conatus*.

The artist must always mediate external otherness, then, but this does not mean that the artist ever simply copies it. Art still attests to the freedom and play of the imagination. Here we might pay our respects to nonrepresentational art or, in a different way, to the variegated and richly imagined worlds of science fiction and fantasy. But even seemingly bland artistic copies evince some creativity. Take a second look at that humble art class standby—the still-life painting of a bowl of fruit. The students hang their efforts on the wall, and each is different. Varying ability accounts for some of these differences, but it does not account for all of them. Even here, in this seemingly most straightforward act of imitation, there is the mark of the artist as creator, of a shaping, imaginative mediation of the original.

What are some ways art creatively mediates external otherness rather than simply copying it? For one, the artwork presents significance. Recall the discussion of perception in chapter 1. All perception involves imaginative

intermediation, a sifting of significance out of the "muddy flux of happenings" (*PO*, 103). Our perception is "poetic" in that it frames significances within this flux. Art itself "carries through in a heightened manner the quest for such unities" (*PO*, 104). The painting, the poem, the sculpture, the short story—all offer an "aesthetic framing" of significance that asks for our attention. The artist's eye gives shape, winnows the significant from the insignificant, offers the essential.[8] Indeed, this is undoubtedly a major contributor to art's power. We are always immersed in sensual excess, but art and literature offer us an explicit framing for our attention. To use Paul Weiss's language, the artwork is an "emphatic" in this regard.[9] It presents itself with emphasis, calling out for our attention.

Such aesthetic framing is not a sheer imposition onto flux. It too involves intermediation. I paint the bowl of fruit from my seat at the end of the table. I see it from only one angle. Attending to the bowl, I am aware of the partiality of my perspective. As the natural light in the room plays upon the fruit, I am aware of shifts in its appearance. I see that the original is not statically fixed. It manifests in shifting ways. The artist's mindful attention thus yields a painting where what is still is nonetheless dynamized via light, shadow, life, decay. Here the still-life breakfasts and banquets—and the *vanitas* paintings as well—of the Dutch Golden Age come to mind. Consider also, though, how the Impressionists are truer to some aspects of the aesthetics of happening than a more naturalistic realism. They capture the fluidity of perception, the fluidity and excess of things' aesthetic manifestations. Desmond points to "Monet's late paintings at Giverny: the pond, the lilies, the water, the Japanese bridge, all partake of a shimmering energy, out of which they struggle to emerge and into whose vibrating heart they are enfolded again" (*DDO*, 155). Merleau-Ponty traces this development into the twentieth century. He claims that Cézanne (a great still-life painter in his own right) breaks "the 'skin of things,'" the lines of illusionist painting.[10] Cézanne is attuned to how "all flesh, and even that of the world, radiates beyond itself."[11] Merleau-Ponty notes, though, that this is not the artistic death knell of the line. Impressionism does not kill it so much as free it, and it returns with revivified power in Klee and Matisse. Earlier techniques are never fully abandoned or rendered obsolete, Merleau-Ponty argues, no matter what avant-garde manifestos may proclaim:

> Because depth, color, form, line, movement, contour, physiognomy are all branches of Being and because each one can sway all the rest, there are no separated, distinct "problems" in painting,

no really opposed paths, no partial "solutions," no cumulative progress, no irretrievable options.[12]

Desmond would say that because reality is overdetermined, the modes of mimesis are plural. Many mediations are possible.

Paintings have a literal frame. The stage frames the dramatic performance. Music, Desmond notes, "tends to frame in time" (*PO*, 104). But by aesthetic framing Desmond is not concerned with such "physical limitation" so much as "a concentration of attention" (*PO*, 105). He is interested in how the artwork "frames" our attention in a certain way.[13] The Romantic fragment, for instance, is still aesthetically framed for Desmond.[14] Likewise, Desmond notes how contemporary art often seeks to break free of literal frames, "sometimes to deny art's isolation from its others, sometimes to subvert the commercial packaging of artworks as commodities, sometimes to question the very ideal of wholeness" (*PO*, 105). Yet if "the literal frame deconstructs itself," such art nonetheless still offers "metaphorical framing, namely, a different concentration of mindful attention" (*PO*, 105). We might think here of installation art, such as the mirror-lined "Infinity Rooms" of Yayoi Kusama. Desmond claims that in daily life our perception is often structured by "an instrumentalizing framing." Our projects, anxieties, and egos determine what we see as significant. Such instrumentalizing framing is part of the daily grind. At times it makes us grind reality to fit our ends. Aesthetic framing challenges this. It offers something "akin to a contemplative concentration of mind, releasing wonder before the density of givenness, feeding a hope that all perception is not profane" (*PO*, 104). Aesthetic framing beckons beyond instrumentalism. It invites agapeic mind. Such framing helps explain the appeal of art.

In this regard, Desmond notes the artist's impressive "tolerance" of otherness. Tolerance here "is an active respect of the other, a courtesy to its being, an engagement with otherness that is not dominating" (*PO*, 105). Art calls forth the artist's powers of imagining otherness, of imaginatively othering oneself. Keats notes how the receptive poet can, in a sense, become the sparrow pecking in the gravel through such othering.[15] Again, even a seemingly straightforward mimetic artwork is marked by creativity—here in the mode of imaginative identification. Keats also notes how art calls for "negative capability," the ability to mindfully dwell in uncertainty and ambiguity.[16] Here we might note how such negative capability, with its respect for uncertainty and for what inevitably evades the artist, helps keep imaginative identification from becoming tyrannical. It

allows imaginative identification to be a gift of recognition rather than an imposition. Desmond wonders at the ability of great writers as different as Shakespeare and Dickens to create worlds full of differentiated characters.[17] Murdoch's claim that literature helps us recognize that other people exist again comes to mind.

Something of the artist also infuses art, even art of seemingly straightforward imitation or of imaginative identification. Hegel notes how art involves the self-othering of the artist. The artist's (self-)discovery pervades the work. In art, the idea is rendered as the sensual ideal. Hegel claims that the "highest task" of art is "revealing to consciousness and bringing to utterance the divine nature, the deepest interests of humanity, and the most comprehensive truths of the mind."[18] Desmond wishes to balance the Hegelian emphasis on self-mediation here with more attention to art's mediation of external otherness, but he agrees that Hegel points to some essential aspects of art.

Think once more of art as a framing of significance. This framing is not only about what the artwork "depicts." It is also about the *how* of any depiction. The framing communicates a sense of awareness, an attunement to significance, a mindfulness, a way of seeing. Even a depiction of the most isolated landscape is suffused with this artistic awareness. Desmond is especially concerned with how the artwork can incarnate astonishment or perplexity. Sometimes this is dramatically rendered rather than implicit. In Walt Whitman's "When I Heard the Learn'd Astronomer," for instance, the speaker sits in a stale lecture hall listening to the astronomer's stale talk. The astronomer approaches the universe through "proofs" and "figures." The anaphora of the poem's first four lines captures the droning lecture. The speaker becomes "tired and sick." (Is he bored? Exhausted from trying to keep up with the math? Soul sick at the quantification of nature? Reeling from perplexity?) He leaves the lecture hall, "rising and gliding," to be alone in "the mystical moist night-air," where he "Look'd up in perfect silence at the stars."[19] The assonance and alliteration of the poem's final lines suggest the move from the quantitative to the qualitative. They suggest the rebirth of awe, the renewed intimacy with the strangeness of being after the alienation of the lecture. Whitman's poem does not simply dramatize an experience of wonder. It incarnates wonder.

Art can of course incarnate any number of moods or tones. They are often ambiguous and difficult to describe. Langer claims that the artwork expresses "*what life feels like.*"[20] She holds that this is the real purpose of art. Artists may think that they are simply imitating nature, but they are

actually offering an artistic "*insight* into the nature of sentience," a "picture of vital experience."[21] She ties this to what Desmond calls our inner idiocy, our singular experiences that evade determinate wording but which can often find fuller expression in art. A person's inner life, Langer explains, "is usually but vaguely known, because most of its components are nameless, and no matter how keen our experience may be, it is hard to form an idea of anything that has no name. It has no handle for the mind."[22] Yet "what language does not readily do—present the nature and patterns of sensitive and emotional life—is done by works of art. Such works are expressive forms, and what they express is the nature of human feeling."[23] Langer claims the feeling of life cannot be fully pinned down within the artwork (by reducing it to the particulars of, say, a painter's use of color or a poet's apt phrase) nor fully captured in discursive language. It can only be intuited in an encounter with the work itself. Paraphrasing or description of the artwork—such as my paraphrase of Whitman's poem—cannot convey the "felt life" of the work. Our attempt to name it as a mood or tone is always an oversimplification, even if a necessary one.

The artwork is not simply an image of an original, then. It is an "imagistic original" or "original image" (*IU*, 76). It has its own integrity. The artwork does not simply reflect the world. It is a world unto itself.[24] This is perhaps most explicit and developed in the epic, where a cosmos is created, populated, explored. The epic aims at comprehensiveness, to be both cosmology and cosmos. Consider the shield of Achilles as an image of epic comprehensiveness within the *Iliad*. It stretches to contain all of life, the country and the city, birth and death, war and peace, destruction and harvest, funeral and festival. Only a god could have gotten all of that on a shield. Only a hero could carry it. (Consider also W. H. Auden's reforging of the hero's shield as a vision of comprehensive war in the age of serviceable disposability.) There are still impressive poetic forays into epic expansiveness. Consider, for instance, Derek Walcott's *Omeros*. Without eliding the differences between ancient epic and modern novel, we can note a similar world-building expansiveness in many prose fictions as well, often with an explicit nod to the epic tradition. We see this in novels as different as the mock epics of Miguel de Cervantes and James Joyce; the vast social tapestry in George Eliot's *Middlemarch*; the sweeping historical epics of Leo Tolstoy, William Faulkner, Gabriel García Márquez, and Toni Morrison; or the mythopoeia of C. S. Lewis and J. R. R. Tolkien. But not only expansive works are worlds. As the poems of John Keats, Rainer Maria Rilke, or Anna Akhmatova suggest, a lyric is its own "small cosmos" (*PO*, 92).

Still, the world of the artwork remains open to our shared world. "A primary reason why traditionally art was seen as imitation," Desmond notes, "was that it opened contact between the artwork and the larger extra-artistic world" (*PO*, 89). Each work of art is *a* world in communication with *the* world. The artwork is again an open whole. This doubleness is central to Desmond's account of art. The communication of the artwork with the wider world is why the characters in a novel can awaken us to the humans that surround us. It is why a poem about nature can move us to care for nature. It is why the epic can orient a society. Lewis Hyde recalls, "I went to see a landscape painter's works, and that evening, walking among pine trees near my home, I could see the shapes and colors I had not seen the day before. The spirit of an artist's gifts can wake our own."[25] This is a crucial power of art, one bound to some notion of art as mimesis. Aesthetic theories that deny this power ultimately hobble art.

We are in a better position now, however, to see that this power is not simply a referral of the artistic image to its "real world" original; nor must we choose between the singular integrity of the artwork and the artwork's power to attune us to the wider world. For Desmond, perhaps the most fundamental ethical affordance of art is its ability to draw us into attentive mindfulness of singularity. First and foremost, it draws us into mindful contemplation of the artwork's own singularity. The true "usefulness" (or "uselessness," if you prefer) of art is that it draws us beyond use. The artwork reminds us that there is value beyond use value. The artwork is itself rich with equivocal value. As Brian John Martine observes, the artwork returns us to an origin, to something akin to the original, overdetermined porosity from which all of our meaning-making endeavors arise: "The artwork holds out the possibility of a return to origins of the most fundamental sort. We find in it a rich ground of being and meaning, not limited by the particular demands of this or that end."[26] The artwork's aesthetic framing of significance can by extension teach us to better frame significances in the "muddy flux" of happening. The "felt life" of the artwork can cultivate our own feel for life. It can coax us into mindfulness that dwells on the artwork first, but perhaps later on the world. The overdeterminacy of the artwork can attune us to the overdeterminacy of the world beyond. It can suggest the idiotic singularity of the artist, and it can stir us in our own idiotic depths. Desmond would say that the artwork does not point beyond itself to the universal. It instead incarnates the intimate universal. We discover the universal within the work's intimate singularity. Rather than seeing the

artistic image as simply borrowing its value from an original, then, we might ponder the possibilities in Gadamer's provocative claim that "the work of art signifies an increase in being."²⁷

This increase or augmentation can take many forms—some surprisingly literal. Consider Joyce's Dublin and Faulkner's Yoknapatawpha. One can map them onto the historical Dublin or Lafayette County. While one can track the references to places, to historical persons and events, the fictive worlds of Joyce and Faulkner cannot be collapsed into their real-world counterparts. That said, it is also true that Joyce's Dublin and Faulkner's Yoknapatawpha not only reflect some aspects of their originals—they also shape those originals. They have transformed how we see and experience the actual Dublin and Lafayette County. Desmond offers Verona as another instance. In the wake of *Romeo and Juliet*, Desmond notes, "Letters from all over the world, and in all tongues, arrive in Verona addressed to Il Club di Giulietta" (*IU*, 62). Verona's volunteer "Giuliettas" answer them. The artwork increases or augments the reality.²⁸

For Desmond, then, imitation and creativity can never be fully separated. Still, certain extremes are possible. There are dangers in a one-sided emphasis on either imitation or creation. Too flat a conception of imitation results in work that is itself flat, derivative. The creative interplay of the imagination cannot be fully repressed in an artwork, but it can be given a very short leash. At the other end, an inflated conception of the artist brings its own dangers. The artistic "genius" is an ambivalent figure. One danger is an excessive fixation on the self. Without patient openness, the artist risks becoming self-enclosed, trapped in mirrors. The "genius" can at times be a charlatan, especially when there is a hot market for works of genius. Desmond points to Salvador Dalí "in later life, signing *empty sheets for cash*" (*AOO,* 277).

The modern emphasis on novelty courts this danger. In the early twentieth century, the restless Romantic genius gave way to "a cult of novelty." Desmond observes that "words like 'interesting,' 'exciting,' [and] 'original,' have replaced beauty, while the ugly has been replaced by words like 'boring,' 'dull,' [and] 'derivative.'" (*PO,* 93). The cult of novelty, Desmond notes, rejects what came before precisely because it came before. It constantly seeks the new, and especially the transgressive new, but with diminishing returns as the public becomes harder to shock. And while this cult tries to strike a radical pose, its members often become "panderers" who are interested in monetizing novelty or gaining celebrity.²⁹ Desmond points to Piero Manzoni

canning and signing "90 samples of his own excrement" and then selling them to museums "for impressive sums" (*AOO*, 67). Desmond wryly notes that some of these cans later exploded.

Another danger of the egocentric artist, already hinted at, is colonization of otherness rather than recognition of it, a forgetting that, as perceptive as even a "genius" may be, the artist's eye still sees from a limited perspective. There are always reserves within the other (and within the self for that matter) that evade determinate wording or representation. The mindful artist recognizes that "the artwork can offer an enclosure for aesthetic mindfulness without implying any totalizing violence" (*PO*, 104). Mindful artists, working "between" imitation and creation, disclose but also know that they do not disclose all.

Between Inspiration and Skill

Art also involves the imaginative mediation of inner otherness. Inspiration is a traditional word for this. Like imitation, it has fallen out of critical favor, but Desmond thinks it still names something essential. Inspiration relates to our constitutive porosity, a porosity that extends into our inner depths. Because of this porosity, no rigid opposition is possible between external and internal otherness. In inspiration "something is communicated enigmatically to the soul from beyond itself," Desmond says, "but it enters most intimately into that soul, so its strange transcendence is also intimate immanence" (*AOO*, 37).[30] An external catalyst often releases inner otherness. Recall from the last chapter how the strike of beauty can seed a desire to create beauty, can spark the eros of inspiration. Kathleen Raine explains, "It seldom happens when one has leisure, pencil, or notebook, but rather when one is receiving impressions, from walking along in the country or the city or reading a book." Inspiration comes like "a flash of light on the mind, as one sees a fish dart in the stream."[31] At other times the inspiration seems to bubble up from within. "As the artist works," writes Hyde, "some portion of his creation is bestowed upon him. An idea pops into his head, a tune begins to play, a phrase comes to mind, a color falls in place on the canvas."[32] Sometimes the inspiration can be vague. One starts with a fuzzy idea and develops it. No-nonsense writers scoff at waiting for inspiration. If you want to be inspired, they say, write. Sure enough, you jot down a few tentative lines and get into a flow. But this flow still suggests a release of inner otherness. The process of writing or painting can be one of ongoing

discovery, of ongoing inspiration. What shows up on the page or canvas can surprise the artist.[33]

Sometimes inspiration is a profound experience of transcendence. We might think of Coleridge's "The Eolian Harp" where the poet, like creation itself, is moved to song by the divine wind. Jane Kenyon asks, "Who is it who asks me to find / language for the sound / a sheep's hoof makes when it strikes / a stone?"[34] The poem can seem to be dictated, as in Czeslaw Milosz's "Secretaries." Inspiration can be forceful. It can press upon, even possess, the artist. Northrop Frye warns that the Muses can be "ravening harpies who swoop and snatch and carry off, who destroy a poet's peace of mind, his position in society, even his sanity."[35] Rilke: the inspiring angel can be terrible. At times inspiration comes in what seems like an ecstasy or a trance. Theodore Roethke offers an account of "that particular hell of the poet: a longish dry period."[36] Roethke had all but given up. He thought he "was done." But then inspiration struck:

> Suddenly, in the early evening, the poem "The Dance" started, and finished itself in a very short time—say thirty minutes, maybe in the greater part of an hour, it was all done. I felt, I *knew*, I had hit it. I walked around, and I wept; and I knelt down—I always do after I've written what I know is a good piece. But at the same time I had, as God is my witness, the actual sense of a Presence—as if Yeats himself were *in* that room. The experience was in a way terrifying, for it lasted at least half an hour. That house, I repeat, was charged with a psychic presence: the very walls seemed to shimmer. I wept for joy. . . . He, they—the poets dead—were with me.[37]

Inspiration overpowers here. The poem is a gift received with gratitude. The inspiration Roethke describes is the "strong transcendence" associated with mystical experience.

There are old names for this kind of inspiration: the Muses, the *daimon,* the Holy Spirit. Federico García Lorca speaks of the *duende,* Rilke of the angel. While we tend to associate traditional conceptions of art with mimesis, these names attest to ancient ways of thinking about art in terms of inspired creation. "Ancient peoples," Desmond explains, "honored the poetic power, wondering about its perhaps divine source (the poet as shaman, magus, sage)" (*PO,* 90). In the Western aesthetic tradition, Plato is an important origin point for thinking about both imitation and inspiration.

Divine madness—mania—appears throughout Plato's dialogues. It can inspire philosophers; Socrates himself is under its spell at times. The *Phaedrus* surveys different sorts of divine madness. In this dialogue, Socrates claims that "the best things we have come from madness, when it is given as a gift of the god."[38] The *Phaedrus* includes the story of the cicadas, who were once men so taken by the music of the Muses that they sang ceaselessly and thus died of starvation.[39] Socrates is himself inspired during his second speech on love.

Plato's *Ion* focuses on the inspiration of the poet and the rhapsode. Here, just as he does in the *Republic*, Socrates claims that poets lack true knowledge about the things they depict. They can describe a thrilling chariot race, but this does not make them charioteers. Still, the poet does have divine inspiration, an inspiration that passes from the Muse to the poet to the rhapsode and finally to the audience, like magnets suspended from a lodestone. This inspiration makes the poet "an airy thing, winged and holy."[40] This is a key text for later Neoplatonists, who see such inspired art as providing access to the realm of the Forms. But many critics detect irony in Socrates's praise of the inspired poet. (The irony is undeniable in Socrates's response late in the dialogue to Ion's claim that the rhapsode has a general's knowledge of war.) Desmond sees a true ambivalence or ambiguity in the dialogue, and indeed, "the ambiguity of Socrates' attitude is persistent, which does not mean his affirmative admiration is feigned, nor his guarded diffidence unreal" (*AOO*, 45). In his treatment of both mimesis and mania, Plato acknowledges danger and possibility. The poetic image can be a corrupting influence, but it can also direct us to the Good. In either case, there is no denying its power. Madness can be either divine or merely mad. Discerning this is difficult. It calls for situational judgment, "a discernment more like *phronēsis* than like *theōria*" (*AOO*, 46).

The Muses can be wooed, but never coerced. The artist can try to unclog the inner porosity, to be more fully open to the otherness within and without. This is another practice of receptivity. If the artist simply waits indifferently for inspiration, it may never come: "There must be as much of patient readiness in the wooing as there is of expectant attention" (*IU*, 81). There are more active ways of courting the Muse. Walking has been the preferred method for many a poet (and philosopher—Desmond himself is a long-distance runner). Keeping a notebook, writing down dreams, reading, fiddling with a line—all can be forms of wooing.

But the wooing can be more fraught. It can be "an ambiguous promiscuous eros in which *passio* and *conatus*, patience and striving, interlock in sometimes wondrous, sometimes grotesque, sometimes even obscene

embrace" (*IU,* 82). The pursuit of inspiration can become decidedly esoteric, as in the automatic writing of Yeats, André Breton, and the Beats. James Merrill pursued inspiration at the Ouija board, conjuring up a host of spirits (including the spirit of Yeats). Arthur Rimbaud advocated a self-destructive derangement of the senses. Artists have often turned to mind-altering substances. Coleridge claims in the preface to "Kubla Khan" that the poem was written in an opium reverie. Théophile Gautier, Charles Baudelaire, Alexandre Dumas, and Victor Hugo were all part of the Club des Hashischins. The painter Henry Fuseli purportedly ate raw pork for its hallucinatory effects. Henri de Toulouse-Lautrec and Paul Gauguin preferred absinthe. Many an artist has become an alcoholic or an addict while pursuing inspiration.

The pursuit can become desperate, distorting the artist's life, distorting relationships with friends and family. Patient wooing can give way to mining for material. The artist can become a vampire, as in Edgar Allan Poe's "The Oval Portrait," where a painter is so absorbed in painting his wife that he does not—will not—realize that the sitting is killing her. She slowly wastes away in the miasmic tower-studio.[41] Her life fades as the portrait becomes more vivid. At the other end of the spectrum, artists can drain themselves, transfusing their own blood into the work. The necessary withdrawal of the artist can become a shadow existence. Nathaniel Hawthorne feared this was his fate while writing his early tales as a bachelor in Salem. There are other ways of trying to force the Muse that are not necessarily destructive of self or others but of art. A feigned or forced inspiration results in art that is thin, derivative, or contrived.

What of the relationship between inspiration and skill? Socrates repeatedly claims that the poet does not possess *technē*. This challenges the common view in his time of the poet (and Homer preeminently) as polymath, as possessing knowledge about chariot driving, medicine, fishing, divination, and war, to name arts discussed in the *Ion*. Socrates holds that the poet does not know these arts as well as their direct practitioners. Stephen Halliwell explains that "the *Ion* brings to bear on poetic interpretation, and therefore implicitly on poetry itself, an extremely demanding model of what might count as skill (*technē*) and knowledge. In brief, Socrates treats poetry as constative, declarative discourse."[42] Socrates at times seems to treat poetic claims as strictly "veridical."[43]

Yet surely there is another type of skill proper to the poet—the skill involved in crafting a poem, the mastery of language, form, and meter. There is the painstaking work of revision, which requires its own set of skills. Again, there is the artist's trained eye. While charioteers may be

skilled at driving chariots, they are not necessarily skilled at describing or painting them. Perhaps the *Ion* simply takes this skill for granted. Socrates does seem to acknowledge that painting involves mastery and discipline early on in the dialogue, but he eventually folds even these technical skills into inspiration. In terms of artistic technique, however, there is continuity between the poet and the artisan. One can practice making both beds and sonnets. The master carpenter is more likely to craft a well-made bed than the apprentice carpenter; the master poet is more likely to craft a well-made sonnet than the apprentice poet.

Here the roots of poetry in the Greek *poiesis* (making) and of art in the Latin *Ars* (fitting together) are important. Aristotle's *Poetics,* with its technical attention to plot, meter, and character, is concerned with the well-made tragedy. And in general, Aristotelian and later Scholastic approaches to art have emphasized the poet as maker, as craftsman. In the early twentieth century, for instance, Ananda Coomaraswamy sought to recover traditional conceptions of art in response to the privileging of fine art divorced from craft, the rise of the creative "genius," and "art for art's sake."

Desmond's metaxological approach is salutary here. The relationship between inspiration and skill is better conceived as a "between" than an opposition. For even if inspired, an unskilled poet is likely to produce inferior art. Paul Claudel says of great poetry that "inspiration by itself would not suffice" because "to meet the work of grace, the subject would have to respond not only with perfect good will, simplicity and good faith, but also with exceptional natural abilities, governed and administered by a hardy, prudent and subtle intelligence, as well as a consummate experience."[44] Claudel holds that the reverse is true as well: "There is not a single poet who does not need to *inspire* before he *respires.*"[45] Even consummate skill without inspiration can result in poetry that is technically exquisite but hollow. The relationship between skill and inspiration is both dynamic and intimate. In great art, Desmond holds that "*technē* is enfolded in a finesse" (*IU,* 83). Claudel's metaphor is instructive. The relationship between inspiration and skill is as intimate as breathing.

Between Tradition and the Individual Talent

Reading poetry can also unlock inspiration. The poet sets aside the book and picks up the pen. The poet likewise develops artistic skill and sensibility not only through practice, but also through the study of other works.

Sometimes a poet makes the relationship to a tradition explicit through direct reference or allusion. A poet writes "in the tradition of" another poet or a movement. Conversely, a poet may explicitly reject or challenge another poet or movement. At times, though, influences have been so thoroughly absorbed that the poet is no longer consciously aware of them. In the *Phaedrus,* Socrates says that his own words may well be the words of others, that he "was filled, like an empty jar, by the words of other people streaming in through my ears, though I'm so stupid that I've even forgotten where and from whom I heard them."[46] Desmond makes a broader point about language: "Our own words are not our own. They are endowed with a plurivocal heritage" (*WDR*, 207). A poem is not unique because it is hermetically sealed from influence. It is unique at least in part because of its unique constellation of influences.

Poststructuralist attempts such as Roland Barthes's to disenchant or even dismantle the author often overstate their case.[47] They minimize how the author is not merely open to influence but an open *whole* that imaginatively mediates. They are not wrong, though, that otherness flows through the author; nor are they wrong that the possible meanings of a work exceed conscious authorial intent. Likewise, poststructuralist accounts of "dialogism" (Mikhail Bakhtin) or "intertextuality" (Julia Kristeva) rightly insist that texts are always already in conversation with each other, at a deeper and more pervasive level than explicit allusion. Seamus Heaney, to offer one example, retrospectively realized that "certain lines" in his early poem "Digging" "conformed to the requirements of Anglo-Saxon metrics."[48] In a 1992 interview, Cormac McCarthy acknowledged his debts to Faulkner by saying, "The ugly fact is books are made out of books."[49] Why is this an ugly fact? Here again, we see the modern emphasis on autonomy. Absolute distinctiveness has become the key aesthetic criterion. Ezra Pound's directive to "make it new" has become a dominant slogan. Yet, in practice, modernist art tended to make the past new rather than simply leaving it behind. This is certainly the case with Pound and T. S. Eliot's densely allusive, explicitly intertextual poetry.

Eliot addresses this in his classic 1919 essay on "Tradition and the Individual Talent." The tradition of his title refers explicitly to "the main current [of poetry], which does not at all flow invariably through the most distinguished reputations."[50] Eliot expects writers to study the classics, but there is also a second, broader sense of tradition in the essay. Poetry is "a living whole of all the poetry that has ever been written."[51] By writing a poem, one inevitably participates in this living tradition. Tradition in this

broad, proto-Gadamerian sense is unavoidable.[52] It provides the means of critical judgment, because the artist will "inevitably be judged by the standards of the past."[53] But it is also generative, because "we shall often find that not only the best, but the most individual parts of [a poet's] work may be those in which the dead poets, his ancestors, assert their immortality most vigorously." A major reason to study the artistic past is to deepen these inevitable dynamics.

Eliot contrasts this fluid conception of tradition with the widespread understanding of tradition as "following the ways of the immediate generation before us in a blind or timid adherence to its successes."[54] This is not how good art makes use of the past. Eliot rather insists that good art *does* inevitably make use of the past, and not just by rejecting it. He counsels the artist to study the past to cultivate a "historical sense," to gain an awareness of the richness of possibility, for "if you compare several representative passages of the greatest poetry you see how great is the variety of types of combination."[55] He also counsels the artist to be aware of how the present is always changing, of how the past looks different from the perspective of each new now, with each new work of art. In this regard, the past is never static. Eliot conceives the relationship of tradition and individual talent as a dynamic between, one in which influence moves in both directions. It is metaxological in this regard.

There is a polemical edge to Eliot's essay. It is critical not only of widespread misconceptions of tradition but also of the cult of personality in art. Eliot argues that the artist should pursue a "process of depersonalization." This will allow the artist to better become a "medium" between past and present. Again, there is some affinity here with Desmond's philosophy. Eliot's kenotic process attests to the poet's porosity. But there is a danger that Eliot, in a different way than the postmoderns, puts too much emphasis on the openness of the artist and not enough on the artist as a whole when he advocates "a continual extinction of personality."[56] Desmond would say this is too extreme, even artificial. The dynamic mediation of the artist will always be marked by her intimate singularity, and this is not a fault.

Desmond frequently writes of his philosophical "companions," the thinkers from the past who continue to guide and challenge his thoughts. Desmond often approaches these companions with gratitude, even when he is sharply critical of aspects of their thought. "One's attitude to past philosophers," Desmond claims, "cannot be defined by simple rejection. One learns from them, even when one disagrees with them. And even in disagreeing with them, one ought to have a hermeneutic generous enough to allow one to make strong intelligible sense of their essential contributions" (*BB*, xvi). Artists, too, can have their key companions. Steiner calls them "elected presences," pointing

to the "'fellow-travelers,' teachers, critics, dialectical partners, to those other voices within their own which can give to even the most complexly solitary and innovative of creative acts a shared, collective fabric."[57] As Harold Bloom famously argues, these relationships can be anxious ones.[58] They can become rivalries. But a true companioning relationship also entails gratitude for the gift of influence and example. Desmond invites us to see the companioning relationship as involving not only erotic struggle but also agapeic affirmation. Think again of Roethke's account of inspiration. Overwhelmed with gratitude for the poem that breaks his long dry spell, he offers thanks to Yeats and "the poets dead." Many writers, critics, and artists have sought to recover neglected forebears. Consider Alice Walker's efforts to find and restore Zora Neale Hurston's gravesite, to get her forgotten masterpiece *Their Eyes Were Watching God* back into print. The gift of influence gives rise to agapeic affirmation and care. The gift becomes a gift exchange.

In premodern literature, Dante and Virgil are perhaps the paradigmatic companioning relationship, one that reveals the possibilities of both rivalry and affirmation. In the *Commedia,* Dante's attitude toward Virgil is often one of reverential gratitude: "'My Guide! My Lord! My Master! Now lead on: / one will shall serve the two of us in this.'"[59] Virgil leads him out of the dark wood and safely through Hell and into Purgatory. Indeed, Virgil's influence is never left behind. Robert Hollander points out that "the *Aeneid* remains a presence through even the realms of heaven."[60] Traditionally, Virgil is read as the allegorical figure of reason in the *Commedia,* but Dante consistently refers to him as the "Master" and "Poet." As Aristotle is the Philosopher for Aquinas, so Virgil is the "Poet" for Dante. Virgil is both pinnacle and great representative of the poetic tradition.

Reflections on Dante's own relationship to this poetic tradition run throughout his epic. Consider his invocation in the *Inferno*'s second canto:

> O Muses! O High Genius! Be my aid!
> O Memory, recorder of the vision,
> here shall your true nobility be displayed!

> Thus I began: "Poet, you who must guide me,
> before you trust me to that arduous passage,
> look to me and look through me—can I be worthy?"[61]

In the first stanza, the author Dante invokes the Muses and their mother, Memory, as he begins his poem. In the second stanza, the character Dante asks Virgil if he is worthy to undergo the journey. Note how the invocation

of the first stanza inflects the question to Virgil; *the* "Poet" Virgil is being asked about *this* poet Dante's artistic as well as general worthiness.

Virgil provides this poetic validation in Canto IV when he introduces Dante to the other great poets of antiquity—Homer, Horace, Ovid, and Lucan. Upon his return to their domain in Limbo, a voice proclaims Virgil "the Prince of Poets."[62] Virgil does not bask in this praise but instead expresses his own gratitude for past and subsequent masters:

> "Since all of these have part in the high name
> the voice proclaimed, calling me Prince of Poets,
> the honor that they do me honors them."[63]

After talking among themselves, these great poets "turned and welcomed" Dante "most graciously."[64] At this he sees his "approving Master smile."[65] Virgil graciously receives praise, and he graciously bestows validation in turn on his predecessors and peers and on Dante.

Canto X perhaps offers a contrasting, dismissive attitude to the poetic past. Dante encounters the father of a fellow poet. The father asks why his talented son was not chosen for the honor of Dante's journey. Dante replies, "'Not by myself am I borne / this terrible way. I am led by him [Virgil] who waits there, / and whom perhaps your Guido held in scorn.'"[66] The scorn here is ambiguous, but perhaps it is not a matter of sheer artistic genius that separates Guido and Dante, but of respect for the poetic past. Dante acknowledges this past as a companioning power, as a guide.

Virgil and Dante's parting in Purgatory is one of the most poignant scenes in the *Commedia*. Beatrice arrives to be Dante's new guide, and the sight of her overwhelms him with joy. He turns, with a fitting line from the *Aeneid* on his lips, to find that Virgil has already departed. He laments that "Virgil had gone. Virgil, the gentle Father / to whom I gave my soul for its salvation!"[67] Robert Hollander calls this scene the death of Dante's "poetic father."[68] He points out "the extraordinary double sense of the last line, which makes Virgil not only a guide within the fiction but the agency of Dante's potential salvation in actuality."[69]

There is another side to Dante's relationship to his poetic father and to the poetic past, however. Steiner claims, "The step-by-step renunciation of Virgil's guidance is the axis of the *Purgatorio*."[70] Their parting? "Loving parricide is a twilit act."[71] The *Commedia* can be read as a Bloomian "strong misreading" of the *Aeneid*. Look again at how Dante dramatizes his acceptance into the great poetic pantheon. The *Commedia* is hardly a work of

self-effacing humility. (Dante acknowledges that pride is his besetting sin in the *Purgatorio*.) Is the *Commedia* a work of inspired synthesis or a work of audacious pride? After all, Dante lays out (and populates!) Hell, Purgatory, and Heaven. He claims that this is the truth—a vision—rather than a fiction. Dante claims prophetic inspiration. There are real tensions here, but Bloom nonetheless exaggerates when he claims that "though he says otherwise, Dante usurps poetic authority and establishes himself as central to Western culture."[72] Bloom's Dante is a glorious heretic, driven more by ambition than by divine inspiration.

As his own claim of "twilit parricide" suggests, Steiner acknowledges the anxieties in the *Commedia*. He holds, though, that artistic rivalry can itself be "a donation, a dialogue of generosity. Master artists and craftsmen pace one another as do great runners."[73] Desmond concurs: "There are modes of agon and companioning empowered by a secret love rather than antagonism" (*G*, 5). Steiner claims that the *Commedia* is, on the whole, much less a poem of rivalry than one of collaboration. It is filled with celebrations of "the enigma of shared origination."[74] It "sounds in depth the modulations of collaborative *poiesis*. The voyage is crowded with artists. . . . Above all, it is poets, epic, philosophic, lyric, whom Dante implicates directly in the introspective process of his own making."[75] Desmond would say that it is a poem about poetic companionship. The poem ends in Heaven, where love transcends earthly rivalries. Consider the theological rivalry between the Franciscans and Dominicans. In Paradise, the Dominican St. Thomas sings the praises of St. Francis (Canto XI), and the Franciscan St. Bonaventure sings the praises of St. Dominic (Canto XII). In Paradise, we are beyond erotic rivalry. We are in the realm of agapeic praise.

Chapter 4

Sacred Aesthetics

As we have seen, Desmond recognizes the "too-muchness" of being, including its aesthetic excess. As a philosopher of religion, Desmond notes how various religious forms (animism, polytheism, pantheism, monotheism) attend to the excess of being. They recognize this excess as a show of sacred worth, as a hierophany. Moderns often dismiss religion as a human projection onto the blank screen of reality, but Desmond insists that religion begins not in projection but in response to the sacred mystery and excess of being. Desmond claims that the widespread loss of the sacred in modernity has had profound effects. It facilitates the ethos of serviceable disposability, as well as the displacement of our hunger for ultimacy onto consumption or ideology.

This chapter recapitulates the trajectory of Part 1 as a whole. It begins in the "aesthetics of happening" broadly and ends with a narrower focus on art. The first section traces some general ways in which religious forms mediate the excess of being. The second section looks at the consequences of the marginalization of the sacred in modernity. The third section turns from this more descriptive philosophy of religion to Desmond's constructive account of God as the agapeic origin. Desmond notes "hyperbolic" happenings in everyday life that offer intimations of this origin. At the end of this section, I explore how the poetry of Gerard Manley Hopkins helps inspire Desmond's philosophy and his "hyperbolic" approach to God. The fourth section discusses the shared roots of religion and poetry, especially the similarities between prayer and poetic inspiration. It goes on to address a shared limit of religious and poetic language in their approach to the unsayable. The final section of this chapter sketches the modern attempt to find a surrogate for religion in art. It traces how, in Desmond's argument, we ask

"too little" of art today because we asked "too much" of autonomous art before 1913. Desmond calls for a renewed interplay between religion, art, and philosophy. Together they might cultivate an ethos beyond serviceable disposability.

Before beginning the chapter proper, it might be useful to say more about how Desmond defines religion, philosophy, and art. Religion is "a comportment towards being in which the sense of the holy predominates" (*PO*, 113). It entails worship, prayer, and ritual. Philosophy is the searching "eros of thought" (*PO*, 18). It entails "the mindful asking of the fundamental questions" (*PO*, 20). Art is marked more by imaginative urgency. It seeks to incarnate the richness of being in its creations. Obviously, these are not exclusive, univocal domains. Nor does Desmond mean these as univocal definitions.

Again, at their origins, they cannot be neatly distinguished. For instance, we now think of theory as a conceptual model. We associate it more with philosophy than religion or art. Yet theory derives from ancient *theōria*, a contemplative seeing—more specifically a contemplation of the sacred festival.[1] Religion, philosophy, and art cannot be separated from one another here. This is not simply an etymological fossil. Recalling the origins of theory in *theōria*, we become aware of how religion, philosophy, and art still often involve contemplative ways of seeing.

They still intertwine today, and in more ways than this. No absolute distinctions can be drawn. Religious faith seeks understanding. The urgency of art and philosophy can lead to religious ultimacy. Philosophy advances arguments via anecdote, image, and metaphor. Art raises fundamental questions. They can also, and Desmond would say rightly, challenge one another, of course. Art can call both otherworldly faith and abstract thought back to the concrete. Religion can chastise philosophy when its questioning becomes corrosive. It can call both philosophy and art back to spiritual seriousness. Philosophy can challenge dogmatic brittleness or fanaticism in religion. It can test the artist's images for counterfeit richness. Desmond would say that they need each other in both these affirmative and critical senses. They are kin that need to stay in conversation with each other, no matter how heated the family dynamics may become. When they close themselves off from each other, he claims, they atrophy. Religion becomes fideistic, fundamentalist, threadbare. Philosophy becomes an insular game of either technical minutia or hubristic system-building—thought merely "thinking itself" rather than opening itself to recalcitrant otherness. Art becomes merely aesthetic in the thinnest contemporary sense of the word. Indeed, this is the story of art in

modernity told in the final section of this chapter. And, of course, all three atrophy when they are not sourced in astonished wonder. This is Desmond's story of modernity as a whole.

Hierophany

Some of the most influential modern theorists (Feuerbach, Marx, Freud) treat religion as a human projection. Humans knit religion out of their hopes and fears and drape it over reality. Given his emphasis on receptivity and the "too-muchness" of being, Desmond unsurprisingly challenges this conception of religion.[2] He claims that religion begins with the strike of wonder. This could be wonder at the beauty of a sunrise or the sublime power of a storm, at the strange inner otherness discovered in our dreams or visions, at our sense of kinship and difference from other creatures and the natural world. Religion responds to the many wonders of being, and it does so in many ways. This focus on receptivity and response might seem to lead us to a second skeptical modern theory: religion offers crude explanations for what we can now better explain with science. Astronomy, meteorology, biology, psychology—they provide accurate explanations for what religion once explained via superstition, sacrifice, and "just so" stories. Explanation is indeed one function, especially of archaic religion, though Western science has at times returned in chastened humility to what it once scoffed at in "primitive" superstition or folk medicine.

Desmond would hold, though, that this second skeptical theory reduces the primordial wonder at the roots of religion to curiosity about how things work. It thereby elides a deeper astonishment at the excess and mystery of being. It also elides how this wonder stirs desire, an "urgency of ultimacy" that prods us to ask not only how things work but also why things are and how one should live. This urgency responds to "the lure of a more demanding, yet satisfying otherness" (*PO*, 115).[3] It leads not only to inquiry and speculation but also to prayer, reverence, worship, and—at times—perplexed despair. It launches humans on vision quests and pilgrimages. The urgency of ultimacy can fuel fanaticism, but it can also inspire lives of self-sacrificial service. The urgency of ultimacy drives not only religion but also "spiritually serious" philosophy and art. For Desmond, this urgency is constituent in the human condition.

Desmond is particularly interested in religion as a response to the excess and mystery of being. "Since everything existing participates, simply

as being, in the ultimate ground of being," Desmond avers, "all being may occasion the appearance of the divine. All being may be hierophanous" (*BHD*, 96–97). Desmond would therefore agree with Mircea Eliade's claim: "Man becomes aware of the sacred because it manifests itself, shows itself, as something wholly different from the profane."[4] Religion is of course plural. The very term suggests a false unity and narrowness. Desmond recognizes this. He is interested in how religious forms respond to this excess and mystery in different ways, how they evince and cultivate various attunements.[5] Cyril O'Regan explains that for Desmond "religion covers a spectrum of disclosures of the sacredness of reality, at various levels of reflection, and attended to more nearly by the individual or the community."[6] Animism, for instance, attests to a mysterious depth and resonance in all things: "All is alive in an ensouled way" (*GB*, 181).[7] Polytheism honors the potencies and powers that pervade things and in which humans can participate. Desmond notes, "The pantheon is a community of plurality, and yet the gods are often shown in the splendor of individualized thereness" (*GB*, 188). The gods differentiate and consecrate every aspect of life. Pantheism attests to a sense that the divine pervades the whole, to a sense of englobing divine unity: "As the aesthetic show of the divine, nature is as if it were the body of God" (*GB*, 231). Mystical religion cultivates contemplative patience and a sense of our own strange inwardness, of how our inner depths open on the wellspring of being. It offers "a kind of fertile formlessness" that melts the hardened *conatus* and purifies desire (*GB*, 261). "Inner" and "outer" porosity are once again linked, because unclogging the former often leads to a broader attunement to being. The inward turn of mysticism can, and should according to many religions, ultimately return us to the world in, say, Buddhist compassion or Christian love.

This is not to deny unsettling possibilities. Religion is again plural. Pantheism can become an absorbing god, collapsing difference into ultimate sameness. Polytheism can be cosmopolitan and inclusive with an open pantheon. But its gods—as Socrates noted—can behave in ungodly ways. They can even be particularist gods of blood and soil, as in the neo-paganism of the Nazis. Mystical inwardness can become insular and world-denying. The personal relationship between God and human can obscure the rest of creation. The "elect" of the gods or God can claim a mandate for the destruction of nonbelievers. The false prophet or corrupt cleric can manipulate unsuspecting believers. Desmond's account of religion recognizes the range of possibilities. His account is partly descriptive and partly normative. He surveys the various ways that different religious forms mediate the excess

and worth of being, but he is also pursuing a capacious affirmation of this excess and worth.

The religious quest for ultimacy, its attunement to the excess and especially the mystery of being, raises the question of an absolute origin or source. Desmond notes that within polytheism there is often a god above the pantheon that answers to this origin. The God of the Abrahamic faiths, who creates ex nihilo, offers such a radical origin. Desmond, as we will see in the next section, builds on the traditions of classical theism in his account of the "agapeic" origin that gives rise to a community of singular beings. Monotheistic creation poses its own dangers, though. The emphasis on a radically transcendent creator runs the risk of denigrating the sensual excess of creation. Believers can denigrate this excess as a distracting, "worldly" temptation. Desmond recognizes this. His own religion is one of "sacramental earth." Against more world-denying forms of Christianity, for instance, he claims that "pagan love of the earth is always asked, love of the good of elemental being, astonishment before the river that runs, the surf that pounds, the clear blue of the ether, the blinding dazzle of new snow, the musk on the fields in spring" (*GB,* 190). Desmond suggests that interreligious dialogue can call Christians to attend more fully to the excess of being, to both learn from other religions and to develop the affordances of its own traditions. As Takeshi Morisato explains, Desmond recognizes the "plurivocal senses of the divine."[8] A metaxological approach allows for continued, discerning dialogue between different religions, a between, rather than a dialectical synthesis or a univocalizing claim that truth resides in one tradition alone.

At the same time, Desmond challenges popular caricatures of Platonism and Christianity as indifferent or hostile to the world. These traditions often link beauty to theophany—a disclosure of the divine. In Plato's *Phaedrus,* for instance, eros stirred by beauty is the winged chariot that offers a glimpse of the Good. The emphasis can fall on leaving the material world behind, but it can also fall on how the material world is itself abundantly endowed with goodness and beauty. Desmond frequently notes that the demiurge in the *Timaeus* crafts the world to maximize beauty. Brendan Thomas Sammon explains that in Genesis, when God appraises the creation as "very good," the Hebrew "word *tov* has the sense of something well-made, which includes being attractive or pleasing when seen."[9] A psalm proclaims, "The heavens are telling the glory of God; and the firmament proclaims his handiwork" (19:1). Ben Sira, like the voice of the whirlwind in Job, wonders at the varied beauty, power, and mystery of creation: "Look upon the rainbow, and

praise him who made it, exceedingly beautiful in its brightness. It encircles the heaven with its glorious arc; the hands of the Most High have stretched it out" (Sirach 43:11–12). Ben Sira concludes, "Many things greater than these lie hidden, for we have seen but few of his works" (43:32).

There is a pronounced tradition of theophany in patristic and medieval Christianity.[10] Hans Urs von Balthasar observes of patristic commentaries on the opening chapters of Genesis that "the Fathers regarded beauty as a transcendental and did theology accordingly."[11] Dionysius the Areopagite's *On the Divine Names*, where beauty is a divine name and the beautiful creation is theophanic, broadly influenced Christian theology, informing, for instance, the architecture of the great cathedrals.[12] The world, like stained glass, is shot through with divine light. Medieval figures as different as John Scotus Eriugena, Hugh of Saint Victor, Francis of Assisi, and Hildegard of Bingen approach the world as a theophany. "A constantly recurring theme in medieval times," Umberto Eco summarizes, "was the beauty of being in general. It was a period in whose history darkness and contradiction may be found, but its philosophers and theologians had an image of the universe that was filled with light and optimism."[13]

Desmond holds that nominalism, which emerged in late medieval theology, helped undermine and eventually displace this rich conception of God and creation. The nominalist God is not the continual source of Being, infusing it with beauty and light, but a particularly great being. Thus separated from its creator, creation is no longer a theophany. This ultimately clears the way for more world-denying—and more instrumentalizing—forms of belief. This conception of God, for instance, makes it far easier to reinterpret the Genesis mandate of stewardship as one of absolute dominion and exploitation. Resultant forms of Christianity, Desmond readily acknowledges, helped form the ethos of serviceable disposability.

As we will see in a later section, Desmond finds affordances for thinking about both origins and beauty in premodern Christian thought. Desmond is also drawn to the "power" of monotheism "to marry the universal and the singular" in a particularly striking way (*IU*, 42). The God of Abraham is both radically transcendent and radically personal, the source of all being and the intimate source of my being. In Augustine's famous formulation, God is "more inward than my most inward part and higher than the highest element within me."[14] Our intimate depths become the place where we meet the ultimate Thou. This transformative meeting is mediated by the religious community and extends to the neighbor and the suffering stranger. The universal and the singular meet here as "the *intimate universal*: a community

of being that in promise extends to all, but that appeals to what is most intimate in the depths of the singular soul, and within which that intimate appeal finds itself addressed in a unique way."[15]

Consider the two names God gives to Moses on Mount Horeb. The voice from the burning bush says, "I AM WHO I AM" (Exodus 3:14). Theologians often take this name as a testament to God as the source of being, as the source of creative power. This name suggests radical transcendence as well as radical origination. "I AM WHO I AM" could be God's way of telling Moses that he cannot be grasped. (This means that such a God also evades the post-Heideggerian charges of onto-theology.) But God goes on to give Moses a second identification. He is "the God of your fathers, the God of Abraham, of Isaac, and of Jacob" (Exodus 3:16). He is a transcendent creator but also intimate, a God of covenant and relationship, of encounter and prayer. This God is concerned with individuals, with the community to which they belong.[16] Desmond would say that this God reveals himself as both universal *and* intimate.

Modern philosophers often recoil from a personal God to which one can pray. Their god, if they allow one, is often a staid first cause, a cool mathematician that keeps its distance.[17] One speaks *of* but not *to* such a god. Dennis Vanden Auweele remarks, "Many philosophers would naturally agree that to pray to Spinoza's Substance, Descartes' *Res Absolutans*, Kant's *ens realissimum* or Hegel's Absolute Spirit is awkward to say the least."[18] There is a desire in modern philosophy to rationalize religion, to purify it of subjective experience. In the wake of Kant, many philosophers are suspicious of prayer as debasing. Many endorse his stark opposition of contemplation and action, prayer and service.[19] Indeed, the false opposition between action and contemplation is to some degree characteristic of modernity as a whole. This distorts the complementarity of the religious life, which at its best is both singular and communal, contemplative and active.[20] As noted earlier, unclogging the inner porosity in prayer and contemplation can open one anew to others.

Consider intercessory prayer for others, which is perhaps especially likely to draw skepticism from philosophers. They may be skeptical about either its efficacy or the way it could substitute for active, direct care for the other. The latter is undoubtedly a real danger. There are flippant, thoughtless, even callous ways to pray for others. There are (counterfeit?) prayers that shirk action or real concern. There are also serious prayers, however, that are part of a serious *askesis*. Howard Thurman notes that, setting aside the question of intercessory prayer's supernatural efficacy, "the man who shares

his concern for others with God in prayer" ultimately "exposes the need of the other person to his total life and resources, making it possible for new insights of helpfulness and creativity to emerge in him. In other words he sees more clearly how to relate himself to the other person's need."[21] If a friend is in the midst of a life crisis, prayer for that friend will prepare us to offer more mindful help—whether that help be material aid or advice or (and here prayer can be an especially helpful practice) listening. If we find a family member or a coworker to be frustrating, prayer about that relationship may yield new patience or new possibilities of action. It may also lay bare the ways in which our own foibles and shortcomings contribute to the trying situation.

In general, a philosophy of religion that dismisses prayer is likely to be insensitive to our inwardness and especially its porosity. Desmond holds that prayer is the paradigmatic return to the *passio*. It cleanses our porosity and cultivates receptivity. There is nothing univocal in prayer. It calls for finesse, and it likely calls for experience. If one has not seriously pursued prayer as a spiritual practice, it is easy to reduce it to something simple and simple-minded. But Desmond reminds us that a philosophical scoff at prayer is a scoff at the vast majority of humans throughout history and across cultures who have practiced varied forms of prayer and spiritual contemplation. Furthermore, Desmond raises the question of how modern philosophy's failure to seriously attend to prayer and contemplation contributes to its reductive models of human subjectivity.

The Sacred in a Time of Serviceable Disposability

Even a nonbeliever might feel compelled to name being as sacred. The opposition of belief and unbelief can be too brittle. Regardless of explicit belief, one may turn to religious language to describe the experience of beauty, to call a concert or a striking view "transcendent," for instance. The atheist Schopenhauer describes beauty using the language of grace and Sabbath.[22] Much poetry and painting, regardless of religious intent, seems to depict a world charged with sacred significance. Amit Majmudar argues that poetry is "an animistic, if not pantheistic, art—an art that dates back, and is most at home in, a world where everything is meaningful and hence soulful, and where God is not removed from the natural world."[23] Purportedly secular literature by purportedly secular writers can still reflect something of this. Richard Kearney notes that authors like James Joyce, Virginia Woolf, and

Marcel Proust are far from orthodox believers—or from belief at all—but nonetheless have a "sacramental imagination."[24] They offer "a mystical affirmation of incarnate existence." Kearney notes in them a possibility between belief and atheism that is not indifferent agnosticism. He calls it "*anatheism*—the return to the sacred after the disappearance of God."[25] Kearney claims that much modern art and literature is "anatheistic" in this sense.

Desmond agrees, but he also cautions that secular namings of the sacred are hard to sustain. They become increasingly equivocal as religion loses sway, and this weakens the sense of transcendence they offer. This is cause for concern because the sacred is the most profound recognition of worth beyond utility.[26] Desmond asserts that "evacuation of faith in God" has had much to do with the rise of the ethos of serviceable disposability. We have lost the sense of the world as God's good creation, of "God as the ground of all good, good in an ontological sense, as well as an ethical."[27] Even those who go to church on Sunday might not see the world that way. In arguing that the eclipse of God contributes to the ethos of serviceable disposability, Desmond does not suggest that atheists or agnostics or "nones" cannot lead virtuous lives. The belief that this is the only life and the only world can lead to compassion and care. Desmond's point is more that the eclipse of God emaciates the ethos of being. A world shorn of the divine is often one where all valuations are human valuations. We are not the recognizers of value but the bestowers of it. Nietzsche wishes to bend this toward aesthetic possibility, but it more readily bends toward serviceable disposability. Desmond points out that the paradigm of human-as-bestower-of-value is haunted by the fear that this value is only "as-if" value. If all being is inherently valueless, are we not valueless as well? We may hunger for substantial otherness in such a world, but the urgency of ultimacy goes unmet. There are existential costs to a lost or weakened sense of the sacred. Few wish to be lords over an ontological scrap heap. They wish to be at home in a rich community of significant beings and significant things. They wish to venture forth into a full world.

Ethically, the ecological crisis brings this to a head. As noted in chapter 2, pragmatic rationales should not be brushed aside. If we destroy the world, we destroy our own lives. But they are not enough to protect everything that needs protection, and they are likely not enough to summon the resolve needed to deal with the crisis, especially because it calls for generational thinking beyond our own lifetimes. As we have seen, Desmond claims that environmental ethics needs a philosophical critique of reductive empiricism and a recovery of the aesthetic and ontological worth of things. He claims

that this recovery must be in some sense religious: "The earth has been neutralized, univocalized, made mere indifferent matter for instrumental use. If we are to allow the earth to offer more, to let its many voices speak once more, some reawakening of religious astonishment is required" (*PO*, 158).[28]

In the ethos of serviceable disposability, time as well as space is evacuated of meaning. It becomes the "homogenous, empty time" decried by Walter Benjamin.[29] Often it becomes a string of workdays interrupted by weekends and vacations, which provide recuperation from work. Desmond contrasts this with true "festive being," which "breaks through the closure of the functional system of instrumentalized life" (*PO*, 301). What modernity loses is a sense of sacred time in which work is not merely in the service of worship and festivity but consecrated by them. "In a fully liturgical culture," Catherine Pickstock argues, "all activities are to a degree brought within the scope of liturgical enactment, just as originally art was not a privileged domain, but referred to a skill, or a thing made well. This ensures in theory that nothing is merely instrumental, and that every act exceeds itself, since every act becomes an ecstatic celebratory offering."[30] Desmond, who expresses sympathy with Pickstock's work in this regard, says that liturgy and ritual shape an ethos of being. They consecrate time and ensure that labor and use are not simply instrumental.

It is easy for us to project our sense of homogenous time into the past, where a different chronology reigned, a time that was structured by natural and liturgical cycles. Byung-Chul Han observes,

> In the Middle Ages, the *vita activa* was still altogether imbued with the *vita contemplativa*. Work was given its meaning by contemplation. . . . The medieval calendar did not just serve the purpose of *counting* days. Rather, it was based on a *story* in which the festive days represent narrative resting points.

The calendar provided "narrative bonds," so that "the time of hope, the time of joy, and the time of farewell merge into each other."[31] The point is not nostalgia for the medieval peasant's often harsh life. The point is to unsettle our own sense of time and to note how while we may have leisure time, we often struggle not to be restless in it. Without the "resting points" and "bonds" offered by ritual, Han notes that our time often lacks duration. It "whizzes" by. The events along life's way also lose some significance. Middle class American rituals of initiation into adulthood, for instance, are decidedly thin (Getting a driver's license? Attending prom? Going to college?). Life is

no longer a pilgrimage or a quest. I might live vicariously through the movies or through video games. I might read Joseph Campbell and set out on the hero's journey, taking my cues from myth and premodern initiation. This may provide solace and direction, but without communal mooring I might again be haunted by the suspicion that I am only an "as-if" hero on an "as-if" journey. In the end, Han holds, our lack of ritual transitions, of rites of passage, often makes us more malleable consumers: "Thus, we age without growing *old,* or we remain infantile consumers who never become adults."[32]

Language also shows this impoverishment. The language of gratitude and blessing, of virtue and vice, does not come so easily to the tongue. Humans are no longer a mysterious "image of God," the world no longer a creation or cosmos. More reductive metaphors drawn from the machine or, more recently, the digital device come to the fore.[33] We reduce persons first to atomistic individuals and perhaps now to "bare life" or data points. The decisive events of life—birth, love, death—are increasingly treated as mere biological processes. Even "the self becomes a cold, abandoned sanctuary," Desmond notes. "We are left with the dark gropings of the psyche inside, the blind forces of a dedivinized, indifferent nature outside, and the meaningless collision of these two" (*PO,* 152).

These stark narratives are far from the whole story, of course. By historical standards, those in the developed world live in unprecedented material abundance. In several important measures—and this is not to downplay the exceptions and disparities—standards of living have tended to improve around the world. This is no small thing. Not all secular moderns live lives of existential shallowness and dread. Many live quite admirable lives of care, commitment, and contemplation. Still, I suspect that most will recognize at least some symptoms of the malaise outlined above.

A different sort of qualification is in order. Modernity involves significant disenchantment, but it is not entirely disenchanted. Religion is proclaimed dead and then it revives, sometimes in surprising ways and in surprising places. As Desmond notes, "The history of the relation of religion and secularity in modernity is immensely complicated and answers in no univocal sense to the narrative of a necessary secularization with advancing modernization" (*IU,* 24). To name one important example, the recognition of human dignity that represents modernity at its best has religious roots. The Bible and the pulpit were often used to justify prejudice and slavery, but they were also crucial to the great movements for the abolition of slavery and for civil rights.[34] Institutional religion today is neither impotent nor completely marginalized, despite rising numbers of unaffiliated.

Modernity also has its share of enchantment beyond institutional religion. Max Weber seems to proclaim the iron cage of secular modernity but frequents a spiritualist commune.[35] Desmond might wryly note the spaces between the bars on the cage. To use his preferred metaphor, the porosity of modernity is not fully clogged. Furthermore, even if a religious language and imaginary have been increasingly displaced, the deeper structures of modernity are still shaped, for better or worse, by submerged and often forgotten theologies.[36] Political, social, and economic thought are full of secularized theological concepts. Consider the afterlife of Providence as "Progress" or as the "invisible hand" of spontaneous order. Consider the different fall narratives that show up in philosophy and social thought.[37] Consider how Western politics periodically flares with religious fervor, at times in a millenarian mode, at times in an apocalyptic.

There is also mis-enchantment in modernity.[38] The urgency of ultimacy tries to make power or status or money ultimate. The mis-enchantment of consumption is widespread in modernity.[39] As Marx observes, the commodity becomes a fetish.[40] Production within the ethos of serviceable disposability can crudely instrumentalize labor and the natural world, but its commodities are enticing idols that promise fulfillment—at least until the commodity is attained, when it often loses its allure. The idol is found to be less serviceable than expected. It becomes disposable, and another soon takes its place. The distention of desire becomes an (anti-)religion, once conducted in the gaudy temple of the shopping mall, now usually conducted via personal devotion to the personal device. Desmond notes, "We are being (re)made into willing victims by the masters of serviceable disposability. Aesthetic addictions—we want our fix; we get delirium tremens without our 'things.' " (*IU*, 288). We might become exhausted, thinned out, by this religion.[41] At other times, though, the malnourishment can seem nourishing enough. We can "become blandly, even chirpily at ease with the desolation" and with our restless desire (*PO*, 158).

At times we shop for a spiritual fix. "As devotees of the religion of shopping," Desmond observes, "we can shop around for the right technique(s) of mindfulness. The market for different practices of New Age mysticism offers diverse therapeutic options for what is sometimes hard to distinguish from spiritual narcissism" (*G*, 181). Yet seriously pursued spiritual *askesis* can indeed counteract the distention of desire. This is obviously true of contemplative practices from both East and West, which appeal to many burnt out on consumption. We can illustrate the possibilities of such *askesis* by returning briefly to Moses and another theophany on the mountain.

Desmond points out how the Ten Commandments are not simply moral rules. They draw us out of I-it relationships into I-Thou relationships. They call us to recognition of God and neighbor. The purpose from this angle is not restriction but "agapeic release in community" (*EB*, 197). The first commandment calls us away from false gods—not just the golden calves of the ancient world but also the idols of mammon in our own day. The final commandments take us inward, to cleanse our desires of consumptive lust and envy. The third commandment offers a Sabbath rest, an opening to agapeic festivity, the opportunity for us to join in proclaiming the primal "It is good."

God's Grandeur

But what is Desmond's own conception of God? Desmond's God is not a super-being, à la the Zeus of mythology. Nor is Desmond's God a demiurge. His God is the hyper-origin of all being (and thus not a being at all). Today, both fundamentalist believers and their atheist critics often conceptualize God as the demiurgic cosmic engineer. For them, a creator God would be in competition with, say, theories of evolution or different cosmological models. But this confuses processes of immanent becoming—how things change—with the coming-to-be of anything at all, including the laws of physics. In Aquinas's terms, it confuses primary and secondary causation. These conceptions of God-as-engineer often dominate popular debate, but they are of relatively recent provenance. They have roots in the nominalist theology of the late Middle Ages, in the deist god of the Enlightenment, in the natural theology of Paley, in the fundamentalist reaction to evolution (and the Social Darwinism that at times accompanied it). Older theistic traditions hold that God is not a being but the origin of being, that creation is not demiurgic but ex nihilo, that it did not happen at one moment in the primordial past but remains ongoing as God continues to ontologically sustain all that is.[42] Desmond draws upon these traditions in his account of God as the agapeic origin.[43]

Does he cross over from reason into revelation, from philosophy into theology in doing so? Desmond would again argue that the boundary here is porous but that there is a boundary nonetheless. He argues that philosophy must test and question religious claims *while* remaining "porous to the possibility that there are forms of religion that communicate from a space of significance more ultimate than philosophy itself."[44] As a philosopher,

Desmond does not simply take over his answers from religious tradition. He draws on them, and tests them, in his attempt to think through the ambiguities of existence. As noted earlier, at times Desmond writes more as a general philosopher of religion. This is the case in his important early discussion of religion in *Philosophy and Its Others,* and it is true as well of several sections in *God and the Between*. In his more constructive accounts of the origin and the agapeic community, he more clearly writes as a philosopher within the Catholic tradition. At the risk of crudity where finesse is called for, he draws on the Bible, for instance, mostly to help him make (philosophical) sense of hyperbolic dimensions of being, of perplexities about radical origination. And even here, he would want us to think about these hyperbolic dimensions of being as not only responded to in Christianity but as being taken up by religions in a variety of ways. They can perhaps be understood as the religious equivalent of the "potencies" or affordances he discerns underpinning more determinate ethical systems. Nonetheless, Desmond holds that if humans are constitutively religious, if they are marked by the urgency of ultimacy, there can be no rigid oppositions here. There will be a certain porosity between the religious philosopher and the philosophical theologian.

As one would expect, Desmond's account of the origin is meant to affirm rather than explain away the "too-muchness" of being. If being is overdeterminate, its origin must be even more so. Desmond argues this should be enough to answer the Heideggerian charge of ontotheology:

> But if creation has to do with the coming to be of the determinate, it cannot be grasped in determinate representations or concepts. This means that [the] creator as origin is not a *first being* whence other beings become: the ultimate source of coming to be cannot be a being in that determinate sense. It cannot be assimilated to the terms of Heidegger's critique of "ontotheology." (*GB,* 242)[45]

The agapeic origin is not a determinate explanation that dissolves the mystery of being. The excess of being points to the greater excess of the origin.

Likewise, Desmond's agapeic origin preserves the singular uniqueness of things. In light of the teeming variety of singular beings, Desmond claims, "The origin is not for the world *in general* or creation in the mass; it is for the intricacy of the singular in the intimate universal. How else think

a coming to be that in creation itself shows such an astonishing intricacy of individualized definition?" (*GB,* 168). The agapeic origin knows each sparrow and numbers the hairs of the head (Luke 12:6–7). The agapeic origin "affirms" things in their singularity. Again, this is Desmond's reading of Genesis, where God sees each creation as "good."

The agapeic origin also releases things into freedom. The origin endows their dynamic becoming, their dramas of selving. The agapeic origin is not Sartre's god, then: an insufferable limit on freedom. It is not a puppet master. On the contrary, there is something unsettling about the freedom the origin grants. There can be horror at how God "makes his sun rise on the evil and on the good, and sends rain on the just and on the unjust" (Matthew 5:45). The freedom that the agapeic origin endows us with allows for evil. But the origin also endows us with the freedom and the ontological surplus to serve agapeically, to affirm the goodness of the other as other, to care for the other even to the point of self-sacrifice.

For Desmond, this is what the origin ultimately asks of us—to pass on, to return, the agapeic gift via our freedom. "God as absolute is agapeic service," Desmond writes, "his creation the origination of the between as the promise of agapeic community, his passion for humans a compassion that we too will mindfully participate in the community of agapeic service" (*GB,* 321). Where does the origin ask this? In the manifestation of the worth of the other and in our own intimate depths. Desmond concludes, "The call of this life is to live the holy in the good of being" (*GB,* 338).

For Desmond, the question of the origin, the question of God, does not draw us away from or downgrade the immanent. The question arises precisely because of the too-muchness of being, because of "happenings within immanence that yet cannot be entirely determined in the terms of immanence" (*VB,* 195). Immanence itself turns out to be porous. We do not experience transcendence beyond being but within it.

Desmond points to "hyperbolic happenings" within immanence that throw us upward metaphorically, that raise the question of the origin, the question of God. These do not constitute proofs of God's existence, because a "proof becomes a means of connecting, in the end, the determinate with the determinate, or the indefinite with the determinate" (*GB,* 131). Desmond offers ways or "probes" rather than proofs. "Way" suggests the experiential nature of Desmond's approach, and it also suggests a certain attunement. Recall the discussion in chapter 1 of how different moods attune us to being in different ways. "Proof" suggests an ethos of detached, philosophical

reason where the *conatus* is to the fore in the cut and thrust of debate. But Desmond's ways call for an ethos attuned to wonder, a reopened porosity and a cleansed perception, a mindful attention to the richness of being.[46]

Desmond delineates four hyperbolic dimensions of being: the idiotic, the aesthetic, the erotic, and the agapeic.[47] We have touched on these before, but they have a different valence and import here. The first hyperbole is the "idiocy of being," the strangeness that things exist at all, that there is something rather than nothing. This idiocy can be understood in diverging ways. The world can be taken as simply "there," without rhyme or reason, or the world can be taken as pointing toward an origin. The idiocy of being can be "taken for granted as the final surd, just senseless idiocy; or taken as granted, though as disquieting us with its radical ambiguity, and in that ambiguity tantalizing with a light that is not its own light. It is the second way that leads to the thought of God" (*GB*, 130). As Duns puts it, "Rekindled astonishment [at the contingency of being] does not prove God's existence. But by unclogging our porosity, it can purge our senses and permit us to perceive a halo of gratuity surrounding finite being."[48] There is kinship here with Aquinas's own way from possibility and necessity.[49] Desmond's hyperbole, with its attention to first-person experience, perhaps brings out the existential, experiential reserve within Aquinas's "forensic" discourse.[50]

Desmond's second hyperbole deals with the aesthetic, with how being manifests itself sensually. The intelligibility of being offers a bridge between the "idiotic" and "aesthetic" ways. Desmond quotes Einstein: "The world of our sense experience is comprehensible. The fact that it is comprehensible is a miracle" (*GB*, 139n18). This intelligibility suggests that being is not an "absurd surd," just mutely there. It is instead a "surplus surd" that "makes all finite intelligibilities possible. Presupposed by all finite intelligibility, it is not itself a finite intelligibility" (*VB*, 203). It is strange that being exists. It is strange that it is intelligible. It is strange that its intelligibility is overdetermined, continually funding insights and findings. This can lead to the thought of God. Desmond again draws close to Thomistic tradition, which holds that the intelligibility of being does not dissolve its mystery but deepens it. In Jacques Maritain's formulation, "There is in fact no mystery where there is *nothing to know*: mystery exists where there is *more to be known* than is given to our comprehension."[51] The orders and symmetries that emerge in nature offer intimations of an origin as well. Desmond's God is not Paley's watchmaker. He is neither a demiurge nor an "intelligent designer," engineering the particularly difficult pieces via special creation.[52] The orders of nature have their immanent explanations in physics and

biology, but they can also stir the deeper ontological astonishment in yet another way. Why order at all?[53]

The aesthetic hyperbole also returns us to beauty and the sublime: "The aesthetic glory of finitude is impossible to characterize exhaustively in finite terms" (*GB*, 11). Experiences of beauty—especially natural beauty—are often some of the most profound of people's lives. They can be transcendent experiences. Plato notes how beauty seems to give the soul wings, to offer an intimation of the divine. The Book of Wisdom holds, "For from the greatness and beauty of created things comes a corresponding perception of their Creator" (13:5). How does the beauty of creation offer this perception? Jean-Louis Chrétien claims, "The excess of the beautiful over itself, in its manifestation, refers to another, anterior excess, the excess by which the Good surpasses everything that it gives forth."[54] He goes on to elaborate on the theology of St. Hilary of Poitiers, in language that again resonates with Desmond's own: "The sense of beauty is that it exceeds our sense, always gives itself in addition. The world's beauty refers us to God's beauty in the way that something elusive refers us to something even more elusive, and not in the way that a copy refers us to a model, both of which would fall, in a banal way, within the compass of our minds."[55] Again, this is far from a univocal, step-by-logically-secured-step proof, but it names an intimation that beauty can convey, especially when we are receptively attuned, of a sense of more, of an elusive wellspring within singular instances of beauty.

Desmond discerns another bridge here between the idiotic and the aesthetic. Recall from chapter 1 how things are haloed by the enigma of their existence. Their radiance is not only sensual. It has this ontological dimension: they evoke ultimate questions about why they have come to be. Beauty can be theophanic in this way.[56] Hans Urs von Balthasar observes, "We 'behold' the form; but, if we really behold it, it is not as a detached form, rather in its unity with the depths that make their appearance in it. We see form as the splendour, as the glory of Being." Balthasar specifies that "this never happens in such a way that we leave the (horizontal) form behind us in order to plunge (vertically) into the naked depths."[57] This is close to Desmond's point about the hyperboles in general. They are paradoxical. They throw us or point us upward, but they also never fully leave the "horizontal" behind. Beautiful things are not mere occasions or stepping stones to transcendence. The hyperboles emerge from, and indeed call for, the fullest attention to things. To experience the transcendent via this beautiful painting or song is hardly to stop attending to it. To be struck by the strangeness of *this* child existing is hardly to brush the child aside.

To experience something transcendent in my love of *this* child is hardly to diminish the child. The opposition of "this-worldly" and "other-worldly" can only distort descriptions of hyperbolic experience. There is a sense of "above" and "below" at play, but they are experienced as a between. In transcendent experiences of beauty (and experiences of prayer and contemplation too), we go up and down the sacred mountain, up and down the divine ladder.

As for the sublime, it has roots in what Rudolf Otto calls the numinous, the *mysterium tremendum,* holy dread. Otto claims this pervades "the atmosphere that clings to old religious monuments and buildings, to temples and to churches."[58] In premodern religion, the numinous is often encountered in the desert and on the mountain, on the vision quest. The Romantic sublime, with its own love of craggy mountains and cataracts, often retains a sense of this. As noted in the last chapter, many recent thinkers of the sublime see this as "nostalgia for the absolute," a confusion of negation for the numinous. This is a formidable critique. John Milbank argues, though, that the postmodern sublime has its own submerged, and questionable, theological roots because it figures the absolute as "sheer unknowability."[59] Its absolute is rooted in the nominalist God that came to the fore at the dawn of modernity. It displaced the earlier patristic and medieval conception in which "the unknown is not simply that which cannot be represented [as it often is in the postmodern sublime], but is *also* that which arrives, which ceaselessly but imperfectly makes itself known again in every new event."[60] Desmond renews this older account. The absolute is not simply behind or beyond the material but is intimated in the manifestation of the material. Desmond claims the rending sublime "brings to mind, in the flesh, the sacred" (*IU,* 101). The sublime is a hyperbolic happening, an experience where the between of immanent and transcendent, of natural power and divine power, resists dualization.

Desmond's third hyperbole is the "erotics of selving." This has to do with our own coming-to-be. We are not self-creating. We are ontologically sourced. This sustains our continued being and richly so. It funds our continual becoming and self-exceeding, on which we cannot fix a limit. We cannot anticipate ahead of time the ways in which we might grow and change. We cannot pin down the possibilities of our own selving. We are "both finite and yet infinitely self-surpassing" (*VB,* 211). Recall Desmond's reading of the birth of Eros in the *Symposium*. Our desire is born of both lack and plenty. Our self-surpassing is not only out of need. It is also an exuberant excess. It is "a matter of *endowed enabling,* of being endowed as

enabled to be. Something other than self-enabling enables self-enabling" (*VB*, 213). This "something other" can be another intimation of the origin.

There are other intimations in our selving. Consider how strange it is that we can be struck by the mystery of being. Consider the urgency of ultimacy. The fact that humans are metaphysical creatures, that they ask *why*, is hyperbolic. It presses well beyond our basic needs for survival. Our urgency is excessive, even infinite, and this too can be seen as pointing toward God. Desmond claims that "there seems [to be] no proportionate response to our patience, openness, and hunger" (*GB*, 285). We seem to be hungering for an infinite response.[61] Desmond also notes the moral exigencies in our selving. Culture inflects our ethical selving, but Desmond is interested in the underlying exigency itself, of the way the ethical puts a claim on us: "We are called to be good, and we are good, but we are not the good, the good that endows us and calls us to be good" (*GB*, 145). The call of the good offers another way to the divine.[62]

But we are not always good, of course. If there is something hyperbolic about the human capacity for good, there is also something hyperbolic about the capacity for evil. Our selving can become tyrannical, lording over others, delighting in our perceived superiority. It can become an infernal or demonic erotics of selving, one that answers to the call of evil rather than the good. Augustine notes that "neither lions nor dragons have ever waged such wars with their own kind as men have fought with one another."[63] The human capacity to recognize evil is itself hyperbolic: "The horror of evil floods into mindfulness and we humans alone are devastated with this" (*GB*, 148). The "problem" of evil is the thorniest of them all for believers in a good God. It is less a problem to be rationally solved than a mystery to be lived, to use Marcel's distinction. As Renée Köhler-Ryan notes, "When evil fits too neatly into a systematic account, the result can be even more dissatisfying than when it is overlooked entirely."[64] Why my suffering? Why the suffering of those I love? Why the suffering of the innocent? Why suffering at all? This is the anguish of any serious believer in a good God. This challenge is at the heart of Dostoevsky's witness—the tortured children who haunt *The Brothers Karamazov*. We might think too of the bereaved parent. Consider the haunting artwork of Käthe Kollwitz, born of world war and the death of her own son Peter. Given such evil, "is the origin good? We each may have to sweat blood with this tormenting question, urgently and as singulars, each of us suffering, like Jesus, our own night in Gethsemane garden" (*GB*, 145). But Desmond joins Aquinas in discerning another paradox here.

Radical evil poses *the* question about the goodness of God, but without God we cannot truly name evil as evil—not as an "enigma of evil" rather than a purely natural phenomenon (*GB*, 149). How to account for the hyperbolic horror, outrage, perplexity, fixation, fascination? Evil itself can offer an intimation of the origin in this regard.

Desmond's final hyperbole is the "agapeics of community." This has to do with our "being with," our constitutive porosity and relationships to others. It concerns our sense of beings beyond their instrumental value for us. Marcel explores something crucial to the agapeics of community when he contrasts instrumentalizing relationships of "having" with relationships of "being." In the latter—perhaps with family, spouses, or friends—we discover an inexhaustible depth and richness, both in the other person and in the relationship.[65] We leave behind the realm of the "I" and enter the realm of the "we," of "communion." Love thus discloses an (over-)fullness of being. For Marcel, as for Desmond, this can point the way to God.

Desmond is also broadly interested in our capacity for agapeic affirmation, for the affirmation of the good of the other as other, the affirmation of things and others that offer no narrow good for us. Again, he holds that this is not simply our power, though we can cultivate and mediate it. It is part of the ontological excess with which we are endowed, an excess that allows us to go far beyond what we need for mere survival. In theological language, it is a gift of grace. As Terence Sweeney explains, "We find in the between that love, community, and generosity *happen. Agape is active* and sources the *possibilities* of our good activities."[66] For Desmond, the pinnacle of the erotics of selving is transcendence of the self in agapeic service: "This may extend from *incognito* acts of everyday consideration all the way to sacrificial love, in which one lays down one's life for another" (*GB*, 156). This too can be an intimation of the origin. We might think here of the hyperbolic witness of the saints, recalling once more St. Francis kissing the leper. Desmond claims that agapeic servants of the good form a loose "agapeic community." This is his take on Augustine's "City of God which, in the between, will always mingle with the City of Man" (*GB*, 157).[67] Again, Desmond's indirect ways do not constitute a definitive argument. The "too-muchness" of the between calls for continual discernment. But the hyperboles of being are also not simply indeterminate, and philosophy cannot ignore them without ignoring something important.

Before bringing this section to a close, and as a segue to a more direct focus on art, we might consider these hyperboles in relation to one of Desmond's most important companions—Gerard Manley Hopkins, someone

who likewise lived "between" philosophy, religion, and art. Desmond draws the language of selving from Hopkins's poem "As Kingfishers Catch Fire," which describes the dynamic becoming of things, while Desmond's singular idiocy has a root in Hopkins's concept of "inscape." Many of Hopkins's poems incarnate agapeic astonishment. They at times explicitly "hurrah" this affirmation.[68] (The "dark sonnets," on the other hand, incarnate perplexity.) Throughout his work, Hopkins discerns a God of excess and a God who attends to the singular.[69]

If one were to approach Desmond's thought through a single poem, Hopkins's "God's Grandeur" would be a fitting choice. It expresses Hopkins's own concern with how instrumentalism can obscure the worth of being and how it can reduce creation to exploitable resource. Such instrumentalism entails gross insensitivity to both creation and creator, an insensitivity to a "grandeur" that is at times striking, that "will flame out" dramatically, but which at other times is subtle, oozing out like fine oil from pressed olives. This numbness may be as old as Adam's curse, which Hopkins alludes to in "man's smudge" and in the toiling generations, but the poem perhaps suggests that it has "now" intensified in modernity. Note that "trade" comes before "toil" in the poem. Perhaps this trade is the reduction of creation to commodity, which in turn results in a toil divorced from care and gratitude. Kevin Hart notes that in the poem, "dominion has been exercised without stewardship, and man has become alienated from the earth (Ruskin) and from his labor (Marx)."[70] The bare ground, Hart observes, suggests not just the removal of vegetation but the barrenness of exhausted fields. The shod feet suggest how our artifice alienates us from creation.

The failure to see the grandeur of God in the world leads to a failure to "reck his rod" in care for the sacramental earth. This results in both degradations of the land and spiritual barrenness. Hart hears in the insensitivity to the "ooze of oil / Crushed" an echo of Micah 6:15 (among other passages of scripture). We are not anointed by the oil. We do not drink the wine. Trade and toil rule, recessing reverence and festivity. Yet the grandeur is still there:

> And, for all this, nature is never spent;
> There lives the dearest freshness deep down things;
> And though the last lights off the black West went
> Oh, morning, at the brown brink eastwards, springs—
> Because the Holy Ghost over the bent
> World broods with warm breast and with ah! bright wings.[71]

Note that in the poem there is no antagonism between the beauty of the world and divine beauty. Here, as in many of Hopkins's poems, natural beauty is sacred, theophanic. To use Desmond's parlance, it is hyperbolic. It throws us toward God, but this does not downgrade natural beauty. It instead affirms its sacral significance. Hyperbolic beauty throws us toward the creator but also returns us to the creation with heightened awareness and a vocation of care. "God's Grandeur" is ultimately an exhortation to see the "too-muchness" anew, to marvel at "the dearest freshness deep down things," to answer the agapeic invitation of creation with praise and care. This exhortation echoes throughout Desmond's writings.

Poetry, Prayer, and the Unsayable

Without denying the variety of traditional societies, in general their "religion" is not easily cordoned off from the rest of their "culture," from their political arrangements, economic activity, communal life, family structures, sexual practices, architecture, and warfare. In them, "the whole is the holy" (*PO*, 113). There may be sacred and profane, but there is not a secular realm waiting beneath a religious veneer. The secular as we know it is a modern Western formation, as is the notion of religion as one sphere within a broader culture, or of religion as a private rather than a public matter.[72]

Archaically, then, art and religion cannot be disentangled. Desmond claims that they share origins in astonishment and perplexity. This is expressed in religious rituals, in mythic images and narratives. Nietzsche explores the roots of tragedy in the music and dance of religious ritual.[73] Drawing on Yoruba tradition, Wole Soyinka shows that these dynamics are not limited to an exceptional Greece.[74] William Franke notes the roots of poetry across many cultures in ritual, in inspired or prophetic speech. "In the history and prehistory of human societies," he writes, "poets, prophets, and seers (the word *vates* can cover all three) have often been virtually indistinguishable from one another." Even with modern differentiation, Franke avers that "the two still need to be understood together as reciprocal and symbiotic in their origins, aims, and purposes." Poetry, with its genesis in ritual, often involves "evocations of things unseen or seen in their higher meanings."[75] Desmond likewise notes that art shows its religious roots when it affirms the rich, mysterious value of things. This is especially important within the ethos of serviceable disposability. Here Desmond gives a nod to the late Heidegger, who in his wish to resist being's reduction to a "standing reserve" turns to the consecrating poet, to Hölderlin in particular, who "utters the holy."[76]

Inspiration is another mark of kinship. Franke traces a Neoplatonic thread in Western poetic and religious traditions, running from the Renaissance through Romanticism to the present day, where poetry understands itself as "prophetic revelation."[77] More humbly, the poem is often considered a type of prayer. This has become something of a cliché, a poetic platitude. The interviewer asks the poet: What are your poems? The answer: They are a kind of prayer. Still, there is little doubt that many affirmative poems, secular or religious, are indeed something like prayers of praise. Many poems are expressions of gratitude, perhaps offered to no particular god, but grateful nonetheless. Recall the story of Roethke's gratitude in the last chapter, gratitude for the gift of poetic inspiration after a long dry spell. As noted earlier, agapeic astonishment can be a sort of implicit prayer, so a poem that grows out of this experience would, in a way, make this prayer explicit. Poems can also grow out of perplexity. They can be existential laments, expressions of deep hurt and pain.

Are such poems really prayers, though, or is there simply a close kinship, a close analogy? This is not easy to say. Is the poem of an overtly religious poet more truly a prayer? Is the seemingly prayerful poem of the atheist who sneers at the suggestion a prayer nonetheless? Is the former prayer becoming poetry, the latter poetry (despite authorial intent) verging on prayer? Desmond notes some self-consciously " 'post'-religious art" that presents itself as "prayer without praying" (*AOO*, 267). Maritain recognizes the closeness of a certain type of poet to the religious contemplative:

> [The poet's] aim is to create something which gives joy to the spirit, in which shines the radiance of a form; he gazes into things and offers a witness, tremulous as it may be, to the spirituality which fills them; he is connaturalised, not to God himself, but to the mystery, which comes from God and is scattered through all things, of those invisible powers which play through the universe.

However, he concludes, "Prayer, sanctity, mystical experience—poetry, even 'pure poetry,' is none of these things." It is instead "their most beautiful and dangerous natural symbol."[78] Once more, though it may seem like a dodge, Desmond would claim the need for finesse, perhaps even more than Maritain's scalpel cut, between the poetic and the mystical. (Consider his own poems-prayers-philosophical meditations at the beginning of chapters in *God and the Between* and *Godsends*.)

This does not mean that anything goes, though. The claim to prayer is a claim to spiritual seriousness. The porosity is between spiritually serious

poetry and spiritually serious prayer, both of which open (beyond) the self. The claim that one's poem is a prayer can be a mere figure of speech. It can be self-indulgent or lazy (as can be the claim that one's lazy prayer is a prayer). For Desmond, "The porosity of prayer is the original site of communication between the divine and the human."[79] Contemplative prayer is an *askesis*, a cleansing of the porosity. Such prayer calls for silence: "The silence of prayer is a space of intimate and open porosity, awaiting the advent of communication" (*IU*, 435n28). Silence allows one to transcend instrumental mind and reach agapeic mind. As Max Picard notes, silence "does not fit into the world of profit and utility; it simply *is*."[80] The poet, too, can seek inspiration in this space of silent porosity.

Rilke's *Letters to a Young Poet* are interesting in this regard. The letters propose a contemplative, even ascetical regimen for the aspiring poet. The letters commend silence, and the first counsels Rilke's interlocutor not to worry about publication or even writing poetry. Instead, he says the young poet should become more attuned to himself and to the world around him, to discover the otherness both within and without: "If your daily life seems poor, do not blame it; blame yourself, tell yourself that you are not poet enough to call forth its riches; for to the creator there is no poverty and no poor indifferent place."[81] Rilke says the young man may not become a poet, but this contemplative practice will still be valuable. And if he does become a poet, his words will be born out of the richness of silence, out of openness and attunement, rather than out of vain, grasping aspiration. Rilke decries from within poetry the possibility of spiritually unserious art, the possibility of poems as counterfeit prayers, of pseudo-poets as pseudo-prophets or pseudo-seers.[82]

Philosophers and theologians at times raise this concern. Socrates's ambivalence about mania has much to do with this possibility of feigned inspiration, the possibility of a charlatan. Kierkegaard, the Lutheran Socrates, is scathing on this danger. Like Plato, he is both a poetic philosopher and a fierce critic of the poets. Kierkegaard polices the boundary between the religious and the aesthetic in the wake of a Romanticism that often absorbs the former into the latter. In "The Lilies of the Field and the Birds of the Air," Kierkegaard offers a series of reflections on Matthew 6:25–34, in which Christ counsels his followers to "look at the birds of the air" and to "consider the lilies of the field." The birds and the lilies—the natural world—can teach us to become silent and stay silent. For even in the daytime of field or forest or seashore, when they are "vibrating with a thousand notes and all is like a sea of sound, there still is silence out there; each one

in particular does its part so well that no one of them breaks the solemn silence, and not all of them together."[83] In this silence, we learn something fundamental about contemplative prayer: "to pray is not to hear oneself speak, but it is to be silent, and to remain silent, to wait, until the man who prays hears God."[84] For Kierkegaard, as for Desmond, prayer is less about the words one says than the porosity one cultivates.

According to Kierkegaard, the poet can mislead us about the bird and the lily. Often the poet is too anxious to write poems. While the birds and the lilies are silent, Kierkegaard's poet is loquacious, rambling on and on and on. The chattering poet claims to long for the "solemn silence" of forest or field, to escape "the human world where there is so much talk."[85] Yet the poet is impatient in the silence. The poet writes a poem at the first hint of the ineffable and then runs back to the human world to show it off. Kierkegaard's poet can mislead in other ways as well. The poet can bemoan our inability to be like the bird and the lily, can make it sound like their silence is no longer an option for us alienated moderns when, in fact, it is perennially available to us. Kierkegaard suggests there is an art of alienation that is complicit in the spiritual vapidity it laments. It makes us think there is no escape when there is. Kierkegaard is clear: the self-absorbed artist is more spiritually impoverished than the "common" believer humbly attuned to silence. Desmond would agree with this, while stipulating that not all poets are the kind Kierkegaard (poetically) excoriates here. Desmond affirms art and literature much more capaciously, but his critiques of artistic self-absorption can still be scathing. There is indeed a danger in literature (and, of course, in religion and philosophy too) of counterfeit profundity.

If there is kinship between religion and poetry in the shared roots of wonder, porosity, and silence, there is also kinship at the limit, where language seems to break down before exceeding realities or simply miss elusive ones. On the one hand, language is infinitely versatile and fecund. Poetry rightly revels in this. On the other hand, the greater a poet's ability, the more she may be frustrated by what evades precise or adequate saying. This is an ancient problem in theology as well. How does one talk about a transcendent God? All naming, all description and imaging, seems inadequate at best, idolatrous at worst. The proscription on images in Judaism, Islam, and some forms of Protestantism recognizes the dangers here.[86] The apophatic approach to the divine is to say what God is not, to insist on the inadequacies of all God-talk.[87]

But apophasis has traditionally been accompanied by the recognition that we must still risk talking about God in a positive way. The "cataphatic"

strategy approaches the transcendence of the divine via self-consciously figurative language, through analogy, for instance.[88] Here the conception of God as hyper-determinate is more to the fore. God's excess allows us to approach him through language but never to make him determinate in it. Another strategy for talking about a superabundant deity is to give God a plurality of names with an understanding that those names offer only partial, figurative illuminations of the divine surplus. Ryan Duns points to the wide variety of metaphors for God in the Bible: "from leavening yeast to the gracious host of an eternal banquet, from a rock to the Father of all, these metaphors conjoin the finite with the infinite and provoke the imagination to ponder the various ways the finite is porous to and communicative of the infinite and the divine."[89] In Christian theology, there is Dionysius the Areopagite's seminal reflection on the divine names. In Jewish mysticism, there are the Kabbalah and the seventy-two names of God. In Islam, there are the ninety-nine names of Allah.

Poetry also probes the limits of what can be said.[90] Poetic language is yet another "figurative" strategy by which to approach the divine. The writings of the mystics are often richly poetic. They at times take the explicit form of poems or hymns. St. John of the Cross offers one prominent example. His major works are poems with prose commentary. Desmond takes something of the same approach in *God and the Between* and *Godsends*, where each chapter begins with a poem. As one might expect, these poems often approach the unsayable:

> Between the intimate silence
> & the hearing of love
> It sounds and recedes
> It sings its face
> & it is always
> More than what faces us
> Beyond all faces
> It is never faceless (*GB*, 191)

The communication from the divine takes place between the wordless silence and the "hearing of love." It "sounds and recedes." Desmond's poem tries to word this elusive communication, to give sound to the space between silence and love. But this is an elusive space. Note that love, the seemingly more determinate pole, notoriously frustrates those who try to word it in an adequate way. Love seems to call for ever more words to amplify and

clarify and verify, but a deluge of words risks cheapening it, risks descending into chatter. Desmond's minimalist poem tries to be true to what happens between silence and love, to respect the fragile overdeterminacy.

Many of the best poets—religious, secular, and between—probe the unsayable. In an 1876 letter, Emily Dickinson writes, "Nature is a Haunted House—but Art—a House that tries to be haunted."[91] This aphorism offers a provocative suggestion about artistic mimesis. As noted in the last chapter, artists who attend to nature do not find stable models but shifting, elusive ones. They find nature to be "haunted." They are confronted by things in their mysterious singularity, in their ever-shifting aesthetic presencing, in their ever-shifting relations to one another. Heraclitus, at the origin of Western philosophy, claims that nature loves to hide. Riffing on Heraclitus and resonating with Dickinson, Desmond writes, "The artist as lover of surfaces is also a lover of what surfaces, what reveals itself and hides" (*GBPB*, 66). Does God surface? Does God haunt nature? This question echoes throughout Dickinson's poems: "The Missing All—prevented Me / From missing minor Things."[92] Or,

> By homely gift and hindered Words
> The human heart is told
> Of Nothing—
> "Nothing" is the force
> That renovates the World—[93]

Franke sees Dickinson's theological queries as profoundly apophatic, ranging well beyond, and at times raging against, "the rigid Puritanism of her social ambience."[94] God and death, to which Dickinson's poems continually return, are where language most fully encounters its limits. They are the ultimate excess and the ultimate negation. But Dickinson's poetry also testifies to the elusiveness of the everyday, to an unsayable dimension in all things, in all experience: "To tell the Beauty would decrease / To state the Spell demean—."[95] Surely this is a perennial experience of poets—the paradoxical way in which their poetic words draw power from something that, ultimately, cannot be said, which both endows and chastens their speaking. Franke notes that poets can be quite loquacious on the topic of the unsayable.[96] Desmond would see this as evidence that they are often probing the overdetermined dimensions of reality.

This is not to say that the elusive or unsayable cannot render us (at least temporarily) speechless. We are again returned to silence and to how it

may attune us to the unsayable.⁹⁷ Think of the Pythagoreans' vow of silence, of the importance of silence as a spiritual discipline in monastic traditions both East and West. Silence may also be a way of honoring the unsayable, of avoiding a betrayal of it in words. (Is this the meaning of Wittgenstein's famous final line in his *Tractatus*?) Jean-Louis Chrétien, like Picard before him, argues that silence is not simply an "absence of sound." It is qualitatively rich: "Every time that we are attentive to it, it manifests itself as filled with meaning; it calms us or makes us feel euphoric, it causes us joy or anguish, it instils boredom or anxiety in us."⁹⁸ Picard claims there is chatter that merely obscures the silence, but there is also authentic speech that is born from it.⁹⁹ Such speech would be on the one hand more measured and incisive, but on the other it would be born of an awareness of what exceeds and evades saying. "The unsaid haunts all saying," writes Desmond, "but some saying carries the silence of the unsaid in itself" (*PU*, 36).

Asking Too Much, Asking Too Little

Given the ancient kinship between religion, art, and philosophy, how did we arrive at the contemporary situation in which they are seemingly so distinct? In which they are often hostile to one another? Given their ancient centrality, how did we arrive at a present where all three have been more or less marginalized? Desmond provides some answers to these questions by tracking the strange course of art in modernity. He claims in an aphoristic passage, "Too much has been asked of art, with the result that too little, or almost nothing, is now being asked of art" (*AOO*, 265). This final section of Part 1 seeks to explicate this passage. It surveys Desmond's account of art's fate in modernity, its prospects for today, and the need for a renewed kinship between art and its ancient siblings to counter modernity's "pervasive sense of the *valuelessness of being as such*."¹⁰⁰

Religion, philosophy, and art became more independent at the dawn of modernity. The ascendency of nominalist theologies, the tug-of-war between philosophy and theology in the late medieval universities, and the shifting political, religious, and intellectual landscapes of Renaissance, Reformation, and Enlightenment all contributed. So did the rise of modern commerce, trade, and production. With the rise of mass production and the displacement of artisan production, for instance, art increasingly came to mean fine art. "At the same time that artisans were losing autonomy, social status, and creative control of their crafts," Natalie Carnes observes, "artists were gaining

ground in those very areas while acquiring a kind of spiritual status."[101] Art benefited from new bourgeois audiences and the invention of new technologies like the printing press. This increased independence released generative energies in art. Hence, the great boom of art in modernity.

At the same time, religion, long the sponsor of art, often lost touch with the aesthetic or even turned against it.[102] Embattled and often brittle, traditional religion seemed to have lost its power to "enchant" the world. As religion seemed to fade and art to thrive, many thought that art itself could carry the banner of transcendence, that art could reenchant a disenchanted cosmos, that it could provide spiritual solace and ethical guidance.[103] This was the Romantics' great hope, taken up in turn by the Victorians and many modernists and then largely abandoned in late/postmodernity. Desmond notes that this hope was far from groundless. Real capacities of art sourced it, capacities that art's autonomy put into new relief and that modern thinkers often theorized in sophisticated ways. Too much may have been asked of art in modernity, but it was asked not just in response to modern ills or the lost sway of religion—it was also asked because of powers that art manifested.

The high hopes for art took markedly different forms. Claims for the power of art and beauty recur in treatises, poems, and manifestos. Desmond notes how the "opera house" was compared to a "temple," the "museum" to a "church" (*AOO*, 277). Many philosophers, from the early Schelling to the late Heidegger, took art as their guide. In their fascination with the ancients, many Romantics thought a renewed mythology would in turn renew modern culture. This concern dominates German Romanticism through Wagner and Nietzsche. Hölderlin attempted to bring together Christianity and the classical pantheon, and especially Christ and Dionysus, but a preference for the classical over the Christian was common. In Nietzsche, this preference becomes an overt war on Christianity for its purportedly enervating effects.[104]

Many thinkers attempted to re-found culture upon art or the aesthetic. At the origins of Romanticism, Schiller argued that an "aesthetic education" could counter the Enlightenment's overemphasis on abstract reason and bring order to political chaos. The turbulent modern state could give way to a harmonious aesthetic state. Beauty could balance competing human drives, allowing for equipoise and a willing adoption of the moral law. In the wake of Romanticism, Matthew Arnold offered his own program for an aesthetic education to counter the reductionism of the market and the social unrest it generated. In his poem "Dover Beach," Arnold feared that religion's "melancholy, long, withdrawing roar" would leave us "on a

darkling plain / Swept with confused alarms of struggle and flight, / Where ignorant armies clash by night."[105] Arnold's social criticism argued that, given religion's decline, artistic culture must prevent "anarchy." He recommended, for instance, that the masses should memorize poems like they may have once memorized Bible verses or prayers. In the early twentieth century, George Santayana celebrated the Catholicism of the cathedrals and the *Commedia* as an aesthetic achievement but insisted that it had no metaphysical purchase. He was a lapsed Catholic in his aesthetics and a materialist in his metaphysics. For Santayana, the imagination is powerful, but it is not disclosive. It offers the aesthetic illusions we need to live well in a meaningless universe.[106] Theodor Adorno is a key figure at the end of this loose tradition, both critical of it yet not entirely outside it. A sharp critic of the culture industry, Adorno nonetheless defends lyric poetry and beauty against strident Marxist critiques. He defends art's ability to move us beyond the instrumental. Nonrepresentational art, such as the paintings of Mark Rothko, appealed to Adorno because they cannot be co-opted for ideological purposes. Like the messianic negative theology that also interested Adorno, such art points beyond the present. It promises, or holds out the possibility, of the new.[107]

The Romantic "Imagination" issued a more direct attack on modern reductionism. It promised to restore our awareness of both the resplendence and sensual givenness of the world and of our own latent depths. The Romantic imagination is a disclosive imagination. It discloses things in their richness and deeper significance. It revels in the fulsomeness of a world that modernity's calculating reason treats as inert. It sees the divine shining through the material world. It resists the Enlightenment's flattening of the human person. The Romantics of the British Isles marshaled this imagination against the Industrial Revolution, the sensationalism of John Locke, and the utilitarianism of Jeremy Bentham. A recovery and re-theorization of the Neoplatonic imagination proceeds through the Cambridge Platonists, William Blake, William Wordsworth and Samuel Taylor Coleridge, William Butler Yeats, Edwin Muir, and Kathleen Raine.

This is only a partial sketch at best, but it suggests the diverse ways art was asked to re-enchant modernity. It also suggests that religion is not simply absorbed into art. Religion is often ambiguously at play beneath the primacy of art. There is "equivocation on the religious all over the place" (*AOO*, 282). The central characters in this story recognized the magnitude of the task of re-enchantment, the difficulty of translating something as various as art into a means of social renewal. Indeed, the story of art in modernity is not really

one of jealously guarded autonomy. It is more the story of a search for new moorings for new art, a search for some way to give art greater cultural traction. Schiller, Arnold, and their various followers emphasize education, while many others turn to a potentially shared mythology. Some looked to a more robust notion of tradition (Edmund Burke, Johann Gottfried Herder, Joseph de Maistre, and later T. S. Eliot). Some looked to Eastern religions (Schopenhauer, Ralph Waldo Emerson, Ezra Pound, the early Eliot), while others attempted an aesthetic apologetics for Christianity (François-René de Chateaubriand) or an aesthetic reimagining of Christendom (Novalis). Some interrogated and rejected the modern autonomy of art. The Nazarene painters are important in this regard, as are a line of thinkers including William Morris, John Ruskin, Ananda Coomaraswamy, Eric Gill, and Frithjof Schuon, who sought to renew artisanship in a time of mass production. They rejected the distinction between handicraft and fine art and sought to recover traditional conceptions of art. Some theorists and practitioners of the Romantic imagination—perhaps most notably Coleridge—framed it in terms of traditional Christianity. Hegel and Schelling attempted to recover a richer dialogue between philosophy, religion, and art, with the priority falling on philosophy for Hegel and art for Schelling.

There is much to learn from this modern quest to re-enchant the world through art. It helped shape the contemporary situation, and it continues to have its followers.[108] Desmond is himself influenced by its key figures. It kept certain possibilities alive, offered rich theorizations, and achieved some lasting successes. It inspired many remarkable works of art. Still, the increased autonomy of art introduced ambiguities and stresses that dashed its highest hopes. Few people today talk about art in the grand, sweeping ways that were pervasive in 1800 or even 1900. Modernity left a treasure trove of masterworks, but art proved unable to unify and enchant the way religion once had. Terry Eagleton observes that, unlike art, religion has "the capacity . . . to unite theory and practice, elite and populace, spirit and senses, a capacity which culture was never quite able to emulate."[109] Catherine Pickstock notes liturgy's perhaps unique ability to hold "the ethical and the aesthetic together."[110] Desmond agrees, noting that religion can "concretize" an ethos in ritual and practice, and that it tends to be more wide-reaching, communal, and lasting than autonomous art. Nietzsche somewhat jeeringly calls Christianity "Platonism for 'the people,'" but Desmond thinks he actually points out something good here.[111] At its best, religion extends contemplation beyond the philosophical elite. It opens it to all believers, anchoring it in shared liturgies and devotional practices. "The religious is

the more democratic art of the ultimate [compared to philosophy or art],"
Desmond writes, "imaging a culture's divination of original being, sustaining
publicly this divination by ritual practices, even while rooted secretly in
often unarticulated intimations of transcendence as other. And while in the
intimacy of the soul it keeps open the porosity between the human and the
divine, yet it also issues in ethical life that publicly enacts its most secret
love of what is ultimate" (*AOO,* 290). Religion has a powerful capacity—
undoubtedly wounded but not entirely lost in modernity—to cultivate a
broad ethos of being and practices of attunement, to mediate between the
individual, community, and cosmos.

This shared, holistically cultivated ethos can be dynamic and generative in terms of art because of its archetypal narratives and overdetermined symbols. Hans-Georg Gadamer argues that modern attempts to anchor art in culture via education or mythology, on the other hand, resulted in further fragmentation. "The experimental search for new symbols or a new myth," he writes, "which will unite everyone may certainly create a public and create a community, but since every artist finds his own community, the particularity of this community-creating merely testifies to the disintegration that is taking place."[112] The Nazis co-opted this fragmented project in their spectacles, their counterfeit iconography and liturgy, all secured by authoritarian force—hardly the aesthetic state imagined by Schiller. Furthermore, art's autonomy proved curse as well as blessing, as art was increasingly seen as mere entertainment or personal solace, diversion or distraction from the real work of business and science. Pickstock makes the provocative claim that in modernity, "The very categories 'real life' and 'art' are as it were the result of the *wreckage* of the liturgical, a wreckage which has been intensified the more art has become a sealed domain of 'fine art' cut off from craft, while making useful things has become increasingly reduced to the merely technical."[113] The ideal of *l'art pour l'art,* which from its nineteenth-century French proponents through Oscar Wilde, Walter Pater, and the Bloomsbury Group resisted the reign of pragmatic instrumentalism, was turned against art and presented as evidence that art is simply superfluous. What seemed like freedom often meant being covertly positioned by the invisible forces of the market.

Desmond argues that the transcendence of religion became more equivocal in art, often reduced to the merely aesthetic.[114] The wider cultural ethos is again important here. If the artwork invites us to see the world anew, as overdetermined and saturated with worth, this is not necessarily taken as disproving the reductive modern ethos. It could be taken instead as

an aesthetic trick, a way in which art makes the dull, valueless world seem fresh again. The artwork has not shaken the scales from our eyes in this case. It has instead cast a glamour. Perhaps the popularity of contemporary art with serious religious or ecological concern may be explained, at least in part, by how it decisively moves beyond the "aesthetic" in the modern, reductive sense. It clearly makes claims about reality as such.

The early twentieth century saw renewed interest in art and ontology, with thinkers as different as Maritain and Heidegger arguing that art discloses being in its depth and mystery. But the work of the Russian Formalist Victor Shklovsky may be more revealing about the status of art in modernity. In his 1917 essay "Art as Technique," he describes how easy it is for perception to become "habitual," "automatic." Art "defamiliarizes."[115] It makes us see again and see anew. (So far, Desmond would nod in agreement.) But Shklovsky is far more ambiguous about the ontological implications of this than Maritain and Heidegger (or Desmond). He at times hints that our habits inure us to being's richness. But the stronger suggestion is that art spices up a bland reality. In this equivocation, and especially in its tilt toward bland being, Shklovsky's essay seems more indicative than, say, Heidegger's "The Origin of the Work of Art," of the attitude toward art that would pervade the twentieth century.

Desmond notes that the "death of God" was soon followed by proclamations of the death of art and philosophy. He again points to how the impoverished modern ethos affects not only religion but also its ancient siblings:

> It is significant that the death of one is followed or accompanied by the death of another, as if for one to continue the others must continue also, or for one to be re-born the others must also come to life in a new way. Or perhaps each must be rooted in a shared milieu, rich enough in metaphysical and spiritual resources, to nourish the extreme demands each, at its best, makes of the human being. We now seem to lack such a milieu, and the wings of creative venturing which can be birthed there. (*AOO*, 266)[116]

The displacement of religious traditions plays a part here as well—scripture and a shared religious language; symbols like the ark, dove, lamb, and cross; mysteries of the faith like the Trinity and the Incarnation. Even religion's cultured despisers frequently draw upon this inheritance, but it becomes

less available to them as it fades in the culture at large. It is often replaced by metaphors drawn from the machine, or more recently, the computer or the Internet.

To some degree, art in late modernity seemed to turn on itself—or at least to turn on beauty. The early twentieth century marks a significant shift. Some modernists showed high regard for beauty. Others scoffed at it. Art became anti-art when Marcel Duchamp signed a urinal "R. Mutt" in 1917 and drew a moustache on a postcard *Mona Lisa* a couple of years later.[117] Beckett's plays, ironic but also achingly apophatic, differ markedly from the irony of the aforementioned signed (and sold) cans of excrement. Desmond notes that the avant-garde doctrine is often one of desecration, but the desecrations eventually become banal.

There is an honest art of alienation, though, and it makes sense that art takes on a darker cast in the wake of two World Wars and the Shoah, in the shadow of nuclear war and ecological disaster. Artworks that enact alienation and violence can help us see the tragedy anew, with fresh horror. They can shake us out of lethargy. Even in jaded form they may resist the flattening of the human. Contrast the challenging otherness of such works with what Byung-Chul Han calls "the smooth," a pervasive new aesthetic of the twenty-first century. This aesthetic smooths out anything that resists or evades self-mediation. Han points to the high-culture kitsch of Jeff Koons and the waxed bodies of pornography, but, most importantly, he points to the design aesthetic and user-friendly interface of the devices in every pocket, the smoothness of the swipe. Beauty may seem to return, but it is a smoothed-out beauty that neither strikes nor wounds.[118] Desmond would call it a counterfeit beauty.

Still, Desmond holds that we can still recover a richer ethos of being—mainly because being itself remains rich, and we remain porous to it. We can continually discredit this richness, writing it off as a subjective trick or simply superfluous, but it still grabs our attention. It continually raises the question of whether our reductive accounts are adequate. Even the most hardened, skeptical (post)modern can still be struck by wonder, including via the beautiful poem or painting. If we asked too much of art in modernity, Desmond stresses, we should be wary of asking too little now. Art can help us see the world and its inhabitants anew, to see them in their sensuous givenness as more than raw material. The aesthetes were not wrong that the artwork gives the lie to a reductive utilitarianism. Art continues to provide spiritual nourishment to many. It continues to teach attention and patience in a restless time. It also continues to play key roles

in the broader culture. It is celebrated for the self-expression it offers, for the way it can give the marginalized a voice. Many would still nod their head at Murdoch's assertion that art helps us better recognize others. The best of today's films and television shows are intricate human dramas. Desmond acknowledges this, and acknowledges it as important, but he would hold that art's ability to "re-enchant" the world beyond the human, its ability to offer stronger forms of transcendence, its attunement to the sacred and to God, is where we now ask too little.[119]

Art is nonetheless tenacious. David Walsh claims that "even when the whole world is shaken, even when the faith sustaining civilization erodes, art nevertheless prevails."[120] The poet, as Hölderlin attested, can keep something important alive in times of need. Heidegger, inspired by this claim, holds that the poet can still name the holy, the sacred, can consecrate a space for the arrival of the god(s). The thinker can help secure this revelation, can show that the naming is not merely "aesthetic," that it bears on being. Desmond would agree. But according to Desmond, art and philosophy cannot transform modernity's ethos on their own. The dialogue of thinker and poet is too narrow. The dialogue needs to be between philosophy, art, and religion. "Alone," Desmond claims, "art cannot offer the sanctuary wherein the seed of spirit can survive the uprooting storm of nihilism" (*AOO*, 289). It must dip its roots in the spring of mysterious being that it shares with authentic religion and philosophy. Merleau-Ponty wrote in a late essay that "the depth of the existing world and that of the unfathomable God come no longer to stand over against the platitudes . . . of 'technicized' thinking."[121] Desmond argues that we need to recover both. This is the shared work of the three ancient children of wonder, the three ancient siblings. This does not exclude quarrels, and it does not necessitate art or philosophy's subservience to religion.[122] Consider the artistic fecundity of the Renaissance, where the autonomy of art increased but where art also remained open to religion, philosophy, and a still wonder-filled science. Desmond claims, "Our time finds finesse for this porous threshold [between the poetic and sacred] sometimes weakened, sometimes not present at all, though sometimes it seems to undergo astonishing resurrections."[123] The aim is for a "posthumous wonder" on the other side of what Desmond, following Vico, calls our contemporary "barbarism of reflection." For Desmond, art alone cannot undo the ethos of serviceable disposability, but perhaps religion, art, and philosophy together can do so. Perhaps they can do so in time to remedy our deepening ecological, social, and spiritual crises. Perhaps, as Desmond's nod to Vico's cyclical history suggests, they will at least do so when those crises reach their breaking point.

PART 2

READING IN THE BETWEEN

Chapter 5

Epiphanic Encounters

The first section of this chapter transitions from the wide-ranging aesthetic concerns of Part 1 to the more focused literary concerns of Part 2. It sketches out a "metaxological" approach to literature, situating it vis-à-vis other prominent approaches in literary studies. The focus of this chapter, though, is epiphanic encounters in literature—especially encounters between humans, between humans and things, and between humans and places. Desmond does not offer a specific account of such epiphanies, but his treatments of wonder, of human relations, and of the overdetermined artwork are amenable to one.[1]

The chapter extends Desmond's metaxology in this regard. It claims there are typically four movements in an epiphany:

1) There is a positive or determinate disclosure of the other.

2) There is at the same time an awakened sense of the other's overdetermined mystery.

3) There is a resultant self-transformation.

4) There is an extension of wonder at the other to wonder at being more broadly.

The epiphanic encounter is another experience of wonder. Sometimes wonder-as-astonishment marks the epiphany, at other times wonder-as-perplexity, at yet other times there is something of both. The point is not to offer some rigid formula or cookie-cutter methodology. One of the four

epiphanic movements may be more pronounced than the others. Epiphanies can be one-sided or mutual. There are many sorts of epiphanies. We must attend to each in its specificity. Some epiphanies may not be illumined by this approach at all. This chapter hopes to show, though, that Desmond's metaxology nonetheless offers affordances for illuminating a wide variety of epiphanic encounters.

The second section of this chapter ranges widely across epiphanic encounters in narrative art. Such encounters are as ancient as narrative itself, but they take on a new centrality in twentieth-century fiction. After sketching this history, and after taking some bearings from Desmond's philosophy, the second section considers several twentieth-century narratives built around epiphanic encounters: James Joyce's "The Dead," James Baldwin's "Sonny's Blues," Zora Neale Hurston's *Their Eyes Were Watching God*, and Flannery O'Connor's "A Good Man Is Hard to Find." The third section of this chapter discusses epiphanic encounters with things. It begins with Rilke's marvelous torso, then moves on to the epiphanies of everyday things offered in Pablo Neruda's odes. The third section also considers Charles Taylor's account of epiphanic art as an attempt to combat instrumentalism and re-enchant the world in modernity. The final section of this chapter considers the poetry of place, ranging from the regionalist fiction of Sarah Orne Jewett to the poetry of Patrick Kavanagh to the writings of Wendell Berry.

Criticism in the *Metaxu*

Desmond holds that the literary work, like the artwork in general, is over-determined. It is rich, yielding an indefinite number of plausible readings. It is also ambiguous, containing elisions, ironies, contradictions. This means that no critic gets the final word about a work of literature. Desmond would readily acknowledge, for instance, that his own readings of, say, Hopkins or *Hamlet* are not exhaustive or incontestable. He turns to literary works to think through his philosophy, but he does not aim to absorb them into it without remainder. He sees them as conversation partners. He repeatedly claims that art is one of philosophy's necessary "others." As we have seen in the case of Hopkins's poetry, Desmond finds not only illustrations but also insights in literary works.

Desmond holds that, in general, the critical endeavor is best understood as an intermediation between critic and text. Desmond thus rejects resolutely "objective" accounts of criticism, which hold that there is a single, univocal

meaning in a text waiting to be uncovered. This reduces the richness of the work. "Objective" accounts may be motivated by a concern with the integrity of the artwork and its ability to communicate. They may also be motivated by concern with the integrity of criticism itself, by fear that unless criticism yields univocal results it is not properly a "science." At other times, "objective" accounts may be motivated by the critic's desire for control, by a desire to master the work and to lay bare its meaning.

Desmond likewise rejects resolutely "subjective" accounts of criticism, which hold that *we* alone are rich with possible meaning. Such accounts hold that the work is negatively indeterminate, that meaning is always our imposition or our creative projection or, as students in Literature 101 are sometimes wont to say, our opinion. Such accounts brush aside how a plausible reading must be attentive to particulars of the work, its nuances and ambiguities. Attending to these particulars allows us to weigh and debate readings, to find some more plausible than others. Brian John Martine explains that while "every attempt to fully encompass its being must fail, the artwork is nonetheless open to reflective dialogue. We can come to know it as we come to know one another, without insisting upon some logically misbegotten sense of mastery."[2] A resolutely subjective account flattens the intermediation—the back and forth between reader and work, the careful attention to the work's particulars—into a one-sided mediation from the side of the reader. Because of this, it cannot adequately address how a poem can surprise or challenge or baffle us, how it can grant us an unexpected revelation, how we can share in a conversation *about*—and indeed *with*—it. It cannot address all the ways, profound or mundane, in which literature affects us.

Still, there is some truth in subjective accounts. People do, of course, read works in different ways. This is in part due to their different experiences and identities, which attune them to different aspects of the work and lead them to read those aspects in different ways. Furthermore, every act of reading involves an imaginative mediation on the part of the reader. Take one classic example: Ezra Pound's "In a Station of the Metro." The reader might imaginatively supplement the two-line poem with a bustling station scene, one that each reader will imagine differently, but which might include the sounds of chattering voices and shuffling feet and rolling carts, in turn heightening the tension implied by the poem's comparison of the crowded station to the seeming stillness of the petal-covered tree bough. Rita Felski speaks of this imaginative supplement as a process of "co-making."[3] Many critics argue that the work is actually in the act of co-making, rather than

in the reader or the book alone, that the work is this "between." Desmond would again stress that reading is an intermediation, with genuine mediation from the side of both reader and poem. Reading is trans-subjective and trans-objective. It cannot be simply reduced to either pole. Another example: it is common to hear that one can grow up and grow old with a novel. One will read *Middlemarch* or *Moby-Dick* very differently at twenty, forty, and sixty. Is this because the reader has changed? Yes. Is this because the reader attends to different facets of the novel with each reading? Yes. Reader and text are deeply, inextricably linked in the intermediation. Furthermore, the intermediation always happens in a particular time and place, which shapes the reading as well. Reading *Moby-Dick* on a park bench in Albuquerque will be a different experience than reading it on a wharf (or in a pub or on a ship's deck) in New Bedford. Reading it in "dead wintry bleakness" will be different than reading it in "pleasant, holiday weather."[4] Felski observes of a hypothetical reading of Chekhov how "differing things come together; the singular qualities of Chekhov's writings, to be sure, but also, perhaps, a battered biography unearthed in a secondhand bookstore, a course on Russian literature taken in college, a friend's account of an off-Broadway performance of *Uncle Vanya*."[5] The intermediation of reader and text is itself mediated by a great number of other factors.

Felski claims that we must account for both the "singularity" and the "sociability" of literary works, the way they have unique integrity but also always exist in a web of relationships.[6] Desmond's concept of the "open whole" is illuminating in this regard. The work is a whole in that it is singular. This is another reason why criticism can never fully account for the work. There is something irreducible about it, something that will always be lost in the move to criticism, something that can only be directly experienced. The New Critics, Susanne Langer, and others were not wrong to warn against the dangers of paraphrase in this regard. But the work is an "open" rather than a hermetically "closed" whole. As discussed in chapter 3, the work always mediates external otherness. The artwork is its own world, but it is also in communication with the wider world. This allows it to be a source of insight beyond the page. Works are also open in that they are shaped by (and shape in turn) the world around them, by both the context in which they were written and the context in which they are read. Works are "open" in that they draw on shared language, language that they can deploy in surprising or novel ways but never fully uproot from shared context. Recall, too, the complex web of relations among texts discussed in chapter 3.

Desmond's philosophy offers some illuminating critical concepts—overdeterminacy, porosity, *passio,* posthumous mind. This study explores some of these concepts' affordances for literary criticism. But because a metaxological approach recognizes the work as overdetermined, it affirms the possible insights of any number of critical approaches and their attendant concepts—biographical, formalist, feminist, historical, and so forth. (Indeed, metaxology is probably less an approach than a framework for describing what happens in any responsive critical reading that attends to the particulars of the text and is aware of its own limits.) Desmond would caution against turning any approach into a rigid methodology that claims exclusive authority. There are at least three dangers here. The first is that a rigid methodology may become formulaic, a cookie cutter that carves the same shape into every text.[7]

The second is that, even when practiced with attention to a work's nuances, a methodology that claims too much authority, that claims it knows what the work is really about, will always delimit the range of possible meanings in questionable ways. Desmond is not impressed, for instance, by Freud's (in)famous reading of *Oedipus the King*. To reduce the probing drama of Sophocles, its "profound metaphysical pathos," to an "Oedipal complex seems its utter trivialization" (*PO,* 337n12).[8] The much-maligned author-focused approach, to take up another methodology, can yield insights by studying an author's drafts, letters, interviews, and personal library, but a methodology riveted to authorial intent will unduly narrow the range of possible meanings. Works mean more than their authors intend. Authors can at times be poor guides to their works. By comparison, historical approaches may allow for a wider range of possible meanings. Situating a work within its historical milieu can be illuminating, but rigidly "historicist" approaches are again questionable. As Felski argues, in such approaches the historical context becomes a determinate "container." The critic's task is to return the text to its proper container. Felski explains: "History, in this light, consists of a vertical pile of neatly stacked boxes—what we call periods—each of which surrounds, sustains, and subsumes a microculture."[9] This obscures the porosity between periods. Rigidly historicist approaches tend to emphasize discontinuities rather than continuities. Thomas Pfau notes how they reflect a broader modern tendency "to rely almost without thinking on a vocabulary of breaks, ruptures, and caesurae, and a nomenclature of 'epochs.' "[10] As Northrop Frye points out, they privilege the "horizontal" axis of a work's historical milieu over the "vertical" axis of the literary traditions to which the work also belongs.[11]

Such approaches also often brush aside how the work resonates across time, how it can move and challenge readers today. This raises a third possible problem with rigid methodologies. They at times conceive of critics as being armored against the allure of texts. Good critics are supposed to maintain unflinching scholarly objectivity or critical distance. They are to be all *conatus* and no *passio*. The text does not challenge or illuminate or startle them. If the text does move the critic, this is superfluous—if not dangerous—to the critical inquiry qua critical inquiry. But this ends up brushing aside some of the most fascinating aspects of literature—its ability to strike us with wonder or draw us into a world, the whole range of ways in which it can engage us in mind and soul.[12] Acknowledging these aspects does not mean turning criticism into an idiosyncratic enterprise or the classroom into an emotive book club. It means being mindful of our receptivity to the text. It means attending to the text's rhetorical dimensions and the complex intermediation at play in reading.

Detached critics are likewise careful not to treat characters too much like real persons.[13] They remind us that characters are mere constructs. We should not become too attached to characters or too outraged by them. These prohibitions often imply disdain for ordinary readers, who become "emotionally invested." As Toril Moi shows, however, the "taboo" against treating characters like people, while posing as critically rigorous, "turns out to be a veritable iceberg of unexamined theoretical assumptions," often relying upon false oppositions between, say, attention to the character and attention to the words on the page, between character criticism and formalist criticism.[14] A critic can of course attend to both the person-like qualities of the character and its status as a fictional construct. George Steiner asks: "What *imitatio* of divine or organic creation, what vitalizing technique make possible the begetting and durability of an Odysseus, an Emma Bovary, a Sherlock Holmes or a Molly Bloom? Sartre's contention that these [characters] are nothing but scratches on a page is both incontrovertible and risibly inadequate."[15] To turn the charge around, attending to the character can keep the formal analysis from becoming too simplistic or univocal. Attending to character can mean attending to the intricacies of the text, to its ambiguities. The assumption seems to be that if critics attend too much to characters, criticism devolves into either fandom or flat moral homiletics. Moi points to Stanley Cavell's readings of Shakespeare as evidence that this is a caricature.[16] Rejecting character-based criticism means rejecting reflection on any number of interesting, pervasive ways in which we respond to literary characters. Moi notes how characters "can

place claims on us, claims we may feel compelled to respond to. We can love them, hate them, acknowledge them, imitate them, be inspired by them, carry them in our hearts and minds, think about them when we want to understand our own lives."[17] As Moi suggests in this last point, if we insist on treating characters solely as constructs, we severely limit the insight literature can provide into life. We lose track of what Ralph Ellison calls "a characteristic of the novel which seems so obvious that it is seldom mentioned, and which as a consequence tends to make most discussions of the form irritatingly abstract:"

> by its nature the novel seeks to communicate a vision of experience. . . . When successful in communicating its vision of experience, that magic thing occurs between the world of the novel and the reader—indeed, between reader and reader in their mutual solitude—which we know as communion.[18]

Desmond would concur. When critics deny or diminish this communication, receptivity to the work is muted. They reduce the "communion" of reader and work to a dualism of critic and text, with the former privileged over the latter.

Such a critical stance ultimately undersells the importance of art. It asks "too little." Consider, with the argument about character in mind, the importance of narrative beyond the page. Each human life, with its beginning in birth, ending in death, and unfolding over a span of time, has an implicit narrative shape. The common metaphor of the "journey of life" suggests this. We might note, too, how we exchange "life stories" when getting to know someone. We have an existential need to make the narrative of our life coherent.[19] Richard Kearney quips, "Every life is in search of a narrative."[20] When our life takes a significant turn, we revise our narrative, parsing what led to the turn, how it illuminates or revises the significance of what came before, what it portends for the future. A failure to make narrative sense of one's life can lead to crisis.

Desmond might say that the aim is to gain a sense of one's life as an open, dynamically unfolding narrative.[21] For there is danger at the other end of the spectrum too. A lack of narrative coherence can lead to crisis, but a rigid sense of one's life narrative can lead to trouble as well. The strong desire for a particular goal or dream can be a positive eros for excellence if it involves a responsive companioning of *conatus* and *passio*, of striving and openness. If the *conatus* is hardened, though, one can easily become

indifferent to others or to the vicissitudes of life. A strong orientation to a goal, to a specific narrative shape for one's life, can become rigid or delusional. (Fitzgerald's Gatsby is a complex study of the possibilities and dangers of such an eros.) Desmond would say that I must remain open to others and to changing circumstance even as I discern the narrative shape of my life.

The implicit narrative shape of the human life undoubtedly contributes to the human fascination with narratives *about* lives. This fascination goes deeper than the desire to be entertained or the pleasure of vicariously living out fantasies. Narratives are often about transformative quests or journeys, about the precarious passage into adulthood, about a hero's triumph or downfall, about facing death. Sometimes they follow a life from beginning to end. Narratives concern the possibilities and pitfalls of our lives, of our continual selving. But narratives also show how others mediate this selving. To return to the *Commedia,* Dante's transformation (like Augustine's in his *Confessions*) is facilitated by guides and the encounters throughout his journey. Each canto brings new encounters that shape him. The protagonists in narratives may be shaped by fate and divine powers, by chance and circumstance, by encounters or relationships with others, by the places in which they find themselves, by grappling with, or tapping into, one's inner otherness. The point is that they will always be shaped by something or someone—indeed by many somethings and someones.

Narratives about lives invite reflection on our own lives and the influences upon them. Dramatic irony, which is often central to narrative tension, can teach us that we too are often unaware of the influences on our own lives. It can help us become aware of what we do not know. Narratives can augment practical wisdom in these regards. Kearney discerns "a two-way passage from action to text and back again," in which "we are simultaneously aware of a narrator (telling the story), narrated characters (acting in the story) and [ourselves as] a narrative interpreter (receiving the story and relating it back to a life-world of action and suffering)."[22] The more one looks at the intermediations between fictional narratives and life narratives, between literary characters and our own character and our understanding of others, the more complex they become. Desmond stresses this as well. Our encounters with art and literature are never closed off from the wider world. The intermediations between reader and text have their own integrity, but they are not hermetically sealed from life. A metaxological approach to literature has affinities with the constructive hermeneutics of Desmond's friend Kearney (and with Gadamer and Ricœur before Kearney). But it also warns against the ways in which hermeneutic approaches can be

reductive if they become too narrowly textual, if they focus exclusively on the relationship of critic and text and thus neglect Kearney's turn back to life, or if they mute the work's capacity to strike and stir by focusing too much on the initiative of the critic.[23]

In recent decades, constructive hermeneutics have shaped literary studies far less than the hermeneutics of suspicion or negative critique. Here the mood is not one of critical detachment so much as wariness.[24] This further mutes the affirmative possibilities of literature. Suspicion descries the play of power behind the poem. Of course, the play of power is often real enough. As Desmond's own criticisms of serviceable disposability suggest, such critique has a necessary role. Still, Desmond warns that "negativity must presuppose some more affirmative promise of thought if it is not to dissolve into a finally nihilistic outcome" (*GBPB,* 336).[25] Hypertrophied critique can easily become cynical, and it can thereby drain being of value in its own way, unintentionally colluding in the ethos of serviceable disposability.

A metaxological approach to literature would instead be marked by patient openness and a certain critical humility. Michael Martin, one of the few literary scholars to draw on Desmond, calls this an "agapeic criticism."[26] The guiding mood is mindful receptivity. It attends to how we are affected by works, how they can strike us with wonder and draw us in, how we can be moved by them and learn from them. It is ready to affirm. Still, such a criticism is not agapeic in the sense of always affirming. It receives the literary work as a gift, but this need not be naive. It can still discern poisoned gifts or gag gifts. A metaxological approach, an agapeic criticism, can issue in critique, but it entails an attentive openness and patience prior to such critique. With the humanities in crisis, there is a growing sense that literary studies needs to find a new balance between affirmation and critique. Desmond's thought can contribute to that search for balance.

From Recognition to Epiphany

With these guiding remarks on metaxological criticism in mind, we turn to this chapter's main focus—revelatory encounters in narrative art.[27] Ancient literature is full of them. They appear throughout myth and epic and scripture. Consider three famous examples from the *Epic of Gilgamesh,* the *Iliad,* and the Book of Genesis. At the beginning of his epic, Gilgamesh has built a great city with a magnificent temple. Yet Gilgamesh is also imperious, as self-enclosed as the city of Uruk within its unconquerable wall. He is

tyrannical, enslaving the men and exploiting the women. The people lament this and hold that "the king should be a shepherd to his people."²⁸ The gods hear. They create Enkidu to match the king. But it soon becomes clear that Enkidu is not meant to overthrow Gilgamesh. Enkidu is meant to teach him friendship and how to be a shepherd to his people. Enkidu is an apt tutor. He grows up with the gazelles, caring for the herd, rescuing animals from traps. Gilgamesh sends a temple prostitute to trap him in turn, but he ends up learning about more than sex from her. She takes him among the shepherds, where he becomes their friend and the guardian of their flocks. Enkidu first visits Gilgamesh in the king's dreams, slipping over the wall of his *conatus* into the *passio* of sleep. When Enkidu finally arrives in the city, they fight, shaking the walls and snorting "like bulls locked together." Gilgamesh eventually throws Enkidu, who responds not with a redoubled attack or with submission but with honest admiration: "There is not another like you in the world." There is a moment of mutual recognition. They "embraced and their friendship was sealed."²⁹ Gilgamesh of "many moods" will continue to be imperious, but he has learned of friendship. He will learn through this to be a better king. He wins the fight, but in a sense Enkidu topples his wall.

The *Iliad* provides a second example. Regal Priam, king of Troy, becomes a humble supplicant, begging the body of his son from the man who has defiled it: "I have endured what no one on earth has ever done before— / I put to my lips the hands of the man who killed my son."³⁰ Proud Achilles, relentless in his grief and rage, is moved by the king's words. He is respectful, even tender. They cry together, each for his own griefs but perhaps also for the other's griefs: "Then, when brilliant Achilles had had his fill of tears / and the longing for it had left his mind and body, / he rose from his seat, raised the old man by the hand / and filled with pity now for his gray head and gray beard, / he spoke out winging words, flying straight to the heart."³¹ This encounter loosens something in Achilles. It changes him.

The Joseph cycle in Genesis 37–50 offers a third example. Joseph's half-brothers sell him into slavery. They lead their father to think he is dead. They perhaps presume he is dead themselves. Years later, after yet another descent into the social "death" of false accusation and prison, Joseph has become second only to Pharaoh himself. Joseph's brothers journey into Egypt during a time of famine to buy some stockpiled grain. They encounter Joseph in his role as governor: "Thus Joseph knew his brothers, but they did not know him" (42:8). It is a painful moment for Joseph, one in

which he is understandably torn and wary. He tests them. The culminating test: will they dispose of their youngest brother, Benjamin—Joseph's full brother, Rachel's other son—like they once did him? They will not. They have changed. They have become their brother's keepers. They regret the envy that led them to betray Joseph. He reveals himself to them, saying "do not be distressed, or angry with yourselves, because you sold me here; for God sent me before you to preserve life" (45:5). The old wounds heal. The relationship is renewed.

These three encounters differ in important ways. They depict markedly different relationships in different contexts. The style of narration and level of detail varies. There was extensive cultural interaction within the ancient Near East, but the works nonetheless reflect different cosmologies, different conceptions of the gods or God and of the human, different ideas of the good life. The encounters play different roles in the dramatic structures of the works, in the rise and fall of the action. There is much suggestion from the beginning of the *Epic of Gilgamesh* that Enkidu will change Gilgamesh, that they will become friends. The Joseph cycle is marked by dramatic irony. The reader knows what the brothers do not, that Pharaoh's governor is the sibling they once sold. What transpires in the meeting of Priam and Achilles is perhaps more unexpected, offering first-time readers of the *Iliad* their own dramatic revelation about the greatest fighter among the Greeks.

The encounters also have some important similarities. All three are profoundly transformative, changing the course of the lives involved. They are moral in the broad sense of the word, leading not only to a more determinate change of behavior but also to a reckoning with what matters in life. Recall the insight Desmond adapts from Aristotle: art lifts significances out of the flux of existence. Here art lifts the significant, transformative encounter out of the string of more mundane interactions.

Epiphanic encounters in literature can provide insight into encounters and relationships beyond the page. They can give readers a sense of the importance and variety of such encounters. They can also encourage readers to reflect on and clarify the transformative encounters in their own past. They can help readers search out the narrative shape of their own lives. Furthermore, epiphanic encounters within works of literature are often epiphanic for the reader as well. We in some way undergo the epiphany. We may join in the joy of the new friends, the tears of enemies united by pain and loss, or the joyous tears of the reconciled brothers.

Aristotle notes the importance of revelatory encounters in one of the foundational works of literary criticism. He claims in the *Poetics* that scenes

of recognition (*anagnorisis*) or discovery are fundamental to a good tragedy. He gives recognition a broad definition. It is "a change from ignorance to knowledge, and thus to either love or hate, in the personages marked for good or evil fortune."[32] Aristotle claims that the most powerful tragedies combine recognition with a reversal of fortune: Oedipus recognizes that Jocasta is his wife *and* his mother. He blinds himself. He falls from king to outcast. Jocasta has her own earlier recognition, which leads her to hang herself. The revelation of the other and self-revelation are linked. The Delphic maxim's injunction to "know thyself," clearly connected in the tragedy to knowing others, reverberates like approaching thunder in Sophocles's drama. Oedipus is finally struck near its end by the lightning of recognition. *Oedipus the King* can leave us pondering a tragic dilemma: lack of self-knowledge is dangerous, but self-knowledge is risky as well.

Aristotle privileges the kind of recognition seen in *Oedipus the King*, but he also notes the range of possibilities: "The Discovery, then, being of persons, it may be that of one party only to the other, the latter being already known; or both the parties may have to discover themselves."[33] It may be about "whether some one has done or not done something."[34] Recognition may be one-sided or mutual. It may be deep or superficial. Aristotle's recognition is capacious and not necessarily revelatory in the profound sense. His emphasis is more on plot than character. Still, it hints at epiphanic possibilities.

The term epiphany arrives much later in the history of literary criticism. James Joyce makes important use of it in the early twentieth century.[35] It shows up in Stephen Dedalus's aesthetic musings. In *Stephen Hero*, young Stephen describes moments of epiphanic disclosure in which "the soul of the commonest object, the structure of which is so adjusted, seems to us radiant. The object achieves its epiphany."[36] The focus here is on revelatory encounters with things, but such encounters can also take place between people. The term's religious origins point to this possibility.[37] We can turn once more to an ancient text. The Feast of the Epiphany celebrates the arrival of the Magi in Bethlehem (Matthew 2:1–12). They have used their knowledge of the stars to reach this town, and they gain new, determinate knowledge there. *This* is the baby for which they have searched. This recognition opens the deepest mystery, though. What does it mean for this flesh-and-blood baby to be the new king, to be the Messiah? The determinate knowledge intimates something ungraspable. The wisdom of the Magi is not only their uncovering of this determinate knowledge but their recognition of what exceeds their determinations, a recognition conveyed in their worship of the

child and their offering of gifts. Furthermore, this recognition will change them and their sense of the world in profound ways—perhaps in ambiguous and difficult ways, as T. S. Eliot's poem "Journey of the Magi" imagines.

The biblical narrative of the Epiphany suggests the four movements noted at the beginning of this chapter:

1) There is a positive or determinate disclosure of the other.

2) There is at the same time an awakened sense of the other's overdetermined mystery.

3) There is a resultant self-transformation.

4) And there is an extension of wonder at the other to wonder at being more broadly.

Richard Kearney claims that the magi's epiphany "signals the traversal of the finite by the infinite, of the particular by the universal, of the mundane by the mystical, of time by eternity."[38] He notes that the literary epiphanies of the heterodox Joyce maintain some sense of these traversals. We are again at the porous boundary between religion and art.

Returning to Joyce, Kearney points to a key moment in *Ulysses* when Stephen seemingly lets go of his literary pretensions. He leaves the National Library, the literati (and would-be literati), and his convoluted theory about *Hamlet* behind. No longer striving to be an artistic genius, he is now able to see the world around him anew. Paradoxically, he gains an artist's eye when he leaves art behind. He finds himself newly attuned to what Kearney calls the "epiphany of the everyday."[39] This transformation hinges on Stephen's encounter with Leopold Bloom. Their meeting involves an "instant of recognition" for Stephen in which he "suddenly 'sees' what he had previously been blind to—the Other," and it is "that other who will lead him out of the self-enclosed, self-regarding circle of literary solipsism away, back, down, out onto the streets of the ordinary universe."[40] Bloom guides Stephen through the streets of Dublin, through epiphanies of the everyday, but their meeting is itself an epiphanic encounter. It transforms them both.

Such encounters can reawaken us to the other *as* an other, beyond our projections or assumptions or stereotypes, beyond our routinized relationships, beyond our self-absorption. We learn something about the person, but we are also newly aware of what we do not know. As David Walsh remarks, "Persons disclose by not disclosing."[41] As we have seen, such encounters are

as old as narrative itself. George Steiner observes, "Great poetry is animate with the rites of recognition."[42] Nonetheless, epiphanic encounters are particularly pronounced in twentieth-century fiction, especially short fiction, where they often form the climax of the narrative.[43] Indeed, such epiphanies are so widespread that they at times become predictable convention. The encounter with the other is also at the heart of twentieth-century philosophy. Before returning to literary instances of such encounters, then, it is worth considering some relevant aspects of Desmond's own account of our relations with others.

In his early work *Desire, Dialectic, and Otherness*, Desmond draws a distinction between "self-will" and "goodwill." He notes how easy it is for our relations with others to be marked by a self-will that ranges from unconscious or semi-conscious egotism to a "Satanic refusal" of the other's worth (*DDO*, 165). In self-will, the *conatus* is to the fore and the *passio* is recessed. Eros becomes domineering. But our relationships can also be marked by goodwill, by an agapeic openness to and affirmation of the other. Relationships often involve a mixture of both, of course, an oscillation between the two. We can nonetheless cultivate agapeic goodwill in our relationships with others. (A literary pedagogy can play a part in this.) A striking encounter with the other can also break through even the most stubborn self-willing. Again, the epiphanic encounter is an experience of wonder in this regard. Such encounters may lead to ethical selving, a "turning of self-insistent desire to the ethical other as a value in itself" (*PO*, 184).[44] But one may also recoil from the epiphanic encounter, from the challenge that it entails.

This recoil can be understandable at times, even appropriate. Recall Sartre's look. The striking encounter with the other may reveal our bad faith relationships or the ways in which we have been deluded by ourselves or the other. Still, Desmond worries about how in at least the early Sartre we are always "essentially in conflict" with the other (*DDO*, 163). The Sartre of *Being and Nothingness* all but denies the possibility of goodwill, of agapeic affirmation, of love. Desmond sees something lopsided in how "much of the contemporary discussion [of the other] has taken place in the shadow of Hegel's dialectic of master and slave, regarded by some thinkers, though not Hegel himself, as the essence of human relations" (*DDO*, 163). In Marcel's terms, this forecloses the possibility of a "we," of "communion," of a relationship of mutual regard rather than agonism.

Levinas's awe before the face of the other is more apt for many epiphanic encounters. Levinas recognizes the transcendence of the other and the ethical dimension of the encounter.[45] Yet Desmond notes the asymmetry of the Levinasian encounter, the way the self is radically undone before the

other. Certain epiphanic encounters do seem asymmetrical in a Levinasian way. But for Desmond the emphasis on asymmetry can obscure other relational dynamics, especially those that are more reciprocal. Here Desmond is closer to the approaches of Marcel and Martin Buber.

We might return once more to Stephen Dedalus and Leopold Bloom. Their epiphanic encounter begins a relationship. Stephen does not simply see Bloom in his otherness. This seeing—and the ensuing journey together—is key to Stephen's own selving. Their meeting and journey are key to Bloom's selving too. The epiphany is mutual. Desmond's metaxological intermediation illuminates the reciprocal dynamics of such an encounter, the ways in which Stephen is transformed by his encounter with Bloom, and vice versa. It also illuminates how their epiphanic encounter attunes them more broadly to the mystery and excess in their surroundings.

Returning to Joyce's novel reminds us of the danger of any critical or philosophical account, which will tend toward the general and schematic unless it attends to the particulars of the concrete instance. There might be significant patterns in epiphanic encounters, but each is also singular. In turning to other such encounters in literature, then, we must be cognizant of how a metaxological approach illumines them and of how they in turn prevent it from ossifying into a formula, the kind of critical cookie cutter denounced in the first section of this chapter. These instances can give us a sense of the variety of epiphanies. The rest of this section briefly surveys several epiphanic encounters in twentieth-century fiction that suggest some of these possibilities. It begins with another work in Joyce's oeuvre: "The Dead."

There is a double or two-part epiphany in this novella. Throughout "The Dead," Gabriel Conroy comes across as decent but also as somewhat pretentious and self-absorbed. At the end of his aunts' dinner party, flush with his own self-deemed success in giving a speech, Gabriel has an encounter that breaks through at least some of this self-absorption. He sees his wife at the top of a staircase. He sees her not as familiar Gretta but as "a woman" newly strange to him.[46] On the way to their hotel, he ponders the luminous moments of their relationship: "Moments of their secret life together burst like stars upon his memory."[47] By the time they arrive at the hotel, this renewed awe at their relationship has given rise to intense sexual desire. His wonder is further mixed with a longing "to be master of her strange mood," to absorb his renewed sense of her otherness back into their relationship, into his orbit.[48]

But in the hotel, a shaken Gretta shares a story not about their relationship but about the young Michael Furey in Galway who, though in declining health, came to see her in the driving rain before she left for the

convent school. A song she heard at the party, one that he used to sing, stirred these memories of him. Gretta suspects Michael's visit cost him his life. "I think he died for me," she tells her stunned husband.[49] This is the fuller, more humbling epiphany for Gabriel. He has a wounding recognition of Gretta's intimate depths and recesses *separate* from him. He recognizes that his own love is pale next to the aptly named Furey's. He also sees himself anew, sees himself perhaps as he fears Gretta sees him:

> While he had been full of memories of their secret life together, full of tenderness and joy and desire, she had been comparing him in her mind with another. A shameful consciousness of his own person assailed him. He saw himself as a ludicrous figure, acting as a pennyboy for his aunts, a nervous well-meaning sentimentalist, orating to vulgarians and idealising his own clownish lusts, the pitiable fatuous fellow he had caught a glimpse of in the mirror.[50]

Perhaps surprisingly, this wound does not long goad Gabriel to anger and resentment. Ultimately, "Generous tears filled Gabriel's eyes."[51] These tears become a sort of mournful blessing on the living and (perhaps especially) the dead, falling like the snow outside on all: "His soul swooned slowly as he heard the snow falling faintly through the universe and faintly falling, like the descent of their last end, upon all the living and the dead."[52] The epiphany is ambiguous, but it seems to pierce Gabriel's self-absorption.

Desmond notes that our sense of how others see us mediates our self-perception. Nonetheless, "There cannot be a complete coincidence between how I see myself, even as envisaged other, and how the other witnesses me, sees me from an outside otherness" (*EB*, 252). When sharply felt, as it is by Gabriel in this scene, "the smart of [this] disjunction can secrete rancor" (*EB*, 252). Yet Desmond holds there is another possibility: "Here the sense of failure, or guilt, mutates from shame into a form of humility, perhaps a joyous modesty—an entirely energizing affirmation of the sweet gift of being given to self" (*EB*, 252). These words seem too strong to describe what happens to Gabriel at the end of "The Dead," but his generous tears can perhaps be read as a sort of humble affirmation, a fragile goodwill emerging from his shattered self-will.

In James Baldwin's "Sonny's Blues," the epiphanic encounter clearly renews a relationship. The story's two brothers evoke familiar literary archetypes, from the ancient world to contemporary TV dramas. The narrator is

the hardworking, pragmatic brother with a steady job and a family. Sonny is the artistic, seemingly wayward brother. But the setting in mid-twentieth century Harlem particularizes these characters. The narrator is on the brink of despair despite his seeming success. A math teacher, he grapples with how racism and segregation affect his students. They too often end up like Sonny, struggling with addiction: "I was sure that the first time Sonny had ever had horse, he couldn't have been much older than these boys were now. These boys, now, were living as we'd been living then, they were growing up with a rush and their heads bumped abruptly against the low ceiling of their actual possibilities."[53] The narrator does not know how to help his students. He is unsure if he can help them—just as he is unsure how or if he can help Sonny. And while Sonny serves a jail sentence, the narrator's young daughter Grace dies of polio, a devastating loss that profoundly inflects the story even though it is rarely addressed directly.

The narrator has complex feelings about his brother and their relationship. He feels guilt for Sonny's troubles. He believes he should have done more, or at least tried to do more, to prevent them. The narrator wants to understand Sonny better. Yet, for much of the story, he also sees Sonny's passion for music as escapist and unsavory. When a teenage Sonny first told the narrator he wanted to be a jazz musician, the narrator recalls,

> I just looked at him and I was probably frowning a real frown by this time. I simply couldn't see why on earth he'd want to spend his time hanging around nightclubs, clowning around on bandstands, while people pushed each other around a dance floor. It seemed—beneath him, somehow. I had never thought about it before, had never been forced to, but I suppose I had always put jazz musicians in a class with what Daddy called "good-time people."[54]

This initial reaction shapes their relationship for years to come. For the narrator, Sonny's music and drug use are of a piece.

There is a rift between these brothers, and they cannot find the words to cross it. At one point the narrator says, "I wanted to say more, but I couldn't. I wanted to talk about will power and how life could be—well, beautiful. I wanted to say that it was all within; but was it? or, rather, wasn't that exactly the trouble? And I wanted to promise that I would never fail him again."[55] Later that day, at the end of the story, the narrator goes to a bar to see his brother perform. Sonny's music is an epiphany for the narrator.

He comes to the bar to make Sonny feel recognized, but the recognition that takes place is more profound than the narrator anticipated. He comes to grasp something of how Sonny sees himself and his music. He realizes how inaccurate his image of them has been.

But Sonny's music offers even more to his brother. The narrator discovers in it that "freedom lurked around us and I understood, at last, that he could help us to be free if we would listen, that he would never be free until we did." Desmond would call this a cathartic return to the *passio*—to patient, passionate openness—where others are recognized in their suffering. In Sonny's music, the narrator recognizes his "mother's face again, and felt, for the first time, how the stones of the road she had walked on must have bruised her feet." He sees his uncle, who was murdered in an act of racist violence. He sees his daughter again. The music creates an opening that the narrator's words could not, an opening where these loved ones can appear and can be affirmed, an opening where their loss can be recognized. The previous chapter of this study considered poetic attempts to word the unsayable. Music, with its power to communicate without words, can perhaps go further still. Baldwin offers a writer's acknowledgment of this in his own virtuoso description of Sonny's music.

This recognition is tenuously hopeful. (Recall the name of the narrator's daughter—Grace.) It clears a path for Sonny and his brother, one that they can perhaps now travel together. This path remains treacherous, though. The music carries the narrator past his lost loved ones toward "the world [that] waited outside, as hungry as a tiger," where "trouble stretched above us, longer than the sky."[56] This is ominous, but it still offers a spare hope in a story where much of the imagery suggests claustrophobia and entrapment. This story's epiphanic encounter again offers a broader reawakening, a new attunement to reality.

The epiphany is perhaps asymmetrical. The narrator seems to be more profoundly moved than Sonny. There is still a complex intermediation at play, though, a mutual recognition. Sonny affirms this on his end when he accepts the drink his brother buys for him. The drink sits on the piano while Sonny plays—"it glowed and shook above my brother's head like the very cup of trembling."[57] These final words of the story contain an ambiguous but perhaps hopeful allusion to Isaiah 51:22. We do not know what the future holds for the brothers, but there is reason to believe this epiphanic encounter drew them closer to one another, that there is now both deeper understanding and new acceptance of what they cannot understand.

Zora Neale Hurston's novel *Their Eyes Were Watching God* offers a different sort of epiphany, one that dispels a different sort of illusion about the other. Janie's second husband, Joe (whom she calls Jody), helps her escape from her miserable first marriage. They move to the village of Eatonville and begin a prosperous life there. Joe sets about transforming the village into a bustling town. He builds homes, streets, a post office, and a store. But the townspeople note that Joe is more like a boss than a friend and fellow citizen. He at times seems to model himself on a plantation owner. They note the "gloaty, sparkly white" of the house he builds, besides which "the rest of the town looked like servants' quarters surrounding the 'big house.'"[58] Joe's frequent exclamation is telling—"I god."[59] He sets himself up as a sort of local god, and he expects his wife to see him that way. The townspeople invite Janie to give a speech, but Joe cuts her off. He installs a new lamppost early in his time as mayor (note the echo of the creation narrative—"Let there be light"). That night he tells her, "Ah told you in de very first beginnin' dat Ah aimed tuh be uh big voice. You oughta be glad, 'cause dat makes uh big woman outa you."[60] He expects her to draw her whole sense of self from him and his accomplishments.

Their relationship disintegrates as the years pass. Joe keeps Janie separated from the rest of the town and makes her work in his store, where he frequently belittles her in front of others. This culminates in Joe hitting her because of a dinner that did not satisfy him. Afterward "he stalked on back to the store."

> Janie stood where he left her for unmeasured time and thought. She stood there until something fell off the shelf inside her. Then she went inside there to see what it was. It was her image of Jody tumbled down and shattered. But looking at it she saw that it never was the flesh and blood figure of her dreams. Just something she had grabbed up to drape her dreams over. In a way she turned her back upon the image where it lay and looked further. She had no more blossomy openings dusting pollen over her man, neither any glistening young fruit where the petals used to be. She found that she had a host of thoughts she had never expressed to him, and numerous emotions she had never let Jody know about. Things packed up and put away in parts of her heart where he could never find them. She was saving up feelings for some man she had never seen.[61]

This epiphany does not disclose hidden richness in Joe. It discloses that the god was an idol, an "image" that has fallen and shattered. The epiphany disenchants. Janie realizes that she projected a dream on Joe, one that took its bearings from his dream of himself. But now the dream has been dispelled. Early in this passage, Janie describes her interiority as a store with shelves and packages inside it. Recall that she loathed working in the store. This suggests that she has avoided introspection for a long time, that her inner world became unwelcoming to her, probably in part because of the disillusioning truths contained there. Halfway through the quoted passage, however, the imagery of a tree appears. Janie describes her inner life with this metaphor earlier in the novel. Its return suggests that her inwardness is not just a dreaded storeroom but a living thing, with life in dormant roots. She discovers not only a shattered image inside but a "host of thoughts" and "numerous emotions." She discovers the intuition of a lover to come. If the epiphany disenchants Joe, then, it re-enchants Janie's sense of herself and her world.

Flannery O'Connor's "A Good Man Is Hard to Find" offers yet another possibility. Here the epiphany is rejected rather than affirmed.[62] There is a violent recoil from the gaze of the other. In O'Connor's story, a dysfunctional family has a car accident on an isolated back road while on vacation. An escaped murderer—the Misfit—and his henchmen happen upon them immediately after the wreck. When the grandmother recognizes the Misfit from a newspaper story, she begs for her life, saying whatever she thinks will save her skin, while the Misfit's henchmen murder her family.[63] But in a climactic moment, the grandmother seems genuinely moved by the Misfit's own existential angst, and she reaches out to touch him:

> His voice seemed about to crack and the grandmother's head cleared for an instant. She saw the man's face twisted close to her own as if he were going to cry and she murmured, "Why you're one of my babies. You're one of my own children!" She reached out and touched him on the shoulder.

Perhaps the grandmother is still trying to save herself; perhaps she relinquishes self-concern in a moment of genuine compassion for the murderer; perhaps she is somewhere between. Regardless, the Misfit recoils from this unexpected breakthrough of (seeming) compassion: "The Misfit sprang back as if a snake had bitten him and shot her three times through the chest. Then he put his gun down on the ground and took off his glasses and began to clean them."[64] The Misfit springs back from the epiphanic encounter with

the grandmother, and presumably the claim that her compassion puts on him. The cleaning of his glasses is rife with implication. Rather than simply cleaning off the grandmother's blood, it suggests that he saw—or at least thinks he may have seen—something surprising, perhaps even unbelievable, in her. He was confident in his depth and her shallowness. But the epiphanic encounter suggests that she was deeper than he had assumed.

After shooting the grandmother, the Misfit tells his henchman, "She would of been a good woman . . . if it had been somebody there to shoot her every minute of her life."[65] There is a measure of mordant truth in this. It takes the disastrous encounter with the Misfit to draw the family together. Yet the Misfit's words are perhaps also an attempt to contain or distance himself from the epiphanic encounter—to reduce its disclosure to its context. They are perhaps a way of saying, a way of reassuring himself, that her goodness was only born of the coercive moment, that it was only apparent goodness. In this encounter and the seconds after it, the Misfit perhaps passes through all three modes of wonder—astonishment at the apparent agape of the grandmother's touch, perplexity at that touch coming from such a seemingly selfish and simple person, curiosity that reduces it all to circumstance. In short, the Misfit's words to his henchmen could signal an attempt to resist his own ethical selving, which would involve a transformation in how he sees not only her but also the wider world. Rather than the equivocal play of meaningless violence, which he at least claims to take pleasure in by perpetuating in turn ("No pleasure but meanness"), the world and those within it would have a worth he would need to recognize.[66]

Perhaps the Misfit springs away from this prospect as much as from the grandmother. Before the grandmother reached out to him, the Misfit rued that he had not been privy to Christ's miracles. If he had "been there" to see Jesus, he would know whether Jesus was truly the savior or if he was a charlatan. He would know, and he would live differently. For the Misfit, seeing Christ would confirm the possibility of agapeic, redemptive love in a cruel world. He catches an uncertain glimpse of such love in the grandmother. Torn between these possibilities, the Misfit tells his henchman, "It's no real pleasure in life."[67] The epiphanic encounter pierces him, but his is ultimately a clotted epiphany.

Epiphanic Things

Joyce's Stephen is especially interested in epiphanies that reveal "the soul of the commonest object." The term's transposition from religion to art evokes

another kind of mystical encounter in this regard—what Mircea Eliade calls the hierophany, the "manifestation of the sacred," which can take place even "in some ordinary object, a stone or a tree."[68] According to Charles Taylor, the epiphanic art of Western modernity often attempts not only to depict epiphanies but to offer them to its readers. It attempts to re-enchant the world via the work, to offer solace and meaning as the tide of faith withdraws.[69] It attempts to be hierophanous, often because hierophanies have become elusive beyond the page or canvas. Such art reflects the hope, explored in the last chapter, that it offers "the key to a certain depth, or fulness, or seriousness, or intensity of life, or to a certain wholeness" beyond religion. Taylor argues that epiphanic art spans both the Romantics and their modernist critics, such as T. S. Eliot and T. E. Hulme. For both Romantics and modernists, it is a reaction against alienation and instrumentalism, against what Desmond calls the ethos of serviceable disposability. Taylor explains,

> In contrast to the fulness of epiphany is the sense of the world around us, as we ordinarily experience it, as out of joint, dead, or forsaken. The world "in disconnection dead and spiritless," or the world as seen through Blake's vegetative eye, has some affinity with the Waste Land of Eliot. There is a continuing thread here, a critique of the mechanistic and instrumental, as a way of seeing, and as a way of living, and then as the very principle of our social existence, which runs through an immense variety of different articulations, interpretations, and suggested remedies. An allegiance to epiphanic art has almost invariably been accompanied by a strong hostility to the developing commercial-industrial-capitalist society, from Schiller to Marx to Marcuse and Adorno; from Blake to Baudelaire to Pound and Eliot.[70]

As Taylor suggests, epiphanic art comes in many, often divergent, forms. It draws on a range of traditions and ideologies. One important strand begins with the Romantics. It offers epiphanies of "the spiritual goodness, the source of healing in the natural world, which has been rendered banal or dead by our estrangement from it."[71] Taylor notes Novalis, Wordsworth, and Shelley as key representatives. Epiphanic art, albeit in altered form, still offers a bridge to nature even when nature has become decidedly less beneficent in the wake of Schopenhauer and Darwin. Taylor points here to the ecstatic vitalism of Nietzsche and D. H. Lawrence. Taylor surveys the wide variety of modern "epiphanies of being," in which the work portrays

"something—unspoilt nature, human emotion—but in such a way as to show some greater spiritual reality or significance shining through it."[72] At times this something, as Joyce/Stephen suggests, can be a luminous *thing*, even a seemingly common thing. This section briefly takes up such epiphanies. It moves from a striking sculpture to an everyday pair of scissors.

Consider Rainer Maria Rilke's famous poem "Archaic Torso of Apollo." It records the poet's epiphanic encounter with a statue. It is a poem about the transformative call of the beautiful artwork. The sculpture issues a wordless but undeniable injunction: "You must change your life." In a way, the poem is itself a response to the sculpture's call. Apollo is a god of poetry and prophecy. Perhaps the poem is a thanks offering to the god. Perhaps the poem is as much about inspiration as it is about the experience of wonder before the torso. Note that the poem does not simply depict the sculpture. It imaginatively augments the sculpture, evoking its missing face and features. The poem thus "begets" on the beautiful, to use the language of the *Symposium*. Rilke's poem does not revel in this augmentation, though, so much as it dwells on the way the epiphanic encounter with the torso evades and exceeds description. The augmentations are more like soundings of the sculpture's mystery than poetic embellishments. Rilke is a poet well-attuned to the mysterious depths of singular things. The sculpture radiates ontological energy "like a star."[73] Is this the spirit of the artist suffusing the artwork? The richness of the artwork or of being itself? The power of the god (or God)? The closing injunction is likewise ambiguous. How must the poet change his life? Must we too? If so, how?

From one angle, Rilke's poem excludes us from the wonder it evokes. After all, we do not have the speaker's direct experience of the torso. We only read about it, and there are limits to the vicarious experience of an encounter so intimate and singular. From this angle, the "you" of the closing line is the speaker. From another angle, though, the poem does not simply depict an epiphanic disclosure. It evokes the epiphanic power of the sculpture through its own epiphanic power as a poem. Rilke's poem reminds us that literature is particularly apt at depicting epiphanies because it is itself overdetermined—always revealing and concealing, always communicating out of a surplus. In this regard, the closing "you" is also addressed to me and you as readers. For even if we are not directly addressed by the epiphanic torso, we are so addressed by the epiphanic poem.

Rilke's poem (like Keats's famous "Ode on a Grecian Urn") focuses on an archaic artifact laden with mystery and meaning, but epiphanic art can also awaken us to the mysterious within the seemingly mundane. Recall that

in Joyce's *Stephen Hero* even the "commonest object" can offer an epiphany. Or consider Jane Kenyon's "Things," which begins with this stanza:

> The hen flings a single pebble aside
> with her yellow, reptilian foot.
> Never in eternity the same sound—
> a small stone falling on a red leaf.[74]

"What we often take to be trivial can reveal," Desmond observes, "from another perspective, marvelous newness" (*GBPB*, 325). Epiphanic art can provide this perspective. It can make the familiar strange and reveal the seemingly trivial as marvelous.

Felski claims, "A gift of poetry is its single-minded attention to the sheer thingness of the thing, which may paradoxically reanimate and revitalize it, saving it from the abyss of oblivion or obsolescence."[75] Felski points to Pablo Neruda's odes to "common things," such as a pair of scissors, a bar of soap, a tomato. In "Ode to a Pair of Scissors," for instance, Neruda catalogues the scissors' manifold roles in our lives, and he invites us to marvel at the intimacy of these roles, at our intimate but neglected relationship to them. The junk drawer commonplace cuts your umbilical cord at birth, and scissors will also cut out the suit you will wear at your funeral. Rilke's poem evokes the mysterious history of the torso, but the history of Neruda's scissors is itself mysterious, partly because we often take such things for granted but also because most of our own lives—let alone the archaic past—is lost to memory. Poetry, however, can rescue even scissors or a moment in a hen's life from dulled perception. It can offer "a *fresh* attentiveness to things, and a fresh wording of things" (*GBPB*, 327).

As the last chapter noted, though, Desmond suggests that this epiphanic, affirmative power of art becomes increasingly ambiguous over the course of modernity. Taylor agrees. From the late nineteenth century onward, some epiphanic art becomes self-referential. Representational art gives ways to avant-garde epiphanies. "Epiphanies of being" persist alongside them, but the ontological purchase of the artwork becomes ambiguous. Art attempts to enchant, but what does this mean? Does art disclose, transfigure, or merely project? Does it reawaken us to the ontological richness of reality or does it dress a threadbare reality in imaginative robes? Desmond stresses the equivocal position of art within the ethos of serviceable disposability, but he also cautions that we should not shortchange art's powers even if they are compromised. Like Kearney and Taylor, he especially affirms the

appreciation for the everyday world offered by some epiphanic art. In helping us recognize our intimacy with seemingly trivial things, in helping us recognize their strangeness, even their sacredness, such art guides us beyond utilitarian relationships with them. Another strand of epiphanic art does the same for seemingly trivial places.

The Poetry of Place

Concern with place becomes more marked over the course of modernity. Here, too, the contributing factors are undoubtedly manifold, ranging from increased mobility and the rise of tourism to increased urbanization, the industrial transformation of the landscape, and environmental degradation. In the twentieth century, when these trends accelerate, it makes sense that an art and philosophy concerned with place emerges alongside the art and philosophy of alienation. Desmond's philosophy contributes to the former. The practices of "agapeic mind" and the recovery of a richer ethics of other-value can help us become "placed." They can help us dwell more richly and responsibly. Desmond recognizes how the epiphanic literature of place can play a formative role in this as well.

Especially instructive is literature about how one comes to be at home in a place. In *The Country of the Pointed Firs*, Sarah Orne Jewett's lyrical 1896 novel of the Maine coast, the narrator reflects on her arrival at Dunnet Landing: "The process of falling in love at first sight [with a place] is as final as it is swift in such a case, but the growth of true friendship may be a lifelong affair."[76] Jewett's narrator immediately falls in love with the village, but she continually discovers more about it, often in striking epiphanic encounters, and she is continually reminded of what she does not know. The novel is rich with sensuous detail, but it also signals the reserves in both the inhabitants and the place, reserves that only a lifetime of friendship could draw out and which would still not be exhausted. The herbalist Mrs. Todd serves as the narrator's guide to Dunnet Landing. She knows the area's flora and humans better than anyone else. Her wisdom is one of roots, of hidden depths and hidden connections. She is wise about when those roots should be unearthed and when they should remain hidden. *The Country of the Pointed Firs* is a quiet novel, one where the narrator grows in receptivity and mindfulness. Her missteps along the way often come when she assumes too much or forces too much. Jewett suggests the importance of what Desmond calls agapeic mind, of patient openness, in

getting to know a place. Jewett's novel offers yet another instance of what Desmond names the "intimate universal." For it seeks the universal within the intimate and the singular, and it acknowledges that the universal can never be fully abstracted from them. The best literature of place participates in the intimate universal in this way.

Gabriel Marcel claims that even the extended visitor to a place, like Jewett's narrator, can struggle to move beyond the stance of "having," a stance where one seeks to tick off all the sights and experiences it has to offer:

> For some time I have been in a place whose resources at first seemed to me to be inexhaustible; bit by bit, however, I have gone through all the streets, seen all the "places of interest;" and now I am overcome with a certain impatience, boredom, and distaste. I feel as if I were in prison. The place where I was staying was one where a certain number of experiences were to be had, and these experiences have already transpired.

Despite good intentions, even this sensitive visitor has "come there only to increase what I have with a certain number of additional properties." The visitor approaches the place as something to appropriate or even consume. By using the first person in this passage, Marcel suggests that he himself succumbed to this danger. Marcel contrasts this stance of "having" with a relationship of "being." He contrasts his visitor with "anyone who has lived there for a number of years" and who has come to participate "in its life and in what it contains of what is inexpressible and therefore impossible to exhaust." For such a person, "a certain living relationship has grown up between him and this place, this region, which I should like to call a creative interchange."[77] Desmond concurs, noting that "a person can come to love a place in such a way that a rapport is set up between him and it, and the things of daily commerce within that place" (*PU*, 94).

A local culture at its best embodies such a creative interchange. (There are again no guarantees, of course. A mindful wayfarer may at times appreciate and value what locals take for granted, neglect, or exploit.) Its farming practices, industries, infrastructure, architecture, folkways, festivals, stories, art, and religious practices may reflect this. So may its local language. "Place names," writes Desmond, "evoke an entire world of intimate associations" (*IU*, 485n42). John O'Donohue illustrates this phenomenon.[78] He tells of his friend's art gallery in Ireland, which a farmer from "the shores of Loch Corrib" visited each year. Once the gallery owner introduced the farmer to

a poet, and the poet proceeded to point out "all the intricacies and hidden symbolism of the exhibition."[79] The grateful farmer in turn told the poet about the "Teannalach" of Loch Corrib, how "on certain summer days when the lake is absolutely still and everything is silent, I can hear how the elements and the surface of the lake make a magic music together." The gallery owner later asked one of the farmer's neighbors about Teannalach, and the neighbor concurred. "They have that word all right up there where he lives. I have never seen the word written down. And it is hard to say what it means. I suppose it means awareness, but in truth it is about seven layers deeper than awareness."[80] The story attests to the deep attunement possible between people and the particularities of their place. It also implies that the poet, for all his aesthetic insight, had something to learn from the local knowledge of the farmer.

That local knowledge and its naming are themselves poetic. For the poetic is essential to recognizing the rich singularity of a place. This helps explain the appeal and importance of the literature of place, which at its best is attuned to a place "in the singularity of its singularity" (*PU*, 94). Such literature can take many forms, from the ecstatic nature poetry of John Clare, to William Wordsworth's lyrics of the Lake District, to the Brontë sisters' Gothic evocations of the moors, to Claude McKay's vivid longings for his Jamaica home in his New York poems, to the misanthropy and eye for fierce beauty in Robinson Jeffers, to Annie Dillard's meditations at Tinker Creek, to Ernest Gaines's love of rural Louisiana, his grappling with the ways oppression scars that landscape.[81] The local writer need not be rural, as Dickens's London or Joyce's Dublin attest.

The newcomer is not alone in struggling to "be" at home in a place. Restless native sons and daughters may struggle as well. The poet might reawaken to the value of a home place. An epiphanic moment might reveal that home is not merely parochial, that the poet has been numb to its depths. We might think again of Stephen and Bloom in the second half of *Ulysses,* the great modernist retelling of the ancient epic of homecoming. Desmond points too to Patrick Kavanagh's poem "Epic," where the ghost of Homer tells the poet of rural Ireland, worried about his provinciality, that "I made the *Iliad* from such / A local row."[82] Kavanagh's harrowing epic "The Great Hunger" realizes this possibility. It chronicles the humble, bleakly frustrated life of the farmer Maguire.

The reawakening can involve a renewed "creative fidelity," to borrow again from Marcel. For Marcel, creative fidelity is an ongoing attunement, responsiveness, and exchange.[83] Wendell Berry offers a striking example.

Berry left the literary world of New York City to return to a small farm in the Kentucky county where his family had lived for generations. He has proceeded to work the farm and to write about that locale and its inhabitants (under the guise of fictionalized Port William in his fiction) for several decades. Early in *Nathan Coulter,* Berry's first novel, the young narrator has an epiphany while floating down the river, looking up at the trees: "I watched them, letting myself float in the slow current. I thought if I floated to the mouth of the river I'd always be at the center of a ring of trees and a ring of hills and a ring where the sky touched. I said, 'I'm Nathan Coulter.' It seemed strange."[84] Floating on his back gives Nathan a new vantage point on familiar surroundings. The trees and the sky overhead become strange. Nathan wonders at this place, and he also wonders at himself. Indeed, the apparent division between self and place becomes less definite, more porous. Still, this experience clarifies. Over the course of the novel, Nathan will deal with his mother's death and his father's grief and anger. His deepening relationship with the fields and woods will help him do so. Nathan's epiphanic wonder on the river is a formative moment in this coming-of-age narrative. It is an early step—unlooked for but crucial—in Nathan's lifelong process of becoming "placed."

Chapter 6

Tragic Howls and Being at a Loss

Many critics are wary of Aristotle's *Poetics* as a guide to tragedy. George Steiner and Terry Eagleton, for instance, disagree sharply about the nature of tragic drama but agree that the *Poetics* is "a text which raises far more problems than it solves."[1] According to Steiner and Eagleton, tragedy has too often been reified in terms of Aristotle's critical terminology: a formula of *hamartia, peripeteia,* and *anagnorisis* that fits only a few plays, a formula that may make sense for Sophocles's *Oedipus the King* but not for, say, his *Philoctetes*. These are valid criticisms, but they can lead to caricature. Critics and philosophers can find productive affordances rather than rigid formulas in Aristotle's study of tragedy. The very ambiguity of an Aristotelian concept like catharsis continues to spur debate and thought. Steiner and Eagleton themselves acknowledge this. While ranging well beyond the *Poetics,* both return at times to familiar Aristotelian territory.

This chapter takes up Desmond's account of tragedy.[2] Desmond offers both insightful readings of individual tragedies and a striking reformulation of old Aristotelian standbys like *hamartia* and catharsis. He does not offer an exegesis of the *Poetics* so much as a reimagining of key, often ossified concepts in the traditional Aristotelian approach to tragedy. In tragedy, Desmond claims, "The flaw, the *hamartia,* is finally lodged in the imbalance of *passio* and *conatus*. The self-surpassing as erotic sovereignty has lost touch with the more elemental porosity" (*IU,* 110). When this openness is lost, tragic protagonists become in some sense blind, seeing only their own aspirations or fears. They run roughshod over others, asserting their will. The sovereign then becomes a tyrant. Desmond offers two key figures from Shakespearean tragedy as paradigms. The first section of this chapter con-

siders Macbeth, who self-consciously, though reluctantly, becomes a tyrant. The second section considers Lear, who in the distorted self-delusions of an enclosed *conatus* confuses his tyranny with generosity. For Desmond, tragedy strips away characters' self-determination and returns them to porosity. The audience is returned to porosity as well, a process of exposure that can be harrowing and at times leads to despair. Yet this exposure can also lead, in Desmond's take on catharsis, to a renewed sense of the fragile goodness of life. The third section of this chapter considers how both tragic "being at a loss" and catharsis are important for philosophy. Tragedy reminds philosophy of its limits, and it challenges philosophy to attend to the intimate singularity of suffering and loss. In short, Desmond does not offer a simple recapitulation of the *Poetics*.

Macbeth, the Sleepless Tyrant

Recall that, for Desmond, we live our lives between the *passio essendi* and the *conatus essendi*. The latter is our self-affirmation and "endeavor to be." The *passio essendi*, on the other hand, is closer to our constitutive openness. It is a "patience of being" that does not immediately turn to striving. It is an attunement that can be experienced in a variety of ways. As we have seen, silence, contemplation, gratitude, and reverence can mark the *passio*. Returning to the *passio* can be restorative. The *passio* of sleep, so crucial in *Macbeth*, rejuvenates but also makes one vulnerable. Both dreams and nightmares visit it.[3] Restorative experiences of the *passio* are rarely to the fore in tragedy, of course. It often takes us into darker regions and confronts us with radical forms of "being at a loss." Such regions and such loss are all too real off the stage, but they do not constitute the whole of life. Tragic drama provides insight, then, but Desmond does not turn to it, as some thinkers do, to ground a tragic worldview. Still, he attends to how we can experience the *passio* in harsh, even horrible, forms. Bereavement and suffering harrow us with pain. If silence or song often marks more restorative experiences of the *passio*, the cry or howl accompanies experiences of loss or suffering. In tragic drama, the howls of a Heracles or a Lear show how loss and suffering rupture language itself.

Romantic love offers other experiences of the *passio*. It involves vulnerability before the beloved. In the early stages of romantic love, it is common to feel more present, more alive, to see the world as strangely

illuminated. The lover's porosity has been reopened. But the vulnerability such love entails can also mean a quick swing from ecstasy to pain. This, too, is tragic territory. The prospect of losing the beloved can shatter one's world, as in *Romeo and Juliet*. Betrayal in love, even the suspicion of it, can release jealous rage, as in *Medea*, *Othello*, or Racine's *Phèdre*.[4] The chorus in Euripides's *Medea* claims, "There is no bitterness to be compared / With that between two people who once loved."[5]

As noted earlier in this study, the *passio essendi* and *conatus essendi* are not necessarily in opposition to one another. The *passio* can and should companion the *conatus*. When we act, we can do so with a sense of openness and dependence. Still, there are deformations of the *conatus essendi* that are forgetful of, or hostile toward, the *passio essendi*. There can be deformation in "the direction of a tyrannical eros," a domineering desire that resolutely insists on itself (*IU*, 420). This deformed *conatus essendi* tends to instrumentalize others and the world. It can contribute to the modern ethos of serviceable disposability. Ancient and early modern tragedies testify, however, that tyrannical deformations are a perennial danger.

Tragedy is frequently about heroism gone wrong. How does it go wrong? A classic answer is hubris resulting in some mistake (*hamartia*). Desmond adds nuance to this commonplace by exploring the ambiguity of striving and self-transcendence. In themselves, they are goods. Communally, the capacity for self-transcendence gives rise to culture. This capacity also marks the exemplary individual, the hero. In order to transcend the self, though, one must be open to otherness—the mysterious unrealized potential within the self; the potential and needs of others; the challenges or exemplars that others provide; the "companioning power" of the divine.

The capacity for self-transcendence is equivocal. Communally, it gives rise to both culture and war. Individually, the same capacity that allows us to affirm otherness also allows us to threaten it. As we have seen, this can range from overt exploitation to unconscious manipulation. The solution is not to shy away from striving. Despite some marked disagreements with Nietzsche, Desmond shares his scoff at the neutral or lukewarm person. Desmond calls the neutral "a half-self, parsimonious with passion, feeble with the generous gesture. It settles for a negative goal: the mere absence of evil. The contentment of the neutral one is not even the animal's peace. For the neutral wants not to be ill, as opposed to possessing a vigorous health; it tries not to make mistakes as opposed to any bold but dangerous quest for excellence" (*PO*, 50). On the one hand, the half-self may be unable

to affirm the hero, let alone emulate the hero's virtues. On the other, the half-self may be unable to muster the opprobrium necessary to denounce the tyrant.

Desmond acknowledges that, especially in tragedy, the line between hero and tyrant can be hard to discern. Oedipus, for instance, pursues the truth but also rushes to the judgment of Tiresias and Creon. Still, this ambiguity does not negate the hero/tyrant distinction altogether. For the hero of epic and tragedy, self-transcendence is usually a pursuit of excellence in the martial and political realms. It involves decisiveness and action. More than other significant figures in Desmond's body of work, such as the poet or the saint, this sort of hero must operate in the *conatus essendi*. But this decisiveness can and should still be companioned by the *passio*, by an attentive openness to others, by an openness to goods beyond the self. This is key in keeping tyrannical impulses at bay.

Regarding the hero's excellence, then, Nietzsche stresses the will, Desmond the companioning of *conatus* and *passio*. For Desmond, the risk-taking will of the hero does not simply excel beyond the pusillanimous will of the half-self. The hero maintains a patience and receptivity that is lost when the will to power is given too much rein. Desmond's heroic self-transcendence maintains an openness to and mediation of otherness. This is not to say that Nietzsche's hero is a narrowly self-absorbed individual. Gifts to friends are marks of nobility and superiority.[6] There are interesting ambiguities and untaken roads in Nietzsche that Desmond does not want to brush aside. Nietzsche's desire to say "yes" to life and Desmond's own desire to affirm differ in important ways, but they still resonate with each other. Nonetheless, Nietzsche's capacitating energy is will to power, and it finds expression in the hero's self-assertion. Furthermore, Desmond holds that for Nietzsche's Zarathustra, gift-giving "is an overflow of the self-affirming soul that rejoices in itself and that can do no other than give beyond itself, and this giving beyond itself is simply its self-affirmation" (*IST*, 224). This makes the friend more of "an *occasion* [for self-affirmation via gift giving], not properly a beloved in deepest otherness" (*IST*, 226–27). This might look like the overflow of agapeic generosity (recall once more the endowed agapeic potential in eros), but the similarity is only apparent. The overflow is self-affirming rather than other-affirming. Desmond is skeptical, then, of Zarathustra's "gift-giving" virtue. It is marked less by genuine philia or agape than by the will to power.[7]

Desmond's hero can truly serve the other. The self-transcending hero, what Desmond calls the "erotic sovereign," can remain open to agapeic

service. This service is paradoxically the highest form of self-transcendence because it entails going beyond the self to affirm and serve the other.[8] From this angle, Desmond's neutral "half-self" is perhaps more indebted to the "lukewarm" of Revelation 3:16 or to Dante's neutrals than to Nietzsche's "last men." "In erotic sovereignty," Desmond claims, "there is a transcending that leads to a higher selving; in agapeic service there is a release of transcending that is higher than selving, no matter how glorious" (*IST*, 215). Nietzsche does not recognize the possibility of agapeic service. For him, it would be either servility or a smokescreen for the will to power. Desmond claims that Nietzsche "squints when he tries to see a service beyond all servility, and beyond erotic sovereignty, not below it" (*IST*, 215). For his part, Desmond refuses to equate or subordinate self-transcendence to will to power. He draws attention to how the relentless pursuit of the will to power can be self-defeating. It may entail not the innocence of becoming, but an armoring within the *conatus* that paradoxically leaves one more vulnerable. Tragedy often depicts this.

Desmond notes that tragedy tends to focus on "the political power of the erotic sovereigns: Oedipus, Hamlet, Macbeth, Othello, to name a few" (*IU*, 114). Tragic sovereigns often risk tyranny. At times they clearly become tyrants. *Macbeth* is the classic drama of the "tyrannical eros" for Desmond. He returns to it throughout his writings. Indeed, no other literary work receives such frequent and extended attention from him.[9] Among other things, *Macbeth* is Desmond's departure point for a critique of the Nietzschean attempt to go beyond good and evil, especially the attempt to go beyond good and evil by "daring evil" (*IST*, 247):

> In *Macbeth* we are honored with Shakespeare's superiority to Nietzsche in seeing that what is "beyond good and evil," gained by sacrilegious crime, is not, can never be, the "innocence of becoming." It is, and must be, the evil usurpation of what is becoming for a man. It all begins in the betrayal of hospitality, and the delivery over to war as more primordial than the peace of being. (*IU*, 384)

As suggested above, Nietzsche ties the excellence of the hero to self-assertion, courage, and the will. In contrast, Desmond ties heroism to a fluid companioning of *passio* and *conatus*. Desmond's sharp rebuke of Nietzsche does not come from a place of diametric opposition, because Desmond still admires the hero's decisiveness and bravery, but rather at an angle—Nietzsche and

Desmond could, in fact, affirm the same hero up to a point.[10] For Desmond, this point is where the *conatus* recesses the *passio*. When this tipping point is passed, the hero threatens to tyrannize in relationships and risks indifference—or even hostility—to value beyond value for self. In Desmond's reading of the tragedy, Macbeth passes from heroism to tyranny to madness by following exhortations similar to those found throughout Nietzsche: "Lady Macbeth talks to Macbeth as Nietzsche often talked to *himself* (as also later Macbeth did to the prospective murderers of Banquo): kill pity, become hard, screw your courage to the sticking-place."[11] Following such exhortations paradoxically issues in a counterfeit, brittle strength. Macbeth becomes paranoid and cuts himself off from the rejuvenating *passio* of sleep. In making will and war basic, Macbeth ultimately drains the goodness of his existence. He loses track of a goodness before cultural norms of good and evil, one that those norms, at their best, mediate.

Desmond notes how Nietzsche's academic advocates at times "sanitize" him, downplaying his fascination with the figure of the tyrant and the ambiguities of his rhetoric of war and violence.[12] Desmond's analogy between Lady Macbeth's rhetoric and Nietzsche's own is a provocation in this regard. This does not mean, though, that Desmond simply reiterates the flattening critiques and canards of Nietzsche as a proto-fascist. Desmond argues for a complex, equivocal Nietzsche whose rhetoric of war may be taken as a metaphor for "nothing but the energy of creation, but this is [still] a double-edged metaphor that risks a dangerous falsification of the fuller truth of war" (*IST,* 331n10).[13] As we have seen, Desmond himself continually returns to Nietzsche throughout his writings, and not always to critique. Christopher Ben Simpson notes, for instance, how Desmond "gleans" from Nietzsche "the recognition of becoming and the equivocal; the yea-saying, affirmative, Dionysian celebration of the finite and the earth; the critique of rational reductionisms, the nihilism of our merely human valuations; the poetic mode of philosophy (like Plato)."[14] Desmond notes an unresolved tension between the "yea-saying" Nietzsche and the Nietzsche who claims that all value is a human projection on a meaningless nature.[15]

This is perhaps Desmond's main critique of Nietzsche, both broadly and in his readings of *Macbeth*. For Desmond argues that a true "yea-saying" must acknowledge a primordial goodness of being and the necessity of a "healthy" (to use one of Nietzsche's favorite adjectives) rapport with that goodness. Macbeth and Lady Macbeth's attempt to reduce the goodness of trust and loyalty to convention alone, to go beyond good and evil in this sense, ultimately destroys their primordial rapport. It leaves them sleepless.

In this way, Desmond sees *Macbeth* as countering Zarathustra's laugh at the "opiate virtues" that enable sound sleep.[16] There are many sorts of sleep. Desmond would agree that sleep can indeed be "a false being at peace in which the extreme perplexities of life are evaded rather than faced," but this counterfeits restful sleep where there is "genuine being at peace with being" (*IST*, 51). The point is not to live in order to sleep, as Zarathustra rightly derides, but to sleep in a way that allows a fuller wakefulness, a fuller "yea-saying" and becoming. In cutting themselves off from such sleep, Macbeth and Lady Macbeth betray virtues that are not simply opiate.

In Act I, Lady Macbeth claims that her husband's qualms about murdering Duncan are mere weakness. Loyalty and hospitality are covers for cowardice. They are parasitical, sapping her husband's strength. She argues that Macbeth's greatest temptation is not to kill Duncan but to be "afeard / To be the same in thine own act and valor / As thou art in desire."[17] Yet when Macbeth and Lady Macbeth murder the king, they also murder trust, and they soon discover that trust did indeed have positive worth. Having proven untrustworthy themselves, they can no longer trust others and thus become suspicious of all. Paraphrasing the discussion of tyranny in the *Republic*, and writing with *Macbeth* in mind, Desmond calls the tyrant "suspicion incarnate" (*IU*, 383). This is an apt description of Macbeth and Lady Macbeth in the latter half of the drama. They must be constantly on their guard. They cannot rule with trust and gift but only with fear and threat. This ultimately translates into weakness on the battlefield. The Macbeth who carries the day at the beginning of the play can lead by example. He can give trust and receive trust from his soldiers in turn. "Some of the best values of the warrior," Desmond notes, "Macbeth seems to embody when he is *not* king: courage, loyalty and endurance."[18] By contrast, the soldiers who follow "the tyrant" Macbeth into battle at play's end do so unwillingly, out of fear. As Angus discerns, "Those he commands move only in command, / Nothing in love" (5.2.22–23).

Suspicion and fear corrode more than Macbeth and Lady Macbeth's military power. They also corrode their sense of being's goodness. In one of the many ironies of the play, Macbeth and Lady Macbeth murder Duncan in his sleep, and this in turn murders their own sleep. They again discover that the values they seek to transcend are not arbitrary. They are rooted in a literal need for renewing trust, for vulnerable rest. Sleep is both a metaphor for this trust and an actual state of trustful repose. It is a vulnerable, but also renewing, return to the *passio*: "Sleep is not only a restorative of sanity, as Macbeth knew. More deeply, it is restorative of a *native ontological*

faith: lived trust and indeed pleasure in the good of the 'to be' " (*GBPB*, 301). Wracked by suspicion and guilt, Macbeth and Lady Macbeth can no longer allow themselves to be vulnerable, and so there is no way for them to be renewed. Desmond explains, "This sleeplessness is the karma of evil that destroys the ontological peace of the human being at its deepest roots" (*IST,* 59). Their visions of guilt reveal that an armored *conatus* cannot defend them against the otherness lurking within. Macbeth knows that he should repent, but like Claudius in *Hamlet*, he will not surrender his ill-gotten crown to ease his paranoia and restore his inner peace.

Reflecting on Desmond's reading of Macbeth, Renée Köhler-Ryan notes that tragedy often involves absent or partial self-reflection. Dramatic soliloquies can be the occasion for such reflection, for soul-searching that can lead to a new openness and a new course of action. Köhler-Ryan points to an older religious model of such self-reflection beyond the stage, one modeled in Augustine's *Soliloquies* and adapted in Desmond's own philosophy. For Augustine and Desmond, "progressing from exterior to interior requires a sound and humble relationship to the world; extending toward God intensifies self-knowledge."[19] Köhler-Ryan discerns a "thwarted" soliloquy of this sort, a failure to reflect and repent, after Macbeth murders the king. In Act II, Macbeth recalls how, when he was stealing into the king's chambers, the chamberlains awoke in the darkness and prayed. When one cries, "God bless us," Macbeth finds he cannot say, "Amen":

> But wherefore could not I pronounce "Amen"?
> I had most need of blessing, and "Amen"
> Stuck in my throat. (2.2.42–44)

It remains stuck in Macbeth's throat. The prayer or soliloquy that it entails remains thwarted. Köhler-Ryan concludes that Macbeth "questions himself, and reveals how closed off he is to his moral community, how impermeable to divine communication."[20] She points to Macbeth's telling line shortly thereafter: "To know my deed 'twere best not know myself" (2.2.93). The aside we get from Macbeth in Act IV is the "reverse" of Augustinian self-reflection. It is meant to steel his tyrannical resolve to obliterate Macduff and his family:

> Seize upon Fife, give to th' edge o' th' sword
> His wife, his babes, and all unfortunate souls

That trace him in his line. No boasting like a fool;
This deed I'll do before this purpose cool. (4.1.172–75)

Yet even if Macbeth manages to somewhat repress guilt, to temporarily sheath its bloody daggers, as the play progresses, his paranoia grows apace with his tyrannical violence.

Macbeth and Lady Macbeth are ultimately undone by their deeds. Lady Macbeth, who urged her husband to forget the stuck "Amen," apparently kills herself. The world becomes flat and meaningless for Macbeth, "It is a tale / Told by an idiot, full of sound and fury, / Signifying nothing" (5.5.29–31). Macbeth and Lady Macbeth ultimately discover that evil is "sticky," a trope in the play that culminates in the "damned spot" that haunts Lady Macbeth.[21] Their actions are not simple and discrete. Their actions spawn inescapable guilt and paranoia. They also spawn ever more violence. Macbeth and Lady Macbeth find, in Köhler-Ryan's words, that "murder is primal and messy, and it leads to more and more letting of blood."[22]

Macbeth is aware of these dangers. Before the coup, he notes that in carrying it out "we but teach / Bloody instructions, which, being taught, return / To plague th' inventor" (1.7.8–10). After the witches give their first prophecy, he tries to banish temptation by saying that he will patiently wait and see. Even as he gives fuller rein to his desire for power, he never seems fully convinced by Lady Macbeth's rhetoric. Macbeth's qualms are part of what make the play gripping, as are the temptations and influences that move him to push aside those qualms: the exhortations of Lady Macbeth and the prophecies of the Weird Sisters. These influences suggest that even a tyrannical *conatus* retains a degree of porosity. The Weird Sisters become Macbeth's demonic companioning powers, flattering his sense of self-determination with misleading prophecies. One trope in tragedy is the false security of such misunderstood prophecies, misunderstandings often linked to overconfidence or self-delusion. Tragic heroes often mistakenly conclude that the prophecy has allowed them to master the deeper companioning power of fate, to have control over the "recessed relation to what is beyond their self-determination" (*GBPB*, 268).[23] We might think of Oedipus in ancient tragedy or of Melville's Ahab after Macbeth.

The Weird Sisters have an impeccable sense of timing. Recent events have given Macbeth a taste of kingly accomplishment. In overcoming the rebellion, in demonstrating the full extent of his martial prowess, Macbeth has already planted the seeds of temptation within himself. The Weird

Sisters arrive to water those seeds. In this way, it is tempting to see the Weird Sisters as at least in part emerging from Macbeth himself. Desmond has written that there seems to be "an equivocity of evil at work before we *choose* an evil. What repulses us seduces us. (See the child's fascination with excrement, revisited in adult scatology)" (*GB,* 81). This is an explicit theme of *Macbeth,* where foul becomes fair. The Weird Sisters perhaps represent not only temptation, but also the depths within us from which temptation emerges. Because humans are open wholes, that place is equivocal and mysterious. It is inside us, but it is also open to influence. If the Weird Sisters are intimate with Macbeth's psyche, it would be too simple to reduce them to it. Desmond claims, "Macbeth *toys* with an act. But he is also *being toyed with*."[24]

Lear, the Sleepwalking Sovereign

We see tyrannical parallels in *King Lear*. The older sisters, Cornwall, and Edmund pursue sovereignty to first tyrannical and then disastrous ends. "Legitimate Edgar, I must have your land," proclaims Edmund at the beginning of the play (1.2.17). Goneril calls Albany "a moral fool" for his anger at the sisters' power grab (4.2.71). Like Macbeth, their tyrannical eros leads to paranoia and treachery. It dissolves the bonds between them, and they turn on each other. They win the decisive battle against Lear's rescuers. Then they implode.

In his remarks on the play, though, Desmond focuses on how Lear offers a different sort of deformed *conatus*—a self-deception or obtuseness more than a willful tyranny. In Act I, Lear is "regal, sovereign, irascible, impatient, used to getting his way, his will. He acts foolishly, sovereignty sleep-walking in the direction of impotence, into its own undoing" (*IU,* 110–11). Long accustomed to authority, and perhaps especially jealous of his kingly prerogatives due to advancing age, the Lear of the opening "love test" displays a deformed *conatus essendi*. He is so eager to orchestrate his daughters' actions in this pageant that he sees neither the hollowness of Goneril and Regan's hyperbole nor the honesty of Cordelia's taciturn resistance. In the latter he can see only a gross affront to his wishes, one he conflates with betrayal. The banishment of Kent, who tries to make Lear see the truth of the situation, underscores this. Lear thinks he is a generous and magnanimous king, but there is a cataract over his porosity that only allows distortions to make their way through.

As the drama unfolds, Lear "is dragged along the way of truth" (IU 111). On the heath, broken by madness and grief, he undergoes a harrowing return to the *passio*, to openness and vulnerability. Lear is "brought back to the condition of a 'bare forked animal'" (*IU,* 111). While this may seem "to make man's life as cheap as beasts," it "is not the last word" (*IU,* 111). Lear's radical exposure on the heath leads to a new awareness and to true generosity. Desmond explains, "True going down is going up—while untrue going above is to be brought down" (*IU,* 111). On the heath, Lear shows compassion for "Poor Tom," who represents all those who are poor and needy. After making the Fool go into the hovel before him, Lear proclaims,

> Poor naked wretches, wheresoe'er you are,
> That bide the pelting of this pitiless storm,
> How shall your houseless heads and unfed sides,
> Your looped and windowed raggedness defend you
> From seasons such as these? O, I have ta'en
> Too little care of this. Take physic, pomp.
> Expose thyself to feel what wretches feel,
> That thou may'st shake the superflux to them
> And show the heavens more just. (3.4.32–41)

Brought low, Lear paradoxically glimpses a higher kingship in service of this community.[25] The erotic sovereign glimpses the possibility of agapeic service. Indeed, in his concern for the Fool and Poor Tom, Lear realizes this possibility, if only for a moment.

Desmond has little to say about the character of Edgar, but it seems important to note that Poor Tom is Edgar in disguise, and it is particularly fitting that he appears alongside this recognition in Lear. Edgar himself has been returned to harrowing vulnerability—framed by his brother, sentenced to death by his father—but instead of fleeing he patiently waits in disguise for opportunities to serve. He is patient in the face of trials, and he later attempts to instill such patience in his father with the illusory fall, but he also shows decisiveness in his battles with Oswald and Edmund at play's end. In this regard, he offers a heroic companioning of *passio essendi* and *conatus essendi*.[26]

Desmond's account of tragedy clearly adapts the classic Aristotelian concepts of *hamartia* and *peripeteia*, as well as the traditional association of tragedy with hubris. Still, his focus on the deformed *conatus* avoids the rigidity often associated with the post-Aristotelian approaches decried by

Steiner and Eagleton. The *conatus* can be deformed in many ways. Desmond's approach is thus attuned to variations in tragic character and less wedded to a particular plot arc. It delineates between the overtly tyrannical eros of Macbeth and the self-blindness of Lear, and it can illuminate some tragedies that ill fit the classic Aristotelian framework.[27] In Aeschylus's *Eumenides*, for instance, the Furies transform from the vicious companioning powers of a vengeful *conatus* to the "kindly" companioning powers of a hospitable *passio*. Aeschylus also dramatizes the hubristic *conatus* of Xerxes in *The Persians* and the brash impiety of the "seven against Thebes." In Sophocles's *Philoctetes*, the wily tricks of Odysseus contrast with the patient listening of Neoptolemus. Hamlet swings between inaction and impulsiveness, suggesting an "equivocal dis-ease of the *passio* and the *conatus*: their unresolved inner discord; and perhaps this [is] the image of the modern consciousness" (*GBPB*, 315n43). In Calderón's *Life Is a Dream*, Segismundo, treated brutally by his father, must resist the temptation to become a tyrant. The Faust myth, brought to the stage by Marlowe and Goethe, explores a different sort of deformed *conatus*, one that Shelley's *Frankenstein* and Hawthorne's "The Birth-Mark" helped transform into the modern trope of the hubristic scientist (though Prometheus's more ambiguous *conatus* is crucial here as well). These last examples highlight how Desmond's approach can attend to different historical particulars. No approach, of course, could be equally apt for all tragedies. Nor is it even possible to settle on a simple definition of tragedy.[28] Desmond would acknowledge that tragedy is plural. Still, his approach can yield insights into a wide range of works.

Desmond adapts the concept of catharsis, too. To be an attentive audience member of any drama is to be returned to the *passio*. But to experience catharsis through the witness of tragic suffering is to be returned to the *passio* in a particular way. It is to have one's defenses pierced. It is to be exposed to rending energies:

> Catharsis is purgation—unclogging the porosity. There is a horror in this unclogging, for we have covered our more intimate souls with carapaces of powerful protection, and these carapaces are now being pierced and dissolved. This is like a death, bringing us to nothing; but there is a stream of compassion in the purged porosity; the purge allows the fluency of life's energy of affirmation to flow again. (*IU*, 111–12)

For viewers of tragedy, this return to the *passio* is cathartic when it involves both compassion (*eleos*) and dread (*phobos*). Tragic catharsis is an experience

between the two, one that can be reduced to neither. But it is less apt to say that we feel *eleos* and *phobos* than that we are "exposed" to them as the energies on the stage flow out into the audience. Desmond's account of compassion and dread tracks Aristotle's, but perhaps charges it with Nietzsche's sense of the excess of tragedy. There is something of the sacred in this excess, of the ultimate, and like all such experiences it is at the limit of language. It neither easily nor fully translates into words. It leaves us grasping. Catharsis is left famously underdeveloped in the fragmentary *Poetics*, and the concept has proven slippery yet essential in the critical literature on tragedy. Desmond's account suggests that the slipperiness is to be expected. Catharsis involves something that we cannot pin down.

A tragedy like *King Lear* can crack one open. It is a confrontation with the ultimate in death and suffering. It forces upon us the question of the goodness of being itself. There is, therefore, a risk involved in a stark tragedy. Tragedy can lead to a new awareness of the "fragile goodness" (to adapt Martha Nussbaum's phrase) of a city, a family, a life, but in showing them shattered it can also call into question whether existence is truly good, whether it is truly good to exist.[29] "The tragic exposes [the] mind to a radical experience of being at a loss," Desmond claims. "Ingredient in this loss is the possible loss of the worth of being: the horrifying possibility is brought before us, not only that being lacks an ultimate intelligibility, but that at bottom it is worthless, it is valueless" (*PU*, 39). Pessimistic critics of tragedy like Steiner at times try to make it determinate along these lines. Steiner claims that "absolute" tragedy not only calls the worth of being into question but answers the question like Gloucester in *King Lear*: "As flies to wanton boys are we to th' gods; / They kill us for their sport" (4.1.41–42).[30] This attempt to make tragedy determinate has its own problems. It is likely impossible to remove all trace of hope from tragedy, for instance.[31] Steiner's approach leaves little room for the affirmation and compassion that can grow out of tragedy's confrontation with death. Yet Steiner rightly sees that tragedy has ontological bite.

Philosophy at a Loss

We must consider not only Lear's newfound compassion on the heath, but also his grief at Cordelia's death, and especially the howls he utters on stage: "Howl, howl, howl!" (5.3.308). Desmond claims that "when one hears that Howl a crushing night descends wherein the mind is threatened with blacking out or going blank. The mind shudders, as if a dark abyss

had opened and swallowed all sense" (*PU*, 28). Lear's howl resounds back through the play. It dramatizes how the experience of particular losses can trigger generalized despair, an overwhelming sense that life is a cruel trick and that the world is worthless. A tragedy like *King Lear* brings the audience, too, to a place where catharsis can be experienced, with its renewed sense of value, but also to a place where one risks dread alone. Steiner is not all wrong. Encompassing dread is not an inevitability, but it is a possibility.

Desmond claims this dread is an important experience for the philosopher. Tragedy chastens systematic philosophy, with its confidence in the comprehensive power of the logos and its tendency to abstract from the particular into categories or concepts. Systematic philosophy often excludes first-person experience. The experience of the philosopher is hidden behind "an impersonal universal system" (*BHD*, 163). Philosophers who hear Lear's howl and see him carrying the body of Cordelia, who fully reckon with being at a loss, will be left questioning their systems' ability to account for such loss. They will be confronted with the impossibility of words ever doing it justice. For Desmond, a dialectical pivot out of such loss is a dodge. It fails to account for the loss's *particularity*, its *singularity*. "Hegel's dialectical theodicy," claims Desmond, "fails for all Lears, mute before the elemental grief of fathers and mothers, mute before murdered children, the Golgotha of the intimacy of singularity. The rational comfort of dialectics does not comfort" (*PU*, 50).[32] Lear confronts the death of his absolutely singular daughter, and Desmond stresses that all loss is always of the singular.[33]

If there is any widening out here, then, it must still attend to the singular, and it may widen out into a sense of the meaninglessness of existence. These are the despairing words that follow Lear's howl:

> Why should a dog, a horse, a rat have life,
> And thou no breath at all? Thou'lt come no more,
> Never, never, never, never, never.— (5.3.370–72)

Gloucester's comparison of humans to flies reverberates with new force in these lines.

But there is also the possibility of catharsis and compassion, of a new affirmation of the "to be." This too comes through the particular, the intimate. If tragedy confronts us with the "once" passing into the "never more," it can also shock us into seeing the "once" anew.[34] Desmond says this renewed vision can be like a near-death experience. It can be an experience of "posthumous mind," as discussed in chapter 1. Desmond again

points to Dostoevsky's death sentence and then execution-day reprieve, as well as to the biblical story of the binding of Isaac. "Encounter with, or being brushed by the Never [again]," Desmond claims, "resurrects the Once in its splendor. The value of tragic insight offers itself in the precipitation of this ontological joy" (*PU*, 53). Such catharsis can awaken us to wonder at how "a rat, a dog, a horse" actually "live the intimacy of being in their own way, every entity a gift out of nothing by agapeic being" (*PU*, 54).[35]

Tragedy can leave the philosopher at a loss in two ways—before the annihilating "never" and before the wondrous "once." No system can make either fully determinate. A true confrontation with them will always leave the philosopher at a loss for words, or at least at a loss for the right words. Of course, in philosophy such a loss for words is an experience of *aporia*, and this is precisely what Desmond claims tragedy can induce in its returns to the *passio*. Just as Socrates dismantles the philosophical edifices of his interlocutors, so too can Lear's howl (or the experience of tragic catharsis) cut through philosophical systemization. Desmond thus puts a Platonic twist on his reworking of Aristotle. He claims that Plato, perhaps too simply seen as the enemy of tragedy, can help us understand its effects and import.[36]

This quasi-Platonic understanding makes tragedy not so much an antagonist of philosophy as a necessary companion. Tragedy can call philosophy back to the experience of humans as fragile creatures of the between who must perennially wonder at the mystery of being, which includes the perplexing mysteries of suffering and death. Philosophy can, and should, try to be systematic, but it cannot yield a complete closed system that does justice to existence. Tragedy can make the philosopher dwell on being at a loss, can make the philosopher more aware of the silences and mysteries that surround any utterance. It can challenge the philosopher to seek the universal not in abstractions but within the elusively intimate. It can remind the philosopher that other voices are needed, including the poetic voice, and that art remains philosophy's necessary and never fully subordinated interlocutor because it deals in particulars.

King Lear does not end with a howl. It ends with Edgar's first halting attempts to speak of loss and to begin the work of healing: "The weight of this sad time we must obey, / Speak what we feel, not what we ought to say" (5.3.392–93).[37] There is an echo of Edgar in Desmond's own words: "Philosophy must go on. . . . It can only go on[, however,] if it is honest about loss, if it keeps before its thinking the image of death, the memory of the dead" (*PU*, 44).[38]

Chapter 7

Redemptive Laughs and Festive Rebirth

This chapter moves between tragic lack and comic excess, between weeping and laughter. It begins with Desmond's account of affirmative laughter. This sort of laughter affirms life despite its tensions and absurdities. It offers another way of undoing the hardened *conatus* and returning to the *passio*. It can ultimately be redemptive, reopening relations and possibilities. The chapter moves on to read Herman Melville's *Moby-Dick* as a tragic work that is nonetheless full of laughter. *Moby-Dick* suggests the variety and frequent ambiguity of laughter. Still, affirming laughter is important in Melville's novel, especially the affirmative laugh that Ahab cannot muster. The third section turns to comedy proper and especially to Aristophanes's comic lampooning of philosophy. Desmond argues that it is important for philosophy to be able to laugh at itself. This laughter keeps philosophy humble, but it also affirms the tension between "grounded" life and speculative thought. It can even encourage a light-footed, laughing philosophy. The fourth section turns to festivity. It notes the festival's ethos-shaping ability to offer communal affirmation and an elevated experience of time. It explores how the ethos of serviceable disposability has weakened these aspects of festivity in modernity and how art can help keep a fuller festivity alive. The final section considers Charles Dickens's *A Christmas Carol* as a work of festive anamnesis for both Scrooge and the reader.

Laughter and Affirmation

Two approaches to laughter dominate the Western philosophical tradition.[1] One approach links laughter to a sense of superiority: the laugher laughs

at an inferior. This theory has ancient roots. In the *Philebus*, for instance, Socrates sees at least one type of laughter as entailing an unsavory, indeed malicious, contempt for the vices of others.[2] Hobbes offers an important early modern articulation of the superiority theory. *Leviathan* claims that laughter is self-aggrandizing. People laugh out of satisfied pleasure at their own actions or abilities, or they laugh at "the apprehension of some deformed thing in another, by comparison whereof they suddenly applaud themselves." Hobbes sees such laughter as a compensatory delight in the "defects of others." "Great minds" are unlikely to be laughers. They "help and free others from scorn; and compare themselves only with the most able."[3] Freud much later distinguished between "innocuous" laughter and a "tendentious" laughter at others. "In the case of tendentious jokes," Sonja Madeleine Tanner explains, "Freud suggests that we take pleasure in indulging lustful, aggressive, or cynical instincts from which we must at other times restrain ourselves."[4]

A second major approach links laughter to incongruity, such as when an expectation is comically subverted. This theory has ancient roots as well in both Aristotle's *Rhetoric* and Cicero's *De Oratore*. In modernity, Francis Hutcheson criticized Hobbes's account as too narrow because "laughter often arises without any imagined superiority of ourselves."[5] Hutcheson instead argued that laughter is "generally" caused by the

> bringing together of images which have contrary additional ideas, as well as some resemblance in the principal idea: this contrast between ideas of grandeur, dignity, sanctity, perfection, and ideas of meanness, baseness, profanity, seems to be the very spirit of burlesque; and the greatest part of our raillery and jest is founded upon it.[6]

Kant offers a significant incongruity theory in his *Critique of Judgment*. A surprising twist thwarts the understanding but stirs our innards and "has a beneficial influence on our health."[7]

Henri Bergson combines the superiority and incongruity approaches. He claims humor is directed at how the rigid actions of others—"a certain *mechanical inelasticity*"—leave them unable to adjust to shifting circumstances.[8] Bergson offers "the case of a person who attends to the petty occupations of his everyday life with mathematical precision," and who is therefore the easy target of "a mischievous wag" who might, for instance, replace the routine-bound person's ink with mud.[9] The disconnect between the routinized

behavior and the concrete situation makes Bergson's creative take on laughter a kind of incongruity theory. Bergson's emphasis on responsiveness is close to Desmond's emphasis on the fluid companioning of *passio* and *conatus*. But Bergson's account is a hybrid theory—one that appeals to superiority as well. Laughter often mocks the rigid person. Bergson claims there is an "*absence of feeling* which usually accompanies laughter."[10] He goes on to argue that "the comic demands something like a momentary anesthesia of the heart. Its appeal is to intelligence, pure and simple."[11] Mocking laughter of course exists, but Desmond suspects that even in such laughter "an energy other than that of the intellect is at play" (*GBPB*, 279). Laughter involves the intellect, but it also involves the body. Regardless, the kind of *passio*-returning laughter that most interests Desmond is different from Bergson's laughter at the routinized dupe. It is a laughter "with" rather than a laughter "at."

These theories offer insights into two important categories of laughter, but they do not exhaust the possibilities.[12] Laughter is plural and often ambiguous. Nietzsche is particularly well-attuned to this. He contributes to both the superiority and incongruity theories, but his oeuvre contains many sorts of laughs. Desmond likewise holds, "One can laugh in many different ways, in many different voices. Some laughter is full of resentment or disgust or violence. Some laughter, even though coupled with the clearest consciousness of radical absurdity, is like a benign amen on being" (*BHD*, 273). This kind of affirming laughter most interests Desmond. It has received scant attention in the philosophical tradition. He finds affordances in Plato and Hegel, but Nietzsche is again an especially important interlocutor.[13]

Nietzsche often associates laughter with superiority, especially in *Thus Spoke Zarathustra*. He does not, however, share Hobbes's qualms about such laughter. "Not by wrath does one kill," says Zarathustra, "but by laughter."[14] The "last men" laugh derisively at Zarathustra when he comes down from the mountain to exhort them and to prophesy. Theirs is a "herd" laughter of social complacency, of contempt for what might challenge them and their settled ways. It is the scornful laugh of the "neutral" or the "half-self" discussed in the last chapter. So far, Desmond might share in Nietzsche's critique of such a crowd, even if he is no disciple of the gospel Zarathustra offers them. For his part, and here the distance between Nietzsche and Desmond again opens up, Zarathustra laughs from the "heights," hurling laughter like lightning bolts or spears down at his enemies. He has "often laughed at the weaklings who thought themselves good because they had no claws."[15] Zarathustra is well-attuned to the subversive power of laughter, its ability to undercut and unsettle. Perhaps most provocatively for Desmond, however,

Zarathustra presents laughter as a means of affirmation, a "golden-emerald delight" even in the face of life's evils and sufferings: "for in laughter all that is evil comes together, but is pronounced holy and absolved by its own bliss."[16] In this way, Zarathustra's laughter can transform incongruity or absurdity rather than simply registering it.

Desmond again comes close to Nietzsche on this point, but key differences remain. Desmond claims Nietzsche is at times capable of true laughter at himself. Zarathustra's laughter, though, even his self-laughter, tends to privilege the *conatus* and self-transcending. Laughter is part of Zarathustra's training regimen to become the overman. Zarathustra teaches his disciples to laugh at themselves so that they might, in part, be impervious to others' mockery. It aims to free them from the need for social, ethical, or religious crutches. In this regard, there is still a link between the Nietzschean affirming laughter of *Thus Spoke Zarathustra* and superiority.

Desmond would not deny that Nietzsche points out and illustrates many real varieties of laughter, but he is interested in self-transcending laughter that involves a release from the will. Such laughter results in new openness rather than impervious self-sufficiency (though this openness entails its own resilient strength). It involves not just an affirmation of life but also a willingness to surrender certain strivings:

> A person marked by a good sense of humor gives expression to a character marked by a more or less habitual attunement to the *passio essendi* and to the recurrent discordances between it and the overreaching claims of the *conatus essendi* in human life. The release of laughter for this person is profoundly humane. It is not a laughing *at* but a laughing *with,* and is so because this person witnesses in his or her laughter the wisdom of being able to laugh at themselves. . . . A deadening seriousness falls on human commerce when we lack the lightness of touch that shows us to be intimate with the comedy of our own finiteness. Strangely again this intimacy is felt as lightening, as exhilarating even: the same things of importance can still be done, and their importance recognized, but they are carried differently now, indeed we may experience ourselves as being carried rather than [having] to be the carrier of the burden of serious things. (*GBPB,* 320)

There are significant echoes of Nietzsche here—especially in the emphasis on lightness and exhilaration—but for Desmond the lightness and exhilaration

are achieved by a release from the will and a return to the *passio*. Dissolving the calcified *conatus* leads to renewed community (a "laughing with" rather than a "laughing at"). It restores one to generous fellow-feeling. There is an affirmation of our place in the community of being in such laughter: "The body beside itself [in laughter] shows our bodies to be not our own but mysteriously incorporated in a body greater than our own: the archaic flesh of being" (*GBPB*, 316). A laugh can return us to the body, to the earth, to the other, to a delight in them. Contra Zarathustra, such laughter embraces an equality within the human community, which is not necessarily a herd.[17] Desmond's affirmative laughter is itself plural. There are laughs of straightforward affirming delight—the child's laugh, for instance, at a newly hatched bird or a beautiful day or an uncle's funny face. Desmond is especially interested, though, in affirming laughter that responds to absurd or fraught situations. He notes how laughter can restore some joy even in strange or stressful situations. Laughter can be redemptive in this regard, a resurrection out of potential despair. But again, one does not have to achieve the lonely heights to find these kinds of affirmative laughs. They are essential in a broad sense to life and community.

Desmond notes the ability of laughter to transform the seemingly "malign" absurdities of existence "into a benign surd" (*GBPB*, 279). He mischievously observes that Albert Camus's Sisyphus, looked at from another angle, is not unlike Wile E. Coyote, speeding over the edge of the cliff, falling, and then dusting himself off to give chase once more. He has the roadrunner to chase again and again instead of a boulder to push. Is making Sisyphus a joke a way of ducking the absurd? Or does it point to a wisdom that evades Camus? Desmond thinks the latter: "Camus does not want us to laugh, but wants moralistically to stick us with absurdity, albeit with a hue of aesthetic existentialist cool, and happiness that can *only* be imagined, if that" (*GBPB*, 311). Desmond finds Nietzsche, who also saw "the *comic* as the artistic discharge of the nausea of absurdity," more profound than Camus on this point.[18]

Desmond argues that good humor, including the ability to laugh at oneself, signals a virtuous character. Good humor prevents self-possession from verging over into self-righteous pride or self-delusion. Self-possession is indeed virtuous up to a point. Striving for full self-possession, though, can be a vice. Because one can never attain it, because the human always remains an "open whole," there is an illusion at work here. The effort to attain the illusory ideal risks becoming "pinched," "prudish," even "joyless" (*GBPB*, 283). The person of good humor has checks on this sort of "moral

corruption" (*GBPB*, 288). Such a person can let go of things and recognize the limits of one's control, while also being prepared to receive things back as a joyful gift.

Desmond thus challenges accounts of virtue that over-privilege composure and discipline. "The moment a Stoic laughs," Desmond claims, "he or she is no longer a Stoic" (*GBPB*, 281). He notes that there is much wariness of laughter in Western philosophical and religious traditions, especially because laughter tends to be "associated with our 'lower' nature, namely the body" (*GBPB*, 282). Furthermore, as we have seen, there is also wariness of laughter as at least potentially cruel. Yet, in characteristic fashion, Desmond notes the texture in these traditions. He observes the subtleties of humor in Plato, "the putative puritan philosopher of the pursed lips" (*GBPB*, 281–82). In the *Nicomachean Ethics*, Aristotle makes the "witty" a social virtue between the buffoonish and the boorish.[19] In the Hebrew Bible, the story of Abraham and Sarah links laughter and miraculous blessing. The laughter is perhaps first incredulous, but it is ultimately genuine. They give their son the name Isaac, which means "he will laugh" (*GBPB*, 278n3). Furthermore, Desmond rejects the depiction (and particularly Zarathustra's depiction) of a dour Christ. He acknowledges that the Gospels do not record Christ laughing. He finds it suggestive, though, that Christ does weep in the Gospels, because weeping and laughter are close kin. Both are an "undergoing of the *passio essendi*" (*GBPB*, 307). Christ's weeping testifies to his enfleshed humanity. Christ feasts as well as fasts, and Desmond also notes a lightness in how he handles thorny situations. He "cannot picture Christ grim" (*IU*, 394).[20] The "carnival" humor of the Middle Ages intrigues Desmond.[21] He also mentions the humor of the Catholic humanists Thomas More and Erasmus, who "were full of jest and wit and had a feel for absurdity; purging, perhaps redeeming laughter was ingredient in their humanistic mission and the reform of manners" (*GBPB*, 320n51). Such laughter is an ingredient in Desmond's mission as well.

Ahab's Absent Laugh

Among novelists, Herman Melville matches Nietzsche and Desmond in his sense of the plurality and ambiguity of laughter. *Moby-Dick* is a capacious novel, one that seeks to contain as much as possible. It is epic in its penchant for catalogue and its attempt to offer a cosmology, though here the cosmology is obscure and marked by perplexity. *Moby-Dick* is encyclopedic

in its collection of whaling knowledge, lore, and trivia, but it does not share the confident epistemology of the Enlightenment encyclopedia. Melville is well aware of what evades or exceeds taxonomy and categorization. The novel's capaciousness extends to genres. One nineteenth-century review of *Moby-Dick* calls it "a most remarkable sea-dish—an intellectual chowder of romance, philosophy, natural history, fine writing, good feeling, bad sayings."[22]

Melville's novel collects laughs as well. Stubb, the second mate, is his own encyclopedia of laughter. Critics tend to write him off as a buffoon or bully. Stubb is indeed limited in that he can only seem to laugh, but he nonetheless laughs in markedly different ways. This makes him more complex than critics often acknowledge. Stubb's laughs can be kind or callous. They can establish camaraderie or reassert the chain of command. They can dissolve the tension in a situation or register his own uncertainty. Some of Stubb's laughs resonate with the superiority and incongruity approaches to laughter, but Stubb's most important sort of laugh affirms. Stubb laughs in a way that allows him to be at home, at least in a makeshift way, in an unsettling world. Ahab, on the other hand, denies himself this sort of affirming laughter. Ahab laughs out of superiority or scornful defiance. An affirming, redemptive laugh would defuse the outrage that fuels his quest. To use Desmond's terms, this laugh would puncture his monomaniacal *conatus* and return him to the *passio*. In a novel full of laughs, it is this absent one that ultimately matters most.

Moby-Dick introduces Stubb as the "happy-go-lucky" mate whose laughter inculcates camaraderie and courage:

> Good-humored, easy, and careless, he presided over his whaleboat as if the most deadly encounter were but a dinner, and his crew all invited guests. . . . When close to the whale, in the very death-lock of the fight, he handled his unpitying lance coolly and off-handedly, as a whistling tinker his hammer. He would hum over his old rigadig tunes while flank and flank with the most exasperated monster. Long usage had, for this Stubb, converted the jaws of death into an easy chair.[23]

Stubb can be jocular and easy with the crew. He can provide the kind of humor that greases hard or dangerous work. His humor can get sailors through a long, unpleasant job, and it can steady their nerves as they close in on an "exasperated monster" of a whale. He sets a joking, tune-humming example.

The first lowering of the whaleboats underlines this by juxtaposing the ways in which the mates urge on their crews. Flask shouts out blunt encouragement. Starbuck whispers calmly to his jumpy boat crew. Stubb lounges at the steering oar and strings together an improvisational mix of jokes and threats. He begins "drawlingly and soothingly," perhaps poking fun at Starbuck (181). But his "exordium" steadily builds in intensity: "every mother's son of ye draw his knife, and pull with the blade between his teeth. That's it—that's it. Now ye do something; that looks like it, my steel-bits. Start her—start her, my silver-spoons! Start her, marling-spikes!" (182). Ishmael remarks on the powerful effect of Stubb's "peculiar way of talking": "He would say the most terrific things to his crew, in a tone so strangely compounded of fun and fury, and the fury seemed so calculated merely as a spice to the fun, that no oarsman could hear such queer invocations without pulling for dear life, and yet pulling for the mere joke of the thing" (182). The charismatic Stubb contrasts markedly with Starbuck and Flask in this regard.

Still, Stubb's humor is ambiguous. He hums merry tunes, but his lance is "unpitying." His humor is often a violent humor, a humor suited to the violent work of hunting whales. It may even be a calculating humor, with its mix of "fun" and "fury." What seems like improvisation and nonchalance is rhetorically dialed to a desired effect—the maximum effort of his crew. Even if Stubb delivers his threats in a jesting tone, the crew is still never quite sure that those threats are purely in jest. Ishmael notes that Stubb's "jollity is sometimes so curiously ambiguous, as to put all inferiors on their guard in the matter of obeying them" (182).

Stubb's whaleboat humor is thus paradoxical in that it both establishes camaraderie with the crew and reinforces his position of authority. This latter effect aligns with the superiority approach to laughter, which suggests another way in which Stubb's jesting threats remain threats. The fear is not only that Stubb will become serious and deliver punishment: his jesting threats also carry with them the threat of jest, of Stubb turning a humor as unpitying as his lance upon a member of the crew. Stubb's unsettling interactions with Fleece and Pip come to mind. If Stubb is the mate most associated with camaraderie, he is also the mate who most blatantly exploits the racial hierarchies of his day, even on the Quaker whaleship. Giddy with excitement over killing a whale, Stubb's humor takes a "sharkish" turn when he forces the Black cook Fleece to prepare a whale steak for him at midnight and then to preach to the sharks.[24] When Pip jumps from the whaleboat in fear and the chase must be abandoned, Stubb says: "We can't afford to

lose whales by the likes of you; a whale would sell for thirty times what you would, Pip, in Alabama. Bear that in mind, and don't jump any more" (321). Here the vicious joke gives way to explicit threat. When Pip jumps again, Stubb does indeed leave him in the water.

In the "Queen Mab" chapter, incongruity is more to the fore in Stubb's laughter. When Stubb complains to Ahab about his captain's deck pacing keeping him awake, he perhaps expects a grumble from Ahab, but he instead receives a deluge of invective that drives him back below the deck. Stubb has never dealt with a captain like Ahab before, and he cannot figure out why he did not stand up to the old man's tirade. Stubb tells Flask about a dream he had in the wake of this encounter. Ahab appears as an inscrutable pyramid. Stubb tries to kick it but ends up stubbing his toe. According to Stubb, "the greatest joke of the dream" is when a merman appears, presents a backside "stuck full of marlinspikes, with the points out" for him to kick, and then convinces Stubb that it was actually an honor to be insulted by Ahab (114). This dream calls to mind the incongruity approach to laughter. Ahab blasts Stubb's expectations and his categories. Stubb is not laughing at Ahab in this scene. (Indeed, here we might see a limit of humor in dealing with tyranny.) He is laughing at the unsettling situation.[25]

Stubb laughs in yet another way, though. He laughs in affirmation of life. This sort of laugh is not necessarily at something particular—the whale, a crew member, a dream. It is instead a laugh that simply affirms, a laugh that expresses, in Desmond's words, "joy in being at all, and enjoyment: affirming nothing, yet nothing but affirming" (*GBPB,* 317). Stubb is described early in the novel as "an easy-going, unfearing man" (105). The novel ascribes this to his laughter and his constant pipe smoking, which seem to inoculate him against the "mortal tribulations" of the world (105). The novel at times seems to suggest that this inoculation is merely a placebo effect. The pipe smoke and the laughs veil the harsh realities of the world. At other times, the novel suggests that Stubb's humor attunes him to real goodness in existence.

Moby-Dick is concerned with the inevitable losses, disappointments, and terrors of life. In the first chapter, Ishmael muses on how "the universal thump is passed round" (21). Desmond's kind of affirming laughter at oneself seems to show up in the novel as one viable response to this. We can think again of Stubb's dream about Ahab, where the language of the "thump" conspicuously recurs when Stubb recalls being kicked by Ahab's whale ivory leg: "And there's a mighty difference between a living thump and a dead thump" (113). Stubb's laughter in this scene may register his

inability to resist the monomaniac, and it certainly registers incongruity, but it also registers Stubb's ability to laugh at himself in a way that prevents resentment or sourness. Alan Dagovitz reads this scene along these lines: "Stubb admits the whole dream seems foolish, but also asserts that it has made him wise—the association between recognizing one's own foolishness and true Socratic wisdom needs no further elaboration."[26] Dagovitz notes that in a novel where the dangers of pride are so apparent, Stubb's humility in this scene should not be brushed aside.

Nor should Stubb's humility in this scene be read as simple cowardice. Stubb is not alone in his failure to resist Ahab. Stubb's ability to laugh at himself in this scene is part of a responsiveness that is in other regards admirable. Dagovitz speaks of the "embodied" wisdom that Stubb shows at his best. Desmond would call it a supple companioning of *passio* and *conatus*. Consider Stubb's lithe ease in the whaleboat. Because the novel uses whaleboat dangers as a metaphor for life, this ease is no small matter.

W. H. Auden accuses Stubb of simply being in denial about the terrors of life. Commenting on Stubb's reading of the doubloon, Auden claims, "A man who makes a religion out of the comic is unable to face suffering. He is bound to deny it and look the other way."[27] Whereas Ahab and Starbuck see grave portents in the doubloon, Stubb offers a comical reading of it in light of the Zodiac. As Dagovitz points out, though, Auden's take on this scene is questionable. For Stubb's reading of the doubloon explicitly notes the travails of life: "To begin: there's Aries, or the Ram—lecherous dog, he begets us; then, Taurus, or the Bull—he bumps us the first thing; then Gemini, or the Twins—that is, Virtue and Vice; we try to reach Virtue, when lo! comes Cancer the Crab, and drags us back" (334). The first chapter's "universal thump" echoes here again. Stubb's laughter does not turn from the travails of life; it affirms despite them. Stubb's final words in the novel, as he goes down before Moby Dick's rage, affirm in the face of "a most mouldy and over salted death": "oh, Flask," he says, "for one red cherry ere we die!" (425).

This is not to say that Stubb offers the noblest or most philosophical sort of affirming laughter. Dagovitz goes too far in naming Stubb the novel's great "hidden philosopher." Stubb may have some of the marks of "good humor," but he is no exemplar of virtue. (Cancer the Crab surely has a hold on him.) K. L. Evans's assessment may be closer to the mark: "Selfish, silly, perverse, Stubb is no captain and should not be followed as one. But in some sense Stubb embodies the carnal rush of terror and amusement that comes from finding oneself at a loss and being able to go on in a

certain way."²⁸ As Evans notes, Stubb lacks the earnestness that Melville also values. We might think of more earnest returns to the *passio*, such as weeping, contemplation, or prayer. These are foreign to Stubb's character. On the first day of the great battle with Moby Dick, Ahab chastises Stubb for laughing at a wrecked whaleboat. Figuratively, Stubb tries to skip the funeral and head for the wake, but then the wake is no longer a wake.²⁹ Auden's indictment seems more appropriate here.

The captain of the *Samuel Enderby* is another key example of affirming laughter. Both he and Ahab have lost limbs to the white whale, but the joking Captain Boomer refuses to ascribe too much intentionality to the whale and does not hesitate to weave his repartee with Dr. Bunger into the story of his injury and recovery. Captain Boomer is capable of an affirming laugh that has allowed him to move past his encounter with Moby Dick. Yet in this brief scene he seems as limited as Stubb, jocular and good-natured but ultimately one-dimensional.

Ahab cannot laugh the affirming laughter of release, but if he could it would arguably be a nobler laugh—and it would certainly be a more philosophical laugh—than Stubb's or Captain Boomer's. It would also be more fully redemptive, given both the compassionate "humanities" and the megalomania Ahab evinces. He is earnest in a way that they are not. He lives the urgency of ultimacy in a way that they do not. Stubb does not deny the chiaroscuro of life, its ambiguous mix of shadow and light, of good and evil, but Ahab has a fuller sense of the shadow in the chiaroscuro. He has wrestled more profoundly with the perplexities of existence. Again, Auden is not entirely wrong. Stubb's laughter is at least in part preemptive. It prevents him from dwelling on the mysteries of existence. It releases him from the urgency of ultimacy. Ahab's redemptive laugh, if he could utter it, would be the laugh of one who fully confronted the intractable mysteries, who plumbed them as far as he could, before making peace with them. His laughter would not dissolve the mysteries, but it would allow him to no longer feel a hubristic need to "strike through the mask" of reality (140). His laughter would signal his ability to affirm existence despite suffering and apparent absurdity. It would be "like a *return to zero* in which we can refresh our interface with creation, and its original potencies of being. Return to zero is a breakdown, but in the breakdown something more original breaks through" (*GBPB*, 313). His laughter would be a release.

Throughout the novel, Ahab tries to avoid anything that could potentially woo him away from his quest for revenge, anything that could offer some release from his monomaniacal willing, any breakdown that could

lead to a breakthrough. Immediately after his run-in with Stubb on deck, and soon after we have heard about the link between Stubb's pipe and his affirmation of the world, Ahab throws his own pipe overboard. He says it no longer soothes and asks, "What business have I with this pipe? This thing that is meant for sereneness, to send up mild white vapors among mild white hairs, not among torn iron-grey locks like mine. I'll smoke no more—" (113). In the final days of the hunt, Ahab forgoes the *passio* of sleep altogether. But he is also tempted by a release from his relentless striving and fixed purpose in new ways during this final push. He is moved by his compassion for Pip; by the entreaties of the captain of the *Rachel* to join in the hunt for his lost son; and by the beautiful weather and Starbuck's pleadings on the day before the battle with Moby Dick. On this day Ahab calls himself an "old fool" (405). He asks himself, "Why this strife of the chase?" (406). There seems to be a yearning for a restorative release: "Close! stand close to me, Starbuck; let me look into a human eye; it is better than to gaze into sea or sky; better than to gaze upon God. By the green land; by the bright hearth-stone! this is the magic glass, man; I see my wife and my child in thine eye" (406). The warm day intimates the elemental goodness within the chiaroscuro of being.

Note how the porosity seems to open up here, beyond this day, beyond Starbuck, to the whole "green land" and across the sea to his hearth, to his wife and son. Starbuck's eye offers an affirmation of Ahab's place within (rather than towering above) the elemental community of humanity. He seems close here to the redemptive tears of release. Indeed, a single tear falls into the sea. Perhaps too he is close to the redemptive laugh of release. Dennis Patrick Slattery notes that Ahab has reentered the waters where he received his wound from the white whale. It makes sense that "consciousness itself or feeling is reawakened."[30] In a way, Ahab's wound reopens. This might renew his desire to wound the whale in turn, but "an authentic breakthrough" could "also occur."[31] The reopened wound could drain and heal. Ahab wavers between these possibilities but ultimately recommits himself to his quest.

Ahab remains with his monomaniacal *conatus*, within the carapace that grew over his old festering wound.[32] He prides himself on being unmovable, on standing "alone among the millions of the peopled earth" with neither "gods nor men [for] his neighbors!" (413). He sees a release from monomania as a temptation toward weakness. But the novel calls that interpretation into question. Ahab has his "humanities," and in the encounter with the *Rachel* Ahab himself sees his failure to help as a betrayal of them.[33] His own decision unsettles him. On the day before the chase, when he resists

Starbuck's exhortation, Ahab suggests that he has lost control of his very willing. He asks, "Is Ahab, Ahab?" and notes that his "own proper, natural heart" resists him (406). The quest that he earlier presented as the apotheosis of his agency now seems to hold him captive. He is trapped within the armored machinery of his relentless *conatus*.

This novel full of biblical allusions ends with two resurrections.[34] Ahab is crucified on the back of the white whale and grimly "resurrected" at the end of the three-day battle as a corpse rising from a watery grave. Ishmael is "resurrected" by Queequeg's coffin-turned-life-buoy. There is a symmetry here, an implied opposition between the destructiveness of Ahab and the friendship of Queequeg and Ishmael. There is a similar symmetry between Ahab's denial of the *Rachel's* quest for help and how the *Rachel*, which still has not found its lost children, does not hesitate to take in Ishmael. The *Rachel* does not hold a grudge and leave him in the ocean. It chooses the path of agapeic service.[35] Still, the closing chapters of the novel hint at the foregone possibility of a different sort of resurrection for Ahab: a death of his monomaniacal will and a resurrection within his humanities, within the human community, and within the world. Rather than a betrayal of his strength, perhaps this would entail a sort of higher strength that recognizes and lets go of what is beyond one's control. Perhaps he needed the strength to weep redemptive tears, to laugh a redemptive laugh. In this novel of many laughs and sobs, it is their absence that marks the novel's ending. They are the "Amen" that Ahab cannot utter.

Can Philosophy Laugh at Itself?[36]

Philosophy needs comedy as well as tragedy for a dialogue partner. Comedy, too, can be both chastening and empowering.[37] In tragedy, the "negative otherness" of loss calls into question the systematic pretensions of philosophy. Lear's howl exceeds and humbles determinate philosophical wording, but it also spurs perplexed thought. It calls for new wording, a wording aware of its own inadequacy. The tragic chastening of philosophy can also be cathartic. It can purge porosity and renew attention to the fragile goodness of singular beings. Comedy can likewise chasten philosophical pretensions, namely by laughing at the dangers of abstraction. Comedy can help philosophy develop the ability to laugh at itself. This does more than chasten. It makes philosophy supple and gives it a sense of possibility. It can encourage a dancing, light-footed philosophy.

A long comic tradition lampoons the philosopher. Consider the story of Thales and the Thracian maid. Thales walks along in deep philosophical contemplation, his head upturned to ponder the heavens. Oblivious to his immediate surroundings, Thales trips into a ditch. A Thracian peasant observes and laughs. Her grounded common sense sends up the philosopher's abstract speculation.[38] Or consider Aristophanes's attack on Socrates in *The Clouds*. Socrates is depicted as a sophist whose "Thinkery" can educate one in the unjust logos of manipulative argument, in how to make the strong argument appear weak or vice versa. But Aristophanes also depicts Socrates and his students as obsessed with minutiae and as abstracted as Thales. The students in the Thinkery try to measure the jump of a flea. A rooftop lizard shits on Socrates while he is looking upward, lost in thought. We first meet Socrates high up in a raised basket pondering the clouds. The clouds themselves become the questionable, shapeless deities of speculative thought. Socrates represents reason in its most abstracted form, Strepsiades the body at its bawdiest. Desmond notes, "Socrates the soaring mind cannot get through to Strepsiades, the debunking, gross body" (*BHD*, 314). The quarrel between philosophy and poetry seems to be out in the open with Aristophanes, to have devolved into mudslinging or worse. At the end of *The Clouds*, an angry mob attacks the Thinkery. This is a markedly violent break with the conventional comic ending. Plato's *Apology* claims that Aristophanes's caricature contributed to suspicions of Socrates in Athens, suspicions that ultimately led to his execution.

If Plato gives us some of the great images of philosophy—the cave, the winged chariot—Aristophanes gives us his own great (anti-)philosophical image—the philosopher with his head in the clouds.[39] This image echoes throughout Western literature. Shakespeare's *Love's Labour's Lost* provides another example. Here the king and his noble companions pledge themselves to three years of celibacy, fasting, and study. Yet they are quickly tempted away from their pledge and into love-struck antics when the princess and her ladies arrive. Jonathan Swift, whom Desmond calls "Aristophanes' modern twin," gives us another example in *Gulliver's Travels* (*BHD*, 304). The men of the flying island of Laputa are lost in speculative thought.[40] They have made great advances in mathematics and music, but they are all but incapable of practicalities. They need their servant "flappers" to poke them so they can avoid the fate of Thales or simply complete the basic tasks of life. The wives of the Laputans, frustrated with their husbands, seek to escape the island and take more "grounded" lovers.

Moby-Dick has its own Aristophanic scene, one in which Socrates's raised basket becomes Ishmael's masthead. The contemplative narrator goes up into the masthead to watch for whales but is continually drawn into reveries. He sees this as a danger for all "absent-minded young philosophers" and warns: "move your foot or hand an inch, slip your hold at all; and your identity comes back in horror. Over Descartian vortices you hover. And perhaps, at midday, in the fairest weather, with one half-throttled shriek you drop through that transparent air into the summer sea, no more to rise for ever. Heed it well, ye Pantheists!"[41] In all these cases the philosopher is depicted as abstracted, out-of-touch, impractical.[42]

The comic critique of philosophy descending from Aristophanes can (and indeed has) become a cliché. It can take the form of crass anti-intellectualism, an insensitivity to contemplative depths and speculative heights. It can champion a reductive "practicality" as healthy common sense. This weakens the resources for resistance when this logic turns grasping or exploitative or when it turns against goods not easily justified by such logic. Think of the humanities trying to justify themselves in the present era of corporate education, justifying themselves to administrators who might see those departments as contemporary Laputas.

But Desmond does not think that philosophy should simply brush aside or bristle at the comic tradition that descends from the Thracian maid and Aristophanes. It can remind philosophy not to lose track of the body and the earth: "The earthiness of Aristophanic comedy can do more than debunk or deflate. It can bring us home to earth in a certain being-at-home with being" (*BHD*, 303). Sometimes philosophers do need Swift's flappers. They need to be reminded that "thought must do more than think itself alone; it must think its other or others. Sometimes speculative mind has to be slapped on the face to be reminded of this" (*BHD*, 305). Philosophy needs to be systematic, but its systems can become blinders. Comedy can knock off those blinders. It can puncture the hardened *conatus* of philosophy, can return it to the *passio*. This is not simple deflation, though, because in the *passio* there is renewed openness, a renewed eros.

Mikhail Bakhtin's discussion of "carnival laughter" and "grotesque realism" are suggestive in this regard. Bakhtin acknowledges the possibilities of purely formal satire or of simple degradation, but he discerns a more complex "folk" laughter descending from the festivals of antiquity and the medieval carnivals. These festivals and carnivals overturned the usual social order. The high were brought low, and the low were elevated. The official

order, including the church hierarchy, was often caricatured. Bakhtin's folk laughter is "universal in scope," and thus includes laughing at oneself: "it is gay, triumphant, and at the same time mocking, deriding. It asserts and denies, it buries and revives."[43] It is tempting to see Bakhtin's carnival or folk laughter as existing somewhere between the affirming laughters of Nietzsche and Desmond. As noted above, though, Desmond's affirming laughter is itself plural, and he is interested in a form like Bakhtin's as well, one in which eros and agape ambiguously intertwine, for Bakhtin claims that the point of carnival laughter was not simple derision: "To degrade an object does not imply merely hurling it into the void of nonexistence, into absolute destruction, but to hurl it down to the reproductive lower stratum, the zone in which conception and a new birth take place."[44] There is renewal and rebirth in such laughter.

Desmond sees a somewhat similar dynamic in Aristophanes, who presents himself as a defender of Athenian tradition, but at times makes the gods themselves the butt of his jokes. In *The Clouds,* the rube Strepsiades claims that rainfall is Zeus urinating through a sieve. In *The Frogs,* Dionysus is mistaken for his servant and whipped. Desmond argues that this is not simple irreverence, but a sort of "sacred folly," an "irreverent reverence." "The gods come to nothing" but then are "reborn as the providers of agapeic festivity. They are offered as sacrifices of laughter" (*IU,* 115). Both Bakhtin and Desmond suggest that this is somewhat hard for us to grasp today, when we tend to make a sharp opposition of reverence and irreverence. Aristophanes's caricature of Socrates may indeed have a sharper edge to it, but a philosophy willing to laugh at itself may find itself not simply hurled into the "void" but into the "reproductive lower stratum," into a place of renewal.

The comic lampooning of philosophy insists on the grounded body as a corrective to speculative abstraction, but Desmond claims it also maintains a sense of the between. It plays on "the elemental lack of coincidence between abstract intellect and reality, speculation and the body, thinking and being" (*BHD,* 304). Comedy can mediate conflict and discordance with laughter. This may not "solve" them. There is laughter that simply pours salt in the wound, and there is a laugh of defensive, parodic irony.[45] But there is also a kind of laughter that excites "a certain joy in discordance" and thereby affirms us as creatures of the between: "Even in the conflict, comedy still affords a celebration of being as festive" (*BHD,* 304).

Furthermore, laughter does sometimes dissolve conflicts, both on the comic stage and off it.[46] "All's well that ends well" is often said with

a chuckle. If there is a kind of laugh that turns a small squabble into a fierce fight, a different sort of well-timed laugh can end a fight and lead to reconciliation. The tension-releasing flexibility of the comic can loosen knotty predicaments. Laughter can break up a brittle status quo and open space for change. It can make a difficult task or a bad situation bearable.[47]

Comedy can puncture self-absorbed systems, but it can also overwhelm them. Comedy often involves a festive excess. Robert Dupree claims, "If there were a rhetoric of comedy—and surely there should be—its main figure would have to be copia, the theme of plentitude and abundance."[48] Desmond concurs, pointing to the suggestive connection between comedy and Comus, the god of fertility. In comedies, characters of all sort and station spill on and off the stage or page. Plotlines and purposes are multiplied and crisscrossed. Comedies at times break out of their own story-world, as when Aristophanes's personified clouds cajole the audience to give them the prize at the festival, or when Laurence Sterne delights in, and delightedly points out to the reader, the formal flexibility of the comic novel. From one angle comedy is a highly formulaic genre, but its formula is one of surprise and unlikely shifts. It is a formula of plenty. Like tragedy, comedy is often predicated on unintended consequences and reversals, but here they tend, at least in the long run, to work in the protagonists' favor.

The sheer excess of comedy can pose a challenge to philosophical systems. Dupree says, "Comic writers manifest a universe that is laden, despite rules and regulations, with more matter and spirit than any individual or society can contain."[49] Put positively, comedy can encourage philosophical suppleness and openness. A philosophy that takes tragedy as a dialogue partner will explore lack, loss, and the limits of agency. A philosophy that takes comedy as its dialogue partner will explore plentitude, renewal, variety, surprise, and possibility. A philosophy that attends to both will explore the hybridity of life in all its overdetermined excess. Philosophy must beware simply making a metaphysics out of genre conventions. But what is at play here is not only philosophy turning images and stories into philosophical propositions but also philosophy drawing tones, styles, dispositions, and moods from literature. It is a matter of allowing a genre to direct the philosopher's attention to certain phenomena.

A philosophy that attends to both tragedy and comedy sees that they cannot simply be opposed.[50] Again, tragic weeping (sometimes to the point of bitter laughter) and comic laughing (sometimes to the point of mirthful tears) can both renew porosity, albeit in different ways. Both tragedy and comedy can also evoke posthumous mind. Tragedy evokes this through

catharsis. Purged by the drama of loss, the audience is newly mindful of life's fragile goodness. The audience sees this goodness with eyes that have returned from the graveside. In comedy, the brush with death and the resurrection in posthumous mind are often explicit in the plot. They are experienced by characters. Northrop Frye notes, "Any reader can think of many comedies in which the fear of death, sometimes a hideous death, hangs over the central character to the end, and is dispelled so quickly that one has almost the sense of awakening from nightmare."[51] He points to how in Shakespeare's "*Measure for Measure* every male character is at one time or another threatened with death." Fielding's Tom Jones is "accused of murder, incest, debt, and double-dealing, [is] cast off by friends, guardian, and sweetheart" before he is delivered by a great comic reversal.[52] The threats in some comedies are dissolved by a "redeeming agent," such as Diana in Shakespeare's *Pericles* or the king in Molière's *Tartuffe*. To Frye's examples, we might add the ritual death and posthumous mind of Segismundo in Calderón's tragicomedy *Life Is a Dream*. He is re-imprisoned with no hope of escape, but then the peasant rebellion frees him and champions him for the throne. In contrast to the brash tyranny of his earlier brief stint as a royal, though, he now aims at virtue. Another example, which we return to later in the chapter, is Ebenezer Scrooge in Charles Dickens's *A Christmas Carol*. Scrooge undergoes a ritual death with the third ghost and is able afterward to see his life anew.

Comedy itself often calls forth affirming laughter. The paradoxical affirmation of tragic catharsis draws significant philosophical attention. The affirmation of comic laughter, paradoxical in its own way, draws significantly less. Both bring philosophy to a threshold beyond which precise determinability is impossible. One needs finesse, including a finessed awareness of the tragic or comic stage as a sacred threshold: "In comedy, in its lowliness, we can see something of sacred idiocy in the irrepressible resurrection of life affirming itself, again and again, even in absurdity" (*GBPB*, 275). Again, Bakhtin's complex folk or carnival laughter comes to mind. The mockery is in the service of an affirming vitality.

In short, Desmond thinks it is important for philosophy not only to give attention to laughter but also to be able to laugh at itself. He notes that we only have the story of Thales's tumble because Plato included it in the *Theaetetus*.[53] Desmond recounts old stories about Socrates clapping at *The Clouds*, about Plato dying with a copy of Aristophanes under his pillow. Socrates and Aristophanes seem to be on friendly terms in the *Symposium*. This sits askance with the caricature of the "logocentric" Plato, but it fits

well with the Plato of *aporia* and philosophical humility, with Plato's Socrates who rather coyly says he knows nothing. Desmond claims that the logos has many voices, and one "is this persistent voice of logos that mocks logos and that will not be silenced" (*BHD*, 253). Desmond goes on to specify that this is not the voice of misology. It would not be a voice of logos if it were. The "questioning voice" that interests him, the one he associates with Plato, is suspicious of claims to reason rather than reason itself. He is not interested in laughter at reason, or laughter at the questions that animate philosophy, but in laughter at a lack of philosophical humility before those questions or at the danger of self-enclosed abstraction. The questioning voice is also important because it challenges philosophy to attend to its others. The laugh of the Thracian maid is both mockery and invitation.

Desmond notes that Plato's dialogues themselves contain comic moments and philosophically significant laughs. Sonja Madeleine Tanner's analysis complements and extends Desmond's own in this regard. She points out how the dialogues draw on comic conventions. Aristophanes's hiccups in the *Symposium* are a recurrent reminder that the dialogue's soaring accounts of eros risk leaving behind the body.[54] In this reading, Plato himself sees both the humor and the philosophical significance of *The Clouds*' laughter at abstracted philosophers. Most significantly, Tanner argues that laughter in the dialogues is often "an invitation to look into the mirror it holds up and to see ourselves for the vulnerable and limited beings that we are. In this sense, laughter can play a positive role in regard to the Delphic imperative to 'know oneself.'"[55]

Desmond acknowledges that philosophical laughter has become more common in the wake of Nietzsche, but it is rarely self-deprecating or humble laughter. As noted above, Nietzsche is perhaps *the* great philosophical laugher. His laughter often mocks, and it often mocks Plato's ugly Socrates in particular. Nietzsche tries to out-Aristophanes Aristophanes. Nietzsche at times verges on megalomania, but at other times his laughter is more truly self-effacing than Zarathustra's. In the writings collected as *The Will to Power*, for instance, Nietzsche acknowledges that his Plato is a caricature.[56] Desmond sees less self-awareness and a less fulsome sense of humor in many of Nietzsche's postmodern followers. They follow Nietzsche in trying to overcome the philosophical tradition, and they mimic his mocking laughter. Yet the post-Nietzscheans, post-Heideggerians, and deconstructionists often do not acknowledge with Nietzsche that their Plato is a caricature. Desmond claims that any fair reading of Plato and the philosophical tradition will see that they are not univocal, that philosophy has always been accompanied by

a questioning voice. Desmond notes the desire among many philosophers and theorists in the wake of Nietzsche to "create the impression of being revolutionary, unprecedented in thinking the other; but then [they] smuggle back ideas that in some form or other are to be found in the tradition" (*BHD*, 265). Furthermore, the need to be at "the margins of philosophy" or "beyond metaphysics" can become a "straightjacket," cutting philosophy off from affordances that are to be found in a generous study of earlier thinkers.

Again, though, self-effacing laughter not only ensures philosophy's humility—it also energizes. A philosophy willing to laugh at itself can be a risk-taking philosophy. Someone too afraid of embarrassment will hang against the wall rather than try out a dance. But someone unafraid of embarrassment might surrender to the beat with a laugh, risking awkwardness but also the possibility of gaining something new. The philosopher who embraces the potential risibility of speculation may be more willing to follow a speculative hunch (and to admit when it doesn't come to much). The links in Nietzsche or Bakhtin between laughter, dancing, and renewal are again suggestive. The result can be a festive and supple mode of philosophical writing—a philosophy that can dance. As Desmond remarks in an interview with Richard Kearney, "I'm convinced there's this jubilating energy in the best of comedy that refreshes your appreciation of being alive at all. And if you can get some of that into thinking, it's the thing to do" (*WDR*, 236).

The Festive in a Time of Need

"What use are poets in times of need?"[57] This question, which appears toward the end of Friedrich Hölderlin's poem "Bread and Wine," has intrigued more than one philosopher.[58] Josef Pieper argues that the poem is about how moderns have "lost the power to celebrate a festival festively."[59] Consider these lines from the poem: "That which is superior had grown too great for pleasure / With spirit among men. And to this day no one's strong enough / For the highest joys, although some gratitude survives quietly."[60] Such gratitude survives in Hölderlin's poetic meditation. It is a smoldering ember of sacred festivity.

This section considers how art more broadly can shelter these embers. First, though, it surveys some major thinkers on festivity and its fate in modernity. The festive comes in many forms, of course. The festivity Desmond evokes is sometimes more carnivalesque, sometimes more Sabbatarian. The major philosophers of festivity, as otherwise different as Friedrich

Nietzsche and Abraham Joshua Heschel, nonetheless tend to agree on two constitutive elements: 1) collective, participatory affirmation and 2) an altered and enriched experience of time.[61] For Desmond, these elements make the festival a crucial influence on a culture's ethos of being.

At its best, festivity affirms the goodness of being beyond mere utility. Festivals bring the community together in celebration, redemptive laughter, and contemplation. For Nietzsche, ancient tragedy testifies to the Greeks' ability to affirm life while facing its horrors. Dionysian festivity entails both primal unity and affirmation. Bakhtin calls the Roman Saturnalia and the medieval carnival "a special condition of the entire world, of the world's revival and renewal, in which all take part."[62] Pieper claims that festive time offers a release from practical concerns that brings with it "expectant alertness" and broad contemplative awareness.[63] Desmond would call this a festive form of agapeic mind. Heschel claims that the Sabbath, the paradigmatic festival in Jewish and Christian traditions, builds "a *palace in time*," one "made of soul, of joy and reticence."[64] Gadamer claims, "Festive celebration . . . is clearly distinguished by the fact that here we are not primarily separated, but rather are gathered together."[65] For Gadamer, too, the festival carries with it a heightened relationship to time.[66] Byung-Chul Han claims, "The festive time as high-time brings the time of everyday life, the ordinary time for work, to a stand*still*. The brilliance of eternity is inherent to festive time."[67] Festivals and rituals "stabilize" time and give it duration. Desmond likewise claims the festival is "a *communal* rapture of the elemental" (*PO*, 298). It "ritualizes a more concentrated, intensive sense of time, where the devouring future is stayed for a brief span, where the grief of the past is submerged in the present enjoyment" (*PO*, 302).

The major philosophers of festivity agree on at least one more thing—the festival has been marginalized, enervated, or co-opted in modernity. It may seem peculiar to worry about the demise of festivity in modernity. Holidays are still the high points and the organizing chronology of the year for many. There are also new forms of festivity—especially in athletics and music. As with art in modernity, the relative autonomy of the festive from religion proliferated options. Furthermore, there is the danger of idealizing premodern festivals, which were often far from agapeic. Violence was at times central to the festival, as in Rome's gladiatorial games. Public executions were often festive occasions. The festival could spark the mimetic violence and scapegoating described by René Girard. The Christian Holy Week, for instance, at times fueled anti-Semitic violence. By contrast, the modern Olympics, a cosmopolitan event that unites people from around the

world, can seem like a purification and crowning achievement of festivity.[68] Desmond would not want to brush all this aside. Modernity has opened up new possibilities for festivity, and older possibilities remain. Festivity, like wonder, continually resurrects itself.

Yet Desmond notes how the temporality of modern work has warped festivity. Time becomes linear and homogenous—an endless string of uniform empty units, Hegel's "bad infinity." The weekend and even the vacation and holiday can take on a purely negative character. They are times to rest for the return of work, an often restlessly anxious rest. They are "a mere endgame, tacked on to the 'real' workday world—a mere adornment, concession or consolation" (*PO*, 302). In the digital age, they are easily spent scrolling on social media or binge-watching television. At a modern festival, "full" time—the release from anxious, empty time—can prove elusive.[69] Again, the digital age seems to exacerbate this. Instead of experiencing the festival, one continually snaps pictures of it or texts ones' friends about it. Devices pull us away from the moment and "fill" every lull.

The festival becomes something to consume. The festival or holiday itself becomes a marketing opportunity, a spur to consumption, even a counterfeit liturgy of consumption. This is another way in which the ethos of serviceable disposability has affected the festival. Think of how Black Friday and Cyber Monday increasingly overshadow Thanksgiving in the United States. The former now begins on Thanksgiving afternoon. Desmond would also note that festivity's increasing separation from religion not only creates new opportunities. It also moves in the horizon of transcendence, draining the festive of spiritual significance, even of the spiritually serious unseriousness of Desmond's Aristophanic comedy or Bakhtin's medieval carnival. As Pieper puts it, moderns may be materially wealthy, but they are often existentially poor. The true festival requires not "the wealth of money, but of existential richness."[70]

Given the attenuation of festivity in modernity, the artwork takes on special importance. There are genetic links between festivity and art. The festival was often the original home of art, and there are ways in which art carries that origin with it. Poetry and song have their roots in communal rites, celebration, and commemoration. In ancient Greece, rhapsodes recited Homer at religious festivals. Tragic conventions reveal tragedy's connection to religious ritual: masks, music, choreography, rhythmic speech. Comedy has festive origins as well. Susanne Langer observes, "Comedy is an art form that arises naturally wherever people are gathered to celebrate life, in spring festivals, triumphs, birthdays, weddings, or initiations."[71] Northrop Frye notes

how comedies often explicitly end in "some kind of party or festive ritual, which either appears at the end of the play or is assumed to take place immediately afterward."[72] The medieval mystery plays, which left their mark on Shakespeare, were great dramatizations of the liturgical calendar, sweeping reflections on not only the unfolding of the Christian story but of how festive time gives recurring narrative shape to each year. Bakhtin argues that the medieval carnival profoundly shaped Renaissance drama and the early novel. It bequeathed an "exceptionally rich and original idiom of carnival forms and symbols" to early modern literature. It was used by Rabelais and Cervantes, by "Erasmus, Shakespeare, Lope de Vega, Guevara, and Quevedo, by the German 'literature of fools' (*Narren-literatur*), and by Hans Sachs, Fischart, Grimmelshausen, and others."[73] One common concern from the Romantics onward, however, is the lack of such a festive context for art in modernity, the way this keeps art from leavening the culture as a whole.

The artwork can also offer the two constitutive elements of festivity: participatory affirmation and a heightened temporality. We are never fully passive before the artwork; our openness to the artwork is a participatory openness, rich with affirmative promise. Likewise, to attend to an artwork is to enter a different temporality. We become lost in a novel or caught up in a drama. (Checking one's phone during a play or film is a sure sign that something has gone wrong.) Music and poetry explicitly shape time via tempo, rhythm, and meter. Pieper says that Hölderlin's question about poetry in a time of need or lack answers itself.[74] Poetry, at least to some degree, treats the need.

This does not mean that the festive aspects of the artwork have not been attenuated in modernity. Gadamer points to how ancient, medieval, and even Renaissance theatergoers clearly saw themselves as participants, whereas contemporary theatergoers see themselves as observers.[75] The participatory element can never be fully effaced from the theater, but it can be recessed. Bakhtin likewise notes that the "grotesque realism" of the carnivalesque, which both pulls down and regenerates, has often given way to a more sterile and purely negative satire. Still, the carnivalesque can resurface. Desmond points to Joyce's *Ulysses* as a great festive novel that ends in the affirmation of Molly Bloom's "Yes."

There is a tension here. Pieper holds that "the fine arts keep alive the memory of the true ritualistic, religious origins of festivals when these begin to wither or be forgotten. And this memory may at some moment succeed in blasting open again the buried entrance." Still, he warns that "the very overestimation of the arts can also obscure this knowledge. The fact that

the arts have their natural place within festivals indicates that they are not themselves the festivals."[76] Again, we can ask too much of art, and we can also ask too little. To close out this chapter, though, we consider one of the most marked examples of festive art "blasting open" into modern life: Charles Dickens's *A Christmas Carol*. While this novella has a somewhat mixed legacy, it proves we should not ask too little of art.

Scrooge and Festive Anamnesis

A Christmas Carol could be read as the re-enchantment of Ebenezer Scrooge's world, and this is not entirely wrong. By novella's end, Scrooge savors the world again. He renews his communal belonging and his commitment to service. In its closing pages, Scrooge laughs a redemptive laugh that affirms the goodness of being. He enters heightened festive time. Still, it is important to note that the ghosts dis-enchant as much as they re-enchant. For Scrooge is bewitched at the beginning of *A Christmas Carol*. The ghosts undo an ancient spell with a peculiarly modern cast—the spell of greed. Scrooge's is the ethos of the counting house. It is one in which all value is measured in money. If something cannot be so measured, it is "humbug." Andrew Smith explains that *A Christmas Carol* is set in an England where wealth had "become less tangible, less visible, in part due to new forms of economic activity (such as, for example, the emergence of the Stock Exchange) and partly because of the prevalence of paper money."[77] At the beginning of the novella, Scrooge seems like an empiricist ready to call humbug on everything unseen (and even startling things seen if they can be ascribed to indigestion), but he most definitely believes in *this* invisible reality.

For Scrooge, holidays do not even have value as time to rejuvenate for work. Haley Stewart observes that his "worldview prizes only utility." This means that "a day off for festivity is merely theft to Scrooge."[78] Christmas is a way for employees to pick "a man's pocket every twenty-fifth of December!"[79] He cannot fathom why his nephew Fred, or his clerk Bob Cratchit, would be grateful on Christmas when they earn so little. He sees their families as expenditures they cannot afford (Cratchit) or bad business deals (Fred). He is pleased that people avoid him on the street. Scrooge incarnates the ethos of serviceable disposability in hyperbolic form (and, of course, in comic caricature). This extends even to whatever crabbed form of religion Scrooge holds. When Marley visits him from beyond the grave, Scrooge cannot believe that one so successful in business would be punished

in the afterlife. The first ghost takes him back to when his fiancée broke off their engagement. She says an "idol has displaced me," the "golden one" of "Gain" (79).

Scrooge's counting house ethos obscures much. The novella's opening pages dramatize this. The town is dressed up in decorations. In the spirit of the elemental community of the festival, both the Lord Mayor and the tailor whom the mayor recently fined for drunkenness prepare for Christmas. But a thick fog obscures these Christmas preparations outside the counting house. The low fires in Scrooge's workplace and in the hearth at his lodgings figure the human warmth recessed within him, as does the deep darkness of his chambers. Scrooge took over these chambers from Marley, but the original owner had been a Dutch businessman who lined the hearth in tiles illustrated with biblical scenes. Scrooge does not spend much time contemplating these, but they too might suggest the dangers of his counting house ethos. They might call to mind the golden calf, mammon, the eye of the needle, the money changers in the temple, and the thirty pieces of silver. They might also evoke the festive counter-ethos of gift, plentitude, and celebration—the water from the rock, manna, jubilee, David dancing before the Ark, the wine at the wedding feast, the loaves and fishes, the prodigal's return.

The Ghost of Christmas Past more explicitly reminds Scrooge of what his greed has obscured. He first returns Scrooge to a lonely boarding school boyhood in which he took solace in books like *Arabian Nights* and *Robinson Crusoe*. Watching his younger self read, Scrooge finds himself carried back into the delights of the imagination: "To hear Scrooge expending all the earnestness of his nature on such subjects, in a most extraordinary voice between laughing and crying; and to see his heightened and excited face; would have been a surprise to his business friends in the city, indeed" (72). The ghost thus begins by recovering the imagination and imaginative art from the realm of "humbug." The next scene is from later in Scrooge's childhood, when his sister Fan comes to deliver him from the glum boarding school. Here familial love and care come to the fore. The next is from Scrooge's apprenticeship with Fezziwig. It reminds him of the delight of his former employer's holiday parties. The scene presents Fezziwig and his wife as embodiments of festivity. They are associated with generosity, laughter, and dance. Fezziwig shows that festivity can leaven work and rescue it from mere utility. Crucially, Fezziwig turns his business into the site of the party. Again, Scrooge is carried away by the scene. The ghost baits him by calling the party "a small matter" that cost little money.

Scrooge becomes "heated by the remark" and speaks "unconsciously like his former, not his latter, self."

> "It isn't that, Spirit. He has the power to render us happy or unhappy; to make our service light or burdensome; a pleasure or a toil. Say that his power lies in words and looks; in things so slight and insignificant that it is impossible to add and count 'em up: what then? The happiness he gives, is quite as great as if it cost a fortune." (78)

The final two scenes concern Scrooge's ex-fiancée. They are far less pleasant for Scrooge. In the first, she breaks off the engagement. Scrooge's protest that Fezziwig's gifts cannot be measured in money is now confronted by her accusation that he weighs "everything by Gain" (80). In the second scene, she is married with a large and happy family. Her husband comes home and says that he has seen Scrooge sitting in his office, "Quite alone in the world, I do believe" (83). These scenes remind him of the romantic love he lost and the potential family life he gave up with it. Stewart observes, "In order to take the first step toward affirming the goodness of existence, Scrooge must acknowledge all his self-inflicted losses as true losses."[80]

The first ghost's strategy, then, is largely one of *anamnesis*. He seeks to remind Scrooge of what he already knows or once knew. He brings out what is recessed in his memory, in his soul, beneath his counting house ethos. It is also important to note that these scenes build some sympathy for Scrooge. They show that he *can* be reawakened, that there is still some non-monetary richness within him. Each scene makes him reconsider encounters from the evening before he was visited by Marley and the ghosts. The scene of young Scrooge reading makes him wince at his earlier treatment of the caroling boy. The scene with Fan recalls his brusque treatment of her son Fred. The scene with Fezziwig recalls his miserly treatment of Cratchit. The scenes also suggest how difficulties in Scrooge's life contributed to his becoming a curmudgeon. Fan suggests that their father was a harsh man. The coldness of the boarding school prefigures the coldness of Scrooge's office. Scrooge's ex-fiancée suggests that his hunger for gain began in fear of poverty.

The second spirit is the ghost of the festive present. He is a spirit of gratuity and goodwill. We first meet him in Scrooge's chambers surrounded by a great feast:

> Heaped up on the floor, to form a kind of throne, were turkeys, geese, game, poultry, brawn, great joints of meat, sucking-pigs,

long wreaths of sausages, mince-pies, plum-puddings, barrels of oysters, red-hot chestnuts, cherry-cheeked apples, juicy oranges, luscious pears, immense twelfth-cakes, and seething bowls of punch, that made the chamber dim with their delicious steam. (86)

The feast's abundance contrasts with the meager gruel Scrooge consumed in these chambers earlier. The sensual variety of this feast also contrasts with the abstract wealth of the counting house. The earlier fog, the earlier darkness of the chamber, gives way to a different opacity, the dense steam rising from the feast. This ghost represents not only feasts of plenty but also "qualitative richness," to use Desmond's term. Hence the extended visits to Fred's and Bob Cratchit's homes, which are imbued with a spirit of festivity and where Scrooge is mocked but also earnestly toasted. The Cratchits, in particular, are blessed by this spirit despite their poverty:

They were not a handsome family; they were not well dressed; their shoes were far from being water-proof; their clothes were scanty; and Peter might have known, and very likely did, the inside of a pawnbroker's. But they were happy, grateful, pleased with one another, and contented with the time; and when they faded, and looked happier yet in the bright sprinklings of the Spirit's torch at parting, Scrooge had his eye upon them, and especially on Tiny Tim, until the last. (99)

The ghost also represents the qualitative richness of festive time. His personality matches its heightened exuberance. He asks Scrooge if he is familiar with any of his older brothers, of which he has "more than eighteen hundred" (87). The ghost and his brothers suggest the nonidentical repetition of the festival—the continuity without exact replication that allows it to be both perennially old and perennially new.

The Ghost of Christmas Present offers the most pointed and direct critique of Scrooge's counting house ethos. He represents festive giving as much as celebration. Richard Hughes Gibson claims that Dickens's Christmas books urge "Christlike openhandedness." Dickens wrote *A Christmas Carol* at least in part as a response to the widespread exploitation of child labor in England, and in particular to a parliamentary report from the Children's Employment Commission. Critics point out that direct representations of child labor are notably absent from the novella. Still, at the end of his visit to Scrooge, the Ghost of Christmas Present lifts his robes to reveal Ignorance

and Want personified as two impoverished children: "Yellow, meagre, ragged, scowling, wolfish; but prostrate, too, in their humility" (108). Scrooge asks if they have "no refuge or resource," and the Spirit returns Scrooge's words from earlier in the work: "Are there no prisons? . . . Are there no workhouses?" (109). Earlier in his visit, the Spirit takes Scrooge to a hovel on a desolate moor where miners nonetheless sing Christmas songs. The novella is often didactic—"unabashedly preachy," in Gibson's phrase.[81] This scene at the mining hovel does not receive as much overt commentary as some of the others. Still, like the scene at the relatively better-off Cratchit home, it may suggest the human capacity for festivity even in desperate circumstances, a capacity that gives the lie to Scrooge's exploitative reduction of humans to their use value or account balance.

The Ghost of Christmas Yet to Come confronts Scrooge with the fate that awaits him if he does not change his ways. He takes Scrooge to a rag-and-bone shop in London's slums. Three women arrive there after pillaging the home of a recently deceased businessman: "This is the end of it, you see! He frightened every one away from him when he was alive, to profit us when he was dead! Ha, ha, ha!" (117). One woman even stole his bed curtains and blankets. The dead man is Scrooge, of course, and he undoubtedly knows this even as the Spirit takes him to the cold chamber where the body lies covered only in a sheet. The women deal with him according to the ethos of the counting house. They liquidate his possessions and treat his corpse as rubbish. When he asks the Spirit to show him "any person in the town, who feels emotion caused by this man's death," the Spirit takes him to the house of a young couple who are relieved that their unrelenting creditor is dead (119).

The third spirit also shows Scrooge that Bob Cratchit's son Tiny Tim has died. The second spirit stirred Scrooge's admiration and affection for Tiny Tim, and Scrooge now rues the passing of the boy who brought so much warmth wherever he went. Here the reversal of Scrooge's values is complete. He sees the worthlessness of his crabbed life of business "success," and he sees the great worth of this sickly boy, who at the beginning of the novella he undoubtedly would have seen as a parasite on society. "These horrors startle Scrooge into supplication for a transformed life and future," Stewart writes, "not merely because he fears death but because the goodness of existence has become strikingly clear."[82]

After his night of ghostly visits, Scrooge changes his ways. He himself now embodies festivity. Tiny Tim helps us to see this transformation as more than self-interest. Scrooge may want to save himself from a bleak death and

Marley's fate, but he also wants to save Tim and to sustain the families and communities that he has scorned, undermined, or exploited. Scrooge offers a radical example of posthumous mind. He is resurrected to the world, and he now sees its worth beyond monetary measurement.

Dickens's novella stirred festivity in its Victorian readers and in many ways shaped the English Christmas. Of course, it offers a simplistic contrast between festivity and the counting house. The Scrooge at the beginning of the novella, less shrewd than many in his wake, does not recognize the profit possibilities in the holiday. Indeed, if Dickens helped to "invent" Christmas, he also helped to commodify it, as any number of critics have pointed out, given the relatively high price at which *A Christmas Carol* was sold and given the many scenes of "festive" purchasing within it. The novella's festivity perhaps aims to alleviate social ills more than transform the society that produces them.[83] Still, it is a novella that suggests the porosity between art and festivity, that suggests the possibilities (and perhaps also the limits) of art's ability to reenchant a modernity enchanted with disenchantment, a modernity mis-enchanted by wealth.

Conclusion

As this study ends, we might situate Desmond among a few of the many possible relations between literature and philosophy. There are the ancient quarrels. Philosophers note how the poetic image can mystify, mislead, or distort, how it can "conceal as well as reveal" (*PO,* 37). They point out that art can be frivolous, dubious, or even insidious, that its wisdom and depth can be illusory or obscured by dross. Desmond notes "that the poet's image casts its spell and seduces, but the visionary gleam does not always glow. When it fades, skepticism brings the suspicion that it was mere play, a child's game" (*PO,* 38). The philosopher sifts the poet's images, perhaps discovering that some are "empty, images of nothing" (*PO,* 38).

From the other side of the quarrel, poets can follow the lead of Aristophanes and Swift. They can chuckle at philosophers with their heads in the clouds, who have lost touch with body and earth, who trim the world to fit their theories and throw the rest away (or simply build a theoretical cloud cuckoo land), who claim that the proposition and the concept are the only legitimate approaches to truth. Some philosophers agree. If Homer is up against Plato, Nietzsche sides with the blind poet-seer. Nietzsche inaugurates a postmodern line of "treasonous" philosophers, running through Derrida and Richard Rorty, which champions the poets.

Desmond does not brush the quarrels aside. They are part of an honest dialogue between philosophers and poets. The concerns raised need not be slanders or sneers. The philosophers can challenge the poets to reach their highest possibilities, to avoid the shallow decked out as the serious. They can remind the poets that concepts can clarify rather than obscure. The poets can call the philosophers out of the desert of desiccated thought.

Desmond, however, finds the affinities more compelling than the quarrels. Literature provides philosophy with example, instance, and illustration.

This allows the philosopher to think through the particular. In this regard, if the philosopher truly attends to the literature, the example is always more than an example. It anchors philosophical theory in the concrete. It puts pressure back onto the philosophy. Any philosopher who truly attends to art as an illustration must also recognize that any "propositions" or "lessons" deduced from it do not exhaust the artwork. Desmond concludes: "Philosophy explicates and brings to self-consciousness the richness made present in art. But also, the concreteness of art continues as a basic challenge to philosophy, challenge for it to overcome its own tendency to reduce experience to generalized abstractions" (*AA*, 31). Again, the illustration turns out to be more than an illustration. Art incarnates the richness of being. It can teach all of us, including philosophers, to attend to this richness.

Philosophy can also turn more openly to literature for insight and wisdom (and vice versa). Philosophy can take literature as a "companion," moving beyond querulous rivalry to attend to what literature teaches. There are many notable examples, from antiquity to today. In Desmond's philosophy, we might think of how Dostoevsky helped inspire his notion of posthumous mind, of how Hopkins helped inspire his accounts of idiocy, selving, and overdeterminacy. Among other recent philosophers, we might think of Stanley Cavell's meditations on Shakespeare, of Martha Nussbaum's on ancient tragedies and modern novels. At times, philosophers defend literature's ability to provide insight into the world and into our condition against the literary theorists, who can be coldly conceptual in their own way.

Desmond writes between "poetics" and "system." He is not trying to poetically overcome or deconstruct the philosophical tradition, though poetry does help to keep Desmond's system open. Nor is he trying to project aesthetic value onto the meaningless flux of existence, à la the tradition of Nietzschean postmodernism, though he claims that art does incarnate worth. His poetics, like his system, is metaphysical, seeking to evoke the excess and inherent worth of being.

At the most basic level, Desmond claims that both poetry and philosophy are "guardians" of language (*PO*, 36). Philosophers learn their language from other philosophers, but "philosophy as a communication must go to school with, take time for, *skolē* for, the poets" (*GBPB*, 216). This is true of all philosophers, but it is most evident in those who are explicitly "poetic," such as Plato, Kierkegaard, and Nietzsche.[1] This is not simply a matter of adornment, of throwing "drapery over the sturdy drab furniture of thinking" (*VB*, 178). Writing of his own poetic philosophy, Desmond claims it is a matter of "*enactment*: the very concreteness of thinking itself as performed

in fitting words. The words are not just a matter of 'talk about' something, but are uttered or written somehow to bring to pass a happening, to enact it mindfully" (*VB*, 178). Again, Desmond's poetic descriptions are meant to incarnate the richness of being, to word wonder.

The previous three chapters show that genres are not only a matter of convention. They attune us to being in particular ways. This is another way in which philosophers go to school with the poets. Literary genres offer disclosive moods and tones. They focus attention on certain phenomena. They have their philosophical analogues.[2] (Literature can, of course, be influenced in turn by philosophical discourse so that we get "philosophical" poems and novels.) Consider the oracular mood of the lyric epiphany, as evidenced in Hölderlin and Rilke. Consider late Heidegger as a philosophical analogue. Rousseau wrote novels and novelistic philosophy. Hegel's *Phenomenology* has been compared to a *Bildungsroman*. Consider the tragic philosophy of Schopenhauer, Emil Cioran, or Lev Shestov. "There could be no Derrida," George Steiner likewise claims, "outside the wordplay initiated by Surrealism and Dada, immune to the acrobatics of automatic writing. What lies nearer deconstruction than *Finnegans Wake* or Gertrude Stein's lapidary finding that 'there is no there there'?"[3] Cornel West draws on the biblically-inspired prophetic tradition. Satirical philosophy is common, but Kierkegaard and Nietzsche are rare in that they are not only master satirists but also broadly comic. Among contemporary philosophical performers, Slavoj Žižek styles himself "the jester of post postmodernism" (*WDR*, 243). More sober analytic philosophers may not recognize the performance as philosophy at all. But arguably they have not escaped genre conventions either, even if they turn from the literature section of the library to the mathematics section. There are generic and linguistic attunements in New Brunswick, New Jersey, as well as Paris, France.

A philosophy marked by one attunement can be powerful. An epiphanic philosophy such as the late Heidegger's, for instance, is immersive and rife with suggestion. It draws the receptive reader into its mood. The danger of one attunement, though, is that it both reveals and conceals, to use a favorite Heideggerian phrase. The attunement of the genre, as well as its conventions, can be mistaken for a disclosure of the whole. Desmond suggests this is a particular danger of tragic philosophy. It can lose track of the chiaroscuro, the hybridity of life, the goodness that makes tragedy possible in the first place.

What of Desmond's own attunements? Steiner makes a rough distinction between philosophical system-builders and aphorists:

> There are the builders of systems, the architects of enclosure and addicts of totality such as Aristotle, Hegel or Comte. And there are the raiders, often solitary, on meaning and the world, the technicians of lightning striking as it were from the periphery, "lightning" being in both Heraclitus and Nietzsche a methodological password.[4]

Where does Desmond fit, working as he does between system and poetics? Tantalized by the tremendous energy surging in every thunderstorm, some green energy futurists dream of a lightning harvesting system. Desmond envisions something like the philosophical equivalent: a metaphysical system designed to attract wonder strikes, a system that does not dominate or drain but instead draws energy from its openness to the "too-muchness" of being.

In terms of poetics, is there a more recurrent philosophic-literary mood or generic attunement in his writings? Desmond acknowledges that being is said in many ways, by both philosophy and literature. He draws on a range of attunements. Indeed, his philosophy is something like the player troupe in *Hamlet*, amenable to any genre or combination thereof. Desmond's writings are at times tragic, at times comic, at times festive. Cyril O'Regan observes that for Desmond "philosophy is a raid on the inarticulate that enlists in its articulation any and all available forms of discourse (e.g., symbol, myth, comedy, tragedy)."[5] As Ryan Duns notes, Desmond's philosophy is often epiphanic—especially in the "freshness deep down things" way of Hopkins's poetry.[6]

Desmond is a philosopher of an astonishment that continually descends into perplexity and continually returns to astonishment again. More precisely, Desmond is a philosopher of reverent wonder. This is not a blind reverence but one that receives the world as a gift. Desmond notes the early influence of the Romantic poets and of the psalms. The latter, with their astonished reverence and reverent perplexity, may offer the deepest orientation at work in Desmond's philosophy. Perhaps the psalmist's songs echo in Desmond's own songs to being. His philosophy, when it reaches the limits of thought, can sing to the mystery. Again, Desmond may seem to leave philosophy behind here. Philosophy can end in furrowed-brow perplexity, in frustrated *aporia*, but can it end in a song of praise? Desmond says it can.[7] In doing so, he renews ancient possibilities. Consider Catherine Pickstock's argument that there is a "doxological" trajectory in Plato.[8] Consider Jean-Louis Chrétien's claim that "Jerusalem has its gratitude, but Athens has its gratitude too. It is called philosophy."[9] He adds, "Philosophy is a quest imbued with admi-

ration, an inquisitive marvelling."[10] Desmond concurs: "The deep affinity of speculative mind and the religious celebration of festive being is ingrained in metaphysical *thēoria*" (*BHD,* 92). Philosophy, like religion, like poetry, can be a song of praise. Desmond often sings on the shared threshold.[11]

The relationship between philosophy and literature takes us once more to the root and to the limit. Both grow out of myth and out of the archaic wonder that pervades myth. In Donald Verene's formulation, "The speculative imagination and the poetic imagination have a common origin in the mythic imagination, in the narratives from which all human culture arises."[12] Desmond, like Verene, takes his bearings from Vico in this regard.[13] Poetry is more ancient than philosophy proper. Philosophy begins with the poet-seer: "Unlike the modern aesthete, the poet was priestly, regal, heroic, sage, as Vico rightly recalls" (*PO,* 35).[14] Desmond notes that "Parmenides, the philosophical father, was a strange conceptualist poet" (*PO,* 35). Plato, the artists' supposed "arch enemy," nonetheless "voiced the eros of philosophy in dramatic dialogues" (*PO,* 35).

How to understand philosophy's origins in myth and poetry? Perhaps philosophy simply leaves them behind. Philosophy sloughs off their untruths or refines their adulterated truths and then sets out for truth beyond them. Myth is the egg sac from which philosophy emerges and which it then eats for initial strength. Afterward, it leaves the larval life behind. Desmond rejects this account. Philosophy may emerge from myth into its "own" conceptual middle, but it still needs its mythic roots. For those roots draw sustenance from the mystery and excess of being. Vico again: if thought is fully uprooted from myth, desiccation follows. Reason becomes gaunt and even barbarous. The instrumental reigns over a world drained of value. For myth offers "less an indigence of intelligibility than a *reserve of importance* to which every intelligibility is indebted, but which no univocal or dialectical intelligibility can exhaust" (*VB,* 162). Philosophy can draw many determinations out of its mythic roots, but they are never fully exhausted. Desmond claims that philosophy must tend to these roots, and to its ongoing relationship to religion and art, "to continue to be (re)born and to thrive" (*VB,* 163).

William Christian Hackett argues that even when instrumental reason reigns, though, the mythic has not been fully left behind. Instead, the culture has grafted onto a different, less sustaining mythology. A metaphysical background narrative always exists. Another name for this is a myth. Hackett claims that philosophy is always structured by mythic narrative, whether it realizes this or not. All philosophical propositions, no matter how analytic

or how stridently post-metaphysical, belong to a metaphysical backstory, a narrative more or less explicit, more or less coherent. The proposition cannot be neatly divorced from the narrative. Hackett defines myths as "those narratives that tell the story of the whole." One common Enlightenment myth is "the mythification of reason in its emergence from myth."[15] This is a myth of curiosity. It seeks to conceal mystery and astonishment. Why is there something rather than nothing? Why is being intelligible? This myth masks such questions. This myth leads to the barbarism of reflection. Post-metaphysical philosophers might nod in agreement. But the overcoming of metaphysics, Desmond would say, is yet another myth tied up with the Enlightenment conception of a radical rupture with the past. It is a mythic totalization of the supposedly totalizing metaphysical past. The great advantage of the ancient myths (and this is not to deny their dangers) is that they tap into a richer wonder.

If philosophy needs myth at the root, then, it also needs it at the limit. Consider Plato's Socrates. He presses for clarity, for determination, yet "when discursive reason reaches a certain limit, there is a resort to more poetic, and crucially, more mythic ways of speaking" (VB, 162). Vico claims that philosophy draws on the "imaginative universals," the archetypal images, of myth.[16] Plato draws on mythic images, and he also gives philosophy its own imaginative universals:

> But who has endowed the philosophical tradition more richly with its philosophical images, such as the Cave, the Sun, the winged soul, and so on? Do not these images present some of the imaginative universals of philosophy itself, to which thinkers return again and again, and not because they are deficient in speculative reason but because something offers itself for thought that is in excess of the concept, even Hegel's. What Hegel would take as their conceptual deficit may well be a surplus of significance through which the philosopher is endowed with winged thought. (AOO, 19–20)

The continual return to these images is one way in which philosophy footnotes Plato. Or perhaps this is the wrong metaphor—philosophy is not footnoting here so much as begetting on the brilliant image. Perhaps such philosophy is a kind of ekphrastic art. These imaginative universals spur continual thought and reflection. But they also, as O'Regan points out, involve "all levels of the self, the affective, sensory, erotic and somatic as

well as the cognitive level."[17] Plato is once more the great critic of poetry and the great poetic philosopher. Desmond returns to Plato's cave throughout his writings, often pairing it with another imaginative universal—the descent into the underworld.[18] In these final pages, we might take a closer look at these returns, at how they bring together many of Desmond's key concerns. They take us one final time to the intersection of philosophy, art, and religion.

Desmond returns to the cave to explore the possibility of renewing wonder in a purportedly disenchanted world and of thereby affirming the goodness of being. As we have seen throughout this study, a "chiaroscuro" of good and bad, hospitality and threat, joy and suffering plays on the cave wall of everyday experience. This ambiguous hybridity marks every human life. The cultural cave of our day, however, has its own peculiar distortions. The ethos of serviceable disposability pervades it. Within this cave, we can't see the light of the sun—the resplendent, excessive worth of being, the sun itself the blazing emblem of the endowing divine origin. The perplexed philosopher could follow the Platonic path of ascent. Desmond offers his own practices for such ascent. He invites us to cultivate agapeic mind, to leave empiricism and other reductive philosophies behind in the cave. We may not literally ascend, but Desmond would claim that mindful attention to things themselves, to their mysterious *thereness* and aesthetic excess, gives the lie to conceptions of being as valueless and inert. It also allows for a profound affirmation. Reawakened to the mystery and richness of things, we can sing their praise. Returning to the surface in this way also raises the question of the origin, the question of God. The hyperboles of being, as discussed in chapter 4, throw us toward the origin. In staying true to the resplendent, hyperbolic "surface of things," we paradoxically transcend toward the sun (*GBPB*, 67).[19]

In his reflections on Plato's famous allegory, Desmond does not make much of the shadow-casters in the cave. They are intriguingly named *thaumatopoioi*—wonder-workers. In our contemporary cave, we might consider how technological mediation shapes our "ethos of being." We increasingly live in a cave where digital workers and their algorithms try to enthrall us with counterfeit wonder.[20] Desmond has relatively little to say about digital technology and how it reshapes our sense of ourselves and the world. If we increasingly mesh with technology—if our future is cyborg—will we lose our constitutive porosity to external being? Will our existence become so digitally mediated that the wonder of (un-virtual) being can no longer strike us? Will VR Laputans need flappers to return them to (un-virtual)

reality? Desmond's philosophy offers affordances for thinking about such issues, but a kindred spirit like Byung-Chul Han offers more explicit and extensive reflection upon them.[21]

In Desmond's cave, there are other options than Platonic ascent or staying put. He points out that "*different directionalities*" are possible within the cave: "We can move up, we can stay where we are, we can also move down" (*GBPB*, 69). Desmond holds that many moderns pursue the latter. They burrow down deeper in the cave. They seek an origin not in the light above but in the subterranean depths below. Rather than seeking to reaffirm the goodness of being, these philosophers delve into the horror of being. They discover confusion, abyssal darkness, and violence beneath the cave. Playing on the ancient understanding that the human is a microcosm of the Cosmos, they hold that we are not only within the cave of reality—we are also caves ourselves, and there is violence and irrationality in our own deepest chasms and buried passages. Schopenhauer, Nietzsche, and Freud go spelunking in these depths.[22]

Desmond does not simply brush this aside. Violence and flux, intractable ambiguity—these are crucial aspects of existence. If astonished wonder carries us on the path of ascent, perplexity turns us downward. Furthermore, even when we are struck anew by astonished wonder, the equivocal chiaroscuro is never fully resolved. It is constitutive of the human condition. What the ascent secures is not determinate knowledge so much as a renewed attunement to the agapeic dimension of being, a renewed sense of the goodness of the "to be." Perplexity will nevertheless press on us anew. We will always be struck anew by suffering and death, by violence and malice, by doubt and ambiguity. We are bound to return to the cave and bound as well to ponder its subterranean depths.

Given this unavoidable perplexity, given the way it draws us downward, Desmond launches a second foray: Is there a descent that still ends in renewed astonishment? Perplexity can be simply debilitating. It can lead to crippling despair. Desmond again insists there are multiple possibilities for ascent and descent: "There are ways of going up that cast one down: hubris and downfall. There are ways of going down that lead up: redemptive passage through Hell—see Dante conducted by Virgil. There are ways of going up that do go up, ways of going down that go deeper down and don't come up" (*IU*, 310).[23] Astonishment can reemerge out of a perplexity that acts as "a kind of purgatory" (*ISB*, 296). In this sort of perplexity, we find ourselves carried down into dark depths, but the harrowing descent undoes our self-delusions and our fixations. Our *conatus* is humbled. We are

harshly returned to the *passio*, to a cracked open porosity. As Desmond puts it, we become "as nothing" (*GBPB,* 270). Yet this new porosity can open us to more than rending forces. Perplexity can strip us of our pretensions and allow us to see anew, as if reawakened or reborn. It can offer its own form of catharsis or posthumous mind. We find ourselves both rent and renewed, released into a new mode of being.

Desmond points again to Lear on the heath, where, stripped and soaked and humiliated, exposed to the storm and human cruelty, Lear is suddenly overwhelmed by compassion. Desmond also points to Dante going down into hell. Desmond sees the echo of another ancient imaginative universal in both—the descent into the underworld. With Lear,

> We are under the underground, below Plato's cave, where the light above earth does not penetrate. And yet deep down under, the intimacy is not avoided, for we are it, we are in it, and to be so is always to be companioned. The divine is there in the bowels of hell. Jesus harrows hell. Dionysus is also Hades. Orpheus sings in the underworld and the dead and the lords of the dead are moved. (*IU,* 69)

There are agapeic traces even in the underworld.[24] *King Lear* is set in pagan times, but the Christian allusions in Lear's speech on the heath are overt. In Christianity salvation lies through the cross and Christ's descent into hell. Descent can be a sanctifying kenosis; suffering that draws us closer to Christ can issue in Christ-like compassion. Desmond would say that such descent and compassion are not only a theological teaching. They are something of philosophical significance.

Dante's is the most famous literary descent into the underworld. At the beginning of the *Inferno,* Dante is perplexed in the dark wood of error. He tries to take the direct path of ascent, but the monsters of vice turn him back. The shade of Virgil arrives to guide him, but the path to paradise leads down through hell. In the descent, Dante encounters manifold possibilities of self-delusion, vanity, and viciousness. Each encounter is an opportunity for searching reflection on Dante's part. Kathleen Raine notes,

> His journey follows a descending course through ever-narrowing circles, each representing some of the sins that deform the soul; and there, in each of the states, the poet is moved, now with pity, now with horror, to find persons he had known on earth.

> But each successive hell is at the same time a recognition of what lies within himself.[25]

The descent is kenotic. Likewise, "the descent into our interiority can turn into a descent into hell, but in going deeper inward and downward, as the sun too goes under the earth, we can be turned again upward and can ascend to the superior" (*G,* 24–25). Schopenhauer, Nietzsche, and Freud were not wrong about the dark depths of our inwardness, about the violent urges and repressed brokenness that lurk there. But Desmond claims that passing through these, as traumatic as that may be, may allow us to discover an opening to the light of the good, of God, within the subterranean depths. This is one way of understanding Dante's journey downward.

By the time Dante reaches the center of hell his own delusions are undone, his own porosity cleansed.[26] This stands in marked contrast with the Satan he encounters there. Desmond explains that "the frozen Lucifer is beyond all porosity, all permeability: fixed eternally in himself as himself—a parody of divine eternity" (*GBPB,* 97). Virgil and Dante make their way down Satan's limbs and pass through a hole. Suddenly their downward journey becomes an ascent. This reverse is a startling reminder to both Dante and the reader of the paradox of his journey, of how a certain way of going down can, at times, be the only way to ultimately ascend. Now Dante and Virgil climb and emerge beneath the stars:

> He first, I second, without thought of rest
> we climbed the dark until we reached the point
> where a round opening brought in sight the blest
>
> and beauteous shining of the Heavenly cars.
> And we walked out once more beneath the Stars.[27]

The imagery suggests a rebirth for Dante, and the closing lines suggest a rebirth of astonished wonder at the "blest / and beauteous" stars. Guided by Virgil in his poem, Dante in turn acts as a guide for his readers, for us, as we join him on an "inner journey" that begins in and deepens *our* perplexity as well. This journey is a descent, but it is also paradoxically an ascent. We ascend out of the cave and see the surface anew. If the journey begins in perplexity, it ends in renewed astonishment. "To come thus to the surface of things, after hell," writes Desmond, "we begin again to open to the marvel of things. We even begin to wonder if the saturated surface of things is the place of consecration where God gives himself for praise"

(*GBPB*, 98).

What are some of the implications of Desmond's own ascents from the cave and descents into the underworld? For one, they offer existential possibilities. To recapitulate, in the ambiguous between, we can "ascend" through agapeic mind, discerning the good in, say, the aesthetic excess and singularity of being. There is also the possibility, however, of a kenotic "descent" that purges our porosity in more harrowing fashion but ultimately renews our sense of the good. Such kenosis does not abnegate desire but instead, as Paul Camacho writes, "redeems and perfects it."[28] It becomes the agapeic desire of posthumous mind. There is nothing blithe about this possibility, and there are no guarantees. As Desmond says, some descents do not lead back up again. His point is only that some do. Another possible implication of Desmond's ascent and descent: these remain live philosophical options, even in late or postmodernity. Perhaps Desmond suggests that in the wake of Schopenhauer and Nietzsche, a philosophy of ascent alone is not enough. A philosopher who wishes to affirm the goodness of being must risk kenotic descent. Perhaps Desmond also wants us to turn this around, though, to see the possibility that philosophical spelunkers might still resurface to a sunlit world, that philosophy may rediscover its feel for the goodness of being after its sojourn in the chthonic depths. Perhaps this is a possibility for the culture more broadly. Desmond's reflections on Dante suggest again how the ethos of serviceable disposability may be challenged. The philosopher returning to the cave may not be strong enough alone, but a renewed porosity between philosophy, art, and religion may be.

Notes

Introduction

1. Vanden Auweele, "Introduction," in Vanden Auweele, ed., *William Desmond's Philosophy between Metaphysics, Religion, Ethics, and Aesthetics*, 6.

2. Note that Desmond's use of "overdetermined" thus reverses its most common usage in everyday speech, where it means that something is overly specified.

3. Duns, *Spiritual Exercises for a Secular Age*, 203.

4. Language is overdetermined—and not only poetic language. This is a major challenge for more univocalizing approaches to philosophy. See Taylor, *The Language Animal*.

5. See Desmond's discussion of how he writes "between system and poetics" in *VB*, 160–92.

6. Neville, *Defining Religion*, 319. Neville here compares Desmond's metaxological metaphysics with his own metaphysics of harmony.

7. Cyril O'Regan, "Evil: From Phenomenology to Thought," in Vanden Auweele, ed., *William Desmond's Philosophy between Metaphysics, Religion, Ethics, and Aesthetics*, 151. In moving between the phenomenological and the metaphysical, Desmond transgresses the strictures of Husserl and Heidegger. This is a major difference between Desmond and his contemporary Jean-Luc Marion, with whom he nonetheless shares much in common. See Desmond's discussion of Marion in *VB*, 193–225.

8. For Desmond's historical account of philosophical metaphysics in modernity, see *VB*, 17–48.

9. See Aristotle, *Metaphysics*, 1003b6 and 1028a10, in *The Basic Works of Aristotle*.

10. Desmond discusses the unavoidability of metaphysics in *BB*, 3–46. See James L. Marsh, "William Desmond's Overcoming of the Overcoming of Metaphysics," in Kelly, ed., *Between System and Poetics*, 95–105. See also John R. Betz, "Overcoming the Forgetfulness of Metaphysics: The More Original Philosophy of

William Desmond," in Simpson and Sammon, eds., *William Desmond and Contemporary Theology*, 57–91.

11. See, for instance, Heidegger, "The Question Concerning Technology" and Horkheimer and Adorno, *Dialectic of Enlightenment*.

12. See Desmond's autobiographical essay in *PU*, 1–26. Desmond notes that he has lived much of his life away from his Irish home. This particular "between" shapes his writings. His most autobiographical book in this regard is *Being Between: Conditions of Irish Thought*.

13. Weiss, "Reply to William Desmond," 558.

14. *The William Desmond Reader*, ed. Christopher Ben Simpson, is a useful starting point for those new to Desmond.

15. Desmond offers his fullest discussion of Marcel in "Philosophies of Religion." See also Desmond's remarks on Marcel in *WDR*, 241.

16. Gonzales, *Reimagining the Analogia Entis*, 249.

Chapter 1

1. See Maurice Merleau-Ponty's classic study of such dynamics in *Phenomenology of Perception*.

2. Heidegger, *Being and Time*, 87.

3. Desmond has little to say about psychoanalytic theories across his writings. See his mischievous answer to Richard Kearney's question about this in *WDR*, 241–42.

4. Kant, *Critique of Judgment*, 200, §53.

5. Throughout this study, emphasis within a quotation is present in the original.

6. Desmond, "The Porosity of Being," 289. Desmond's language of the hardened heart evokes the great biblical trope of unreceptivity.

7. Balthasar, *Theo-Logic*, 1:45.

8. Marcel, *Creative Fidelity*, 51.

9. Augustine describes our being turned inward on ourselves (*incurvatus in se*). See *G*, 15–17. Renée Köhler-Ryan brings Desmond and Augustine into conversation throughout *Companions in the Between*.

10. Murdoch, "The Sovereignty of Good Over Other Concepts," in *Existentialists and Mystics*, 369. Cyril O'Regan compares Desmond to Murdoch, Simone Weil, Catherine Pickstock, and Jean-Luc Marion in "The Poetics of Ethos." In a series of important review essays, O'Regan offers both insightful analysis and a thorough examination of Desmond's influences and conversations with other thinkers.

11. Murdoch, "The Sublime and the Beautiful Revisited," in *Existentialists and Mystics*, 284.

12. Stein, *On the Problem of Empathy*, 63. This sort of empathy is primordial perception rather than an analogy established between my feelings and those of another.

13. Such listlessness calls to mind the "noonday devil" of *acedia*, tormentor of the desert monks but still stalking modernity.

14. Desmond offers his fullest discussion of the ethos of serviceable disposability in *EB*, 415–41.

15. For this critique of Nietzsche, see Desmond, *BB*, 509, and "Ethics and the Evil of Being."

16. Buber, *I and Thou*, 11.

17. See Byung-Chul Han's discussion of the "achievement subject" in *The Burnout Society*.

18. Augustine, *Confessions*, 1.12.19.

19. See the grotesque distention of greed, lust, and gluttony in Martin Scorsese's 2013 film *The Wolf of Wall Street*.

20. Morisato, *Faith and Reason in Continental and Japanese Philosophy*, 102.

21. Desmond, "The Porosity of Being," 289.

22. See Hadot, *Philosophy as a Way of Life*. See also Duns, *Spiritual Exercises for a Secular Age*, which approaches Desmond's philosophy as a way of life. In *Effort and Grace*, Simone Kotva argues that Hadot overemphasizes effort in his account of spiritual exercises, thereby privileging a certain kind of Stoicism. Desmond's spiritual exercises, like those that most interest Kotva, stress a paradoxical mix of activity and repose. She traces a history of such exercises through the French Spiritualist philosophical tradition of Maine de Biran, Félix Ravaisson, and Simone Weil. She also points to contemporary thinkers such as Jane Bennett and Isabelle Stengers.

23. See Han, *The Scent of Time*. There is increased interest in contemplation as a remedy to contemporary ills across a range of fields and perspectives. See, for instance, Summit and Vermeule, *Action versus Contemplation* and Iten, "Contemplative Practices as Rhetorical Action for Democracy."

24. Duns, *Spiritual Exercises for a Secular Age*, xxii.

25. The name here suggests contemplative traditions of both East (mind[fulness]) and West (agapeic).

26. The story of such a reprieve figures prominently in Dostoevsky's novel *The Idiot*. See Morisato, *Faith and Reason in Continental and Japanese Philosophy*, 91–96. The Irish myth of Oisín provides Desmond with another key illustration of posthumous mind. See *PO*, 278–81.

27. See also Desmond's variations on the parable of the prodigal son in *G*, 183–213.

28. Robinson, *Gilead*, 6.

29. Robinson, *Gilead*, 5.

30. Robinson, *Gilead*, 28.

31. Robinson, *Gilead*, 9.

32. Pieper, *Only the Lover Sings*, 33.

33. Pieper, *Only the Lover Sings*, 36.

34. Other vocations cultivate their own heightened ways of seeing. Here it is useful to think of art in the old, broad sense. The hunter, farmer, guard, carpenter, mason, doctor, and teacher all train their senses in certain ways. We might surmise that for most of human history people had to be broadly attentive to the aesthetics of happening to secure their livelihood. See the story of the fisherman who learned to navigate by sight in Serres, *The Five Senses*, 251–53.

35. See Marcel, *Creative Fidelity*, 38–57. There is also some affinity with the late Heidegger's Eckhart-inspired *Gelassenheit*.

36. Desmond can be brought into conversation here with Hubert Dreyfus and his students, who draw an account of "skillful coping" out of Heidegger and Merleau-Ponty. See Tao Ruspoli's 2010 documentary on their work, *Being in the World*.

37. Marcel, *Being and Having*, 173.

38. Desmond adopts the post-Kantian, Coleridgian distinction between the primary imagination that synthesizes perceptions and the secondary imagination, which imagines various possibilities. Still, Desmond's imagination does not simply act upon otherness. It is a "threshold power" continually shaped by the otherness we receive in our porosity. See *PO*, 83–87 and *WDR*, 206.

39. Desmond defines things "in the most general sense" as "certain determinate happenings of the power of being. In that sense, human beings are things too" (*BB*, 299). See the extended discussion of things in *BB*, 299–330.

40. James, *Some Problems of Philosophy*, 50. See also Bruce Wilshire's study of aural excess in *The Much-at-Once*. On affinities between Desmond and the pragmatists, see O'Regan, "Metaphysics and the Metaxological Space of the Tradition," 546–47.

41. Wordsworth, "'The World Is Too Much with Us,'" in *Selected Poems*, 144.

42. Abram, *The Spell of the Sensuous*, 51.

43. We might here contrast Desmond and Byung-Chul Han. The latter largely links the mystery of otherness with indeterminacy, which means that he stresses how it evades and escapes rather than exceeds our powers of determination. (An important exception is Han's account of the excess of poetic language.)

44. The examples of Cézanne and Fabre are drawn from Berry, *Life Is a Miracle*, which is insightful on how "a place, apart from our now always possible destruction of it, is inexhaustible" (139).

45. Abram, *The Spell of the Sensuous*, 64.

46. Heidegger, *Introduction to Metaphysics*, 2.

47. Many philosophers would deny that this is a legitimate philosophical question. Within recent continental philosophy, Quentin Meillassoux offers a formidable critique of such wonder at the "facticity" of being—at there being something rather than nothing—as well as of phenomenological "correlationism." See Meillassoux, *After Finitude*. Desmond has not engaged Meillassoux at length, but two recent essays compare the metaphysics of Meillassoux and Desmond and argue for Desmond's greater persuasiveness. See Sandra Lehmann, "Metaxology and New Realist Philosophy," in Vanden Auweele, ed., *William Desmond's Philosophy between Metaphysics,*

Religion, Ethics, and Aesthetics, 77–91. See also Corey Benjamin Tutewiler, "On the Cause of Metaphysical Indeterminacy and the Origin of Being," in Simpson and Sammon, eds., *William Desmond and Contemporary Theology*, 93–116. See also Catherine Pickstock's apposite engagement with Meillassoux throughout *Aspects of Truth*.

48. Desmond notes that the self can seem to be nothing substantial at all. David Hume (and Derek Parfit) was not wrong to challenge John Locke's conception of a stable self. But Hume was not entirely right either: "When Hume looked into himself and found no self, it was Hume himself who found no self. Hume already had to have had this prior sense of himself in order to look at all, and in order to be able to know that he found nothing" (*PU*, 56). Hume fails to account for this "more basic self-relativity" (*PU*, 56).

49. Likewise, we can never know the intimate idiocy of other living things. See Nagel, "What Is It Like to Be a Bat?" There has been scientific research and philosophical reflection on plant "consciousness" in recent years. See Irigaray and Marder, *Through Vegetal Being*. For development of Desmond's thinking in these regards, see Peter Scheers, "Towards a Metaxological Hermeneutics of Plants and Animals," in Kelly, ed., *Between System and Poetics*, 279–92.

50. Augustine, *Confessions*, 10.8.15.

51. See Whitehead, *Science and the Modern World*, 58–59. Desmond endorses Whitehead's critique of "simple location" in *BB*, 305–6. Desmond can be profitably compared to philosophers in Whitehead's tradition such as Paul Weiss, Robert Cummings Neville, and Joseph Grange in the United States or Isabelle Stengers in Europe.

52. Simpson, "Introduction," in *WDR*, xiv.

53. Westphal, "William Desmond's Humpty Dumpty Hegelianism," 354.

54. There are similarities between Desmond's metaxological dialectic and Marcel's "creative interchange" and Martin Buber's "dialogical principle," though Desmond develops it in a more capacious metaphysics. Interesting comparisons can also be made to Luce Irigaray's reworking of Hegel. See, for instance, the introduction to Part I and "Approaching the Other as Other," in Irigaray, ed., *Luce Irigaray*, 3–7, 23–31.

55. Whitehead, "Immortality," 700.

56. Houlgate, "William Desmond on Philosophy and Its Others," 382.

57. Desmond does not simply dismiss Hegel's dialectic but maintains it as one of four crucial approaches to being: the univocal, the equivocal, the dialectical, and the metaxological. He argues that the metaxological is the fullest approach because it preserves what is uncovered by the other three approaches. See Desmond's early discussion in *DDO*, 4–9. For a study of Desmond's philosophy oriented around this fourfold approach to being, see Simpson, *Religion, Metaphysics, and the Postmodern*.

58. Heidegger, *Being and Time*, 176.

59. In *Image and Presence*, Natalie Carnes makes a distinction between literal desire and literalized desire. The former "identifies a good desire," the latter "a perverse one." Literal desire "simply names desire for a material good, like sex, food, or

sensual delight. . . . To call it a good desire is to affirm its importance for the life of a material creature and note its capacity to open up and become a desire that is more than literal" (22). Desmond would say it maintains an agapeic potential or capacity. On the contrary, literalized desire "has been reduced to or equated with its consumptive forms; it is desire that forecloses or attempts to foreclose any non-consumptive meanings" (23).

60. Plato, *Symposium* 203d, in *Complete Works*.
61. Plato, *Symposium* 203e.
62. Plato, *Symposium* 210a.
63. Desmond's account of agapeic self-transcendence could be brought into productive conversation with the essays in Jennifer Frey and Candace Vogler's collection *Self-Transcendence and Virtue*.
64. Even John Milbank, a staunch advocate of Desmond's metaphysics, registers this concern. See Milbank, "The Double Glory, or Paradox versus Dialectics," 146.
65. There are affinities here with Abraham Joshua Heschel's classic account *The Sabbath*.
66. See Michel Serres's discussions of bodily joy—breathing, jumping, swimming, playing sports, dancing—in *The Five Senses*, 313–28.
67. Desmond points to the lack of discussion of friendship in modern philosophy compared to premodern philosophy. See *IU*, 364–84.
68. Balthasar, *Theo-Logic*, 1:35.
69. See Desmond's discussion of temptation, hubris, and equivocal desire in *EB*, 269–301.
70. See Plato, *Theaetetus* 155d, in *Complete Works*. See also Aristotle, *Metaphysics*, 982b, in *The Basic Works of Aristotle*. Desmond's fullest discussions of wonder are in *ISB*, 260–300 and *VB*, 96–125. Of course, scholars contest what exactly Plato and Aristotle meant by wonder and point out differences between them. Some contest wonder as a philosophical departure point, pointing to eros instead. Desmond agrees that eros is crucial, but it comes second. It is stirred in our porosity to astonished or perplexed wonder. For a detailed examination of Desmond's Plato, see O'Regan, "The Poetics of Ethos."
71. Desmond turns to a different literary exemplar of perplexity, Dostoevsky's underground man, in *ISB*, 279–80.
72. Melville, *Moby-Dick*, 140.
73. For an apt remark on Ahab from Desmond, see *DDO*, 166. On the relationship between mystery and self-discovery in Melville's novel, see Vaught, *The Quest for Wholeness*, 15–46. See also the illuminating treatment in Mooney, *Living Philosophy in Kierkegaard, Melville, and Others*, 43–65.
74. Pascal, *Pensées and Other Writings*, 72–73, §231.
75. See Desmond's discussion of the wounded heart in *EB*, 242–44.
76. Schopenhauer, *The World as Will and Representation*, 2:160.
77. Alexandra Romanyshyn, "Metaxology and Environmental Ethics: On the Ethical Response to the Aesthetics of Nature as Other in the Between," in Vanden

Auweele, ed., *William Desmond's Philosophy between Metaphysics, Religion, Ethics, and Aesthetics,* 304.

78. Pascal, *Pensées and Other Writings,* 73, §233.

79. On this fixation with evil, see Desmond, "Ethics and the Evil of Being."

80. O'Regan, "Evil," in Vanden Auweele, ed., *William Desmond's Philosophy between Metaphysics, Religion, Ethics, and Aesthetics,* 172. O'Regan probes mythic images of lurid curiosity in relation to literary art: "If Pandora is the symbol of what happens when curiosity insists on an answer, and Bluebeard's Castle the symbol of a death wish, Medusa is the symbol of the writer who comes too close, even as she looks at a slant, looks too long and too keenly, and can never rid her mind of the images of violation" (173).

81. Desmond, "Ethics and the Evil of Being," 428.

82. Dante, *The Inferno,* 7.121–24.

83. See John Milbank on ontologized violence in *Theology and Social Theory,* 278–325.

84. There is no guarantee that a near miss will lead to renewed wonder. Desmond notes that one of the other prisoners reprieved with Dostoevsky went mad.

85. Desmond notes that Aristotle seems to treat wonder as a mere gap in determinate knowledge. Yet Desmond also points to how the *Metaphysics* begins by linking the natural "desire to know" with "the delight we take in our senses," which suggests that we should not flatten Aristotle's wonder too much. *Metaphysics,* 980a1–2, in *The Basic Works of Aristotle.*

86. See the discussion of intelligibility in *BB,* 331–76.

87. See Vico, *The New Science of Giambattista Vico,* 421–24, ¶1100–1106. Desmond also points to Aquinas's distinction between studiousness and curiosity in *Summa Theologica,* II–II, q.166–67.

88. See Mary-Jane Rubenstein's genealogy of such curiosity in *Strange Wonder.*

89. Wordsworth, "The Tables Turned," in *Selected Poems,* 61.

90. Compared with, say, Peter Sloterdijk, Desmond does not dwell on how the built environment affects our porosity, but there are rich possibilities here. Desmond does discuss Hegel and architecture in *AOO,* 115–30, and John Hymers offers suggestive remarks in "Towards a Metaxological Ethics of Architecture," in Kelly, ed., *Between System and Poetics,* 261–77.

91. See Taylor, *A Secular Age* and Desmond's reflection on Taylor's work in "The Porosity of Being." On Desmond and Taylor, see also Duns, *Spiritual Exercises for a Secular Age.* Also see Sweeney, "Ways to God."

92. Desmond, "The Porosity of Being," 289.

93. Sweeney, "Ways to God," 151. He goes on to write: "No thinking can be wholly abstracted from a secondary ethos—if only because language is historicized in an ethos—but thinking may disclose the windows and doors of an ethos" (159).

94. Hegel, *Phenomenology of Spirit,* 60, ¶95. It also establishes a distinction between subject and object and a necessary relation between them, one that gives rise to dynamic mediation.

95. Hegel, *Phenomenology of Spirit*, 60, ¶97.
96. Hegel, *Phenomenology of Spirit*, 58, ¶91.
97. Verene, *Hegel's Absolute*, 44.
98. Verene, *Hegel's Absolute*, 41–42.
99. There is always a risk of oversimplifying Hegel (and curiosity as a mode of wonder). His curiosity is not flatly univocalizing but complexly dialectical, continually unsettling earlier determinations. It may be more accurate to say that there is an interplay of curiosity and perplexity in Hegel, a post-Kantian anxiety that, as Verene puts it, "consciousness cannot demonstrate that what seems to be the case, actually is the case." *Hegel's Absolute*, 53. This ultimately turns Hegel back from external otherness to the self-othering of consciousness.
100. Pickstock, *Aspects of Truth*, xii.

Chapter 2

1. O'Donohue, *Beauty*, 7.
2. Scarry, *On Beauty and Being Just*, 18.
3. Plato, *Greater Hippias* 304e, in *Complete Works*. Recall the famous claim in Dostoevsky's *The Idiot* that beauty will save the world. It is often lifted out of the novel as a slogan. Yet the novel depicts something far more ambiguous than the slogan suggests. Which beauty saves? Which response to beauty saves? The third section of this chapter takes up these questions.
4. Hegel, "On Art," 40. As Desmond's early study *AA* suggests, Desmond agrees with much in Hegel's writings on beauty and art. If Desmond's critique of Hegel was more to the fore in the last chapter, affinities are more to the fore here.
5. See the discussion of these two approaches in Eco, *Art and Beauty in the Middle Ages*.
6. On Desmond, Aquinas, and beauty, see Brendan Thomas Sammon, "The Reawakening of the Between: William Desmond and Reason's Intimacy with Beauty," in Simpson and Sammon, eds., *William Desmond and Contemporary Theology*, 15–56. James Matthew Wilson offers a helpful exposition of both Aquinas's account of beauty and Jacques Maritain's highly influential rearticulation of it in *The Vision of the Soul*.
7. Schopenhauer, *The World as Will and Representation*, 1:196, §38.
8. Schopenhauer, *The World as Will and Representation*, 1:197, §38. See also Desmond's discussion of Schopenhauer in *AOO*, 131–63.
9. Scarry, *On Beauty and Being Just*, 25. See also Jean-Louis Chrétien's survey of how the Platonic and Christian traditions draw on this (somewhat murky) etymology in *The Call and the Response*, 5–32. The call and response has been a major concern in French phenomenology in recent decades.

10. See Schiller, *Letters on the Aesthetic Education of Man*, 133. See also D. C. Schindler's discussion of paradoxical beauty in *Love and the Postmodern Predicament*, 31–48.

11. Weil, "Forms of the Implicit Love of God," 166.

12. See Han, *Saving Beauty*, 63–66, and *The Disappearance of Rituals*, 84–89.

13. See Sartre, *Being and Nothingness*.

14. For Kant, though, this disinterest brackets the content of art. We contemplate the formal beauty of the painting, not what the painting depicts.

15. Hegel, "On Art," 78.

16. Weil, "Forms of the Implicit Love of God," 159–60.

17. Murdoch, "On 'God' and 'Good,'" in *Existentialists and Mystics*, 353.

18. Rilke, "Archaic Torso of Apollo."

19. See Plato, *Symposium* 206b, in *Complete Works*.

20. Scarry, *On Beauty and Being Just*, 3.

21. Desmond points to Milosz's poem "Blacksmith Shop."

22. Weil, "Forms of the Implicit Love of God," 180.

23. Plato, *Phaedrus* 251d, in *Complete Works*.

24. Masters of the Dutch Golden Age likewise used fading flowers to evoke transience.

25. Shakespeare, "18."

26. Shelley, "The Flower That Smiles Today."

27. Frost, "Nothing Gold Can Stay."

28. Kenyon, "Peonies at Dusk," in *Collected Poems*, 254.

29. The crucified Christ puts this ambiguity at the heart of Christianity and the aesthetics that form in its wake. See Carnes, *Beauty*, 125–252.

30. See Aristotle, *Poetics*, 1448b10–20, in *The Basic Works of Aristotle* and Kant, *Critique of Judgment*, 179–81, §48.

31. Kant excludes disgust from the aesthetic in *Critique of Judgment*, 180, §48. Desmond demurs.

32. See Danto, *The Abuse of Beauty*, 49–50.

33. There may be another possibility in the friend's reaction, especially given how Hirst's installation evokes both death and decay (the head) and rebirth (the wriggling maggots, the swarming flies). To find it beautiful may be to affirm the world, death and all, as beautiful. Imagine Nietzsche and Weil standing before the installation. (Weil did have long conversations with the hyper-Nietzschean Georges Bataille.) We might expect sharp disagreement between the great anti-Platonist and the great Platonist, the great immoralist and the great moralist. Perhaps Nietzsche would see the installation as testifying to modern soul-sickness, to nihilism. Or perhaps Nietzsche would say "Yes!" to it as an aesthetic embrace of the primal flux of becoming and destruction, as a testament to invincible life. Likewise, Weil might claim the installation encourages lurid curiosity, that it appeals to baser appetites.

But she might instead say we should embrace the beauty of nature's order despite violence and death.

34. See the 2019 film *Velvet Buzzsaw*, directed by Dan Gilroy, which satirizes a fame- and money-obsessed world of shock art, but which also juxtaposes the gimmicks with art of real perplexity and horror.

35. Scarry, *On Beauty and Being Just*, 83.

36. Desmond's most important discussions of the sublime can be found in *DDO*, 154–63; *EB*, 181–84; *GB*, 134–41; *IU*, 99–110; and *GBPB*, 101–108.

37. See Kant, *Critique of Judgment*, 103–23, §25–28.

38. Han, *Saving Beauty*, 42.

39. See the discussion of the intimate universal in the introduction to *IU*, 1–19.

40. See the discussion of Heraclitus in *VB*, 252–83. Desmond claims that "it is a one-sided picture to think of Heraclitus as stressing only being as becoming," because "equally crucial is the doctrine of the *logos* that runs through all things" (*VB*, 262).

41. Alfred North Whitehead likewise holds, "Every scheme for the analysis of nature has to face these two facts, *change* and *endurance*." *Science and the Modern World*, 88. Whitehead names Shelley as a great poet of change, Wordsworth of endurance.

42. Shaw, *The Sublime*, 212.

43. Kant, *Critique of Judgment*, 120–21, §28.

44. Kant, *Critique of Judgment*, 123, §28.

45. Shaw, *The Sublime*, 167–68.

46. See Žižek, *The Sublime Object of Ideology*. See also Giorgio Agamben's discussion of political "glory" in *The Kingdom and the Glory*. Desmond discusses political appropriations of the sublime in *IU*, 102–10. Philip John Paul Gonzales brings Desmond and Agamben into conversation in "Reactivating Christian Metaphysical Glory in the Wake of Its Eclipse: William Desmond Contra Giorgio Agamben," in Vanden Auweele, ed., *William Desmond's Philosophy between Metaphysics, Religion, Ethics, and Aesthetics*, 209–25.

47. Shaw, *The Sublime*, 197–98.

48. See Philip Shaw's Žižek-inspired discussion along these lines of a scene from a David Lynch film in *The Sublime*, 4–5.

49. See Bataille, *Inner Experience*.

50. On Bataille and Desmond, see O'Regan, "Evil," in Vanden Auweele, ed., *William Desmond's Philosophy between Metaphysics, Religion, Ethics, and Aesthetics*, 151–76. See also Kuiper, "Georges Bataille."

51. Desmond, "Agapeic Selving and the Passion of Being," 100n10. Desmond directs readers to Gabriel Marcel's critique of Bataille in *Homo Viator*, 185–212.

52. See Lyotard, "Newman: The Instant" and "The Sublime and the Avant-Garde," in *The Inhuman*, 78–107.

53. On postmodern art that aims to reawaken wonder via the sublimity of nature, see Kosky, *Arts of Wonder*. He discusses Walter De Maria's *The Lightning Field*, for instance, a mile-wide installation of lightning rods in New Mexico.

54. Blake, "And Did Those Feet in Ancient Time."

55. Romanyshyn, "Metaxology and Environmental Ethics," in Vanden Auweele, ed., *William Desmond's Philosophy between Metaphysics, Religion, Ethics, and Aesthetics*, 312.

56. Romanyshyn, "Metaxology and Environmental Ethics," 304.

57. Paul Kingsnorth offers a bracing critique of such "pragmatic" approaches in *Confessions of a Recovering Environmentalist and Other Essays*.

58. Scarry, *On Beauty and Being Just*, 15.

59. Scarry, *On Beauty and Being Just*, 24–25.

60. Chrétien, *The Ark of Speech*, 78–79.

61. Murdoch, "The Sublime and the Beautiful Revisited," in *Existentialists and Mystics*, 281–82.

62. Murdoch, "The Sublime and the Beautiful Revisited," 282.

63. Murdoch, "The Sublime and the Beautiful Revisited," 280.

64. Nussbaum, *Cultivating Humanity*, 88.

65. Lenin loved Beethoven's *Appassionata* but worried that it made him too compassionate.

66. See also Desmond, "*Paideia*."

67. See Kierkegaard, *Either/Or*.

68. Steiner, *Language and Silence*, ix.

69. Steiner, *Language and Silence*, 5.

70. See Weil, "Morality and Literature."

71. Ethical approaches may likewise fail to attend to the ambiguity of pleasure. This is especially evident in utilitarian ethics, which seeks a sort of mathematics of pleasure. See *EB*, 58–62.

72. See Coomaraswamy, *Christian and Oriental Philosophy of Art*. See also Natalie Carnes's discussion of "fittingness," which bridges craft and fine arts, in *Beauty*, 45–60.

73. It testifies as well to how the purely functional is undesirable or at least markedly less desirable than what is both functional and aesthetically pleasing. Apple, for instance, came to dominate personal technology in significant part because of an aesthetic. Other technology companies were quick to follow.

74. See Han on the aesthetics of the smooth in *Saving Beauty*, 1–22.

75. Hegel, "On Art," 25.

76. Steiner, *Real Presences*, 190–91.

77. Morrison, *Beloved*, 4.

78. Morrison, *Beloved*, 94.

79. Morrison, *Beloved*, 40–41.

80. Desmond recurs throughout his writings to the mythical brass Bull of Phalaris, in which the screams of the tyrant's tortured victim are transformed into "beautiful" music. Is this music a counterfeit of beauty or does it give the lie to the latent links between beauty and goodness? See *IU*, 311–15.

81. Irigaray, "Introduction," in Irigaray, ed., *Luce Irigaray*, 5.

82. See Scarry's critique of extending the "objectivizing gaze" to all aesthetic looking in *On Beauty and Being Just*, 62–82. See also Catherine Pickstock's defense against Derrida of the "Socratic gaze," which is "neither totalizing nor rationalizing, since its 'object' cannot be seen once and for all." *After Writing*, 33.

83. See Desmond's extended discussion of Levinas in "Philosophies of Religion."

84. Levinas, *Totality and Infinity*, 199.

85. Balthasar, *Love Alone Is Credible*, 76.

86. On love and porosity, see Desmond, *IU*, 482n27 and *GBPB*, 33–35.

87. Buber, *I and Thou*, 15.

Chapter 3

1. For Desmond's key discussions of artistic creation, see *AA*, 1–13; *PO*, 83–109; *AOO*, 19–51; and *IU*, 60–88. Early in his discussion in *PO*, Desmond ties art's mediation of internal otherness to creativity broadly. By the end of the section, though, he has turned to inspiration particularly, and inspiration is prominent again in *IU*. This, it seems to me, is a clarifying shift of emphasis, one that I follow in this chapter, because creativity is present in art's imaginative mediation of both external and internal otherness.

2. The fullest accounts in modernity of creativity—such as Goethe's, Hegel's, and Schelling's—maintain some notion of mimesis. Likewise, as Desmond points out, premodern accounts of mimesis are more nuanced than is now appreciated. See Halliwell, *The Aesthetics of Mimesis*.

3. See Desmond's critique of artistic creation ex nihilo in *GBPB*, 196–213.

4. Richard Kearney helpfully describes mimesis as "re-creation" and narrative mimesis as "creative retelling" in *On Stories*, 132–33.

5. Steiner, *Grammars of Creation*, 23.

6. Lindley, "Gift and Mediation at the Heart of Poetry," 150. Lindley's account of mimesis-as-mediation complements the concerns of this chapter in several regards.

7. Langer, *Problems of Art*, 3–4.

8. There is an elaborating echo here of Aristotle's claim in the *Poetics* that poetry is more universal than history because of its winnowing of significance, its giving of narrative shape. Aristotle describes humans as innately and broadly imitative in *Poetics*, 1448b, in *The Basic Works of Aristotle*. Imitation, learning, and pleasure are linked for Aristotle. Consider how children play at adult work: cooking, building, cleaning. Throughout life we learn from others' imitations. Poetic imitation is a paradigmatic instance of this general human behavior for Aristotle. Desmond recognizes the truth in this—one that the modern emphasis on autonomy can again obscure. See *PO*, 88–89.

9. See Weiss, *Emphatics*.

10. Merleau-Ponty, "Eye and Mind," 181.

11. Merleau-Ponty, "Eye and Mind," 186.

12. Merleau-Ponty, "Eye and Mind," 188. Northrop Frye makes a similar point about literature in "Framework and Assumption."

13. This might bring to mind Derrida's argument about the necessity of a frame. See Derrida, "The Parergon." Derrida's frame is not the same as Desmond's "aesthetic framing," though. The latter does not simply "contain." It allows an overdetermined communication. Desmond writes, "As a framed whole the artwork opens us out. The frame is a fenestration: at once an enclosed opening and an opening of mind beyond closure" (*PO*, 104).

14. Desmond endorses Hegel's argument that the whole may contain tension. See *AA*, 77–101.

15. See Keats, "To Benjamin Bailey," in *Selected Poems and Letters*, 257–59.

16. See Keats, "To George and Thomas Keats," in *Selected Poems and Letters*, 260–61.

17. On the "negative capability" of Dickens, with brief reference to Shakespeare, Dostoevsky, and Joyce as well, see *AOO*, 288–89.

18. Hegel, "On Art," 29. For an extended discussion of Hegel's aesthetics, see Desmond's early study *AA*.

19. Whitman, "When I Heard the Learn'd Astronomer."

20. Langer, *Problems of Art*, 59.

21. Langer, *Problems of Art*, 91.

22. Langer, *Problems of Art*, 7.

23. Langer, *Problems of Art*, 8. Desmond would agree with Langer that "felt life" is a crucial dimension of art, but he would hold that it is not the artistic skeleton key. Langer's stress on "felt life" somewhat recesses how the artwork mediates external otherness, for instance.

24. Or we might think of Heidegger—the epochal work of art, such as the Greek temple, discloses a world. Treating such a work as a mere aesthetic object, we obscure the deeper "work" it accomplished for the Greeks themselves. See Heidegger, "The Origin of the Work of Art," in *Poetry, Language, Thought*, 15–87. Desmond would say that the temple inculcates the ethos of being in which the Greeks live. See Desmond's chapter on Heidegger in *AOO*, 209–63.

25. Hyde, *The Gift*, xii.

26. Martine, "William Desmond, the Artwork, and a 'Metaxological' Understanding of Otherness," 345. The artwork as a return to origins is central to Martine's own aesthetics. See Martine, *Individuals and Individuality*, 75–87.

27. Gadamer, "The Relevance of the Beautiful," in *The Relevance of the Beautiful and Other Essays*, 35.

28. Of course, upstanding citizens of Lafayette County and Dublin were not so sure at first that the fictions of Faulkner and Joyce were augmenting their reality.

29. Where does Andy Warhol fit in here? A panderer? A sellout to the ethos of serviceable disposability who presents the advertisement, which Desmond deems

idolatrous, as an icon? Or an epiphanic artist who sees the sacramental in the soup can? See Desmond's remarks on Warhol in *AOO,* 280 and *IU,* 88. On art and money, see Kuspit, *The End of Art.*

30. Desmond discusses the complex relationship between inspiration, mimesis, and eros in his chapter on Plato in *AOO,* 19–51.

31. Raine, "The Writing of Poems," in *That Wondrous Pattern,* 52.

32. Hyde, *The Gift,* xii.

33. On a personal note, when I began writing poetry, I was struck by how I was *struck* by ideas for poems. Usually this was a fairly quotidian striking—an observation on a car ride or a walk would settle in my mind and gradually shape into a poem. On several occasions, though, ideas for a poem—or even a few lines—came to me in surprising clarity either in dreams or in the liminal state between sleeping and waking. In one of these dreams, I walked through the frosty tall grass of my long-dead childhood neighbors' apple orchard, a pen and notebook in hand. I knocked, and the old couple began telling me a story by turns as soon as the door opened. I furiously wrote down their story in the dream, and then wrote it down again in the notebook by my bed when I woke up.

34. Kenyon, "Who," in *Collected Poems,* 136.

35. Frye, "Framework and Assumption," 427.

36. Quoted in Hyde, *The Gift,* 144.

37. Quoted in Hyde, *The Gift,* 144–45.

38. Plato, *Phaedrus* 244a, in *Complete Works.*

39. See Plato, *Phaedrus* 259b–d for the story of the cicadas. See Desmond's discussion in *IU,* 313–15.

40. Plato, *Ion* 534b, in *Complete Works.*

41. Poe's instrumentalizing painter in "The Oval Portrait" complements Nathaniel Hawthorne's instrumentalizing scientist in "The Birth-Mark." One turns his wife into a model. The other turns his wife into an experiment. In both the instrumentalism leads to murder.

42. Halliwell, *The Aesthetics of Mimesis,* 40. Halliwell thinks that Socrates's notion of what would count as knowledge in art is so stringent that the dialogue actually invites the reader to consider alternative models. Desmond holds that the dialogue can be "swiveled" and read as showing the limits of *technē.* See *IU,* 439n17.

43. Halliwell, *The Aesthetics of Mimesis,* 41.

44. Claudel, "Religion and the Artist," 358.

45. Claudel, "Religion and the Artist," 357.

46. Plato, *Phaedrus* 235d, in *Complete Works.*

47. See Barthes, "The Death of the Author." Barthes distinguishes between the "Author" and the "scriptor," leaving a small role for the latter.

48. Heaney, "Introduction," xxiii.

49. Woodward, "Cormac McCarthy's Venomous Fiction."

50. Eliot, "Tradition and the Individual Talent," 51. Eliot claims that the artist should not only be immersed in the literary tradition, though. Later in the essay he says, "The poet's mind is in fact a receptacle for seizing and storing up numberless feelings, phrases, images, which remain there until all the particles which can unite to form a new compound are present together" (55).

51. Eliot, "Tradition and the Individual Talent," 53.

52. On the similarities between Eliot and Gadamer, see Holston, "Historical Truth in the Hermeneutics of T. S. Eliot."

53. Eliot, "Tradition and the Individual Talent," 50.

54. Eliot, "Tradition and the Individual Talent," 48.

55. Eliot, "Tradition and the Individual Talent," 55.

56. Eliot, "Tradition and the Individual Talent," 53.

57. Steiner, *Grammars of Creation*, 85.

58. See Bloom, *The Anxiety of Influence*. Bloom's work does not elide all gratitude between artists and their forebears, but it does foreground anxiety.

59. Dante, *The Inferno*, 2.134–35.

60. Hollander, "Tragedy in Dante's *Comedy*," 48.

61. Dante, *The Inferno*, 2.7–12.

62. Dante, *The Inferno*, 4.80.

63. Dante, *The Inferno*, 4.91–93.

64. Dante, *The Inferno*, 4.98.

65. Dante, *The Inferno*, 4.99.

66. Dante, *The Inferno*, 10.61–63.

67. Dante, *The Purgatorio*, 30.50–51.

68. Hollander, "Tragedy in Dante's *Comedy*," 46.

69. Hollander, "Tragedy in Dante's *Comedy*," 47.

70. Steiner, *Grammars of Creation*, 94.

71. Steiner, *Grammars of Creation*, 97. As we will see, Steiner sees much more than this at work in Dante's treatment of influence. He is critical of Bloom. Yet Steiner himself risks hyperbole in discussing this scene.

72. Bloom, "Introduction," 3.

73. Steiner, *Grammars of Creation*, 87. Bloom comes closer to this position in his late study *The Anatomy of Influence*, where he recapitulates but also revises his earlier work on influence. He notes that when he first published his theory, he often received criticism that he was not attuned enough to influence's affirmative possibilities. He saw his account as a necessary counterbalance. But by the end of the twentieth century, the suspicious reading practices of what Bloom calls the "New Cynicism" dominated literary studies. Bloom thus revises his notion of influence: "*literary love, tempered by defense*" (8).

74. Steiner, *Grammars of Creation*, 88.

75. Steiner, *Grammars of Creation*, 87–88.

Chapter 4

1. On ancient *theōria*, see Nightingale, *Spectacles of Truth in Classical Greek Philosophy*.

2. For Desmond's critique of such projectionist accounts of religion, see *PO*, 111–58 and *BHD*, 139–87.

3. On such urgency, see also the work of Desmond's graduate school mentor Carl Vaught, *The Quest for Wholeness*. Vaught defines this quest as a double movement, simultaneously outward toward others and inward toward the ground of our being.

4. Eliade, *The Sacred and the Profane*, 11.

5. In a largely sympathetic essay, Robert Cummings Neville observes that Desmond "does not engage the Confucians and Daoists, the Hindus and Buddhists, or even the Muslims and Jews, the way he does the philosophers and theologians of the European Greek and Christian West." *Defining Religion*, 326. Desmond acknowledges this, but also notes the ways in which he has "tried to open Western thought, as a kind of thought that thinks itself, to a thought that thinks what is other to itself" (*G*, 136). Some of Desmond's most recent work is explicitly intercultural. See the discussion of "immanence and transcendence in an intercultural perspective" in *G*, 131–55 and the discussion of Sri Aurobindo in *G*, 157–81. See also Morisato, *Faith and Reason in Continental and Japanese Philosophy* on the affordances Desmond offers for comparative philosophy.

6. O'Regan, "What Theology Can Learn from a Philosophy Daring to Speak the Unspeakable," 246.

7. See David Abram's animistic phenomenology in *The Spell of the Sensuous*. Desmond surveys different religious forms in *GB*, 171–278. Desmond acknowledges that each form is itself plural and that he is only speaking about broad contours.

8. Morisato, *Faith and Reason in Continental and Japanese Philosophy*, 114.

9. Sammon, *Called to Attraction*, 12.

10. There is also a tradition of "natural contemplation" that resonates with the wisdom literature of the Bible. It emerges among the desert ascetics of early Christianity and is elaborated in patristic writings. Desmond's agapeic mind can be productively compared to this tradition.

11. Balthasar, *The Glory of the Lord*, 1:38.

12. On Desmond and Dionysius the Areopagite, see Brendan Thomas Sammon, "The Metaxology of the Divine Names," in Vanden Auweele, ed., *William Desmond's Philosophy between Metaphysics, Religion, Ethics, and Aesthetics*, 95–111.

13. Eco, *Art and Beauty in the Middle Ages*, 17. The literature on Christianity and beauty is vast. See, for instance, Balthasar's multivolume *The Glory of the Lord*; Hart, *The Beauty of the Infinite*; Wilson, *The Vision of the Soul*; and Carnes, *Beauty*. Brendan Thomas Sammon's concise study *Called to Attraction* ranges from the Bible to Balthasar.

14. Augustine, *Confessions*, 3.6.11.

15. Desmond, "Consecrated Thought," 5.

16. See *IU*, 431n17. Carl Vaught approaches Genesis and Exodus as a series of individualizing encounters with the divine in *The Quest for Wholeness*, 47–92.

17. Contrast this with the "hot" mathematician Blaise Pascal, who rejected the impersonal god of the philosophers after a profound religious experience. Or with Pavel Florensky, another "hot" mathematician whose great theoretical breakthrough came out of mystical prayer. On the fiery passion of the "Pascalian heart," see Desmond, *IST*, 73–104. On Florensky, see Graham and Kantor, *Naming Infinity*.

18. Vanden Auweele, "Sacredness and Aesthetics," 3. Vanden Auweele's essay is broadly insightful on Desmond and prayer.

19. Richard Kearney notes that Desmond takes his bearings from the patristic and medieval complementarity of action and contemplation. See Kearney, "The Gift of Creation," in Vanden Auweele, ed., *William Desmond's Philosophy between Metaphysics, Religion, Ethics, and Aesthetics*, 271–84. On Desmond and mysticism, see also Patrick Ryan Cooper, "Espousing Intimacies: Mystics and the Metaxological," in Vanden Auweele, *William Desmond's Philosophy between Metaphysics, Religion, Ethics, and Aesthetics*, 129–48.

20. Consider the notion of a vocation. It is singular and indeed singularizing. One is called to become oneself more fully. The call is often born out of contemplation and introspection. But one is also called into the world, into a particular form of life and course of action. This experience of vocation is not limited to priests and the religious. True philosophers and artists have a vocation too. See Desmond, "Consecrated Thought."

21. Thurman, *For the Inward Journey*, 284.

22. See John Gray's discussion of mystical atheism in *Seven Types of Atheism*.

23. Majmudar, "Towards an Evolutionary Theory of Poetry."

24. Kearney, *Anatheism*, 101.

25. Kearney, *Anatheism*, 102.

26. Desmond gives Bataille a nod for recognizing this in regard to sacrifice in *BHD*, 103.

27. Desmond, "Ethics and the Evil of Being," 428.

28. For studies of the ecological crisis as a spiritual crisis, see Nasr, *Man and Nature* and Wirzba, *From Nature to Creation*.

29. Benjamin, "Theses on the Philosophy of History," 261.

30. Pickstock, "Liturgy, Art and Politics," 163. As Pickstock says, she is speaking ideally. She takes her bearings in part from Plato's other ideal city—the liturgical city of Magnesia in the *Laws*.

31. Han, *The Scent of Time*, 88.

32. Han, *The Disappearance of Rituals*, 35.

33. On reductive metaphors and their implications, see Berry, *Life Is a Miracle*. See also Thomas Pfau's account in *Minding the Modern* of how more reductive models of human agency gained ascendency in modern thought.

34. Willie James Jennings explores this tension through searching profiles of historical individuals like Olaudah Equiano in *The Christian Imagination*.

35. See Josephson-Storm, *The Myth of Disenchantment* for an intriguing revisionist reading of Weber in particular and of modernity in general.

36. The possibilities here are diverse, the accounts complex and contested. They range from accounts of relatively straightforward conceptual secularization (Carl Schmitt) to accounts where secular content fills spaces cleared by religion (Hans Blumenberg) to accounts where a forgotten theological legacy shapes modernity (John Milbank) to accounts where Christianity is "misremembered" (Cyril O'Regan).

37. On the recurrence of fall narratives, see Pecora, "Always Already Sin."

38. See McCarraher, *The Enchantments of Mammon*.

39. Han explores another possibility—a mis-enchantment of achievement. We turn ourselves into projects that we relentlessly pursue until we burn out. See Han, *The Burnout Society*.

40. Marx's commodity fetishism stresses the hidden origins of the commodity rather than the aesthetics of the commodity, but any number of thinkers in Marx's wake have stressed the importance of aesthetics.

41. See any Michel Houellebecq novel.

42. David Bentley Hart surveys such theistic traditions—not only in Greek thought and the Abrahamic faiths but also in Hinduism and Sikhism—in *The Experience of God*.

43. See the chapter "Origin," in *BB*, 225–65.

44. Desmond, "Consecrated Thought," 4. Desmond discusses philosophy and theology in *G*, 1–10.

45. On Desmond and the question of ontotheology, see Duns, *Spiritual Exercises for a Secular Age*, 50–127. Duns brings Desmond into conversation with Heidegger, John Caputo, Richard Kearney, and Merold Westphal. See also the book-length dialogue between Desmond and Caputo in Simpson, *Religion, Metaphysics, and the Postmodern*.

46. See Desmond's reworking of St. Anselm's ontological argument in light of the ethos of wonder and prayer in "God, Ethos, Ways." See also Joseph K. Gordon and D. Stephen Long's discussion in "Way(s) to God: William Desmond's Theological Philosophy," in Simpson and Sammon, eds., *William Desmond and Contemporary Theology*, 139–64.

47. On the hyperboles, see *GB*, especially 116–58. See also Simpson, *Religion, Metaphysics, and the Postmodern*, 93–102; Morisato, *Faith and Reason in Continental and Japanese Philosophy*, 87–111; and Duns, *Spiritual Exercises for a Secular Age*, 180–231.

48. Duns, *Spiritual Exercises for a Secular Age*, 191.

49. See Aquinas, *Summa Theologica*, I, q. 2. On Desmond's hyperboles and Aquinas's five ways, see Sweeney, "Ways to God."

50. Desmond's first hyperbole might invite, as a rejoinder, Kant's critique of the argument from contingency. See Kant, *Critique of Pure Reason*, A 603–20, B

631–48. Desmond does not find this critique convincing, though, because Kant models divine causality on immanent becoming rather than on a radical coming-to-be. See *GB*, 131.

51. Maritain, *Art and Scholasticism and the Frontiers of Poetry*, 28n.

52. For Desmond, the more fitting analogy for God is an artist, creating a work of both order and equivocity, rather than an engineer. Univocal approaches to a natural theology of order, wherein creation is like a machine and God is like an engineer, open themselves up to critiques such as Hume's, which marshal the equivocities of nature against the supposedly univocal divine order. See *GB*, 140n21. Desmond notes that, given the penchant for a "mechanical model" in modern natural theology, it is unsurprising that pantheistic approaches, with their emphasis on the organic and on aesthetic excess, have been appealing. See *GB*, 140n20.

53. On the hyperbolic aesthetics of creation's order, see *GBPB*, 99–124.

54. Chrétien, *The Ark of Speech*, 88.

55. Chrétien, *The Ark of Speech*, 93. Chrétien reflects on the exegetical tradition of Wisdom 13. Christian thinkers were on the one hand wary of how natural beauty could enthrall humans and on the other hand intrigued by how natural beauty reflects, and could direct one to, divine beauty.

56. On beauty as theophany, see also Martin, *The Incarnation of the Poetic Word*, 31–39.

57. Balthasar, *The Glory of the Lord*, 1:116.

58. Otto, *The Idea of the Holy*, 12.

59. Milbank, "Sublimity," 213.

60. Milbank, "Sublimity," 217. See also Hart, *The Beauty of the Infinite*, 43–93. Some versions of the postmodern sublime radicalize Hegel's dialectical origin—a nothing negating itself. The emphasis falls on empty indeterminacy rather than positive overdeterminacy. Desmond criticizes Hegel's origin: "*an origin that has to produce itself to be itself, must first be itself in order to produce itself.* And this is to say nothing about the production of what is other to itself" (*BB*, 252). See Desmond, *Hegel's God*. As one might expect, Desmond's criticisms of Hegel's account of God continue to generate debate. See the overview of the debates in Sander Griffioen, "The Real and the Glitter: Apropos William Desmond's *Hegel's God*," in Vanden Auweele, ed., *William Desmond's Philosophy between Metaphysics, Religion, Ethics, and Aesthetics*, 229–42. See also Philip A. Gottschalk, "Panentheism and Hegelian Controversies," in Vanden Auweele, ed., *William Desmond's Philosophy between Metaphysics, Religion, Ethics, and Aesthetics*, 257–67.

61. The paradox of humans as finite creatures with infinite desire/a desire for the infinite is at the heart of *DDO*.

62. Desmond's hyperboles of selving recall the tradition of Augustinian approaches to God, from Anselm to Bonaventure to John Henry Newman. The moral argument for God is Kant's favored approach as well.

63. Augustine, *The City of God*, 12.23, 262–63.

64. Köhler-Ryan, *Companions in the Between*, 23.

65. This is also a central concern in early twentieth-century Jewish philosophy, taken up by Hermann Cohen, Franz Rosenzweig, Buber, and Levinas.

66. Sweeney, "Ways to God," 169.

67. See Augustine, *The City of God*. On Desmond's agapeic community and Augustine's City of God, see Köhler-Ryan, *Companions in the Between*, 101–18.

68. See Hopkins, "Hurrahing in Harvest," in *The Major Works*, 134. See Duns's discussion of Desmond and this poem in *Spiritual Exercises for a Secular Age*, 225–31.

69. Hopkins is influenced by Duns Scotus's concept of thisness or *haecceity*. While Scotus has been criticized as encouraging the pernicious drift to a theological nominalism, Hopkins (and Desmond) find affordances in his attention to the particular. Desmond writes, "The trouble with nominalism is not its emphasis on particularity, but its univocal diminishment of the this" (*PU*, 63n1). See also Anne Carpenter's Balthasar-influenced discussion of Hopkins as a poet of the particular in *Theo-Poetics*, 157–82, which argues that Hopkins ultimately takes his bearings more from Aquinas than Scotus.

70. Hart, *Poetry and Revelation*, 17. Hart offers a nuanced close reading of the poem on pages 11–19 of this study.

71. Hopkins, "God's Grandeur," in *The Major Works*, 128.

72. See Asad, *Formations of the Secular* and Milbank, *Theology and Social Theory*.

73. See Nietzsche, *The Birth of Tragedy*, in *Basic Writings of Nietzsche*. Desmond writes, "We very easily mistake the complexity of Nietzsche, since the heat of his denunciation of Christianity is so blasting that we think of him as radically anti-religious. Yet if we look carefully at his view of art, the carrying of transcendence he asks of art makes little sense without invoking the religious, as a nonindividualistic art of the ultimate, itself as will to power" (*AOO*, 282).

74. See Soyinka, *Myth, Literature and the African World*.

75. Franke, "Poetry, Prophecy, and Theological Revelation." In *Inspiration and Authority in the Middle Ages*, Brian FitzGerald notes that the use of *vates* to refer to both poetic and religious inspiration, to "priesthood, poetry, and prophecy," persists through Peter Lombard but is differentiated by Albert the Great and Aquinas, in part due to increasingly widespread claims to prophetic inspiration in their time.

76. Heidegger, "What Are Poets For?," in *Poetry, Language, Thought*, 94.

77. Franke, "Poetry, Prophecy, and Theological Revelation."

78. Maritain, *The Degrees of Knowledge*, 347.

79. Desmond, "The Porosity of Being," 291.

80. Picard, *The World of Silence*, 18.

81. Rilke, *Letters to a Young Poet*, 17.

82. Anne Carpenter, elaborating on Balthasar, notes that a certain ambivalence nonetheless remains in Rilke's *askesis*. He "sees *poverty* as the answer to love, a state of emptiness by which he like Narcissus may be set free—not for others, but rather so that he might freely love on his own (solitary) terms." Carpenter contrasts this with "poverty *for* others—a *kenosis* with a *telos*." *Theo-Poetics*, 77.

83. Kierkegaard, "The Lilies of the Field and the Birds of the Air," 324.

84. Kierkegaard, "The Lilies of the Field and the Birds of the Air," 323.
85. Kierkegaard, "The Lilies of the Field and the Birds of the Air," 324.
86. See the "between" of "iconophilia" and "iconoclasm" that Natalie Carnes explores in *Image and Presence*.
87. Postmodern thought has deep roots in this premodern apophasis. See Hart, *The Trespass of the Sign* and Franke, *A Philosophy of the Unsayable*.
88. See the discussion of approaching God via metaphor, analogy, symbol, and hyperbole in *GB*, 122–28. See also the discussion of religious representations of the divine in *BHD*, 172–78. Analogy is of course a prominent approach in Catholic metaphysics. Desmond increasingly notes affinities between metaxological and analogical approaches, both of which maintain an open "between." See *VB*, 49–95. See also Gonzales, *Reimagining the Analogia Entis*, 246–87. For a wide-ranging exposition of metaxology as paradox, see Milbank, "The Double Glory, or Paradox versus Dialectics."
89. Duns, *Spiritual Exercises for a Secular Age*, 185.
90. In terms of visual art and the "unrepresentable," consider the rich traditions of Islamic art. See Nasr, *Islamic Art and Spirituality*. Consider, too, the origins of modern abstract art in theosophy and Rudolf Steiner's anthroposophy as seen in the works of Wassily Kandinsky, Hilma af Klint, and Piet Mondrian. Desmond describes the rise of abstract art as "a catharsis of self-centered art" in the wake of the Romantics (*IU*, 87).
91. Dickinson, Letter 459a.
92. Dickinson, "985," in Franke, ed., *On What Cannot Be Said*, 88.
93. Quoted in Franke, "Dickinson (1830–1886)," in Franke, ed., *On What Cannot Be Said*, 85.
94. Franke, "Dickinson (1830–1886)," 84.
95. Quoted in Franke, "Dickinson (1830–1886)," 86.
96. See Franke, *A Philosophy of the Unsayable*, especially 13–14.
97. See Desmond's discussion of solitude and silence in *PO*, 229–42. See also Vanden Auweele, "Silence, Excess, and Autonomy," in Vanden Auweele, ed., *William Desmond's Philosophy between Metaphysics, Religion, Ethics, and Aesthetics*, 195–207.
98. Chrétien, *The Ark of Speech*, 40.
99. See Picard, *The World of Silence*.
100. Desmond, "Ethics and the Evil of Being," 425.
101. Carnes, *Beauty*, 28.
102. See Balthasar, *The Glory of the Lord*, 1:44–77.
103. For a fuller account of this history, see Eagleton, *Culture and the Death of God*.
104. See Desmond's chapter on Nietzsche in *AOO*, 165–208.
105. Arnold, "Dover Beach."
106. Santayana influenced some of the major modernist poets. Both Robert Frost and T. S. Eliot studied with him at Harvard, and both would ultimately position their poetic projects in opposition to his account of the imagination and

beauty. Santayana's work would provide Wallace Stevens, on the other hand, with a major constructive source for his poetry.

107. Adorno does not receive his own chapter in *AOO*, but he is referred to throughout, and especially in the study's final chapter.

108. The Dark Mountain Project is a relatively recent initiative to re-enchant a world in ecological crisis through new stories and works of art. See the manifestos gathered in Kingsnorth, *Confessions of a Recovering Environmentalist and Other Essays*, 257–84.

109. Eagleton, *Culture and the Death of God*, ix.

110. Pickstock, "Liturgy, Art and Politics," 163. See also Pickstock, *After Writing* and *Aspects of Truth*.

111. Nietzsche, *Beyond Good and Evil* in *Basic Writings of Nietzsche*, 193.

112. Gadamer, *Truth and Method*, 79.

113. Pickstock, "Liturgy, Art and Politics," 162.

114. See Desmond's discussion of art, religion, and modernity in *AOO*, 265–94.

115. See Shklovsky, "Art as Technique."

116. Desmond notes elsewhere how "each suffers" when philosophy and religion are resolutely opposed: "Philosophy loses the urgency of ultimacy; religion decays into sentimental effusion, or expires in moralistic platitude, or mutates into the fury of a revolutionary dream of secular salvation" (*G*, 5).

117. There is an irony in that, despite his dismissals of beauty, Duchamp's readymades were often described as beautiful. Desmond might point to how the readymade can awaken us to the aesthetic richness of the seemingly mundane in a wine rack, a snow shovel, even a urinal.

118. See Han, *Saving Beauty*, especially 1–14.

119. On Desmond's metaxology and the films of Terrence Malick, which evoke this stronger transcendence, see Camacho, "The Promise of Love Perfected" and Christopher Ben Simpson, "All Things Shining: Desmond's Metaxological Metaphysics and *The Thin Red Line*" in Kelly, ed., *Between System and Poetics*, 239–59.

120. Walsh, *Politics of the Person as the Politics of Being*, 163. Walsh goes on to say, "The death of God and the death of metaphysics cannot encompass the death of art" (163). Desmond would say, though, that art cannot survive those deaths unscathed. Walsh offers a more sanguine account of art in modernity than Desmond. The two can be read in tension with each other, though the tension should not be overstated. Walsh acknowledges the danger when art "becomes a category separate from life, and then art ceases to be the flash of transparence" (177).

121. Merleau-Ponty, "Eye and Mind," 177. See Richard Kearney's provocative discussion of Merleau-Ponty's "anatheistic" phenomenology in *Anatheism*, 85–100.

122. Desmond is clear on the unifying and vivifying power of liturgy, and on the difficulty of reforming a cultural ethos without it, but his most extended and explicit discussion of politics and religion aims at keeping open an agapeic space

beyond any immanent will to power. Too often, he notes, religion has betrayed the former to pursue the latter. This should reassure critics who worry there is a theocratic agenda lurking behind Desmond's agape talk. Likewise, Desmond's defense of liturgy is not the defense of a single liturgy, nor does he claim that only one single liturgy can reform the ethos of a culture. There are plural possibilities. Desmond notes that the ritual life of every great world religion encourages service and the askesis of self. His point, contra the "New Atheists" of a decade ago, is that all these religions, at their best, mediate a sense of the good that resolutely secular movements cannot. See *IU*, 23–59.

123. Desmond, "Foreword," in Martin, *The Incarnation of the Poetic Word*, v.

Chapter 5

1. Desmond does offer a suggestive account of revelatory disclosure as "godsends" in *G*, 245–71.
2. Martine, "William Desmond, the Artwork, and a 'Metaxological' Understanding of Otherness," 344.
3. Felski, *Hooked*, 6.
4. Melville, *Moby-Dick*, 110, 109.
5. Felski, *Hooked*, 15.
6. Felski, *The Limits of Critique*, 11.
7. See Latour, "Why Has Critique Run out of Steam?"
8. Carl Jung, Freud's renegade student, warned against the dangers of a reductive psychoanalytic approach to art in "On the Relation of Analytical Psychology to Poetry."
9. Felski, *The Limits of Critique*, 156. See also Gadamer's critique of such historicism in Part II of *Truth and Method*.
10. Pfau, *Minding the Modern*, 39.
11. See Frye, "Framework and Assumption."
12. On the recovery of these aspects of literature, see Felski, *Uses of Literature* and *Hooked*.
13. See the three essays challenging the injunction against character criticism in Anderson, Felski, and Moi, *Character*.
14. Moi, "Rethinking Character," in Anderson, Felski, and Moi, *Character*, 39.
15. Steiner, *The Poetry of Thought*, 53.
16. Desmond discusses Cavell in *GBPB*, 214–52.
17. Moi, "Rethinking Character," in Anderson, Felski, and Moi, *Character*, 27.
18. Ellison, "Society, Morality and the Novel," 700.
19. Again consider the narrative-rich worlds of traditional societies and religions—cosmological and communal narratives, fables and parables and myths,

ritualized narratives to mark the passage of the seasons and the major passages of life. People living in these worlds live within, and understand themselves, through such nested narratives.

20. Kearney, *On Stories*, 4. This study is insightful throughout on how "narrative matters." Kearney is influenced by his teacher Paul Ricœur, whom he paraphrases here.

21. Desmond notes the importance of exemplary stories within a culture in *EB*, 452. See Desmond's warning, however, about models of "narrative identity," which may not attend enough to the idiocy of existence, in *EB*, 429–30n7.

22. Kearney, *On Stories*, 151.

23. Desmond notes analogous dangers in philosophy, where hermeneutics can become a "hermeneutic Scholasticism." See *VB*, 129–33.

24. See Felski, *The Limits of Critique*.

25. Desmond has criticized deconstruction in this regard. See *AA*, 77–101 and *ISB*, 89–152.

26. See Martin, *The Incarnation of the Poetic Word*.

27. This section focuses on epiphanic encounters between humans, but encounters between humans and animals are of course crucially important, and there are many compelling literary instances of them.

28. *The Epic of Gilgamesh*, 62.

29. *The Epic of Gilgamesh*, 69.

30. Homer, *The Iliad*, 24.590–91.

31. Homer, *The Iliad*, 24.600–4.

32. Aristotle, *Poetics*, 1452a31–32, in *The Basic Works of Aristotle*.

33. Aristotle, *Poetics*, 1452b3–5.

34. Aristotle, *Poetics*, 1452a36.

35. There is some debate about the origins of the term, though the importance of Joyce is widely acknowledged. For discussions that find origin points before Joyce in, say, Wordsworth or Emerson, see the essays collected in Tigges, ed., *Moments of Moment*. This collection also offers helpful typologies of epiphanies.

36. Joyce, *Stephen Hero*, 213.

37. On the theological roots of Joyce's aesthetics, see Kearney, "Epiphanies in Joyce."

38. Kearney, "Epiphanies in Joyce," 147.

39. Kearney, "Epiphanies in Joyce," 166.

40. Kearney, "Epiphanies in Joyce," 167.

41. Walsh, *Politics of the Person as the Politics of Being*, 157.

42. Steiner, *Real Presences*, 147.

43. The historical roots of this trend are interesting to consider and undoubtedly manifold. The modernists' intense interest in subjectivity can carry with it a sense, at times terrifying, of the opacity of the other or the incoherence of the self. World War I is an important influence here. It helped fuel the literature (and

philosophy) of alienation. At the same time, though, it also fueled a profound sense of the importance of relationships. This gave rise to a different sort of literature (and philosophy) of personal encounter. Both strands likely contribute to the twentieth-century literature of epiphanic encounter. Another root, as discussed in the last chapter and to which we return later in this one, is art's long quest for transcendence in a seemingly disenchanted world. See the related discussion in Taylor, *Sources of the Self*, 456–93.

44. On profound experiences of "moral conversion," which are largely neglected in moral philosophy, see Kristján Kristjánsson, "Epiphanic Moral Conversions: Going Beyond Kohlberg and Aristotle," in Frey and Vogler, eds., *Self-Transcendence and Virtue*, 15–38.

45. See Levinas, *Totality and Infinity*. See Desmond's concern about Levinas's asymmetry in "Ethics and the Evil of Being."

46. Joyce, "The Dead," 209.
47. Joyce, "The Dead," 213.
48. Joyce, "The Dead," 217.
49. Joyce, "The Dead," 220.
50. Joyce, "The Dead," 219–20.
51. Joyce, "The Dead," 223.
52. Joyce, "The Dead," 224.
53. Baldwin, "Sonny's Blues," 832.
54. Baldwin, "Sonny's Blues," 846.
55. Baldwin, "Sonny's Blues," 857.
56. Baldwin, "Sonny's Blues," 863.
57. Baldwin, "Sonny's Blues," 864.
58. Hurston, *Their Eyes Were Watching God*, 47.
59. Hurston, *Their Eyes Were Watching God*, 34.
60. Hurston, *Their Eyes Were Watching God*, 46.
61. Hurston, *Their Eyes Were Watching God*, 72.
62. Desmond discusses another O'Connor Story, "Revelation," in *G*, 264–71.

63. Gothic literature often dramatizes the discovery of hidden viciousness in one we thought we knew well: a neighbor, teacher, priest, lover, parent, sibling, or child (or oneself, for that matter). Shirley Jackson's "Charles" is a powerful short story along these lines. A revelatory encounter can reveal monstrosity in the intimate depths of the other. Desmond claims that we know something of this in ourselves. There are reserves in our intimate depths that can surprise us when they surface in acts of agapeic care. But an "idiocy of the monstrous" also lurks in us, sometimes recessed, sometimes festering, sometimes bubbling up unexpectedly. See Desmond's discussion of this idiocy in *IU*, 222–23. Northrop Frye likewise writes of "demonic" epiphanies in *Anatomy of Criticism*, 223.

64. O'Connor, "A Good Man Is Hard to Find," 152.
65. O'Connor, "A Good Man Is Hard to Find," 153.

66. O'Connor, "A Good Man Is Hard to Find," 152.
67. O'Connor, "A Good Man Is Hard to Find," 153.
68. Eliade, *The Sacred and the Profane*, 11.
69. Taylor defines epiphanic art "as the locus of a manifestation which brings us into the presence of something which is otherwise inaccessible, and which is of the highest moral or spiritual significance; a manifestation, moreover, which also defines or completes something, even as it reveals." *Sources of the Self,* 419.
70. Taylor, *Sources of the Self,* 422.
71. Taylor, *Sources of the Self,* 430.
72. Taylor, *Sources of the Self,* 419.
73. Rilke, "Archaic Torso of Apollo."
74. Kenyon, "Things" in *Collected Poems*, 139.
75. Felski, *Uses of Literature*, 101.
76. Jewett, *The Country of the Pointed Firs*, 1.
77. Marcel, *Creative Fidelity*, 70.
78. Robert Macfarlane offers many more examples of such "place-words" in *Landmarks*. He also documents how these particularizing words are falling out of our common language.
79. O'Donohue, *Beauty*, 130.
80. O'Donohue, *Beauty*, 131.
81. Terence Sweeney draws on Desmond's concept of the intimate universal to offer a searching meditation on McKay's poetry in "Claude McKay's Catholic Poetics and Politics."
82. Kavanagh, "Epic."
83. See Marcel, *Creative Fidelity*, 147–74.
84. Berry, *Nathan Coulter*, 13.

Chapter 6

1. Steiner, "'Tragedy,' Reconsidered," 2.
2. Desmond discusses tragedy at length in *PU*, 27–54 and *IU*, 110–15. Desmond discusses theater in general in *GBPB*, 253–76.
3. On sleep, see *IST*, 33–72.
4. See Desmond's remark on Othello, jealousy, and vulnerability in *EB*, 243n15.
5. Euripides, *Medea*, 324.
6. See "On the Gift-Giving Virtue," in *Thus Spoke Zarathustra* in *The Portable Nietzsche*, 186–91.
7. See the discussion of the "gift-giving virtue" in *IST*, 228–33 and the discussion of "Nietzschean friendship" in *IU*, 373–78. Contrast Nietzsche's hero with

the classical hero of Félix Ravaisson, which is closer to Desmond's own ideal: "They were conscious of an internal force that put them in a position to rise above their circumstances, which disposed them to come to the aid of the weak. They believed that they were called, by their origin, to deliver the earth from the monsters that infested it." "Philosophical Testament" in *Selected Essays*, 295. Ravaisson points to Hercules and Theseus.

8. This means that the saint is the highest exemplar for Desmond, beyond the heroic warriors and leaders of epic and tragedy. As Desmond suggests, though, the hero can become a self-sacrificial servant of the community, of the needy, of the good. It is interesting to think about which figures philosophers take as their exemplars. See again the discussion of philosophy's "others" in *PO*, 15–61. See also Robert Cummings Neville's study *Soldier, Sage, Saint*, which draws on both Eastern and Western traditions.

9. For Desmond's most developed readings of *Macbeth*, see "Sticky Evil" and *IST*, 57–61.

10. "One wonders now and then," Desmond notes, "if in Nietzsche there is a mingling of *passio* and *conatus*, indeed of a kind of agapeics and erotics, but they cannot quite fit the form dictated by the sacred ultimacy of Dionysus, or the ontological ultimacy of will to power (always understood as *self*-affirming)" (*IU*, 301). Byung-Chul Han notes a more contemplative Nietzsche in *The Scent of Time*.

11. Desmond, "Sticky Evil," 150–51. Nietzsche writes, "A criminal is frequently not equal to his deed: he makes it smaller and slanders it." *Beyond Good and Evil* in *Basic Writings of Nietzsche*, 275. Elsewhere: "Not to perpetrate cowardice against one's own acts! Not to leave them in the lurch afterward! The bite of conscience is indecent." *Twilight of the Idols* in *The Portable Nietzsche*, 467.

12. On the "sanitized" Nietzsche, see *IST*, 219.

13. See also Desmond's discussion of Nietzsche's three forms of will to power in *IST*, 200–37.

14. Simpson, "Introduction," in *WDR*, xiv.

15. See Desmond, "Ethics and the Evil of Being," 424–26.

16. Nietzsche, *Thus Spoke Zarathustra* in *The Portable Nietzsche*, 142.

17. Shakespeare, *Macbeth*, 1.7.43–45. References to *Macbeth* and *King Lear* are cited parenthetically hereafter in this chapter.

18. Desmond, "Sticky Evil," 146.

19. Köhler-Ryan, *Companions in the Between*, 83.

20. Köhler-Ryan, *Companions in the Between*, 82.

21. Desmond, "Sticky Evil," 133.

22. Köhler-Ryan, *Companions in the Between*, 92.

23. Shakespeare's Julius Caesar, heedless of the prophecy, is an interesting inversion of this trope, though perhaps such heedlessness is another form of a distorted, overconfident *conatus*.

24. Desmond, "Sticky Evil," 142.

25. There is an old debate on whether *King Lear* should be read in "pagan" or Christian terms. Desmond would likely concur with Regina Schwartz: "While the play is not set in a Christian context, the endorsement of the biblical tradition that elevates love to the highest good is unmistakable. That this is accompanied by sacrifice—of goods, of control, and finally, of life itself—only underscores the ultimate nature of that value." *Loving Justice, Living Shakespeare*, 47.

26. Critics have often found fault with Edgar, but there is another critical strand that reads him more positively. Harold Bloom, for instance, calls Edgar "an uncelebrated hero of the negative way." *Lear*, 150.

27. Again, though, as Eagleton notes, Aristotle is himself suppler in terms of plot than many of his followers.

28. On the difficulties of defining tragedy, see Eagleton, *Sweet Violence*, 1–22.

29. See Nussbaum, *The Fragility of Goodness*.

30. See Steiner, "A Note on Absolute Tragedy."

31. On the question of hope and tragedy, see Eagleton, *Sweet Violence*.

32. Of course, this is not only a danger for philosophical theodicies. It is a general danger for the religious believer. Even when speaking to another bereaved believer, there is the danger of the pat or gauche. The hope for heaven becomes a dismissive, "Of course she is in a better place," lacking both spiritual seriousness and sensitivity. It turns death from a mystery to be lived out in its particularity into a general problem that God has tidily solved. It is telling that Christ weeps for Lazarus before raising him from the dead. Compare the saccharine cliché with Gabriel Marcel's meditations on the afterlife throughout his writings. The hope of a life to come is often a passionate hope for *this* dearly departed. See also Desmond's moving remarks about healing and consoling words in the closing pages of *EB*, 511–14.

33. Desmond also points to how Claudius attempts to bully Hamlet out of his grief by saying that every son loses his father. Claudius in effect seeks to shear Hamlet's loss of its singularity: "The tale of generations is the common story of lost fathers and grieving sons, repeated again and again—all said by Claudius with the intent to rob the singularity of Hamlet's grief of its singular intimacy" (*PU*, 95).

34. Desmond's use of the phrase "never more" in this context is a fitting evocation, intentional or unintentional, of Poe's "The Raven," a tragic poem of haunting loss.

35. The painter-poet David Jones sketched two rats shot in the trenches of World War I. Figuratively, these rats seem to call to mind the dehumanized soldiers reduced to rat-like existence and then exterminated. Yet Jones renders the rats in such detail that we are awakened to their intimate being and indeed their worth—the worth even of vermin that contributed to the misery and horror of trench life—amid such vast loss.

36. Desmond notes the proximity of the *Phaedo* and the *Apology* to tragedy. See *PU*, 37–44.

37. Albany speaks the final lines in the Quarto version of the play, Edgar in the Folio.

38. Note, too, the ambiguity of Lear's own final lines: "Do you see this? Look on her, look, her lips, / Look there, look there!" (5.3.374–75). Some critics read these lines as manifestations of Lear's madness or grief-stricken delusion, others as a vision of Cordelia in heaven. Others read it (to use Desmond's language) as Lear's renewed wonder at his singular daughter as a remarkable "once."

Chapter 7

1. For Desmond's fullest reflection on laughter, see *GBPB*, 277–322.

2. See Plato, *Philebus* 48a–51a, in *Complete Works*. While Plato is often associated with the superiority theory, Desmond would agree with Sonja Madeleine Tanner's argument for a much broader Plato in *Plato's Laughter*.

3. Quoted in Morreall, *The Philosophy of Laughter and Humor*, 19. This is the classic anthology on philosophical laughter.

4. Tanner, *Plato's Laughter*, xxi.

5. Quoted in Morreall, *The Philosophy of Laughter and Humor*, 27.

6. Quoted in Morreall, *The Philosophy of Laughter and Humor*, 32.

7. Kant, *Critique of Judgment*, 203, §54. Schopenhauer offers an important incongruity theory as well. See *The World as Will and Representation*, 1:58–61, §13.

8. Bergson, *Laughter*, 10.

9. Bergson, *Laughter*, 9.

10. Bergson, *Laughter*, 4.

11. Bergson, *Laughter*, 5.

12. Desmond discusses these two theories in *GBPB*, 284–85n12. See also the note on Hobbes, Freud, and Bataille in *GBPB*, 305–6n36.

13. Desmond notes that Hegel, in his lectures, discerns that in Aristophanes "the breakthrough to joy in being is there in laughing even in all breakdown of pretensions, hilarity in all the absurd craziness" (*BHD*, 295). Desmond is not convinced by the widespread view of a humorless Hegel. He suggests that Bataille's and Derrida's critiques apply more to Kojève's Hegel than to Hegel himself. See *BHD*, 251–300.

14. Nietzsche, *Thus Spoke Zarathustra* in *The Portable Nietzsche*, 153.

15. Nietzsche, *Thus Spoke Zarathustra*, 230.

16. Nietzsche, *Thus Spoke Zarathustra*, 342.

17. Desmond has his own scoffing laughs, sometimes at the "neutral," but they are more often at the self-inflated, at those who think they are on the heights. He can play the part of the Thracian maid in this regard. See his remarks on Shakespeare's groundlings in *IU*, 112.

18. Nietzsche, *The Birth of Tragedy* in *Basic Writings of Nietzsche*, 60.

19. See *Nicomachean Ethics*, 1127b34–1128b9, in *The Basic Works of Aristotle*. Hugo Rahner traces the "grave-merry" ideal in classical and Christian tradition in *Man at Play*, 44–56.

20. In "Laughter and the Between," Duncan Bruce Reyburn highlights a number of similarities between G. K. Chesterton and Desmond on humor in general and on humor in Christianity in particular. He offers an insightful analysis of humor through the lens of Desmond's four-fold sense of being.

21. See Bakhtin, *Rabelais and His World*.

22. Evert A. Duyckinck, "A Friend Does His Christian Duty," in Melville, *Moby-Dick*, 610–11.

23. Melville, *Moby-Dick*, 104–5. Citations to the novel are given parenthetically throughout the rest of this section.

24. Fleece arguably uses his "sermon," though, to rhetorically outmaneuver Stubb.

25. Stubb comments on such laughter after Ahab rallies the crew to his quest: "Ha! Ha! Ha! Ha! Hem! clear my throat!—I've been thinking over it ever since, and that ha, ha's the final consequence. Why so? Because a laugh's the wisest, easiest answer to all that's queer" (145).

26. Dagovitz, "*Moby-Dick*'s Hidden Philosopher," 338.

27. Quoted in Dagovitz, "*Moby-Dick*'s Hidden Philosopher," 331.

28. Evans, *Whale!*, 50.

29. Desmond explains, "The festive [wake] is not the opposite of the sorrowful but its recognition and the disarming of its disablement, and release of a new enabling of affirming life" (*GBPB*, 298).

30. Slattery, *The Wounded Body*, 151.

31. Slattery, *The Wounded Body*, 152.

32. *Macbeth* influenced *Moby-Dick*, and there are some similarities between the works' two great tragic figures at the end. Cut off from the *passio* of sleep, both seem to be carried along by an ominous destiny spun out of their earlier willings and equivocal prophecies.

33. We even see an earnest Stubb here: "'His son!' cried Stubb, 'oh, it's his son he's lost! I take back the coat and watch—what says Ahab? We must save that boy'" (398). Contrast with Stubb's earlier abandonment of Pip.

34. See Edward Mooney's discussion of Melville's tropes of death and rebirth in *Living Philosophy in Kierkegaard, Melville, and Others*, 43–65.

35. We might also think of Queequeg, the pagan who outdoes the Christians in agapeic service. Consider how early in the novel he rescues from drowning the very passenger who mocked him. Consider how he dives down to rescue Tashtego from the "tomb" of the whale head when it comes loose from the ship. These scenes prefigure Ishmael's rescue at the very end of the novel—the third rescue from beneath the water, perhaps here not only rich with biblical significance but also contrasting with the three days of Ahab's doomed chase.

36. See Desmond's chapter of the same name in *BHD*, 301–42, which focuses on Hegel's perhaps surprising affinity for Aristophanes.

37. This section focuses on humorous comedy, but comedy of course comes in many forms historically. See Northrop Frye's survey in *Anatomy of Criticism*, 163–86.

38. Aristotle defended the practicality of Thales (and by extension philosophy) against the Thracian maid and her mocking partisans. He claims that Thales was looking at the sky to prognosticate the olive crop, and he did indeed cash in on it next season. Aristotle, perhaps a little defensive on behalf of philosophy, claims that Thales gets the last laugh. See *Politics*, 1259a5–22, in *The Basic Works of Aristotle*.

39. Philosophers themselves have made use of this image. Schopenhauer calls Hegel's speculative system "cloud-cuckoo-land." *The World as Will and Representation*, 1:273, §53. Philosophers can align themselves with the practicality of the Thracian maid. Desmond claims, for instance, "Hegel is to Marx as Thales is to the Thracian maid" (*BHD*, 256–57).

40. See Desmond's discussion of Swift in *Being Between*, 43–48.

41. Melville, *Moby-Dick*, 136.

42. This is not the only stock figure that Aristophanes bequeathed to the comic tradition. Frye notes that Aristophanes's *The Acharnians* "contains the *miles gloriosus* or military braggart who is still going strong in Chaplin's *Great Dictator*." *Anatomy of Criticism*, 163. There is also the self-serving politician of *The Wasps*.

43. Bakhtin, *Rabelais and His World*, 11–12.

44. Bakhtin, *Rabelais and His World*, 21.

45. Desmond finds Hegel's critique of Romantic irony suggestive and extends it to postmodern irony. See *AA*, 116–20 and *BHD*, 296–97. Kierkegaard also examines the double-edged sword of irony. Irony is useful to unsettle complacent interlocutors, but irony is also a potentially dangerous "seducer" for Kierkegaard. Too much irony can leave one incapable of affirmation.

46. Frye notes, for instance, how the rigid antagonists in comedy are often recuperated and reabsorbed into a renewed society at the end of the play.

47. There is a suggestive exegetical tradition beginning with Philo of Alexandria that meditates on the "play" of Isaac/laughter and Rebecca/perseverance. See Rahner, *Man at Play*, 53–56.

48. Dupree, "The Copious Inventory of Comedy," 163.

49. Dupree, "The Copious Inventory of Comedy," 163–64.

50. Sometimes it is hard to tell if a work is a comedy or a tragedy. Beckett's *Waiting for Godot* and *Endgame* come to mind.

51. Frye, *Anatomy of Criticism*, 179.

52. Frye, *Anatomy of Criticism*, 178.

53. See Plato, *Theaetetus* 174a-b, in *Complete Works*.

54. Tanner discusses the hiccups in *Plato's Laughter*, 118–27. See also Desmond's discussion of Aristophanes in the *Symposium* in *BHD*, 325–42.

55. Tanner, *Plato's Laughter*, 154.

56. See Nietzsche, *The Will to Power*, 202.

57. Hölderlin, "Bread and Wine."

58. See, for instance, Heidegger, "What Are Poets For?," in *Poetry, Language, Thought*, 89–142.

59. Pieper, *In Tune with the World*, 59.

60. Hölderlin, "Bread and Wine."

61. Desmond might say that some philosophers of the festive are attuned more to the erotic, others to the agapeic. In others still, like Bakhtin, these mix ambiguously. Such mixing is undoubtedly common in festivals themselves, though they too can tend more toward one (the erotic carnival) or the other (the agapeic Sabbath).

62. Bakhtin, *Rabelais and His World*, 7.

63. Pieper, *In Tune with the World*, 17.

64. Heschel, *The Sabbath*, 15.

65. Gadamer, "The Relevance of the Beautiful," in *The Relevance of the Beautiful and Other Essays*, 40.

66. See Gadamer, "The Relevance of the Beautiful," 41–42.

67. Han, *Saving Beauty*, 69. See also Han, *The Disappearance of Rituals*.

68. Modernity also stages the Dionysian on a grand scale, as evidenced by, say, Burning Man or Coachella.

69. Chanon Ross studies the reduction of festival to spectacle in *Gifts Glittering and Poisoned*. He makes provocative comparisons between the spectacles of ancient Rome and today. Ross draws his title from Desmond, and he draws on Desmond's philosophy throughout the study.

70. Pieper, *In Tune with the World*, 19.

71. Langer, *Feeling and Form*, 331.

72. Frye, *Anatomy of Criticism*, 163.

73. Bakhtin, *Rabelais and His World*, 11.

74. See Pieper, *In Tune with the World*, 59.

75. See Gadamer, "The Festive Character of Theater," in *The Relevance of the Beautiful and Other Essays*, 57–65.

76. Pieper, *In Tune with the World*, 53.

77. Smith, "Dickens' Ghosts," 36.

78. Stewart, "The Sham Practice of Christmas." Stewart reads *A Christmas Carol* via Pieper's account of festivity.

79. Dickens, *A Christmas Carol*, 53. The novella is cited parenthetically throughout the rest of this section.

80. Stewart, "The Sham Practice of Christmas."

81. Gibson, *Forgiveness in Victorian Literature*, 56.

82. Stewart, "The Sham Practice of Christmas."

83. See the trenchant critique along these lines in Smith, "Dickens' Ghosts."

Conclusion

1. Again, there are many possibilities. Some philosopher-writers, such as Gabriel Marcel and Iris Murdoch, prefer to keep their philosophical modes and artistic modes fairly separate. Other poetic philosophers, like Plato and Kierkegaard, deploy poetry against the poets themselves.

2. Philosophy's own "literary" genres—the dialogue and the aphorism—have their roots in drama on the one side and in oracle, proverb, and folk wisdom on the other.

3. Steiner, *The Poetry of Thought*, 11. This study is broadly insightful on the relationship between philosophy and literature and on the philosophical genres of dialogue and aphorism.

4. Steiner, *The Poetry of Thought*, 157.

5. O'Regan, "The Poetics of Ethos," 278.

6. See Duns, *Spiritual Exercises for a Secular Age*, 232–87.

7. On "thought singing its other," see *PO*, 259–311.

8. See Pickstock, *After Writing*. Desmond also points to the implied liturgical horizon of philosophy in the writings of Levinas. See *BHD*, 93–94.

9. Chrétien, *The Ark of Speech*, 116.

10. Chrétien, *The Ark of Speech*, 117.

11. Desmond could be brought into productive conversation with Kierkegaard on the links between wonder, worship, and philosophy. See Wyllie, "The Discourses on Wonder."

12. Verene, *The Philosophy of Literature*, ix.

13. See Vico, *The New Science of Giambattista Vico*, 154, ¶460.

14. On Desmond and Vico, see Cyril O'Regan, "Repetition: Desmond's New Science," in Kelly, ed., *Between System and Poetics*, 65–91.

15. Hackett, *Philosophy in Word and Name*, 279. Hackett explains, "There are myths of myths, hidden myths and unspoken myths, living myths and dead myths, myths rehabilitated, partially or fully, myths that destroy and myths that give life" (279).

16. See Vico, *The New Science of Giambattista Vico*, 154, ¶460 and 310, ¶809.

17. O'Regan, "Repetition," in Kelly, ed., *Between System and Poetics*, 83.

18. See the allegory of the cave in Plato, *Republic* 514a–520a, in *Complete Works*.

19. When we try to ascend beyond the re-illuminated surface toward God, the myths and mystics say that we actually find a different kind of darkness. We might call this, with a nod to Plato and Dionysius the Areopagite, the blinding brightness of the sun. (Or we might think of the mysterious cloud that Moses finds himself in on the mountain.) Desmond would deem this the exceeding overdeterminacy of the origin.

20. Paul Tyson connects these artificers to "transnational corporate power" in his reading of the contemporary situation via Plato's allegory. See "The Politics of the Metaphysical Imagination."

21. Desmond's recent writings contain suggestive remarks in this regard, though, perhaps suggesting a fuller treatment to come. For an overview of Han's writings, see Knepper and Wyllie, "In the Swarm of Byung-Chul Han."

22. For a more developed discussion of Schopenhauer, Nietzsche, Desmond, and the cave, see Knepper, "Climbing the Dark."

23. Two great imaginative universals of ascent in the Bible reveal two very different possibilities—the hubristic building of the tower of Babel, the ascent of the holy mountain.

24. Félix Ravaisson points out that in Egyptian, Greek, and Roman myth, descent into the underworld was descent not only into the nefarious depths but also into the domain from which vegetal life emerged, the domain in which a subterranean light rekindled the sun each night. See "Mysteries: Fragment of a Study of the History of Religions," in *Selected Essays*, 243–44.

25. Raine, "The Inner Journey of the Poet," in *That Wondrous Pattern*, 99.

26. Desmond discusses this scene in the *Inferno* in *GBPB*, 97–98, and *G*, 21–25.

27. Dante, *The Inferno*, 34.139–43.

28. Camacho, "The Promise of Love Perfected," 233.

Bibliography

Abram, David. *The Spell of the Sensuous: Perception and Language in a More-Than-Human-World.* New York: Vintage Books, 1997.

Agamben, Giorgio. *The Kingdom and the Glory: For a Theological Genealogy of Economy and Government.* Translated by Lorenzo Chiesa and Matteo Mandarini. Stanford, CA: Stanford University Press, 2011.

Anderson, Amanda, Rita Felski, and Toril Moi. *Character: Three Inquiries in Literary Studies.* Chicago: University of Chicago Press, 2019.

Aquinas, Thomas. *Summa Theologica.* 3 vols. Translated by Fathers of the English Dominican Province. New York: Benziger Brothers, 1947–48.

Aristotle. *The Basic Works of Aristotle.* Edited by Richard McKeon. New York: Modern Library, 2001.

Arnold, Matthew. "Dover Beach." In *Poetry and Criticism of Matthew Arnold*, edited by A. Dwight Culler, 161–62. Boston: Riverside Editions/Houghton Mifflin, 1961.

Asad, Talal. *Formations of the Secular: Christianity, Islam, Modernity.* Stanford, CA: Stanford University Press, 2003.

Augustine. *The City of God.* Abridged. Edited by Vernon J. Bourke. Translated by Gerald G. Walsh, SJ, Demetrius B. Zema, SJ, Grace Monahan, OSU, and Daniel J. Honan. New York: Image, 1958.

———. *Confessions.* Translated by Henry Chadwick. Oxford: Oxford University Press, 2008.

Bakhtin, Mikhail. *Rabelais and His World.* Translated by Hélène Iswolsky. Bloomington: Indiana University Press, 1984.

Baldwin, James. "Sonny's Blues." In *Early Novels and Stories,* edited by Toni Morrison, 831–64. New York: Library of America, 1998.

Balthasar, Hans Urs von. *The Glory of the Lord: A Theological Aesthetics.* Vol. 1, *Seeing the Form.* 2nd ed. Edited by Joseph Fessio, SJ, and John Riches. Translated by Erasmo Leiva-Merikakis. San Francisco: Ignatius, 2009.

———. *Love Alone Is Credible*. Translated by D. C. Schindler. San Francisco: Ignatius, 2004.

———. *Theo-Logic: Theological Logical Theory*. Vol. 1, *Truth of the World*. Translated by Adrian J. Walker. San Francisco: Ignatius, 2000.

Barthes, Roland. "The Death of the Author." In *Image—Music—Text*, edited and translated by Stephen Heath, 142–48. New York: Hill and Wang, 1997.

Bataille, Georges. *Inner Experience*. Translated by Leslie Anne Boldt. Albany: State University of New York Press, 1988.

Benjamin, Walter. "Theses on the Philosophy of History." In *Illuminations*, edited by Hannah Arendt, translated by Harry Zohn, 253–64. New York: Schocken Books, 2007.

Bergson, Henri. *Laughter: An Essay on the Meaning of the Comic*. Translated by Cloudesley Brereton and Fred Rothwell. New York: Macmillan, 1914.

Berry, Wendell. *Life Is a Miracle: An Essay Against Modern Superstition*. Washington, DC: Counterpoint, 2000.

———. *Nathan Coulter*. In *Three Short Novels*, 1–117. Washington, DC: Counterpoint, 2002.

Blake, William. "And Did Those Feet in Ancient Time." In *The Portable Blake*, edited by Alfred Kazin, 412. New York: Viking, 1959.

Bloom, Harold. *The Anatomy of Influence: Literature as a Way of Life*. New Haven, CT: Yale University Press, 2011.

———. *The Anxiety of Influence: A Theory of Poetry*. 2nd ed. New York: Oxford University Press, 1997.

———. "Introduction." In *Dante Alighieri*, edited by Harold Bloom, 1–10. Bloom's Modern Critical Views. Philadelphia: Chelsea House, 2004.

———. *Lear: The Great Image of Authority*. New York: Scribner, 2018.

Buber, Martin. *I and Thou*. 2nd ed. Translated by Ronald Gregor Smith. New York: Charles Scribner's Sons, 1958.

Camacho, Paul. "The Promise of Love Perfected: Eros and Kenosis in *To the Wonder*." In *Theology and the Films of Terrence Malick*, edited by Christopher B. Barnett and Clark J. Elliston, 232–50. New York: Routledge, 2017.

Carnes, Natalie. *Beauty: A Theological Engagement with Gregory of Nyssa*. Eugene, OR: Cascade Books, 2014.

———. *Image and Presence: A Christological Reflection on Iconoclasm and Iconophilia*. Stanford, CA: Stanford University Press, 2018.

Carpenter, Anne M. *Theo-Poetics: Hans Urs von Balthasar and the Risk of Art and Being*. Notre Dame, IN: University of Notre Dame Press, 2015.

Chrétien, Jean-Louis. *The Ark of Speech*. Translated by Andrew Brown. London: Routledge, 2004.

———. *The Call and the Response*. Translated by Anne A. Davenport. New York: Fordham University Press, 2004.

Claudel, Paul. "Religion and the Artist: Introduction to a Poem on Dante." Translated by David Louis Schindler Jr. *Communio* 22, no. 2 (Summer 1995): 357–67.
Coomaraswamy, Ananda K. *Christian and Oriental Philosophy of Art*. New York: Dover, 1956.
Dagovitz, Alan. "*Moby-Dick*'s Hidden Philosopher: A Second Look at Stubb." *Philosophy and Literature* 32, no. 2 (October 2008): 330–46.
Dante. *The Inferno*. Translated by John Ciardi. New York: Mentor, 1982.
———. *The Purgatorio*. Translated by John Ciardi. New York: Signet Classics, 2009.
Danto, Arthur C. *The Abuse of Beauty: Aesthetics and the Concept of Art*. Chicago: Open Court, 2004.
Derrida, Jacques. "The Parergon." Translated by Craig Owens. *October* 9 (Summer 1979): 3–41.
Desmond, William. "Agapeic Selving and the Passion of Being: Subjectivity in the Light of Solidarity." In *Post-Subjectivity*, edited by Christoph Schmidt, Merav Mack, and Andy R. German, 77–101. Newcastle upon Tyne, UK: Cambridge Scholars, 2014.
———. *Art and the Absolute: A Study of Hegel's Aesthetics*. Albany: State University of New York Press, 1986.
———. *Art, Origins, Otherness: Between Philosophy and Art*. Albany: State University of New York Press, 2003.
———. *Being and the Between*. Albany: State University of New York Press, 1995.
———. *Being Between: Conditions of Irish Thought*. Galway, Ireland: Leabhar Breac, 2008.
———. *Beyond Hegel and Dialectic: Speculation, Cult, and Comedy*. Albany: State University of New York Press, 1992.
———. "Consecrated Thought: Between the Priest and the Philosopher." *Journal of Philosophy and Scripture* 2, no. 2 (Spring 2005): 1–10.
———. *Desire, Dialectic, and Otherness: An Essay on Origins*. New Haven, CT: Yale University Press, 1987.
———. *Ethics and the Between*. Albany: State University of New York Press, 2001.
———. "Ethics and the Evil of Being." In *What Happened in and to Moral Philosophy in the Twentieth Century?: Philosophical Essays in Honor of Alasdair MacIntyre*, edited by Fran O'Rourke, 423–59. Notre Dame, IN: University of Notre Dame Press, 2013.
———. *The Gift of Beauty and the Passion of Being: On the Threshold between the Aesthetic and the Religious*. Eugene, OR: Cascade Books, 2018.
———. *God and the Between*. Malden, MA: Blackwell, 2008.
———. "God, Ethos, Ways." *International Journal for Philosophy of Religion* 45, no. 1 (February 1999): 13–30.
———. *Godsends: From Default Atheism to the Surprise of Revelation*. Notre Dame, IN: University of Notre Dame Press, 2021.

———. *Hegel's God: A Counterfeit Double?* London: Routledge, 2017.
———. *The Intimate Strangeness of Being: Metaphysics after Dialectic.* Washington, DC: Catholic University of America Press, 2012.
———. *The Intimate Universal: The Hidden Porosity Among Religion, Art, Philosophy, and Politics.* New York: Columbia University Press, 2016.
———. *Is There a Sabbath for Thought?: Between Religion and Philosophy.* New York: Fordham University Press, 2005.
———. "*Paideia:* Anachronism or Necessity?" In *Educating for Democracy: Paideia in an Age of Uncertainty*, edited by Alan M. Olson, David M. Steiner, and Irina S. Tuuli, 11–24. Lanham, MD: Rowman & Littlefield, 2004.
———. *Perplexity and Ultimacy: Metaphysical Thoughts from the Middle.* Albany: State University of New York Press, 1995.
———. "Philosophies of Religion: Marcel, Jaspers, Levinas." In *Routledge History of Philosophy.* Vol. 8, *Twentieth-Century Continental Philosophy*, edited by Richard Kearney, 131–74. London: Routledge, 2003.
———. *Philosophy and Its Others: Ways of Being and Mind.* Albany: State University of New York Press, 1990.
———. "The Porosity of Being: Towards a Catholic Agapeics." In *Renewing the Church in a Secular Age: Holistic Dialogue and Kenotic Vision*, edited by Charles Taylor, José Casanova, George F. McLean, and João J. Vila-Chã, 283–305. Washington, DC: Council for Research in Values and Philosophy, 2016.
———. "Sticky Evil: *Macbeth* and the Karma of the Equivocal." In *God, Literature and Process Thought*, edited by Darren J. N. Middleton, 133–55. Aldershot, UK: Ashgate, 2002.
———. *The Voiding of Being: The Doing and Undoing of Metaphysics in Modernity.* Washington, DC: Catholic University of America Press, 2020.
———. *The William Desmond Reader.* Edited by Christopher Ben Simpson. Albany: State University of New York Press, 2012.
Dickens, Charles. *A Christmas Carol.* In *The Christmas Books.* Vol. 1, *A Christmas Carol/The Chimes*, edited by Michael Slater, 38–134. Middlesex, UK: Penguin Books, 1972.
Dickinson, Emily. Letter 459a. *Dickinson Electronic Archives.* September 16, 1998. http://archive.emilydickinson.org/correspondence/higginson/l459a.html.
Duns, SJ, Ryan G. *Spiritual Exercises for a Secular Age: Desmond and the Quest for God.* Notre Dame, IN: University of Notre Dame Press, 2020.
Dupree, Robert S. "The Copious Inventory of Comedy." In *The Terrain of Comedy*, edited by Louise Cowan, 163–94. Dallas, TX: Dallas Institute of Humanities and Culture, 1984.
Eagleton, Terry. *Culture and the Death of God.* New Haven, CT: Yale University Press, 2015.
———. *Sweet Violence: The Idea of the Tragic.* Malden, MA: Blackwell, 2003.
Eco, Umberto. *Art and Beauty in the Middle Ages.* Translated by Hugh Bredin. New Haven, CT: Yale University Press, 1986.

Eliade, Mircea. *The Sacred and the Profane: The Nature of Religion*. Translated by Willard R. Trask. New York: Harvest/HBJ, 1959.

Eliot, T. S. "Tradition and the Individual Talent." In *The Sacred Wood: Essays on Poetry and Criticism*, 47–59. New York: University Paperbacks, 1964.

Ellison, Ralph. "Society, Morality and the Novel." In *The Collected Essays of Ralph Ellison*, edited by John F. Callahan, 698–729. New York: Modern Library, 2003.

The Epic of Gilgamesh. Translated by N. K. Sandars. London: Penguin Books, 1972.

Euripides. *Medea*. Translated by Michael Townsend. In *Classical Tragedy: Greek and Roman*, edited by Robert W. Corrigan, 309–48. New York: Applause, 1990.

Evans, K. L. *Whale!* Minneapolis: University of Minnesota Press, 2003.

Felski, Rita. *Hooked: Art and Attachment*. Chicago: University of Chicago Press, 2020.

———. *The Limits of Critique*. Chicago: University of Chicago Press, 2015.

———. *Uses of Literature*. Malden, MA: Blackwell, 2008.

FitzGerald, Brian. *Inspiration and Authority in the Middle Ages: Prophets and Their Critics from Scholasticism to Humanism*. Oxford: Oxford University Press, 2017.

Franke, William. *A Philosophy of the Unsayable*. Notre Dame, IN: University of Notre Dame Press, 2014.

———. "Poetry, Prophecy, and Theological Revelation." In *Oxford Research Encyclopedia of Religion*, edited by John Barton. Oxford University Press. May 2016. https://oxfordre.com/religion.

Franke, William, ed. *On What Cannot Be Said: Apophatic Discourses in Philosophy, Religion, Literature, and the Arts*. Vol. 2, *Modern and Contemporary Transformations*. Notre Dame, IN: University of Notre Dame Press, 2007.

Frey, Jennifer A., and Candace Vogler, eds. *Self-Transcendence and Virtue: Perspectives from Philosophy, Psychology, and Theology*. New York: Routledge, 2019.

Frost, Robert. "Nothing Gold Can Stay." In *Collected Poems, Prose, & Plays*, edited by Richard Poirier and Mark Richardson, 206. New York: Library of America, 1995.

Frye, Northrop. *Anatomy of Criticism: Four Essays*. Princeton, NJ: Princeton University Press, 1973.

———. "Framework and Assumption." In *Collected Works of Northrop Frye*. Vol. 18, *The Secular Scripture and Other Writings on Critical Theory, 1976–1991*, edited by Joseph Adamson and Jean Wilson, 423–35. Toronto: University of Toronto Press, 2006.

Gadamer, Hans-Georg. *The Relevance of the Beautiful and Other Essays*. Edited by Robert Bernasconi. Translated by Nicholas Walker. Cambridge: Cambridge University Press, 1986.

———. *Truth and Method*. Translation edited by Garrett Barden and John Cumming. New York: Crossroad, 1982.

Gibson, Richard Hughes. *Forgiveness in Victorian Literature: Grammar, Narrative, and Community*. London: Bloomsbury Academic, 2016.

Gonzales, Philip John Paul. *Reimagining the Analogia Entis: The Future of Erich Przywara's Christian Vision*. Grand Rapids, MI: William B. Eerdmans, 2019.

Graham, Loren, and Jean-Michel Kantor. *Naming Infinity: A True Story of Religious Mysticism and Mathematical Creativity*. Cambridge, MA: Belknap Press of Harvard University Press, 2009.

Gray, John. *Seven Types of Atheism*. New York: Farrar, Straus and Giroux, 2018.

Hackett, William C. *Philosophy in Word and Name: Myth, Wisdom, Apocalypse*. Brooklyn, NY: Angelico, 2020.

Hadot, Pierre. *Philosophy as a Way of Life: Spiritual Exercises from Socrates to Foucault*. Edited by Arnold I. Davidson. Translated by Michael Chase. Malden, MA: Blackwell, 1995.

Halliwell, Stephen. *The Aesthetics of Mimesis: Ancient Texts and Modern Problems*. Princeton, NJ: Princeton University Press, 2002.

Han, Byung-Chul. *The Burnout Society*. Translated by Erik Butler. Stanford, CA: Stanford Briefs, 2015.

———. *The Disappearance of Rituals: A Topology of the Present*. Translated by Daniel Steuer. Cambridge, UK: Polity, 2020.

———. *Saving Beauty*. Translated by Daniel Steuer. Cambridge, UK: Polity, 2018.

———. *The Scent of Time: A Philosophical Essay on the Art of Lingering*. Translated by Daniel Steuer. Cambridge, UK: Polity, 2017.

Hart, David Bentley. *The Beauty of the Infinite: The Aesthetics of Christian Truth*. Grand Rapids, MI: William B. Eerdmans, 2004.

———. *The Experience of God: Being, Consciousness, Bliss*. New Haven, CT: Yale University Press, 2013.

Hart, Kevin. *Poetry and Revelation: For a Phenomenology of Religious Poetry*. London: Bloomsbury Academic, 2017.

———. *The Trespass of the Sign: Deconstruction, Theology and Philosophy*. New York: Fordham University Press, 2000.

Heaney, Seamus. "Introduction." In *Beowulf: A New Verse Translation*, translated by Seamus Heaney, ix–xxx. New York: W. W. Norton & Company, 2001.

Hegel, G. W. F. *Phenomenology of Spirit*. Translated by A. V. Miller. Oxford: Oxford University Press, 1977.

———. "On Art." Translated by Bernard Bosanquet. In *On Art, Religion, and the History of Philosophy: Introductory Lectures*, edited by J. Glenn Gray, 22–127. Indianapolis, IN: Hackett, 1997.

Heidegger, Martin. *Being and Time*. Translated by John Macquarrie and Edward Robinson. New York: Harper & Row, 1962.

———. *Introduction to Metaphysics*. Translated by Gregory Fried and Richard Polt. New Haven, CT: Yale University Press, 2000.

———. *Poetry, Language, Thought*. Translated by Albert Hofstadter. New York: Perennial Library, 1975.

———. "The Question Concerning Technology." Translated by William Lovitt. In *Basic Writings*, edited by David Farrell Krell, 287–317. New York: Harper & Row, 1977.

Heschel, Abraham Joshua. *The Sabbath*. In *The Earth Is the Lord's and The Sabbath*. New York: Harper Torchbooks, 1966.

Hölderlin, Friedrich. "Bread and Wine." Translated by James Mitchell. In *European Romanticism: A Reader*, edited by Stephen Prickett and Simon Haines, 684–93. London: Bloomsbury Academic, 2014.

Hollander, Robert. "Tragedy in Dante's *Comedy*." In *Dante: The Critical Complex*. Vol. 2, *Dante and Classical Antiquity: The Epic Tradition*, edited by Richard Lansing, 34–54. New York: Routledge, 2003.

Holston, Ryan. "Historical Truth in the Hermeneutics of T. S. Eliot." *Harvard Theological Review* 111, no. 2 (April 2018): 264–88.

Homer. *The Iliad*. Translated by Robert Fagles. New York: Penguin Books, 1998.

Hopkins, Gerard Manley. *The Major Works*. Edited by Catherine Phillips. Oxford: Oxford University Press, 2009.

Horkheimer, Max, and Theodor W. Adorno. *Dialectic of Enlightenment: Philosophical Fragments*. Edited by Gunzelin Schmid Noerr. Translated by Edmund Jephcott. Stanford, CA: Stanford University Press, 2002.

Houlgate, Stephen. "William Desmond on Philosophy and Its Others." *CLIO* 20, no. 4 (1991): 371–91.

Hurston, Zora Neale. *Their Eyes Were Watching God*. New York: Harper Perennial Modern Classics, 2006.

Hyde, Lewis. *The Gift: Imagination and the Erotic Life of Property*. New York: Vintage Books, 1983.

Irigaray, Luce, ed. *Luce Irigaray: Key Writings*. London: Continuum, 2004.

Irigaray, Luce, and Michael Marder. *Through Vegetal Being: Two Philosophical Perspectives*. New York: Columbia University Press, 2016.

Iten, Michelle. "Contemplative Practices as Rhetorical Action for Democracy." *Journal of Contemplative Inquiry* 7, no. 1 (2020): 125–51.

James, William. *Some Problems of Philosophy: A Beginning of an Introduction to Philosophy*. New York: Longmans, Green, and Co., 1916.

Jennings, Willie James. *The Christian Imagination: Theology and the Origins of Race*. New Haven, CT: Yale University Press, 2010.

Jewett, Sarah Orne. *The Country of the Pointed Firs*. In *The Country of the Pointed Firs and Other Stories*, 1–131. New York: Signet Classics, 2000.

Josephson-Storm, Jason Ā. *The Myth of Disenchantment: Magic, Modernity, and the Birth of the Human Sciences*. Chicago: University of Chicago Press, 2017.

Joyce, James. "The Dead." In *Dubliners*, edited by Robert Scholes and A. Walton Litz, 175–226. The Viking Critical Library. New York: Penguin Books, 1996.

———. *Stephen Hero*. Edited by Theodore Spencer. New York: New Directions, 1944.

Jung, Carl. "On the Relation of Analytical Psychology to Poetry." In *The Portable Jung*, edited by Joseph Campbell and translated by R. F. C. Hull, 301–22. Middlesex, UK: Penguin Books, 1984.

Kant, Immanuel. *Critique of Judgment*. Translated by Werner S. Pluhar. Indianapolis, IN: Hackett, 1987.

———. *Critique of Pure Reason: Unified Edition*. Translated by Werner S. Pluhar. Indianapolis, IN: Hackett, 1996.

Kavanagh, Patrick. "Epic." In *The Great Hunger*, 42. London: Penguin Books, 2018.

Kearney, Richard. *Anatheism: Returning to God after God*. New York: Columbia University Press, 2011.

———. "Epiphanies in Joyce." In *Global Ireland: Irish Literatures for the New Millennium*, edited by Ondřej Pilný and Clare Wallace, 147–82. Prague: Litteraria Pragensia, 2005.

———. *On Stories*. London: Routledge, 2002.

Keats, John. *Selected Poems and Letters*. Edited by Douglas Bush. Boston: Houghton Mifflin, 1959.

Kelly, Thomas A. F., ed. *Between System and Poetics: William Desmond and Philosophy after Dialectic*. Aldershot, UK: Ashgate, 2007.

Kenyon, Jane. *Collected Poems*. Saint Paul, MN: Graywolf, 2005.

Kierkegaard, Søren. *Either/Or: A Fragment of Life*. Edited by Victor Eremita. Translated by Alastair Hannay. London: Penguin Books, 1992.

———. "The Lilies of the Field and the Birds of the Air." In *Christian Discourses, Etc.*, translated by Walter Lowrie, 311–56. Princeton, NJ: Princeton University Press, 1974.

Kingsnorth, Paul. *Confessions of a Recovering Environmentalist and Other Essays*. Minneapolis, MN: Graywolf, 2017.

Knepper, Steven. "Climbing the Dark: William Desmond on Wonder, the Cave, and the Underworld." *Radical Orthodoxy: Theology, Philosophy, Politics* 5, no. 1 (March 2019): 25–46.

Knepper, Steven, and Robert Wyllie. "In the Swarm of Byung-Chul Han." *Telos* 191 (Summer 2020): 33–45.

Köhler-Ryan, Renée. *Companions in the Between: Augustine, Desmond, and Their Communities of Love*. Eugene, OR: Pickwick, 2019.

Kosky, Jeffrey L. *Arts of Wonder: Enchanting Secularity—Walter De Maria, Diller + Scofidio, James Turrell, Andy Goldsworthy*. Chicago: University of Chicago Press, 2013.

Kotva, Simone. *Effort and Grace: On the Spiritual Exercise of Philosophy*. London: Bloomsbury Academic, 2020.

Kuiper, Andrew. "Georges Bataille: The Dark Soul of the Night." *Church Life Journal*, September 14, 2018. https://churchlifejournal.nd.edu/articles/georges-bataille-the-dark-soul-of-the-night/.

Kuspit, Donald. *The End of Art*. Cambridge: Cambridge University Press, 2004.

Langer, Susanne K. *Feeling and Form: A Theory of Art*. New York: Charles Scribner's Sons, 1953.

———. *Problems of Art: Ten Philosophical Lectures*. New York: Charles Scribner's Sons, 1957.

Latour, Bruno. "Why Has Critique Run out of Steam? From Matters of Fact to Matters of Concern." *Critical Inquiry* 30, no. 2 (Winter 2004): 225–48.

Levinas, Emmanuel. *Totality and Infinity: An Essay on Exteriority*. Translated by Alphonso Lingis. Pittsburgh, PA: Duquesne University Press, 1969.

Lindley, Dwight A., III. "Gift and Mediation at the Heart of Poetry." *Communio* 45, no. 1 (Spring 2018): 146–60.

Lyotard, Jean-François. *The Inhuman: Reflections on Time*. Translated by Geoffrey Bennington and Rachel Bowlby. Stanford, CA: Stanford University Press, 1991.

Macfarlane, Robert. *Landmarks*. London: Penguin Books, 2016.

Majmudar, Amit. "Towards an Evolutionary Theory of Poetry." *Literary Matters* 12, no. 3 (Spring/Summer 2020). http://www.literarymatters.org/12-3-towards-an-evolutionary-theory-of-poetry/.

Marcel, Gabriel. *Being and Having: An Existentialist Diary*. New York: Harper Torchbooks, 1965.

———. *Creative Fidelity*. Translated by Robert Rosthal. New York: Farrar, Straus and Company, 1964.

———. *Homo Viator: Introduction to a Metaphysic of Hope*. Translated by Emma Craufurd. New York: Harper Torchbooks, 1965.

Maritain, Jacques. *Art and Scholasticism and The Frontiers of Poetry*. Translated by Joseph W. Evans. New York: Charles Scribner's Sons, 1962.

———. *The Degrees of Knowledge*. Translated by Bernard Wall and Margot R. Adamson. London: Geoffrey Bles/Centenary, 1937.

Martin, Michael. *The Incarnation of the Poetic Word: Theological Essays on Poetry & Philosophy: Philosophical Essays on Poetry & Theology*. Kettering, OH: Angelico, 2017.

Martine, Brian John. *Individuals and Individuality*. Albany: State University of New York Press, 1984.

———. "William Desmond, the Artwork, and a 'Metaxological' Understanding of Otherness." *CLIO* 20, no. 4 (1991): 335–51.

McCarraher, Eugene. *The Enchantments of Mammon: How Capitalism Became the Religion of Modernity*. Cambridge, MA: Belknap Press of Harvard University Press, 2019.

Meillassoux, Quentin. *After Finitude: An Essay on the Necessity of Contingency*. Translated by Ray Brassier. London: Continuum, 2009.

Melville, Herman. *Moby-Dick*. Norton Critical Edition. 2nd ed. Edited by Hershel Parker and Harrison Hayford. New York: W. W. Norton & Company, 2002.

Merleau-Ponty, Maurice. "Eye and Mind." Translated by Carleton Dallery. In *The Primacy of Perception: And Other Essays on Phenomenological Psychology, the*

 Philosophy of Art, History and Politics, edited by James M. Edie, 159–90. Evanston, IL: Northwestern University Press, 1971.

———. *Phenomenology of Perception*. Translated by Donald A. Landes. London: Routledge, 2012.

Milbank, John. "The Double Glory, or Paradox versus Dialectics: On Not Quite Agreeing with Slavoj Žižek." In Slavoj Žižek and John Milbank, *The Monstrosity of Christ: Paradox or Dialectic?*, edited by Creston Davis, 110–233. Cambridge, MA: MIT Press, 2009.

———. "Sublimity: The Modern Transcendent." In *Transcendence: Philosophy, Literature, and Theology Approach the Beyond*, edited by Regina Schwartz, 211–34. New York: Routledge, 2004.

———. *Theology and Social Theory: Beyond Secular Reason*. Oxford, UK: Blackwell, 1997.

Mooney, Edward F. *Living Philosophy in Kierkegaard, Melville, and Others: Intersections of Literature, Philosophy, and Religion*. New York: Bloomsbury Academic, 2020.

Morisato, Takeshi. *Faith and Reason in Continental and Japanese Philosophy: Reading Tanabe Hajime and William Desmond*. London: Bloomsbury Academic, 2019.

Morreall, John, ed. *The Philosophy of Laughter and Humor*. Albany: State University of New York Press, 1987.

Morrison, Toni. *Beloved*. New York: Vintage International, 2004.

Murdoch, Iris. *Existentialists and Mystics: Writings on Philosophy and Literature*. Edited by Peter Conradi. New York: Penguin Books, 1999.

Nagel, Thomas. "What Is It Like to Be a Bat?" *Philosophical Review* 83, no. 4 (October 1974): 435–50.

Nasr, Seyyed Hossein. *Islamic Art and Spirituality*. Albany: State University of New York Press, 1987.

———. *Man and Nature: The Spiritual Crisis in Modern Man*. Chicago: ABC International Group, 1997.

Neville, Robert Cummings. *Defining Religion: Essays in Philosophy of Religion*. Albany: State University of New York Press, 2018.

———. *Soldier, Sage, Saint*. New York: Fordham University Press, 1978.

Nietzsche, Friedrich. *Basic Writings of Nietzsche*. Edited and translated by Walter Kaufmann. New York: Modern Library, 2000.

———. *The Portable Nietzsche*. Edited and translated by Walter Kaufmann. New York: Viking, 1970.

———. *The Will to Power*. Edited by Walter Kaufmann. Translated by Walter Kaufmann and R. J. Hollingdale. New York: Vintage Books, 1968.

Nightingale, Andrea Wilson. *Spectacles of Truth in Classical Greek Philosophy: Theoria in Its Cultural Context*. Cambridge: Cambridge University Press, 2004.

Nussbaum, Martha C. *Cultivating Humanity: A Classical Defense of Reform in Liberal Education*. Cambridge, MA: Harvard University Press, 1997.

———. *The Fragility of Goodness: Luck and Ethics in Greek Tragedy and Philosophy.* Cambridge: Cambridge University Press, 1995.

O'Connor, Flannery. "A Good Man Is Hard to Find." In *Collected Works,* edited by Sally Fitzgerald, 137–53. New York: Library of America, 1988.

O'Donohue, John. *Beauty: The Invisible Embrace.* New York: Harper Perennial, 2005.

O'Regan, Cyril. "Metaphysics and the Metaxological Space of the Tradition." *Tijdschrift voor Filosofie* 59, no. 3 (September 1997): 531–49.

———. "The Poetics of Ethos: William Desmond's Poetic Refiguration of Plato." *Ethical Perspectives* 8, no. 4 (2001): 272–302.

———. "What Theology Can Learn from a Philosophy Daring to Speak the Unspeakable." *Irish Theological Quarterly* 73 (2008): 243–62.

Otto, Rudolf. *The Idea of the Holy.* Translated by John W. Harvey. London: Oxford University Press, 1958.

Pascal, Blaise. *Pensées and Other Writings.* Edited by Anthony Levi. Translated by Honor Levi. Oxford: Oxford University Press, 1999.

Pecora, Vincent P. "Always Already Sin: *Der Sündenfall* and Modernity." *Telos* 178 (Spring 2017): 143–67.

Pfau, Thomas. *Minding the Modern: Human Agency, Intellectual Traditions, and Responsible Knowledge.* Notre Dame, IN: University of Notre Dame Press, 2013.

Picard, Max. *The World of Silence.* Translated by Stanley Godman. Washington, DC: Gateway, 1988.

Pickstock, Catherine. *After Writing: On the Liturgical Consummation of Philosophy.* Oxford, UK: Blackwell, 1998.

———. *Aspects of Truth: A New Religious Metaphysics.* Cambridge: Cambridge University Press, 2020.

———. "Liturgy, Art and Politics." *Modern Theology* 16, no. 2 (April 2000): 159–80.

Pieper, Josef. *In Tune with the World: A Theory of Festivity.* Translated by Richard and Clara Winston. South Bend, IN: St. Augustine's Press, 1999.

———. *Only the Lover Sings: Art and Contemplation.* Translated by Lothar Krauth. San Francisco: Ignatius, 1990.

Plato. *Complete Works.* Edited by John M. Cooper and D. S. Hutchinson. Indianapolis, IN: Hackett, 1997.

Rahner, SJ, Hugo. *Man at Play.* Translated by Brian Battershaw and Edward Quinn. Providence, RI: Cluny Media, 2019.

Raine, Kathleen. *That Wondrous Pattern: Essays on Poetry and Poets.* Edited by Brian Keeble. Berkeley, CA: Counterpoint, 2017.

Ravaisson, Félix. *Selected Essays.* Edited by Mark Sinclair. London: Bloomsbury Academic, 2016.

Reyburn, Duncan Bruce. "Laughter and the Between: G. K. Chesterton and the Reconciliation of Theology and Hilarity." *Radical Orthodoxy: Theology, Philosophy, Politics* 3, no. 1 (September 2015): 18–51.

Rilke, Rainer Maria. "Archaic Torso of Apollo." In *The Essential Rilke*, edited and translated by Galway Kinnell and Hannah Liebmann, 33. New York: Ecco, 2000.

———. *Letters to a Young Poet*. Translated by M. D. Herter Norton. New York: W. W. Norton & Company, 2004.

Robinson, Marilynne. *Gilead*. New York: Picador, 2004.

Ross, Chanon. *Gifts Glittering and Poisoned: Spectacle, Empire, and Metaphysics*. Eugene, OR: Cascade Books, 2014.

Rubenstein, Mary-Jane. *Strange Wonder: The Closure of Metaphysics and the Opening of Awe*. New York: Columbia University Press, 2008.

Sammon, Brendan Thomas. *Called to Attraction: An Introduction to the Theology of Beauty*. Eugene, OR: Cascade Books, 2017.

Sartre, Jean-Paul. *Being and Nothingness: A Phenomenological Essay on Ontology*. Translated by Hazel E. Barnes. New York: Washington Square, 1992.

Scarry, Elaine. *On Beauty and Being Just*. Princeton, NJ: Princeton University Press, 1999.

Schiller, Friedrich. *Letters on the Aesthetic Education of Man*. Translated by Elizabeth M. Wilkinson and L. A. Willoughby. In *Friedrich Schiller: Essays*, edited by Walter Hinderer and Daniel O. Dahlstrom, 86–178. New York: Continuum, 1998.

Schindler, D. C. *Love and the Postmodern Predicament: Rediscovering the Real in Beauty, Goodness, and Truth*. Eugene, OR: Cascade Books, 2018.

Schopenhauer, Arthur. *The World as Will and Representation*. 2 vols. Translated by E. F. J. Payne. New York: Dover, 1966.

Schwartz, Regina Mara. *Loving Justice, Living Shakespeare*. Oxford: Oxford University Press, 2016.

Serres, Michel. *The Five Senses: A Philosophy of Mingled Bodies*. Translated by Margaret Sankey and Peter Cowley. London: Bloomsbury Academic, 2016.

Shakespeare, William. "18." In *Shakespeare's Sonnets and A Lover's Complaint*, edited by Stanley Wells, 32. Oxford: Oxford University Press, 2003.

———. *King Lear*. Folger Shakespeare Library. Edited by Barbara A. Mowat and Paul Werstine. New York: Simon & Schuster, 2016.

———. *Macbeth*. Folger Shakespeare Library. Edited by Barbara A. Mowat and Paul Werstine. New York: Simon & Schuster, 2013.

Shaw, Philip. *The Sublime*. 2nd ed. London: Routledge, 2017.

Shelley, Percy Bysshe. "The Flower That Smiles Today." In *Shelley's Poetry and Prose*, edited by Donald H. Reiman and Sharon B. Powers, 441–42. Norton Critical Edition. New York: W. W. Norton & Company, 1977.

Shklovsky, Victor. "Art as Technique." In *Russian Formalist Criticism: Four Essays*, translated by Lee T. Lemon and Marion J. Reis, 3–24. Lincoln: University of Nebraska Press, 1965.

Simpson, Christopher Ben. *Religion, Metaphysics, and the Postmodern: William Desmond and John D. Caputo*. Bloomington: Indiana University Press, 2009.

Simpson, Christopher Ben, and Brendan Thomas Sammon, eds. *William Desmond and Contemporary Theology*. Notre Dame, IN: University of Notre Dame Press, 2017.

Slattery, Dennis Patrick. *The Wounded Body: Remembering the Markings of Flesh*. Albany: State University of New York Press, 2000.

Smith, Andrew. "Dickens' Ghosts: Invisible Economies and Christmas." *Victorian Review* 31, no. 2 (2005): 36–55.

Soyinka, Wole. *Myth, Literature and the African World*. Cambridge: Cambridge University Press, 1976.

Stein, Edith. *On the Problem of Empathy*. Translated by Waltraut Stein. Washington, DC: ICS, 1989.

Steiner, George. *Grammars of Creation*. New Haven, CT: Yale University Press, 2001.

———. *Language and Silence: Essays on Language, Literature, and the Inhuman*. New York: Atheneum, 1967.

———. "A Note on Absolute Tragedy." *Literature and Theology* 4, no. 2 (July 1990): 147–56.

———. *The Poetry of Thought: From Hellenism to Celan*. New York: New Directions, 2011.

———. *Real Presences*. Chicago: University of Chicago Press, 1991.

———. "'Tragedy,' Reconsidered." *New Literary History* 35, no. 1 (Winter 2004): 1–15.

Stewart, Haley. "The Sham Practice of Christmas." *Church Life Journal*, December 12, 2018. https://churchlifejournal.nd.edu/articles/the-sham-practice-of-christmas/.

Summit, Jennifer, and Blakey Vermeule. *Action versus Contemplation: Why an Ancient Debate Still Matters*. Chicago: University of Chicago Press, 2018.

Sweeney, Terence. "Claude McKay's Catholic Poetics and Politics." *Church Life Journal*, February 1, 2022. https://churchlifejournal.nd.edu/articles/claude-mckays-catholic-politics/.

———. "Ways to God: William Desmond's Recapitulation of Thomas Aquinas's Five Ways." *Philosophy and Theology* 32, nos. 1–2 (2020): 149–72.

Tanner, Sonja Madeleine. *Plato's Laughter: Socrates as Satyr and Comical Hero*. Albany: State University of New York Press, 2017.

Taylor, Charles. *The Language Animal: The Full Shape of the Human Linguistic Capacity*. Cambridge, MA: Belknap Press of Harvard University Press, 2016.

———. *A Secular Age*. Cambridge, MA: Belknap Press of Harvard University Press, 2007.

———. *Sources of the Self: The Making of the Modern Identity*. Cambridge, MA: Harvard University Press, 1989.

Thurman, Howard. *For the Inward Journey: The Writings of Howard Thurman*. Edited by Anne Spencer Thurman. San Diego, CA: Harcourt Brace Jovanovich, 1984.

Tigges, Wim, ed. *Moments of Moment: Aspects of the Literary Epiphany*. Amsterdam: Rodopi, 1999.

Tyson, Paul G. "The Politics of the Metaphysical Imagination. Critiquing Transnational Corporate Power via Plato's Cave." *Im@go: A Journal of the Social Imaginary* 1, no. 6 (2015): 151–70.
Vanden Auweele, Dennis. "Sacredness and Aesthetics: Kearney and Desmond on Prayer." *Modern Theology* 37, no. 1 (January 2021): 3–22.
Vanden Auweele, Dennis, ed. *William Desmond's Philosophy between Metaphysics, Religion, Ethics, and Aesthetics: Thinking Metaxologically.* Cham, Switzerland: Palgrave Macmillan, 2018.
Vaught, Carl G. *The Quest for Wholeness.* Albany: State University of New York Press, 1982.
Verene, Donald Phillip. *Hegel's Absolute: An Introduction to Reading the Phenomenology of Spirit.* Albany: State University of New York Press, 2007.
———. *The Philosophy of Literature: Four Studies.* Eugene, OR: Cascade Books, 2018.
Vico, Giambattista. *The New Science of Giambattista Vico.* Translated by Thomas Goddard Bergin and Max Harold Fisch. Ithaca, NY: Cornell University Press, 1988.
Walsh, David. *Politics of the Person as the Politics of Being.* Notre Dame, IN: University of Notre Dame Press, 2016.
Weil, Simone. "Forms of the Implicit Love of God." In *Waiting for God*, translated by Emma Craufurd, 137–215. New York: Perennial Library, 1973.
———. "Morality and Literature." Translated by Richard Rees. In *The Simone Weil Reader*, edited by George A. Panichas, 290–95. Wakefield, RI: Moyer Bell, 1999.
Weiss, Paul. *Emphatics.* Nashville, TN: Vanderbilt University Press, 2000.
———. "Reply to William Desmond." In *The Philosophy of Paul Weiss*, 558–64. Edited by Lewis Edwin Hahn. Chicago: Open Court, 1995.
Westphal, Merold. "William Desmond's Humpty Dumpty Hegelianism." *CLIO* 20, no. 4 (1991): 353–70.
Whitehead, Alfred North. "Immortality." In *The Philosophy of Alfred North Whitehead*, edited by Paul Arthur Schilpp, 682–700. New York: Tudor, 1951.
———. *Science and the Modern World.* New York: Mentor, 1952.
Whitman, Walt. "When I Heard the Learn'd Astronomer." In *The Portable Walt Whitman*, edited by Michael Warner, 249–50. New York: Penguin Books, 2004.
Wilshire, Bruce W. *The Much-at-Once: Music, Science, Ecstasy, the Body.* New York: Fordham University Press, 2016.
Wilson, James Matthew. *The Vision of the Soul: Truth, Goodness, and Beauty in the Western Tradition.* Washington, DC: Catholic University of America Press, 2017.
Wirzba, Norman. *From Nature to Creation: A Christian Vision for Understanding and Loving Our World.* Grand Rapids, MI: Baker Academic, 2015.
Woodward, Richard B. "Cormac McCarthy's Venomous Fiction." *The New York Times Magazine*, April 19, 1992. https://archive.nytimes.com/www.nytimes.com/books/98/05/17/specials/mccarthy-venom.html.

Wordsworth, William. *Selected Poems*. Edited by Stephen Gill. London: Penguin Books, 2004.
Wyllie, Robert. "The Discourses on Wonder: Foundations of Kierkegaard's Metaphilosophy and Political Theory." *Søren Kierkegaard Newsletter* 64 (2015): 7–18.
Žižek, Slavoj. *The Sublime Object of Ideology*. London: Verso, 1989.

Name Index

Abram, David, 24–25, 26, 232n7
Adorno, Theodor, 63, 122, 152, 218n11, 238n107
Aeschylus, 170
Agamben, Giorgio, 226n46
Akhmatova, Anna, 79
Alighieri, Dante, *see* Dante
Anderson, Amanda, 239n13
Anselm of Canterbury, 234n36, 235n62
Aquinas, Thomas, 3, 26, 47, 48, 89, 105, 108, 111, 223n87, 224n6, 234n49, 236n69, 236n75
Aristophanes, xv, 188–93, 205, 245n13, 247n36, 247n42, 247n54
Aristotle, 3, 4, 65, 86, 89, 141–42, 159–60, 169–71, 173, 176, 180, 208, 217n9, 222n70, 223n85, 225n30, 228n8, 241n44, 244n27, 246n19, 247n38
Arnold, Matthew, 121–22, 123
Asad, Talal, 236n72
Auden, W. H., 79, 184–85
Augustine of Hippo, 17, 18, 27, 32, 98, 111, 112, 138, 166, 218n9, 235n62, 236n67
Aurobindo, Sri, 232n5

Bach, Johann Sebastian, 64
Bacon, Francis, 70–71

Bakhtin, Mikhail, 87, 189–90, 192, 194, 195–97, 246n21, 248n61
Baldwin, James, 7, 146–48
Balthasar, Hans Urs von, 7, 15, 35, 68, 98, 109, 232n13, 236n69, 236n82, 237n102
Barthes, Roland, 87, 230n47
Bataille, Georges, 58, 225n33, 226n49, 226n50, 226n51, 233n26, 245n12, 245n13
Baudelaire, Charles, 85, 152
Beckett, Samuel, 126, 247n50
Benjamin, Walter, 102
Bennett, Jane, 219n22
Bentham, Jeremy, 122
Bergson, Henri, 176–77
Berry, Wendell, 157–58, 220n44, 233n33
Betz, John, 217n10
Biran, Maine de, 219n22
Blake, William, 60, 122, 152
Bloom, Harold, 89–91, 231n58, 231n71, 231n73, 244n26
Blumenberg, Hans, 234n36
Bonaventure, 235n62
Brontë, Anne, 157
Brontë, Charlotte, 157
Brontë, Emily, 157
Buber, Martin, 18, 69, 145, 221n54, 236n65

Burke, Edmund, 52–54, 123
Busca, Antonio, 40–41

Calderón de la Barca, Pedro, 170, 192
Camacho, Paul, 215, 238n119
Campbell, Joseph, 103
Camus, Albert, 179
Caputo, John, 234n45
Caravaggio, 40–41
Carnes, Natalie, 120–21, 221–22n59, 225n29, 227n72, 232n13, 237n86
Carpenter, Anne, 236n69, 236n82
Cassirer, Ernst, 43
Cavell, Stanley, 136, 206, 239n16
Cervantes, Miguel de, 79, 197
Cézanne, Paul, 25, 76–77, 220n44
Chaplin, Charlie, 247n42
Chateaubriand, François-René de, 123
Chekhov, Anton, 134
Chesterton, G. K., 246n20
Chrétien, Jean-Louis, 7, 62–63, 109, 120, 208–209, 224n9, 235n55
Cicero, 176
Cioran, Emil, 207
Clare, John, 157
Claudel, Paul, 86
Cohen, Hermann, 236n65
Coleridge, Samuel Taylor, 83, 85, 122, 123
Comte, Auguste, 208
Coomaraswamy, Ananda, 86, 123, 227n72
Cooper, Patrick Ryan, 233n19

Dagovitz, Alan, 184
Dalí, Salvador, 81
Dante, xv, 7, 39, 48, 89–91, 138, 163, 212–15, 231n71, 250n27
Danto, Arthur, 51–52, 71, 225n32
Darwin, Charles, 152
De Maria, Walter, 226n53

Derrida, Jacques, 205, 207, 228n82, 229n13, 245n13
Descartes, René, 3, 99
Dickens, Charles, xiv, xv, 78, 157, 192, 198–203, 229n17
Dickinson, Emily, 119
Dillard, Annie, 157
Diogenes, 70
Dionysius the Areopagite, 48, 98, 118, 232n12, 249n19
Dostoevsky, Fyodor, 7, 20, 111, 172–73, 206, 219n26, 222n71, 223n84, 224n3, 229n17
Dreyfus, Hubert, 220n36
Duchamp, Marcel, 126, 238n117
Dumas, Alexandre, 85
Duns, Ryan, 2, 19, 108, 118, 208, 219n22, 223n91, 234n45, 234n47, 236n68, 249n6
Dupree, Robert, 191

Eagleton, Terry, 123, 159–60, 169–70, 237n103, 244n27, 244n28, 244n31
Eco, Umberto, 98, 224n5, 232n13
Einstein, Albert, 108
Eliade, Mircea, 96, 151–52
Eliot, George, 63, 79, 134
Eliot, T. S., 87–88, 123, 143, 152, 231n50, 231n52, 237–38n106
Ellison, Ralph, 63, 137
Emerson, Ralph Waldo, 123, 240n35
Equiano, Olaudah, 234n34
Erasmus, Desiderius, 180, 197
Eriugena, John Scotus, 98
Euripides, 161
Evans, K. L., 184–85

Fabre, Jean-Henri, 25, 220n44
Faulkner, William, 79, 81, 87, 229n28
Felski, Rita, 7, 133–35, 154, 239n12, 239n13, 240n24

Feuerbach, Ludwig, 95
Fielding, Henry, 192
Fischart, Johann, 197
FitzGerald, Brian, 236n75
Fitzgerald, F. Scott, 138
Florensky, Pavel, 233n17
Francis of Assisi, 70–71, 91, 98, 112
Franke, William, 7, 114–20, 237n87, 237n96
Freud, Lucian, 70
Freud, Sigmund, 58, 65, 95, 135, 176, 212, 214, 239n8, 245n12
Frey, Jennifer, 222n63
Frost, Robert, 51, 237–38n106
Frye, Northrop, 83, 135, 192, 196–97, 229n12, 239n11, 241n63, 247n37, 247n42, 247n46
Fuseli, Henry, 85

Gadamer, Hans-Georg, 81, 88, 124, 138, 195, 197, 231n52, 239n9, 248n66, 248n75
Gaines, Ernest, 157
Gauguin, Paul, 85
Gautier, Théophile, 85
Gibson, Richard Hughes, 201, 202
Gill, Eric, 123
Girard, René, 17, 195
Goethe, Johann Wolfgang von, 64, 170, 228n2
Gonzales, Philip John Paul, 7, 226n46, 237n88
Gordon, Joseph, 234n46
Gottschalk, Philip, 235n60
Graham, Loren, 233n17
Grange, Joseph, 221n51
Gray, John, 233n22
Griffioen, Sander, 235n60
Grimmelshausen, Hans Jakob Christoffel von, 197
Guevara, Luis Vélez de, 197

Hackett, William Christian, 209–10, 249n15
Hadot, Pierre, 219n22
Halliwell, Stephen, 85, 228n2, 230n42
Han, Byung-Chul, 7, 19, 49, 53–54, 102–103, 126, 195, 212, 219n17, 219n23, 220n43, 225n12, 227n74, 234n39, 238n118, 243n10, 248n67, 250n21
Hart, David Bentley, 232n13, 234n42, 235n60
Hart, Kevin, 113, 236n70, 237n87
Hawthorne, Nathaniel, 85, 170, 230n41
Heaney, Seamus, 87
Hegel, Georg Wilhelm Friedrich, xi–xii, 3, 6, 7, 29–30, 42–44, 46, 49, 57–58, 66, 74, 78, 99, 123, 144, 172, 177, 196, 207, 208, 210, 221n54, 221n57, 223n90, 223n94, 224n99, 224n4, 228n2, 229n14, 229n18, 235n60, 245n13, 247n36, 247n39, 247n45
Heidegger, Martin, 4, 14, 26, 31, 37, 41, 99, 106, 114, 121, 125, 127, 193, 207, 217n7, 218n11, 220n35, 220n36, 229n24, 234n45, 248n58
Heraclitus, 119, 208, 226n40
Herder, Johann Gottfried, 123
Heschel, Abraham Joshua, 195, 222n65
Hilary of Poitiers, 109
Hildegard of Bingen, xiv, 66, 98
Hirst, Damien, 51, 71, 225–26n33
Hobbes, Thomas, 14, 65, 176, 177, 245n12
Hölderlin, Friedrich, 114, 121, 127, 194, 197, 207
Hollander, Robert, 89–90
Holston, Ryan, 231n52
Homer, 79, 85, 90, 140, 141, 157, 196, 205

Hopkins, Gerard Manley, xiv, 7, 112–14, 132, 206, 208, 236n68, 236n69
Horkheimer, Max, 218n11
Houellebecq, Michel, 234n41
Houlgate, Stephen, 30
Hugh of Saint Victor, 98
Hugo, Victor, 85
Hulme, T. E., 152
Hume, David, 221n48, 235n52
Hurston, Zora Neale, 89, 149–50
Husserl, Edmund, 217n7
Hutcheson, Francis, 176
Hyde, Lewis, 80, 82
Hymers, John, 223n90

Irigaray, Luce, 67, 221n49, 221n54
Iten, Michelle, 219n23

Jackson, Shirley, 251n63
James, William, 24, 220n40
Jeffers, Robinson, 157
Jennings, Willie James, 234n34
Jewett, Sarah Orne, 155–56
John of the Cross, 118
Jones, David, 244n35
Josephson-Storm, Jason Ānanda, 234n35
Joyce, James, 79, 81, 100–101, 142–43, 145–46, 151–52, 153–54, 157, 197, 229n17, 229n28, 240n35, 240n37

Kandinsky, Wassily, 237n90
Kant, Immanuel, 14–15, 23, 48, 49, 52–53, 56–57, 59, 60, 99, 176, 220n38, 224n99, 225n14, 225n30, 225n31, 226n37, 234–35n50, 235n62
Kantor, Jean-Michel, 233n17
Kavanagh, Patrick, 157
Kearney, Richard, 7, 100–101, 137–39, 143, 154–55, 194, 218n3, 228n4, 233n19, 234n45, 238n121, 240n20, 240n37
Keats, John, 77–78, 79, 153
Kenyon, Jane, 51, 83, 154
Kierkegaard, Søren, 63, 116–17, 206, 207, 227n67, 247n45, 249n1, 249n11
Kingsnorth, Paul, 227n57, 238n108
Klee, Paul, 76
Klint, Hilma af, 237n90
Köhler-Ryan, Renée, 111, 166–67, 218n9, 236n67
Kojève, Alexandre, 57, 245n13
Kollwitz, Käthe, 111
Koons, Jeff, 126
Kosky, Jeffrey, 226n53
Kotva, Simone, 219n22
Kristeva, Julia, 87
Kristjánsson, Kristján, 241n44
Kuiper, Andrew, 226n50
Kusama, Yayoi, 77
Kuspit, Donald, 229–30n29

Langer, Susanne, 7, 75, 78–79, 134, 196, 229n23
Latour, Bruno, 239n7
Lawrence, D. H., 152
Lehmann, Sandra, 220–21n47
Leibniz, Gottfried Wilhelm, 3, 26
Lenin, Vladimir, 227n65
Levinas, Emmanuel, 68, 144–45, 228n83, 236n65, 241n45, 249n8
Lewis, C. S., 79
Locke, John, 31, 122, 221n48
Lombard, Peter, 236n75
Long, D. Stephen, 234n46
Lorca, Federico García, 83
Lyotard, Jean-François, 59, 226n52

Macfarlane, Robert, 242n78
Maistre, Joseph de, 123
Majmudar, Amit, 100

Malick, Terrence, 238n119
Manzoni, Piero, 81–82
Marcel, Gabriel, xiv, 6, 16, 18, 22–23, 111, 112, 144–45, 156–57, 218n15, 220n35, 221n54, 226n51, 242n83, 244n32, 249n1
Marcuse, Herbert, 152
Marder, Michael, 221n49
Marion, Jean-Luc, 217n7, 218n10
Maritain, Jacques, 108, 115, 125, 224n6
Marlowe, Christopher, 170
Márquez, Gabriel García, 79
Marsh, James, 217n10
Martin, Michael, 139, 235n56, 240n26
Martine, Brian John, 80, 133, 229n26
Marx, Karl, 95, 104, 113, 122, 152, 234n40, 247n39
Matisse, Henri, 76
McCarraher, Eugene, 234n38
McCarthy, Cormac, 87
McKay, Claude, 157, 242n81
Meillassoux, Quentin, 220–21n47
Melville, Herman, 7, 36–37, 134, 167, 180–87, 189, 222n73, 246n24, 246n25, 246n32, 246n33, 246n34, 246n35
Merleau-Ponty, Maurice, 24, 76–77, 127, 218n1, 220n36, 238n121
Merrill, James, 85
Michelangelo, 75
Milbank, John, 7, 110, 222n64, 223n83, 234n36, 235n60, 236n72, 237n88
Milosz, Czeslaw, 51, 83, 225n21
Moi, Toril, 136–37, 239n13
Molière, 192
Mondrian, Piet, 237n90
Monet, Claude, 76
More, Thomas, 180
Morisato, Takeshi, 18, 97, 219n26, 232n5, 234n47

Morreall, John, 245n3
Morris, William, 123
Morrison, Toni, 66–67
Muir, Edwin, 122
Murdoch, Iris, 7, 16, 49, 63, 78, 127, 218n10, 249n1

Nagel, Thomas, 221n49
Nasr, Seyyed Hossein, 233n28, 237n90
Neruda, Pablo, 154
Neville, Robert Cummings, 3, 217n6, 221n51, 232n5, 243n8
Newman, Barnett, 59, 226n52
Newman, John Henry, 235n62
Nietzsche, Friedrich, 18, 35, 66, 101, 114, 121, 123, 152, 161–65, 171, 177–79, 180, 190, 193–95, 205, 206, 207, 208, 212, 214, 215, 219n15, 225–26n33, 236n73, 237n104, 242n6, 242–43n7, 243n10, 243n11, 243n12, 243n13, 248n56, 250n22
Novalis, 123, 152
Nussbaum, Martha, 63, 171, 206, 244n29

O'Connor, Flannery, 150–51, 241n62
O'Donohue, John, 46, 156–57
O'Regan, Cyril, 3, 39, 96, 208, 210–11, 217n7, 218n10, 220n40, 222n70, 223n80, 226n50, 234n36, 249n14
Otto, Rudolf, 110

Paley, William, 105, 108
Parfit, Derek, 221n48
Parmenides, 31
Pascal, Blaise, 37, 38, 233n17
Pecora, Vincent, 234n37
Pfau, Thomas, 135, 233n33
Philo of Alexandria, 247n47
Picard, Max, 116, 120, 237n99

Pickstock, Catherine, 7, 44, 102, 123–24, 208, 218n10, 220–21n47, 228n82, 233n30, 238n110, 249n8
Pieper, Josef, 22, 194–97, 248n74, 248n78
Plato, xv, xvi, 3, 6, 17, 32–34, 44, 46, 48–51, 64, 83–86, 87, 96, 97, 109, 115, 116, 122, 123, 164, 173, 176–77, 180, 188, 192–93, 205, 206, 208, 209, 210–13, 222n70, 224n3, 224n9, 225n19, 225–26n33, 230n30, 230n39, 230n42, 233n30, 245n2, 247n53, 247n54, 249n1, 249n18, 249n19, 250n20
Plotinus, 3, 47, 48
Poe, Edgar Allan, 85, 230n41, 244n34
Pound, Ezra, 87, 123, 133, 152
Proust, Marcel, 100–101
Przywara, Erich, 7
Pseudo-Dionysius, *see* Dionysius the Areopagite

Quevedo, Francisco de, 197

Rabelais, François, 197
Racine, Jean, 161
Rahner, Hugo, 246n19, 247n47
Raine, Kathleen, 82, 122, 213–14
Ravaisson, Félix, 219n22, 242–43n7, 250n24
Reyburn, Duncan Bruce, 246n20
Ricœur, Paul, 138, 240n20
Rilke, Rainer Maria, 50, 63–64, 79, 83, 116, 153–54, 207, 236n82
Rimbaud, Arthur, 85
Robinson, Marilynne, 20–21
Roethke, Theodore, 83, 89, 115
Romanyshyn, Alexandra, 38, 61
Rorty, Richard, 205
Rosen, Stanley, 6
Rosenzweig, Franz, 236n65
Ross, Chanon, 248n69

Rothko, Mark, 122
Rousseau, Jean-Jacques, 207
Rubenstein, Mary-Jane, 223n88
Ruskin, John, 113, 123

Sachs, Hans, 197
Sade, Marquis de, 58
Sammon, Brendan Thomas, 97, 224n6, 232n12, 232n13
Santayana, George, 122, 237–38n106
Sartre, Jean-Paul, 35, 49, 67, 107, 136, 144, 225n13
Scarry, Elaine, 7, 46, 48, 50–53, 62, 228n82
Scheers, Peter, 221n49
Schelling, Friedrich Wilhelm Joseph, 26, 121, 123, 228n2
Schiller, Friedrich, 48–49, 121, 123, 124, 152, 225n10
Schmitt, Carl, 234n36
Schopenhauer, Arthur, 37, 47, 49, 100, 123, 152, 207, 212, 214, 215, 224n8, 245n7, 247n39, 250n22
Schubert, Franz, 64
Schuon, Frithjof, 123
Schwartz, Regina, 244n25
Scorsese, Martin, 219n19
Scotus, Duns, 3, 236n69
Serres, Michel, 220n34, 222n66
Shakespeare, William, xv, 7, 51, 78, 132, 136, 159–60, 163–73, 188, 192, 197, 206, 229n17, 243n23, 244n25, 244n26, 244n33, 245n37, 245n38, 245n17
Shaw, Philip, 55, 57, 226n48
Shelley, Mary Wollstonecraft, 170
Shelley, Percy Bysshe, 51, 152, 226n41
Shestov, Lev, 207
Shklovsky, Victor, 125, 238n115
Simpson, Christopher Ben, 29, 164, 218n14, 221n57, 234n45, 234n47, 238n119

Name Index

Slattery, Dennis Patrick, 186
Sloterdijk, Peter, 223n90
Smith, Andrew, 198, 248n83
Socrates, *see* Plato
Sophocles, 135, 142, 159, 170
Soyinka, Wole, 114, 236n74
Spinoza, Baruch, 3, 14, 31, 99
Stein, Edith, 16, 218n12
Stein, Gertrude, 207
Steiner, George, 6–7, 63–64, 66, 75, 88–91, 136, 144, 159, 169–70, 171–72, 207–208, 231n71, 231n73, 244n30, 249n3
Steiner, Rudolf, 237n90
Stendhal, 48
Stengers, Isabelle, 219n22, 221n51
Sterne, Laurence, 191
Stevens, Wallace, 237–38n106
Stewart, Haley, 198, 200, 202, 248n78
Summit, Jennifer, 219n23
Sweeney, Terence, 42, 112, 223n91, 223n93, 234n49, 242n81
Swift, Jonathan, 188–89, 205, 211–12, 247n40

Tanner, Sonja Madeleine, 176, 193, 245n2, 247n54
Taylor, Charles, 7, 41–42, 152–55, 217n4, 223n91, 240–41n43, 242n69
Thurman, Howard, 99–100
Tigges, Wim, 240n35
Tolkien, J. R. R., 79
Tolstoy, Leo, 63, 79
Toulouse-Lautrec, Henri de, 85
Turner, J. M. W., 55–56
Tutewiler, Corey Benjamin, 220–21n47
Tyson, Paul, 250n20

Vanden Auweele, Dennis, 1, 99, 233n18, 237n97
Vaught, Carl, 6, 222n73, 232n3, 233n16
Vega, Lope de, 197
Verene, Donald Phillip, 43, 209, 224n99
Vermeule, Blakey, 219n23
Vico, Giambattista, 41, 127, 209–10, 223n87, 249n13, 249n14, 249n16
Virgil, xv, 39, 89–91, 212–14
Vogler, Candace, 222n63

Wagner, Richard, 121
Walcott, Derek, 79
Walker, Alice, 89
Walsh, David, 127, 143–44, 238n120
Warhol, Andy, 229–30n29
Weber, Max, 41, 104, 234n35
Weil, Simone, 49, 51, 64, 218n10, 219n22, 225–26n33, 227n70
Weiss, Paul, 6, 76, 221n51, 228n9
West, Cornel, 207
Westphal, Merold, 29, 234n45
Whitehead, Alfred North, 3, 28, 30, 221n51, 226n41
Whitman, Walt, 78, 79
Wilde, Oscar, 124
Wilson, James Matthew, 224n6, 232n13
Wirzba, Norman, 233n28
Wittgenstein, Ludwig, 120
Woolf, Virginia, 100–101
Wordsworth, William, 24, 41, 122, 152, 157, 226n41, 240n35
Wyllie, Robert, 249n11, 250n21

Yeats, William Butler, 83, 85, 89, 122

Žižek, Slavoj, 57–58, 207, 226n46, 226n48

www.ingramcontent.com/pod-product-compliance
Lightning Source LLC
Chambersburg PA
CBHW021936140625
28084CB00013B/35